dream gardens

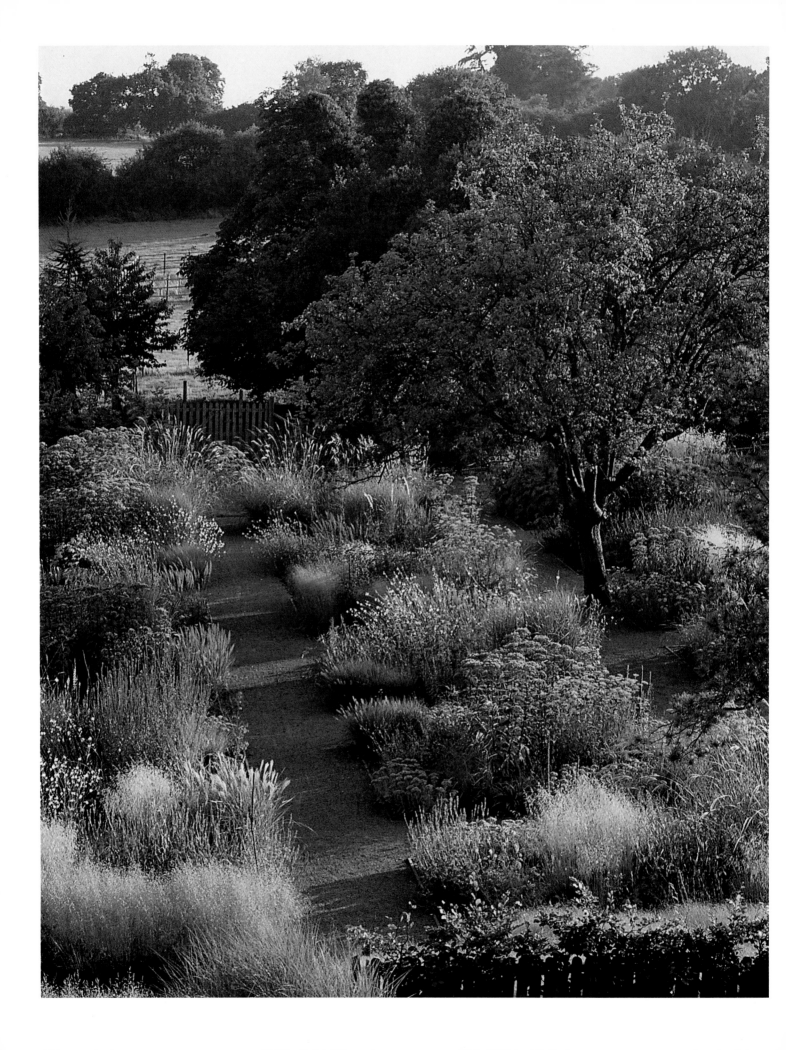

Tania Compton

Andrew Lawson

dream gardens
100 inspirational gardens

MERRELL

LONDON · NEW YORK

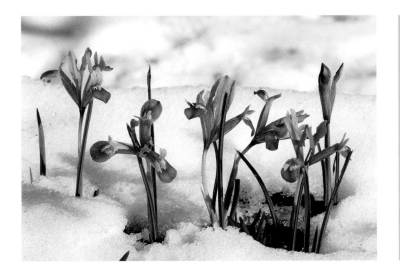

winter into spring

13

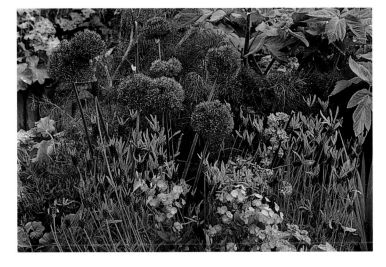

spring into summer

51

summer into autumn

233

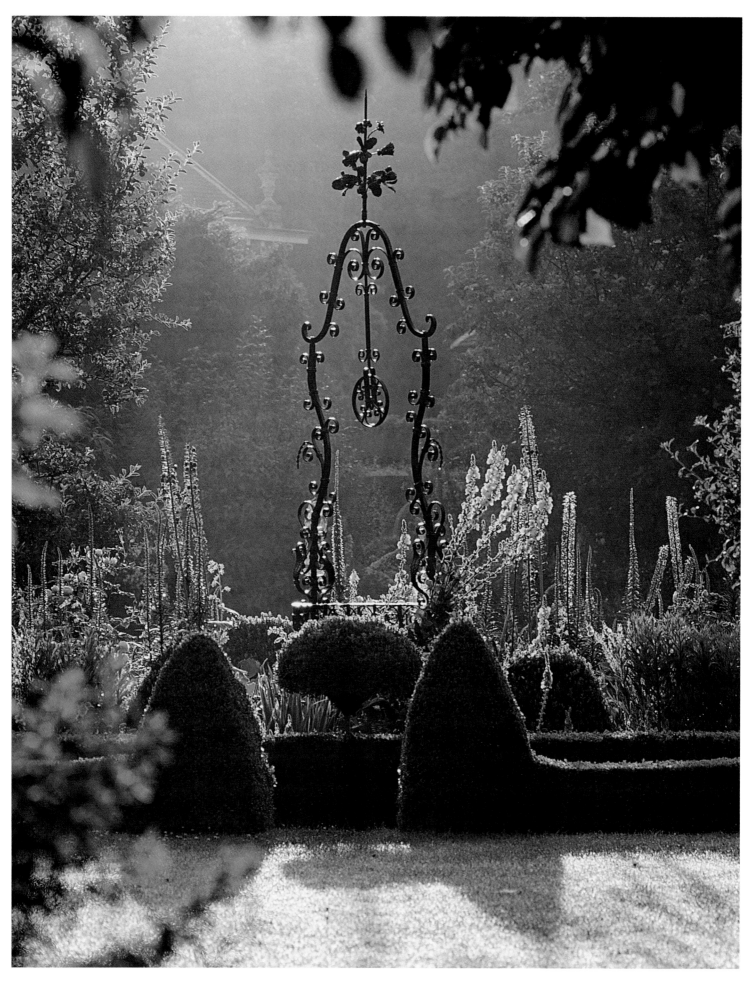

Most creative endeavours are born of a desire to turn a dream into reality. In gardening the dream that may spur the transformation of a featureless site into a garden never ends. For a garden cannot be created and simply left; it needs fine-tuning from year to year, and from season to season, because its appearance changes constantly. There is a time in every garden, however, when all the factors that make it a whole – flower beds and hedges, walls and paths, shrubs and trees, water and sculpture – come together and work a sort of magic. This book is full of such gardens, exquisite creations where fantasy becomes real.

Many people are convinced that the older a garden the more likely it is to have built up an inimitable sense of maturity and romance, with its gnarled trunks of ancient trees, hedges billowing into amorphous shapes and mellow stone seeming to teeter on the brink of being devoured by nature. By the time you get to the end of this book you will see that the patina of age is not everything: gardens in their infancy can likewise induce a dreamlike state.

Most of the one hundred gardens shown here have been photographed by Andrew Lawson over the past decade or so. Just as in our dreams we see edited versions of reality, in this book we see a distilled view of the gardens portrayed. While each garden's style and character shine through, what we see remains a snapshot frozen in time, the record of a day when Andrew rose before dawn to capture the garden in ethereal stillness. Many of the gardens appear effortless, but be warned: we are looking at horticulture at its most accomplished, and gardens that possess a haphazard beauty are

West Green House, Hampshire, see pp. 250–53.

often the hardest to maintain. What they have in common, despite their great diversity of styles, is a deft delineation of space. To achieve a harmonious balance between structure and softness, formality and informality, light and shade sounds quite enough. Add to this the necessary knowledge of plants, soil and climate and you start to understand why gardening is both science and an art form.

Dream Gardens includes exciting examples from the UK, mainland Europe, the United States and Australasia. The masterly gardens of designers Piet Oudolf in The Netherlands, Wolfgang Oehme and James van Sweden (OvS) in the US and Frank Cabot in Canada are seen beside the work of such leading British designers as Christopher Bradley-Hole and Tom Stuart-Smith. From the traditional English garden to sleek modernism, from the idiosyncratic to the classical, this book echoes the great wealth of creative talent that is such a feature of gardening today. There are gardens of exuberant plantsmanship and others with a pared-down, even monochromatic palette. Quirky gardens created by artists and sculptors sit alongside the work of influential garden designers and landscape architects who have the especially hard task of realizing not only their own dreams but also those of their clients.

To their owners and creators these gardens are sensual playgrounds where they are constantly learning about colour and form. We in turn can learn from the ways in which they have responded to a site, by creating an open panorama, for example, a glade carved out in a wood, a sensational herbaceous border or a tranquil pool. The desire to make a garden may be inspired by a longing to re-create

Hummelo, The Netherlands, see pp. 288–91.

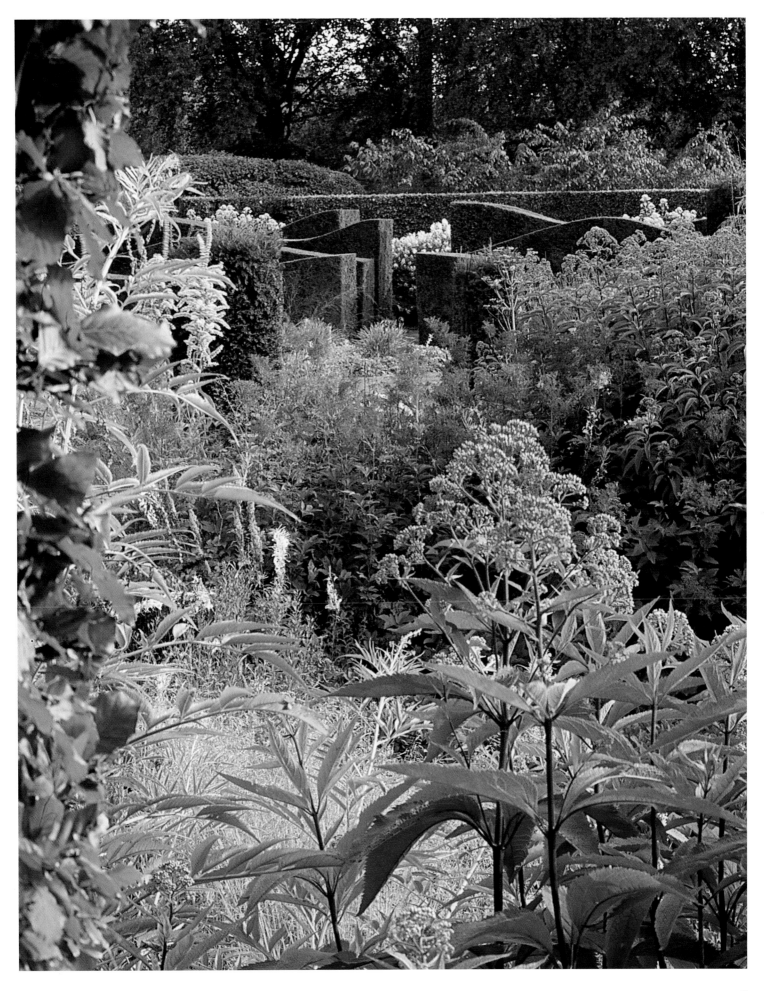

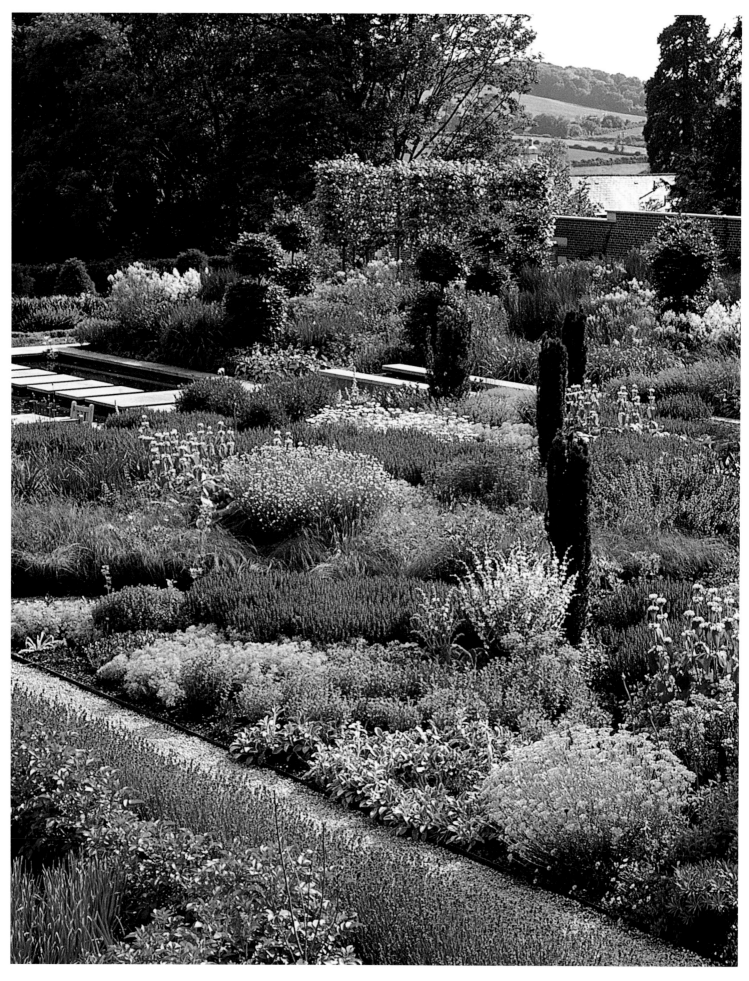

a long-lost and mysterious yet safe place for you, your children and their children. Or it could spring from a sudden passion for plants and the need to give them the space in which to thrive. But all who embark on the labour of love that is making a garden are united in the hope that theirs will have the power to transport them and their visitors briefly into a realm of fantasy.

Gardeners often dream about their own gardens. For even the most romantic among us, unfortunately, such dreams often belong to that twilight zone between sleeping and waking, and are no more than a recitation of the chores that await us rather than a delicious escape from the everyday. We lie and think of the beds that need weeding, seedlings screaming out for potting on or piles of leaves that need gathering up to make leaf mould.

By contrast, the gardens we see when we truly dream are a concoction of memories from gardens we explored as children, those we have experienced as adults and also the gardens we have seen in photographs that imprint themselves on our minds. All the gardens selected for this book have that same power both to inform and to inspire. Whether you are familiar with them or a newcomer to their delights, each is an expression of passion and commitment, the mercurial result of a time-consuming compromise between artistic vision and the forces of nature. It is my hope that this sumptuous visual feast will inspire imaginative attempts to turn garden dreams into dream gardens.

Broughton Grange, Oxfordshire, see pp. 214–17.

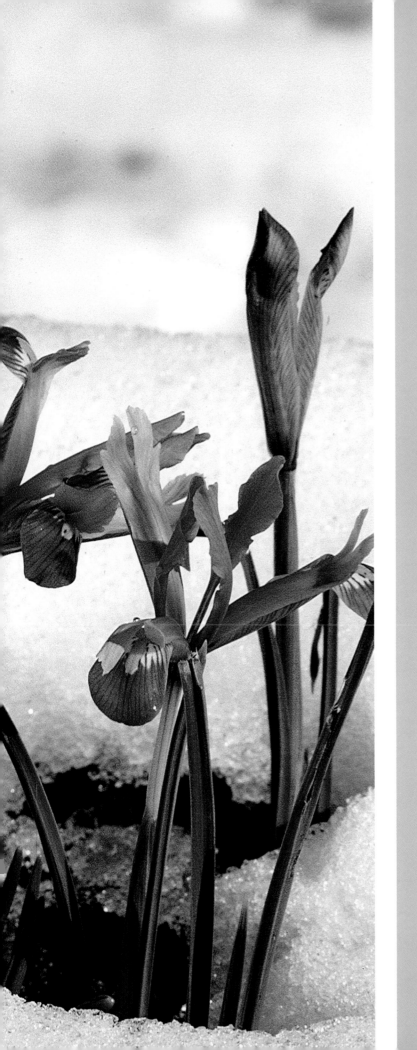

winter into spring

1

The Grove

To the late interior decorator and garden designer David Hicks, what one saw from the windows of a house was every bit as important as the furniture, objects and colours one lived with indoors. An advocate of formal structure and the textural possibilities of using green on green, he contrasted grass, yew, box, beech and hornbeam to great effect. He considered bare branches against a winter sky as important as full foliage in spring and summer, and hated to see flowers from a house, preferring to grow them in enclosures that could be glimpsed through windows cut in hedges or gaps in the tops of doors that he designed in various patterns. The element of surprise was crucial. At The Grove in Oxfordshire Hicks's theories were brought gloriously to life. This is a garden both grand and full of wit and whimsy, where neat, geometric box patterns, sweeping *allées* and avenues stretching into the landscape coexist happily with his folly, the drawbridge of which, when up, signified that he was not to be disturbed.

RIGHT, TOP Rectangular beds of box form a chic modernist parterre in front of the house. They sit below a gentle slope that leads up to a large lawn set in a frame of layered hornbeam hedges. A corner of this living frame has been clipped into a neat niche for an urn on a plinth.

RIGHT, BOTTOM An arch dating from the early nineteenth century leads from the wild garden to an *allée* of *Rosa* 'American Pillar' underplanted with honeysuckle.

OPPOSITE The two-storey castellated pavilion, reached by a drawbridge that spans a small moat, was a gift to Hicks from his wife, Pamela, on his sixtieth birthday. The windowless faces were decorated with ovals of knapped flint.

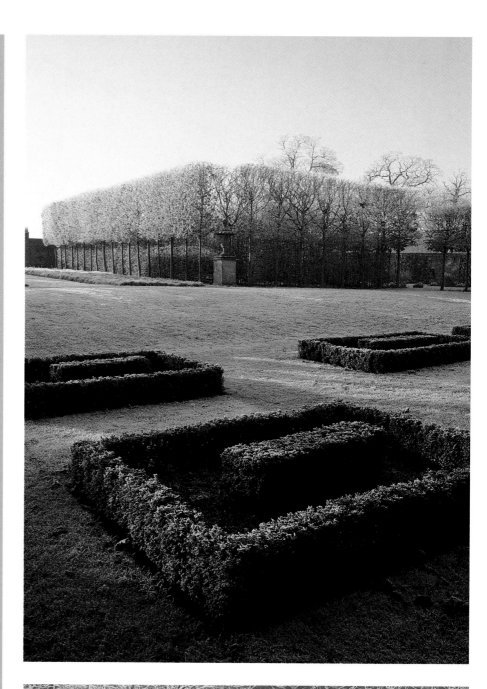

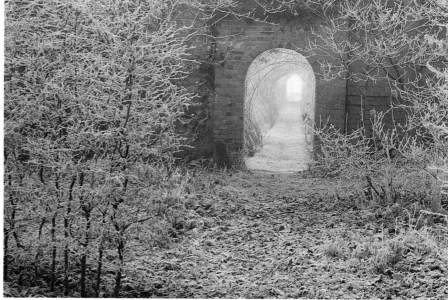

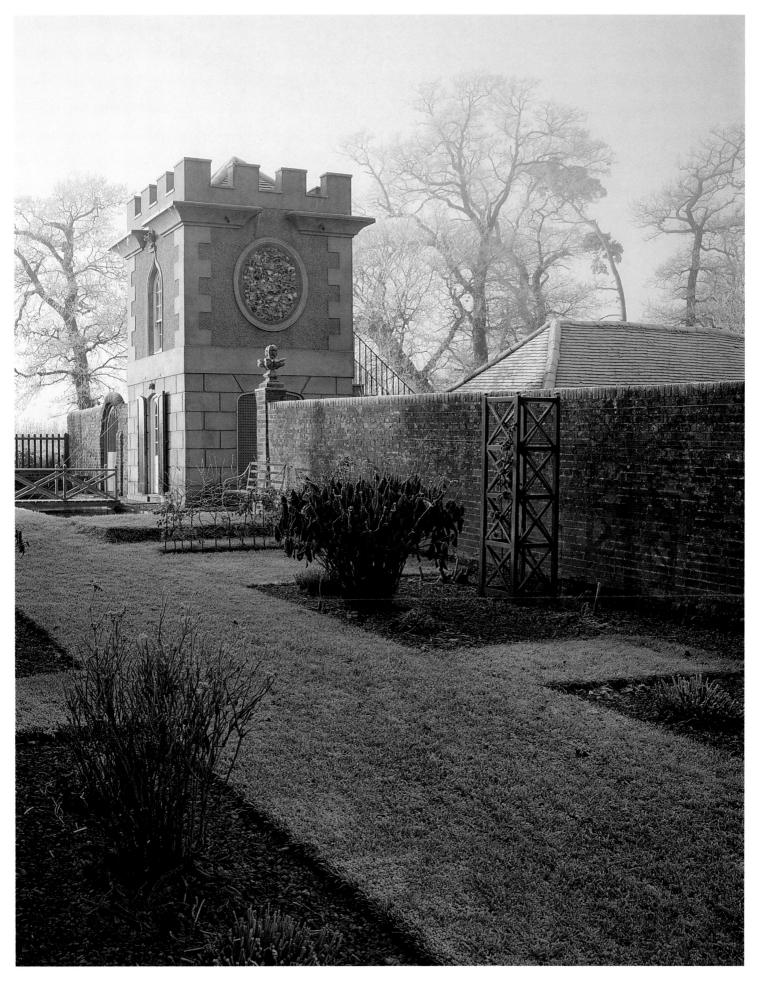

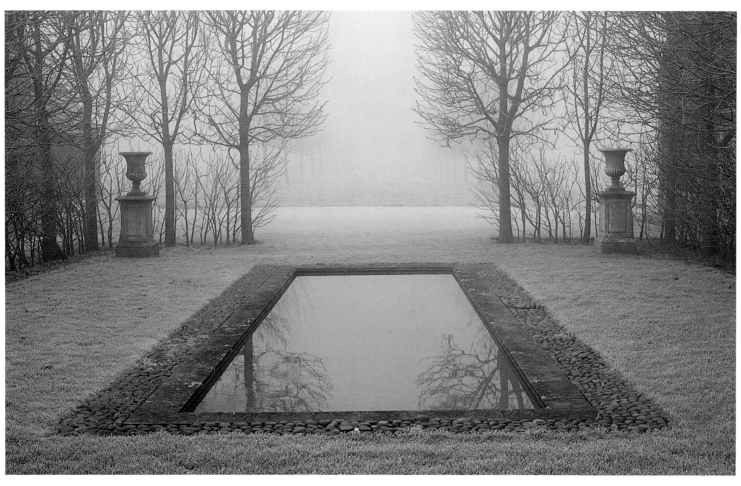

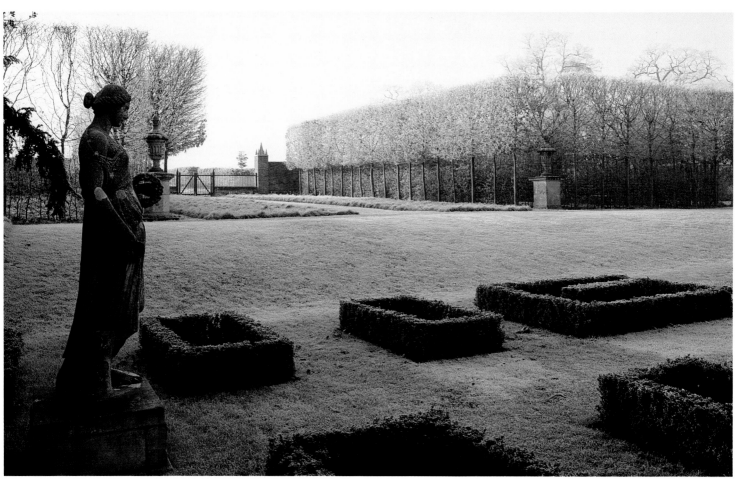

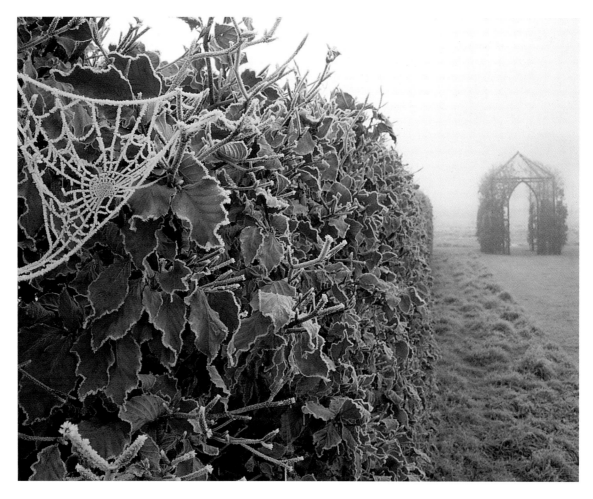

OPPOSITE, TOP This canal doubles as a swimming pool with a black-painted interior. Beyond it stand tall, L-shaped hedges of horse chestnut, *Aesculus hippocastanum*, with a gap to lead the eye into the landscape. Twin urns establish a sense of proportion and symmetry.

OPPOSITE, BOTTOM Presiding over the parterre is a statue of Flora, the Roman goddess of flowers.

ABOVE Strands of rimed cobweb cling to an imposing statue.

RIGHT, TOP A 'Gothick tent' of clipped hornbeam over a metal frame interrupts the main south-facing vista. Subtly tapering hedges increase the impression of perspective and in winter provide a textural contrast with the closely mown and rougher grass bands that direct the eye up through the vista.

RIGHT, BOTTOM The castellated pavilion is to the side of the main vista. Pointed finials on the oak posts and wall buttresses add a sharp, modern edge to the composition.

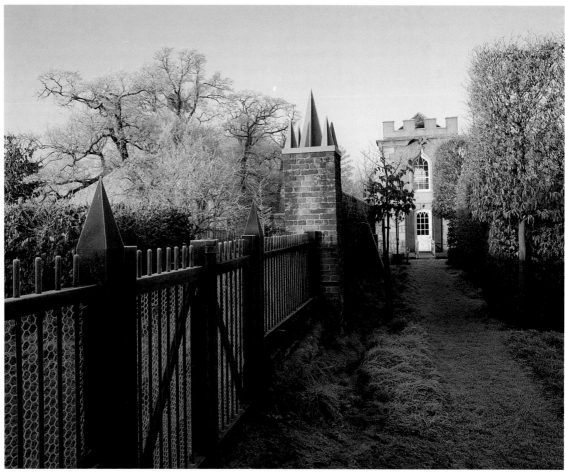

2

Rofford Manor

The true test of any garden is not how it looks in June and July, when borders are brimming and colours explode like fireworks, but how it looks through the long, cold months of winter. A garden that is impressive and immaculate whatever the season is Rofford Manor in Oxfordshire. Hilary and Jeremy Mogford, with the landscape architect Michael Balston, laid down a blueprint of walls, hedges, pleached trees and water that give the garden a neat year-round structure. The abundant topiary, which is executed in unusual and original ways, lends great texture to this garden. Geometric shapes such as rounded domes protruding from cubes are as beautiful seen from an upstairs window as at ground level, while each of the four sections of a small quatrefoil box parterre has a teardrop-shaped centre filled with lavender and a central domed knot.

Sheltered beneath a fork-limbed willow, a hut on a promontory makes an inviting vantage point in winter from which to watch the sun melt the ice on the surface of the lake. Reeds and rushes form a soft-toned rim around the water.

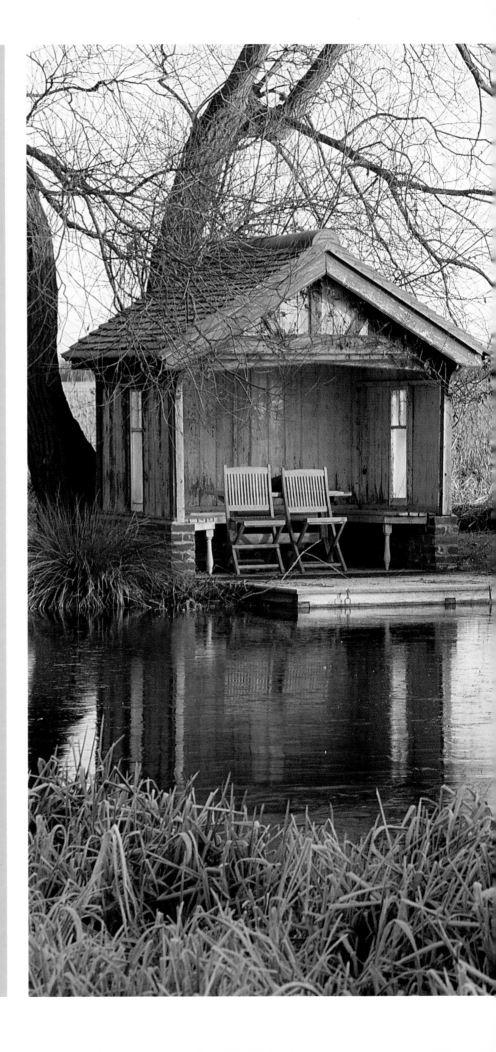

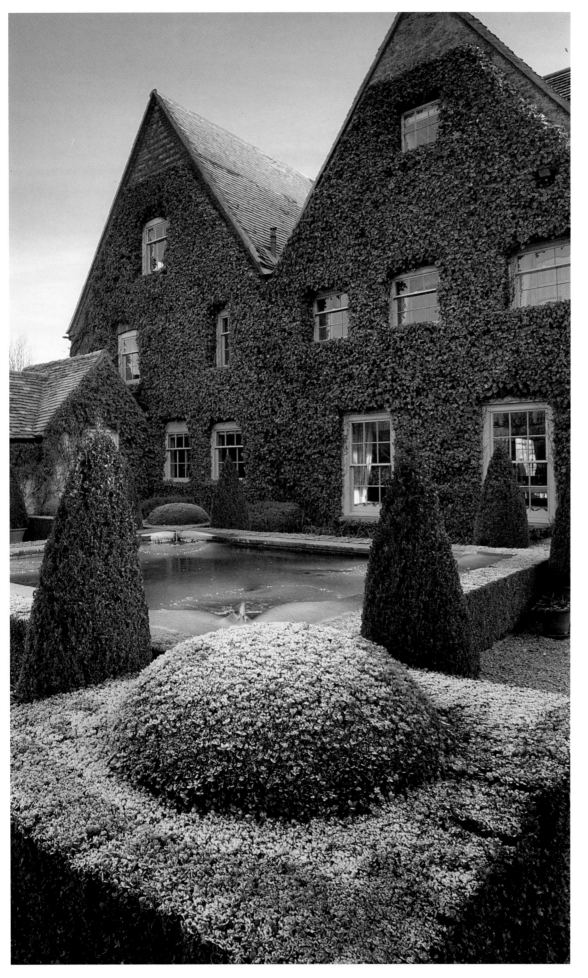

LEFT A screen of cream variegated ivy, *Hedera helix* 'Glacier', disguises the differences between the stone and brick wings of the house. At the centre of the Box Garden is a square stone pool with pyramids, domes and cubes of neatly clipped box topiary at each corner.

ABOVE, FROM TOP A well at the centre of the yard has behind it neatly pleached *Tilia platyphyllos* 'Rubra'; during hard frost a fountain at the corner of the pool is kept running.

OPPOSITE, TOP The outline of neatly trained apples and pears covers an arched metal arbour at the centre of the vegetable garden.

OPPOSITE, BOTTOM LEFT *Fatsia japonica*'s evergreen leaves coated with ice.

OPPOSITE, BOTTOM RIGHT The rimed leaves of a Brussels sprout in the potager beds.

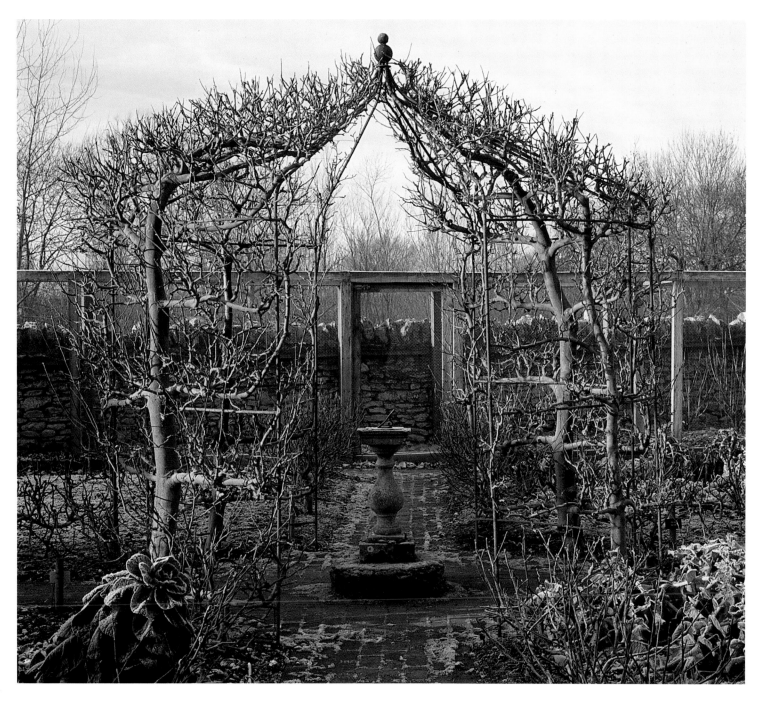

3

The Love Garden

James Ursell's Love Garden was designed as a place in which people could sit, eat, sleep and party, warmed by a central fire pit while celebrating the millennium. Fringed by a canopy of trees but open to the sky, the giant wicker-bowl-like structure was studded with images of constellations, mapped out with pots of evening-scented tobacco plants to mirror the night sky above. Because it was constructed from untreated timber, Ursell knew that in time the Garden of Love would be reclaimed by the surrounding woodland of ash, alder and hazel from which it was coppiced. The twiggy pathway leading to the clearing, at the heart of his father's Devon farm, along with the garden's oval aperture, would likewise rot back into the boggy ground. Ursell also built a nearby dining platform on the island of a tree-ringed lake with a mud oven for cooking produce from the farm and crayfish from the lake.

RIGHT, TOP In the centre was a fire pit around which guests could lie and look up at the night sky, and just above it the oval entrance.

RIGHT, BOTTOM The mud oven was built into a hollow on an island promontory on the property of Ursell's father.

OPPOSITE Under a canopy of beech, ash and hazel a coppiced twig pathway joined the Love Garden to a woodland clearing. The dynamic swirling pattern at the centre of the walk contrasted with an outer ring of twigs and the straight raised pathways.

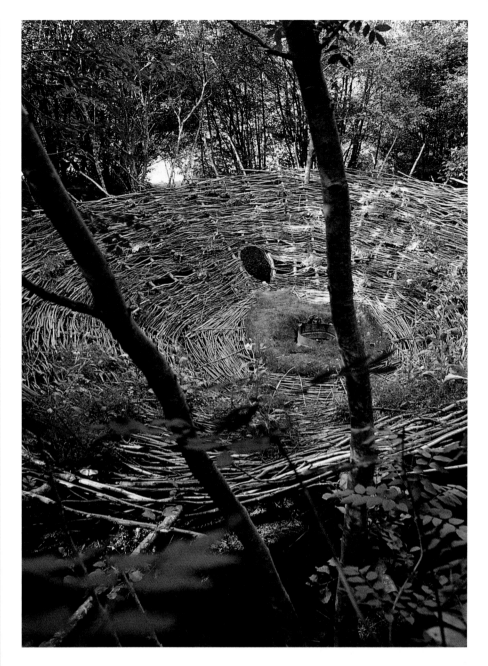

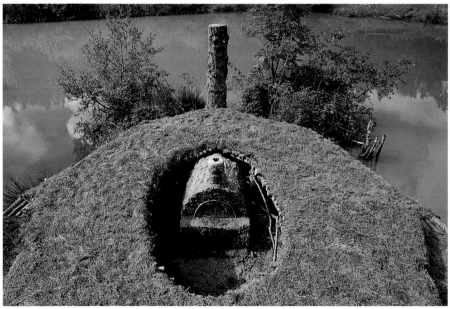

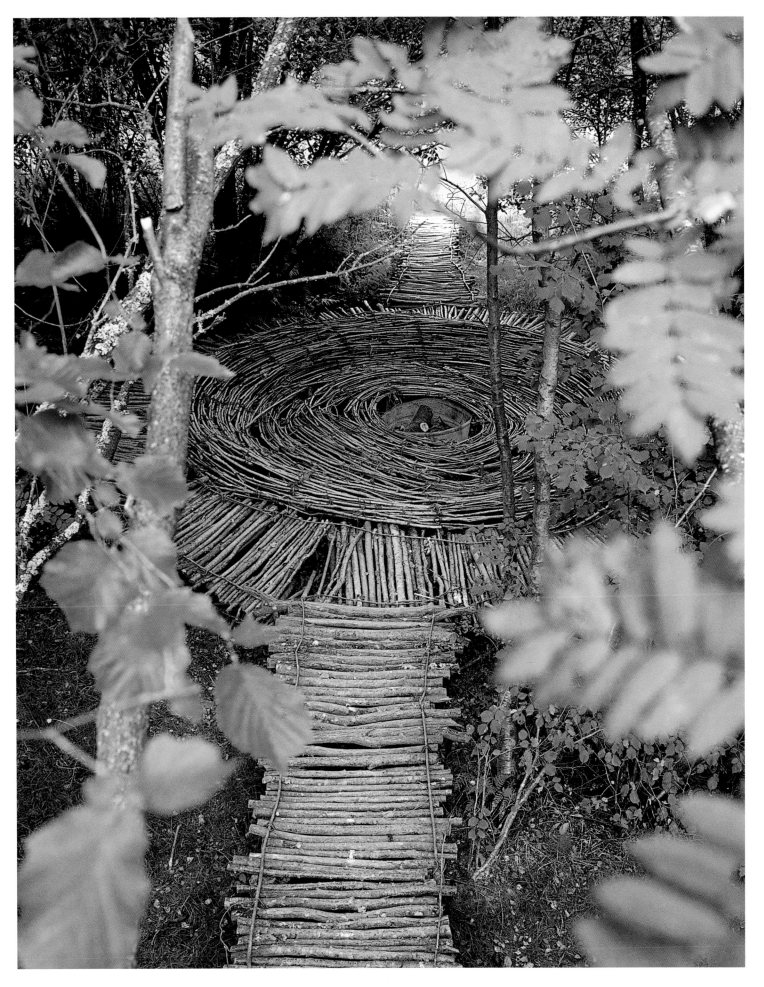

4

The Old Rectory

The deep-green backdrop of rounded box hedges, tall box columns, swelling yew topiary and ancient trees underpins the year-round success of the Gloucestershire garden of the garden designer and writer Mary Keen. Whether in deep midwinter or high summer, these provide a frame to her seasonal blazes of flowering plants. For spring the 0.8-hectare (2-acre) garden in Duntisbourne Rous is planted with exuberant displays of bulbs, pheasant's-eye narcissi in the orchard, and a kaleidoscopic range of tulips. The Summer Garden, with a vast copper planter, four sentinels of fastigiate box and clipped domes of evergreen rhamnus, is planted for late spring with a mixture of tulips that are removed after flowering so that different colour schemes can be experimented with from year to year. The spaces are filled in early summer with tender plants such as dahlias and salvias that flower until autumn. Despite the garden's complex successional planting associations, it retains a timeless atmosphere.

RIGHT Rows of florists' auriculas in their own terracotta pots line the shelves in the auricula theatre that Mary Keen has created in a converted privy. Sheltered from the rain but kept cool and carefully watered and fed, this kaleidoscopic flowering display lasts for weeks.

OPPOSITE, TOP The School Room, nestling under a mature cedar, is anchored to its sloping site by tiered yew topiary. The tall lean-to greenhouse attached to it houses a collection of scented-leaved pelargoniums. *Narcissus poeticus* var. *recurvus*, the old pheasant's-eye narcissus, grows in the grass with cowslips, jonquils and grape hyacinths.

OPPOSITE, BOTTOM The house seen through the canopy of a delicate pink double cherry *Prunus* 'Shirofugen' in The Dell.

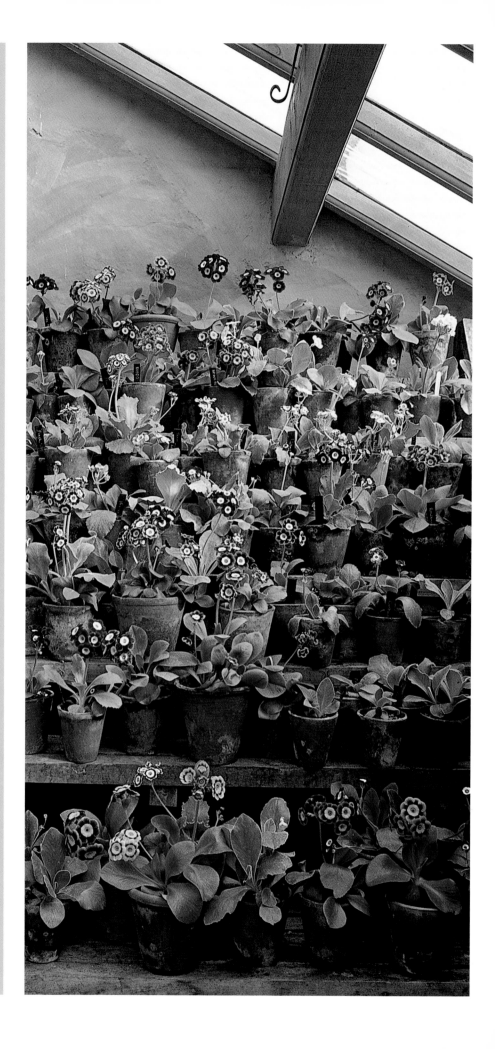

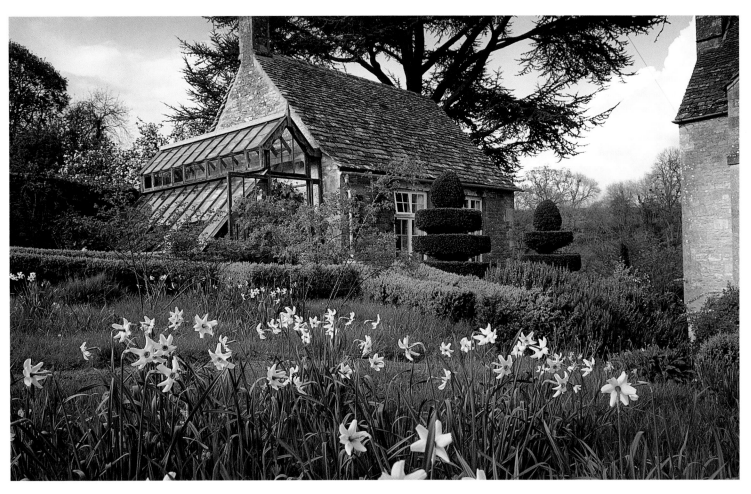

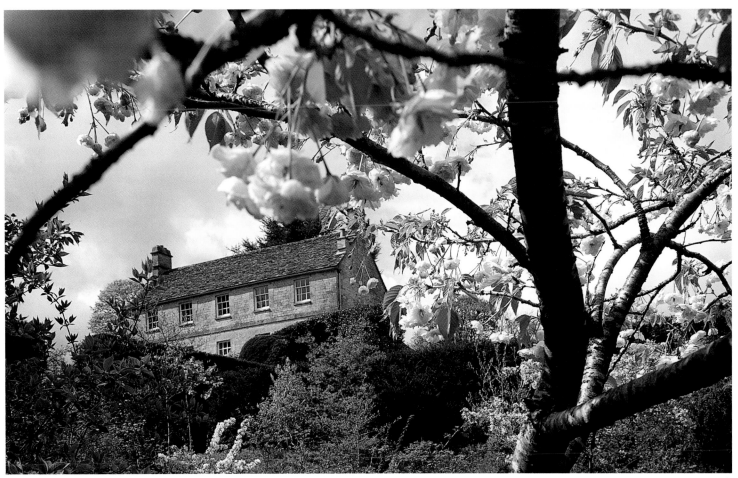

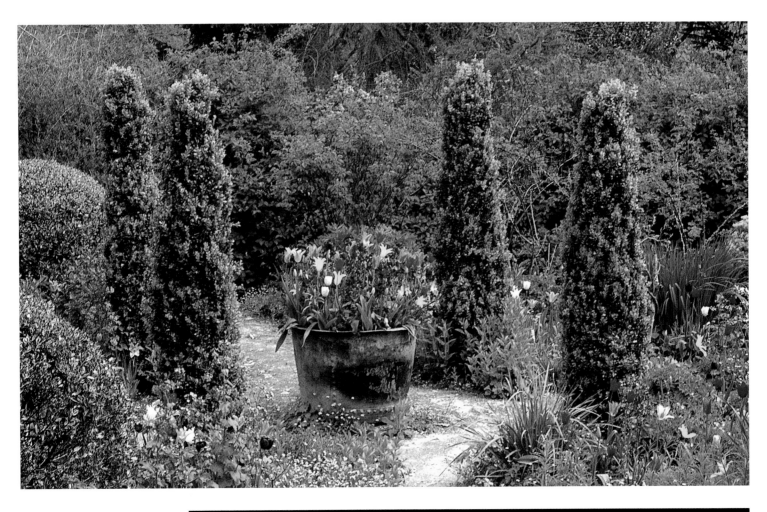

OPPOSITE A narrow border lining a wall has a jaunty spring conjunction of St Brigid anemones and the orange lily-flowered tulip 'Ballerina'.

ABOVE The large washing copper at the centre of the Summer Garden is planted with medleys of tulips and wallflowers. This spring mix included lily-flowered tulips 'Red Shine' and 'China Pink' and yellow 'West Point' with *Erysimum cheiri* 'Blood Red' and the dark-plum, almost black, tulip 'Queen of Night'. Columns of *Buxus sempervirens* 'Greenpeace' give year-round structure and balance the brightness of the tulips in spring. A good purple-flowered form of honesty is allowed to self-seed as a foil to whichever combination of tulips is selected from year to year.

RIGHT A detail of the tulips and the wallflowers in the copper.

5

The Manor House, Blewbury

The immaculate, spring-fed moat beside which thousands of pheasant's-eye narcissi now bloom each spring was an overgrown mass of saplings and arching brambles when, a decade ago, Alice and the late Malcolm Coptcoat moved into the Manor House at Blewbury in Oxfordshire. The garden's 4 hectares (10 acres) have been firmly yet sensitively taken in hand. Box-edged beds filled with silvers and soft blue, lavender, purple sage and Russian sage, *Perovskia atriplicifolia*, impressive in large blocks, complement the medieval west elevation of the house. Apricot and orange flowers in the moat border were chosen to match the mixed warm tones of the brick against which they are seen. In the young orchard a turf mount in the form of a snail's spiral shell blends seamlessly with the orchard grass, which is left to grow long after the bulbs have flowered, creating a froth of cow parsley through which mown paths meander.

RIGHT The moat's reflectiveness was sharply increased by clearing saplings and renovating the timber edging, giving more light to the orchard area of the garden.

OPPOSITE, TOP A mown path that runs parallel to the moat cuts through a swath of pheasant's-eye narcissi.

OPPOSITE, BOTTOM At a junction in the moat is a sculpture, shaded in summer by the arching leaves of *Gunnera manicata*, which is seen here flowering with pheasant's-eye narcissi in spring.

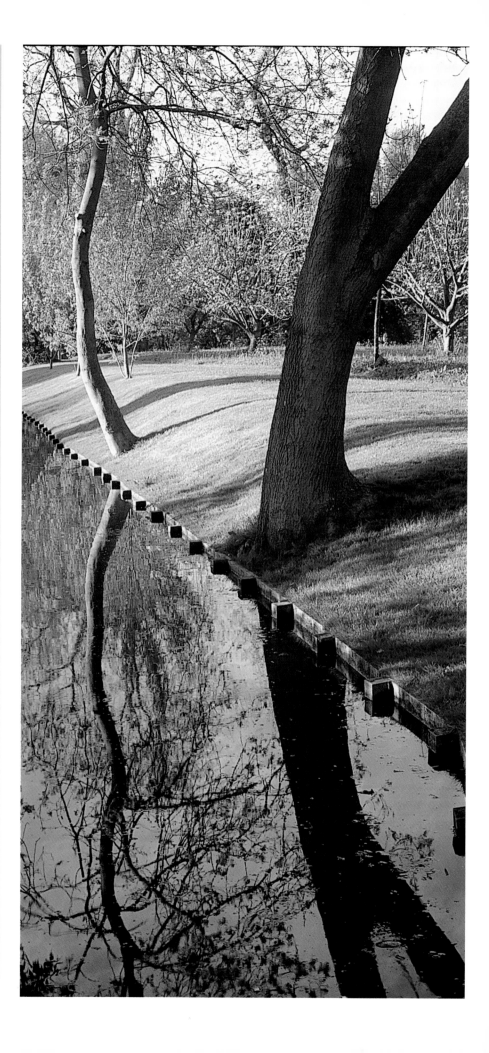

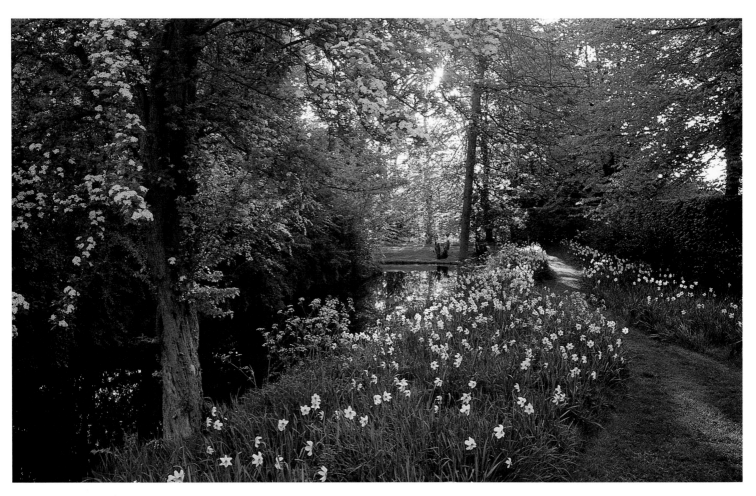

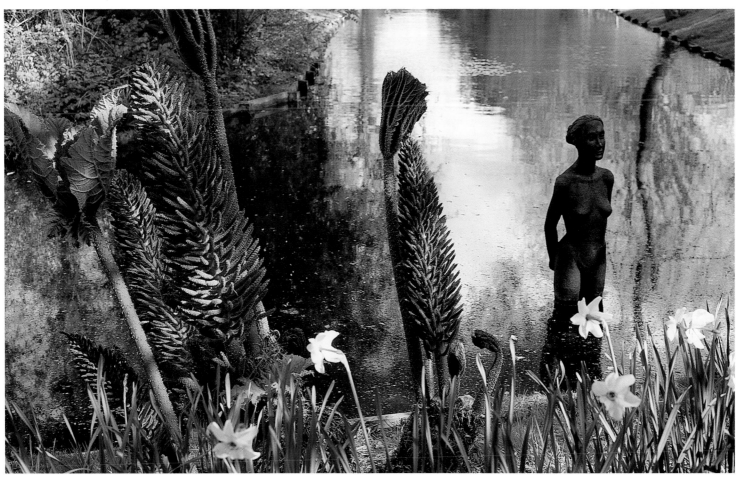

6

Glebe Cottage

The Devon garden of television presenter, writer and nurserywoman Carol Klein has an area of shady woodland that flourishes in two seasons. From early spring it is home to a wide array of bulbs, the yellowing leaves of which, as they fade in summer, are masked by the emergence of a second flush of planting, this time a thick carpet of shade-loving perennials. Some plants are chosen to act as a decorative bridge spanning both seasons: for example, the sword-shaped spears of the variegated *Iris pseudacorus* 'Variegata' are diminutive and in scale with spring bulbs when young, but become tall to contrast with the summer planting. The dense planting of white- and pale-yellow-flowered narcissi acts as a perfect foil to the exotic black-flowered fritillaries and trilliums, the impact of which would otherwise be camouflaged by bare earth. Similarly, the chartreuse-green leaves of *Milium effusum* 'Aureum' make a vivid contrast with wood anemones.

White daffodils, *Narcissus* 'Thalia', pierce a thick carpet of leaf mould in the woodland beds. The stepping-stone path that allows Klein to weed between the crowns of emerging perennials in spring will be engulfed by lush growth a few weeks later. The lime-green catkins and unfurling leaves of the coreopsis are picked up in the spurge-green spring leaves of Bowles's golden sedge, *Milium effusum* 'Aureum'.

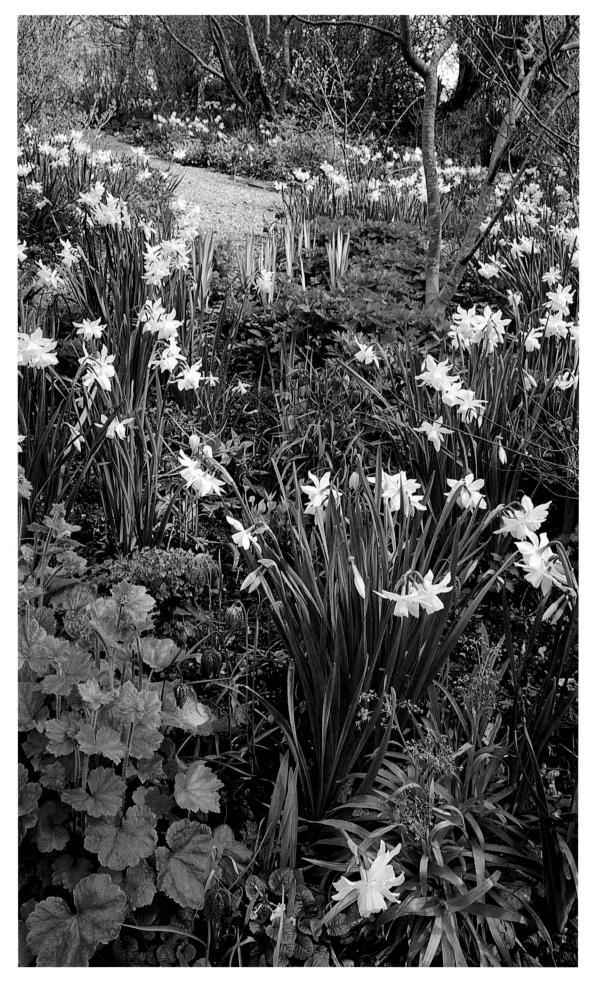

LEFT The ice-white flowers of *Narcissus* 'Thalia' set off the medley of foliage and flowers in the woodland borders. Combined with the nodding purple bells of snake's-head fritillary, *Fritillaria meleagris*, are *Tellima grandiflora*, gentian-blue *Omphalodes cappadocica* and the sword-shaped leaves of *Iris pseudacorus* 'Variegata'.

ABOVE, FROM TOP *Erythronium californicum* 'White Beauty' and a Glebe Cottage pulmonaria, *P.* 'Moonstone', with *Milium effusum* 'Aureum'; *Trillium cuneatum*.

OPPOSITE A low picket fence, painted pale blue, stands in front of a star magnolia, *M. stellata*, that is in flower with *Narcissus* 'Jenny'.

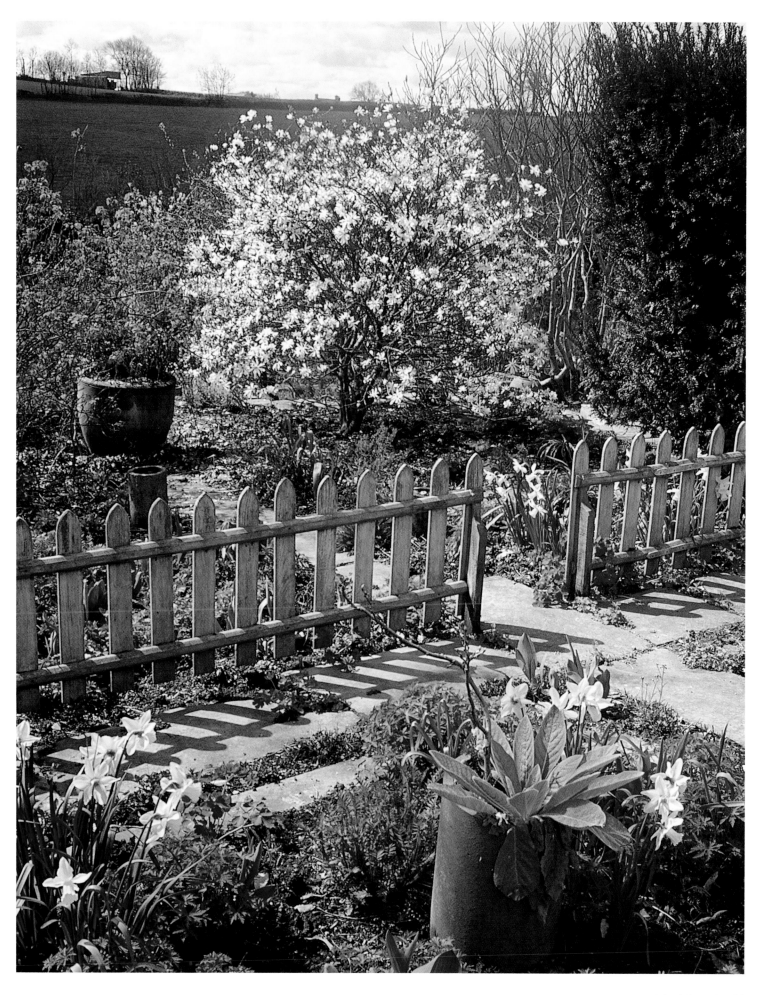

7

Ashton Wold

The late entomologist and gardener Dame Miriam Rothschild filled 60 hectares (150 acres) of her property at Ashton Wold near Peterborough with wild flowers in a determined attempt to counterbalance the devastation caused by overzealous drainage, bulldozers, fertilizers and weedkillers, which had made the countryside "reminiscent of a snooker table". Her views on conservation and her advocacy that gardeners should not battle against nature but do everything in their power to make it flourish had inestimable and enduring impact. She encouraged gardeners to see weeds in a new light and daisies in a lawn were to her "small stars spangling the grass". Exotic orchids were replaced as houseplants in favour of trays of wild flowers. The meadows at Ashton Wold, where one year 115 species of wild flower were counted in a single meadow, illustrate the aesthetic benefits of collating native wild flowers, and have educated gardeners about the benefits they have in attracting and succouring populations of birds, bees and butterflies.

RIGHT The ivy-clad gables of the house are joined by a cascade of *Wisteria sinensis* and white-flowered *Clematis montana* var. *grandiflora*.

OPPOSITE, TOP The lawn in front of the house has become a meadow of cow parsley studded with dandelions and buttercups.

OPPOSITE, BOTTOM The native gean or wild cherry, *Prunus avium*, is underplanted with a mix of delicate narcissi – yellow *Narcissus* 'Hawera' with *N.* 'Silver Chimes' and 'Thalia', both white – and blue *Anemone blanda*.

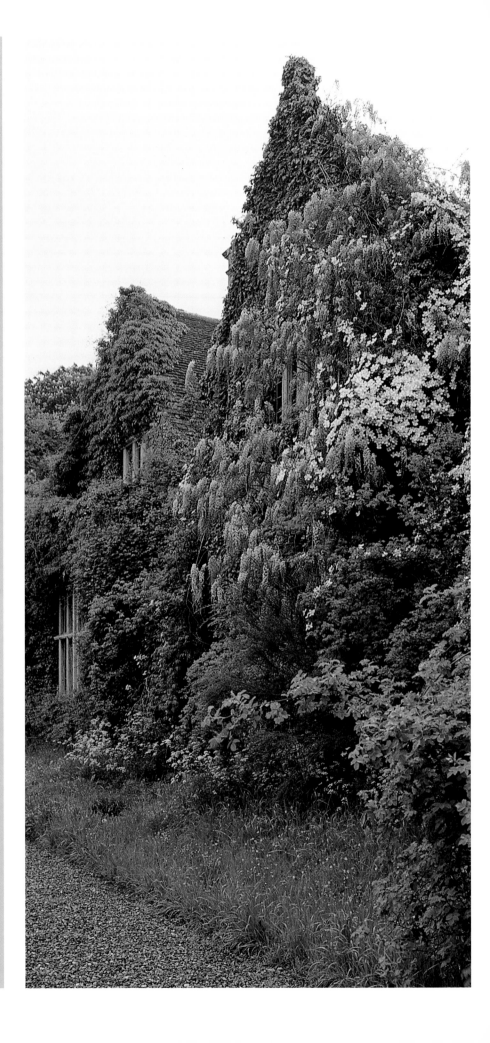

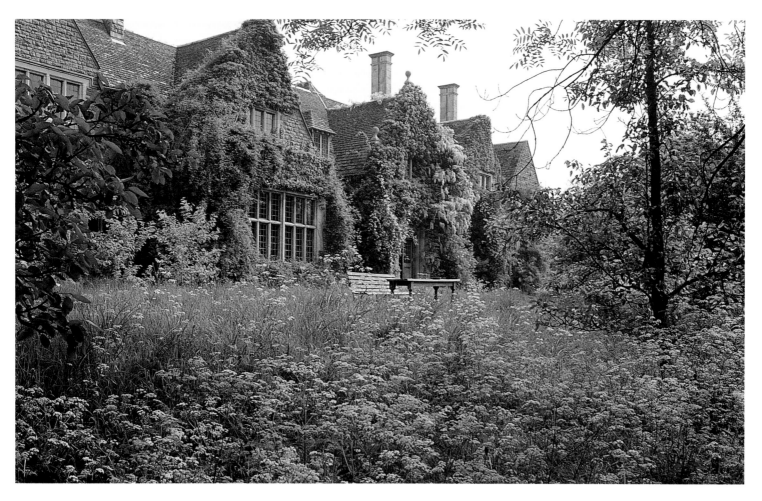

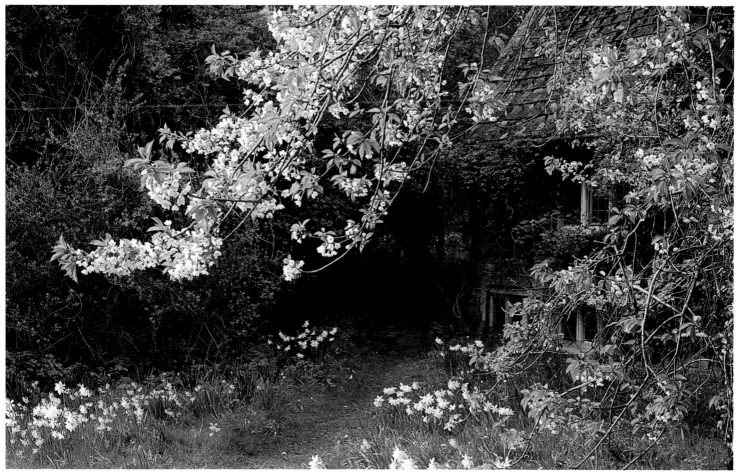

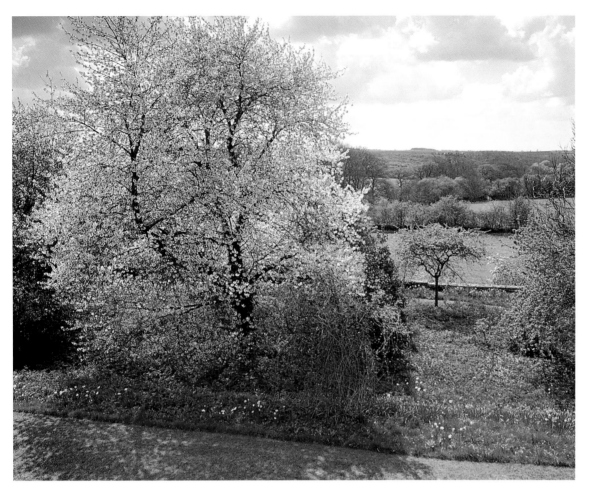

LEFT, TOP The native *Prunus avium* was chosen for both its blossom and good autumn colour and is underplanted with spring bulbs, including *Narcissus* 'Thalia'.

LEFT, BOTTOM Bluebells carpet the woods at Ashton Wold.

ABOVE, FROM TOP The soft pink of *Rosa rubiginosa* blends with the creamy umbels of the native elderflower, *Sambucus nigra*; a meadow mix of corn marigolds, cornflowers, ox-eye daisies and corncockle, *Agrostemma githago*.

OPPOSITE Wooden seed trays lining the inner sill of the dining-room windows are filled with pots of cowslips, oxlips, primroses and cuckoo flower or lady's smock, *Cardamine pratensis*.

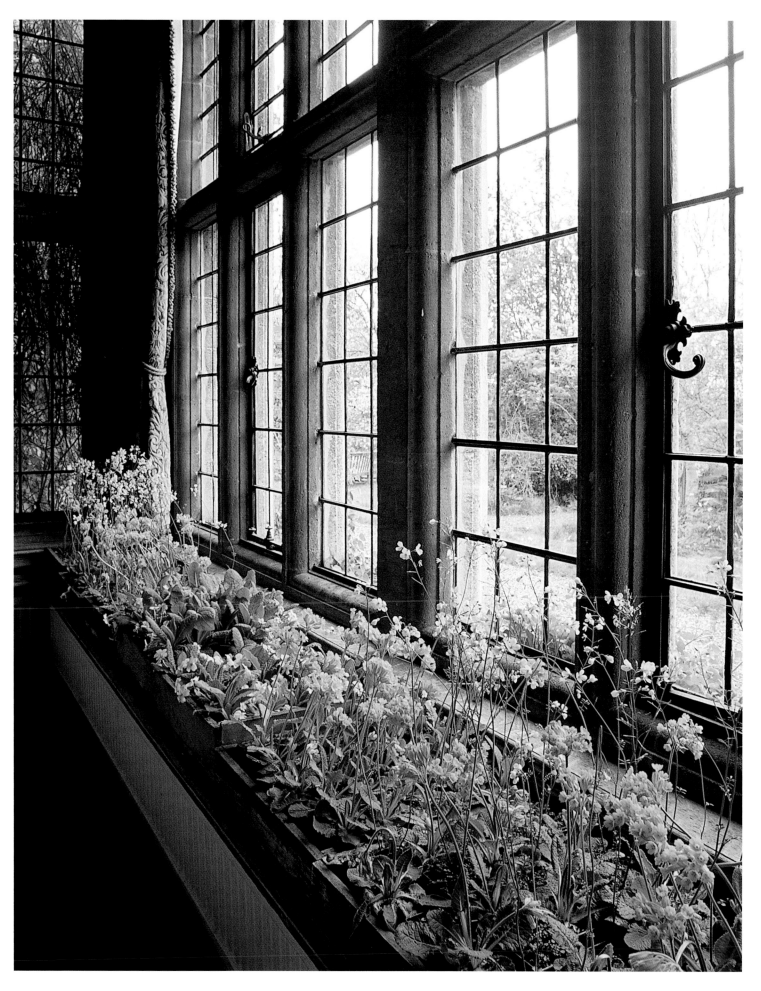

8

La Mortola

Sir Thomas Hanbury was a Victorian who used the fortune he made as a silk trader in the Far East to establish with his brother Daniel what was, by the beginning of the twentieth century, the most important private botanic garden on the French Riviera. The garden was intended as a testing ground for economic and medicinal plants from around the world, and key to its success was its situation on a rocky outcrop, with mountains on three sides and the Mediterranean stretching away to the south-east. The subtropical microclimate allowed vegetation to grow at a phenomenal rate and, even though it is a shadow of its proud late-nineteenth-century self, La Mortola remains a garden of exotic riches in one of the world's most glorious settings. Steps and terraces descend through umbrella pines, cypresses, agaves, aloes and citrus and maquis plants to the rocky shore, taking the visitor on a revelatory horticultural journey through a landscape that is half garden and half woodland.

RIGHT The rich red flowers and sculptural outline of the African aloe offset the earthy tones of the open mausoleum seen in the background. Planted alongside the aloe, with its spine-rimmed leaves, is a tall *Yucca aloifolia*.

OPPOSITE The steeply descending terrain is punctuated by the columnar shapes of cypresses planted on many of the garden's terraces.

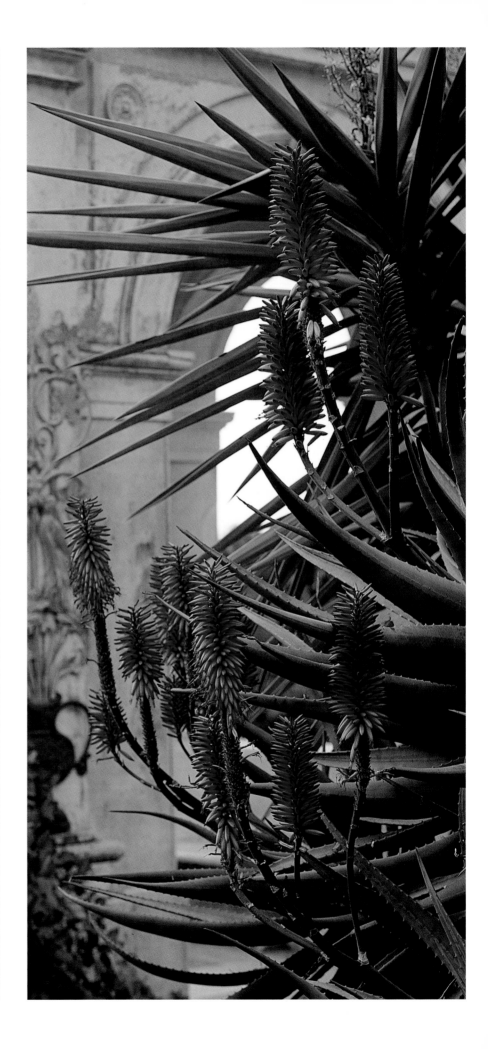

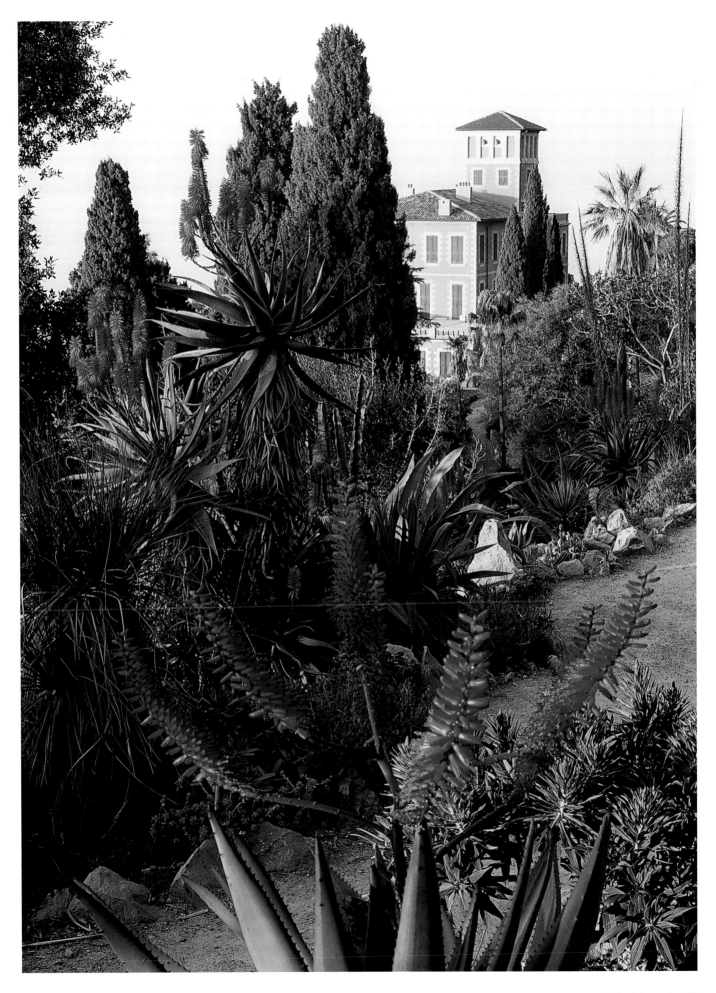

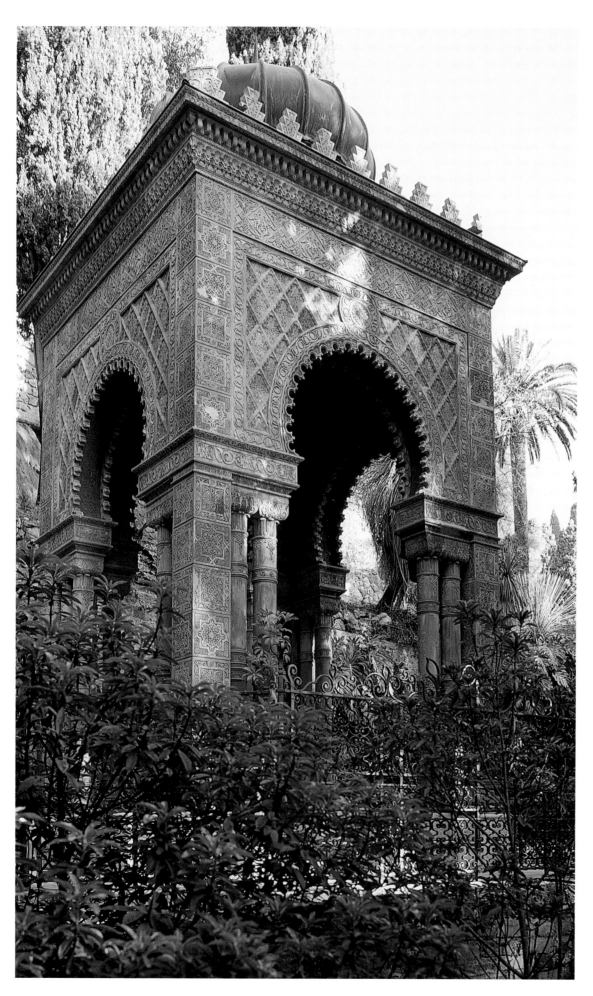

LEFT The Mughal-inspired, onion-domed mausoleum by the San Remo architect Pio Soli stands over the interred ashes of Sir Thomas and his wife Katherine Pease in the centre of the garden. Its warm terracotta limewash adds to the impression of antiquity.

OPPOSITE, CLOCKWISE FROM TOP LEFT
This tumescent bud of an aloe will burst into bright-scarlet tubular flowers; *Agave attenuata* is one of many South American agaves found throughout the garden; spiny hooks grow along the leaves of *Aloe arborescens*; among the many cacti and succulents growing in the garden's dry areas is this greyish-pink *Echeveria* 'Perle von Nürnberg'.

9

Upton Wold

Upton Wold is set in the sort of undulating Cotswold landscape that is of great beauty in a view but harder to manage in the creation of a garden. However, the owners, with the help of the landscape architects Brenda Colvin and Hal Moggridge, reorganized the space to establish areas with a formality and level lines that would match the Jacobean house yet retain a sense of openness. The natural contours of the ground were kept intact around the flat planes to lend contrast. The planting takes this mix of the wild and manicured a step further. Straight lines of pleached hornbeams that cast straight shadows over an expanse of lawn are adjacent to the slopes of an old orchard where daffodils are followed by cow parsley and long grass. A gap in the yew hedge that surrounds the canal garden, with its long, stone-edged, rectangular pool punctuated by two tall jets, leads out into an area of rough grass ending at a natural pond. At Upton Wold the contrasts never jar but instead combine to create a garden of stimulating variety.

RIGHT A gypsy caravan provides shelter and decoration in the wilder reaches of the garden. In spring a sloping meadow is covered in carpets of daffodils, such as the white 'Ice Follies' and 'February Gold'.

OPPOSITE Linking the garden to the fields beyond is a wild area with a mown path that leads through a meadow of long grass with cow parsley and buttercups.

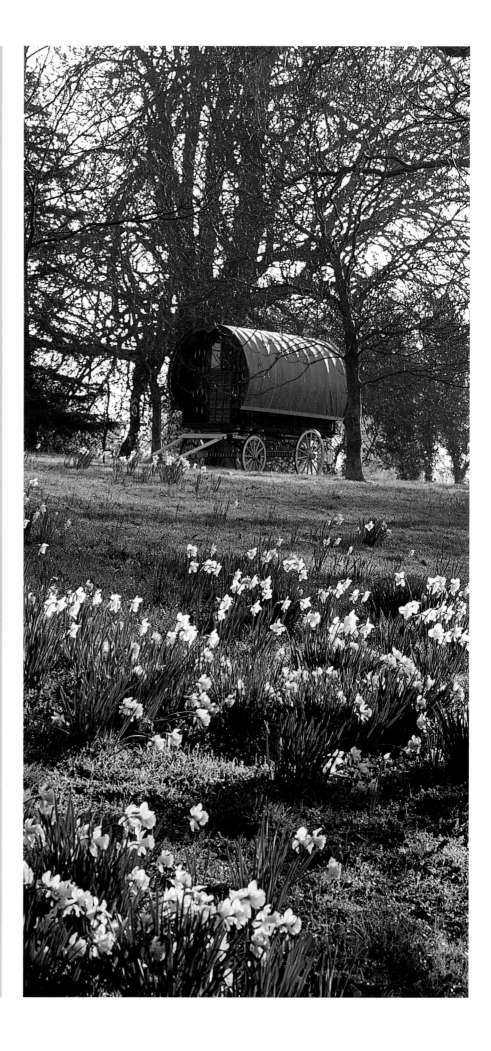

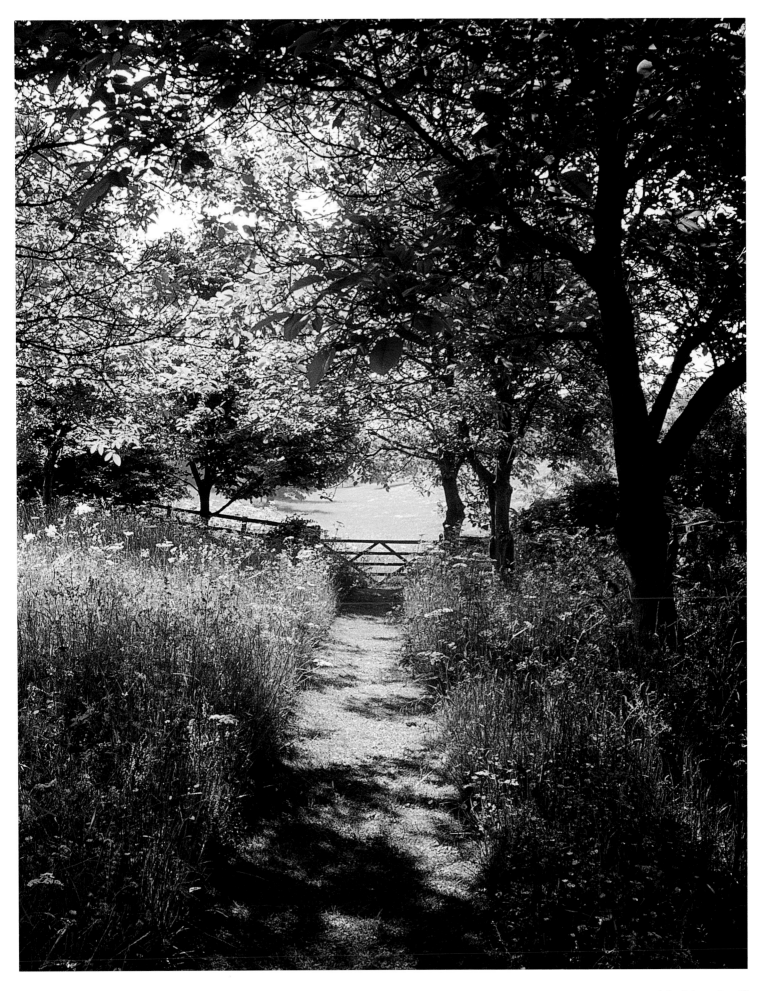

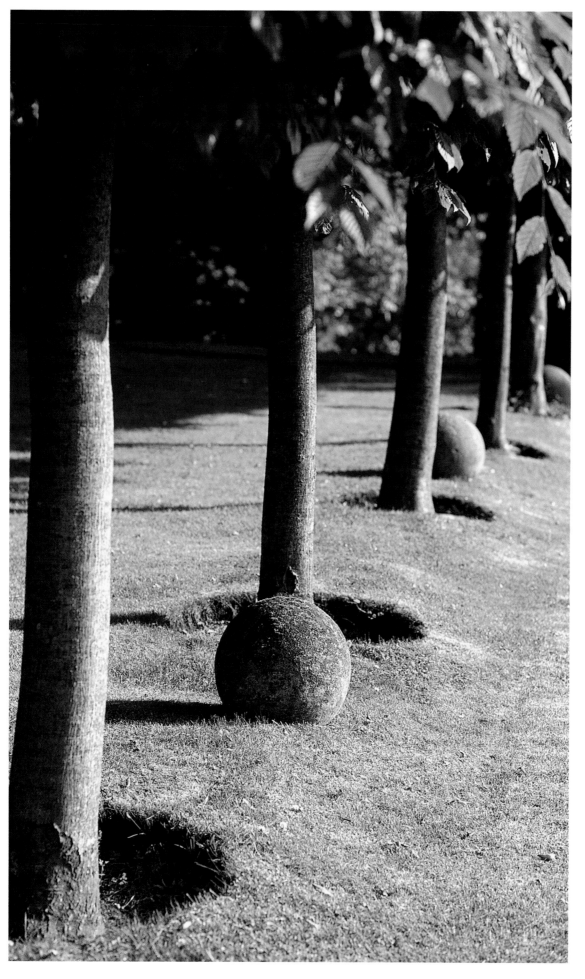

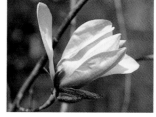

LEFT Pleached hornbeams, interspersed with stone spheres, cast bold blocks of shadow over the lawn in the fruit garden.

ABOVE, FROM TOP An assortment of *Helleborus × hybridus*, the Lenten rose; *Ribes sanguineum* 'Albidum', the white flowering currant, with *Jasminum nudiflorum*, winter jasmine; an opening bud of *Magnolia × loebneri* 'Leonard Messel'.

OPPOSITE, TOP A formal rectangular canal is enclosed within tall yew hedges.

OPPOSITE, BOTTOM A row of box balls flanks the lawn in front of the house. Rising from them, standard pompoms cast strong shadows below *Schisandra sphenanthera* that is neatly espaliered against the wall.

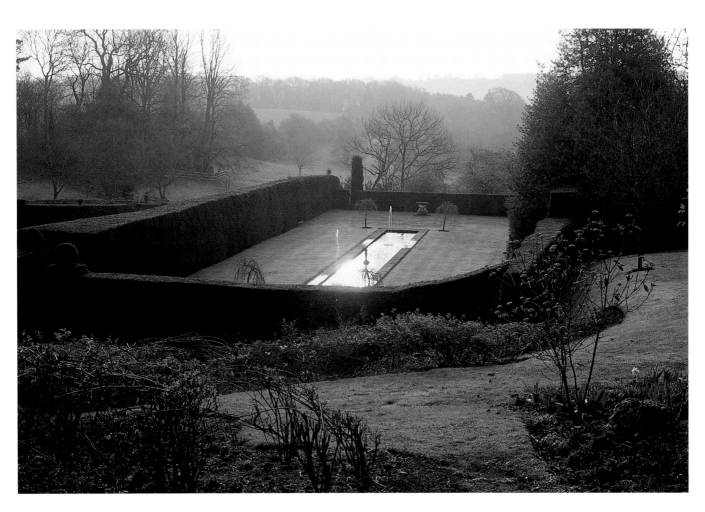

10

Kennerton Green

Marylyn Abbott is an energetic and passionate gardener and writer whose two large properties are on opposite sides of the globe. At Kennerton Green, in the Southern Highlands of New South Wales, Australia, the planting focuses on spring, when the garden is open to the public and before the summer drought sets in. Both here and in her British garden at West Green House in Hampshire (see pp. 250–53), Abbott's gardening style blends innovation and imagination within a traditional framework. Meadow plantings at Kennerton Green include a wondrous mix of powerfully scented white freesias, tiny hoop-petticoat daffodils, *Narcissus bulbocodium*, and bluebells under a grove of white-stemmed birch trees. Wide swaths of mixed tulips and narcissi are planted under flowering cherries to coincide with their blossom. Statuary, of which there is much throughout the garden, includes a delicate ironwork aviary with an impact that is doubled by reflection from the still water of the pond in which it stands.

Plants from many parts of the world have been massed together to create a memorable composition in a meadow at Kennerton Green. The white-stemmed Himalayan birch, *Betula utilis* var. *jacquemontii*, a fine specimen tree, has even greater impact *en masse*. Here, just at the point when it is breaking into leaf, it is underplanted with Spanish bluebells, *Hyacinthoides hispanica*, and divinely scented creamy-white freesias from South Africa. These follow an earlier display of hoop-petticoat daffodils.

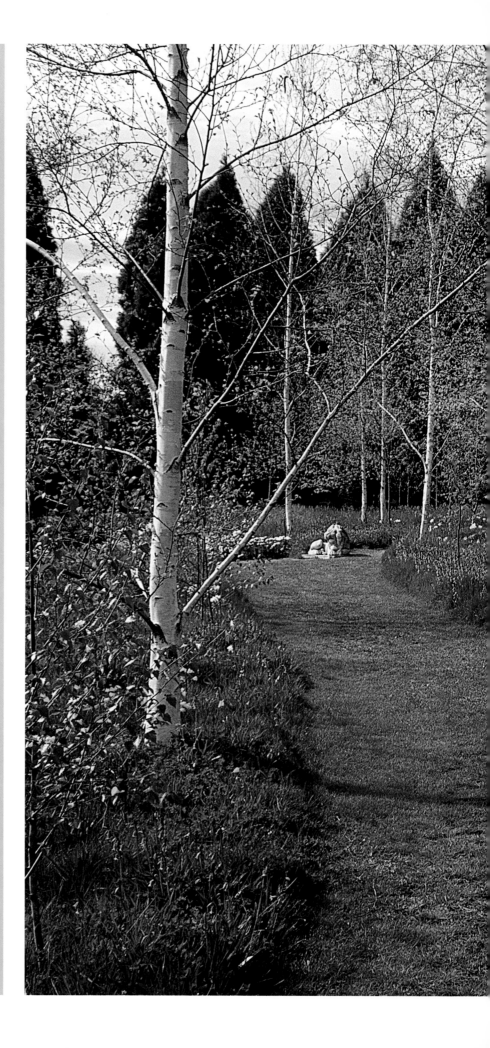

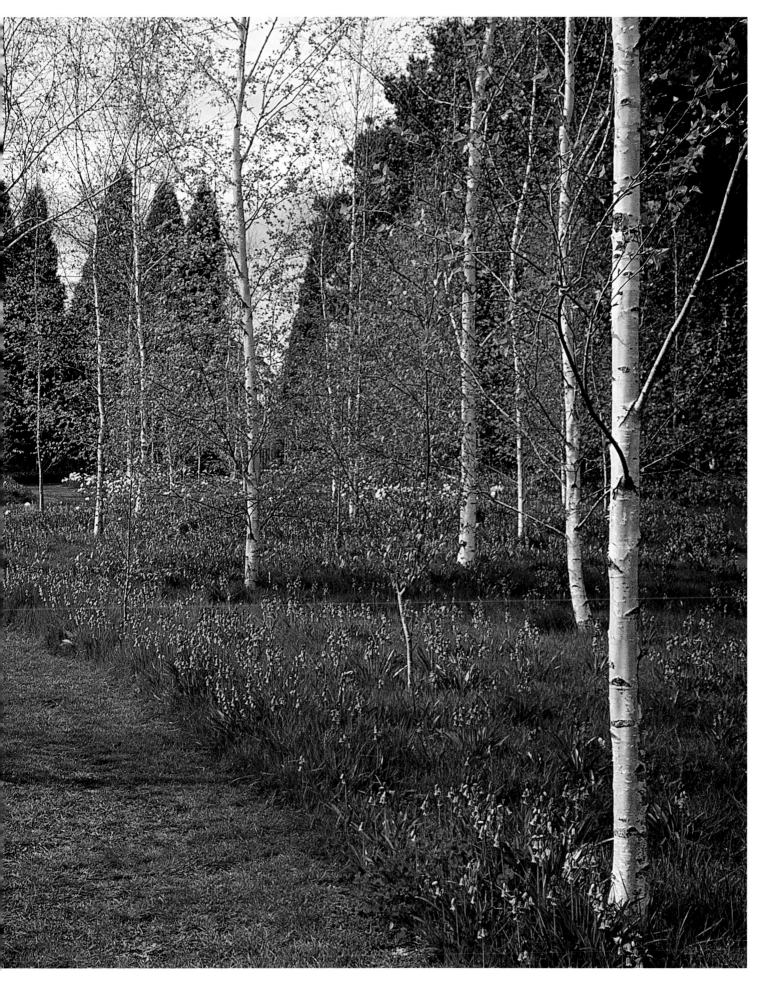

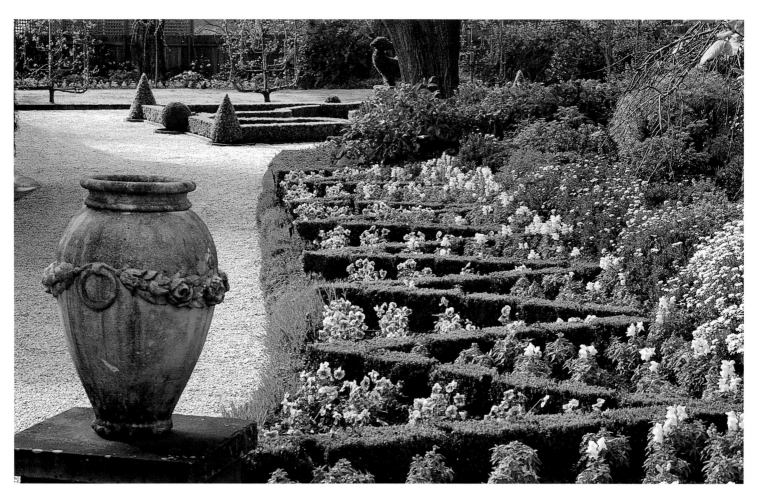

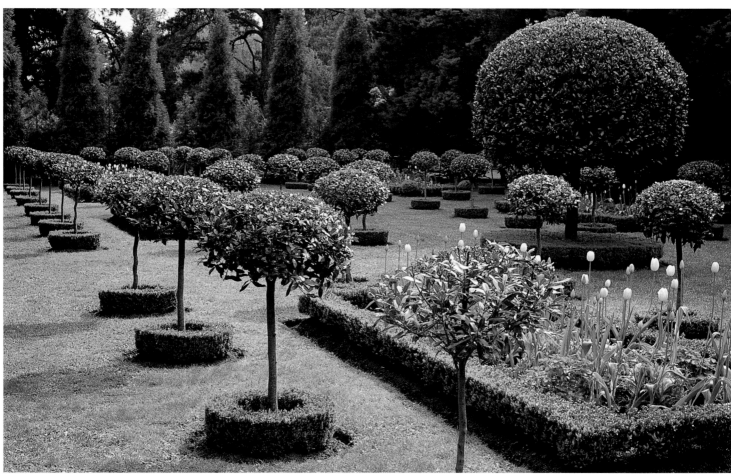

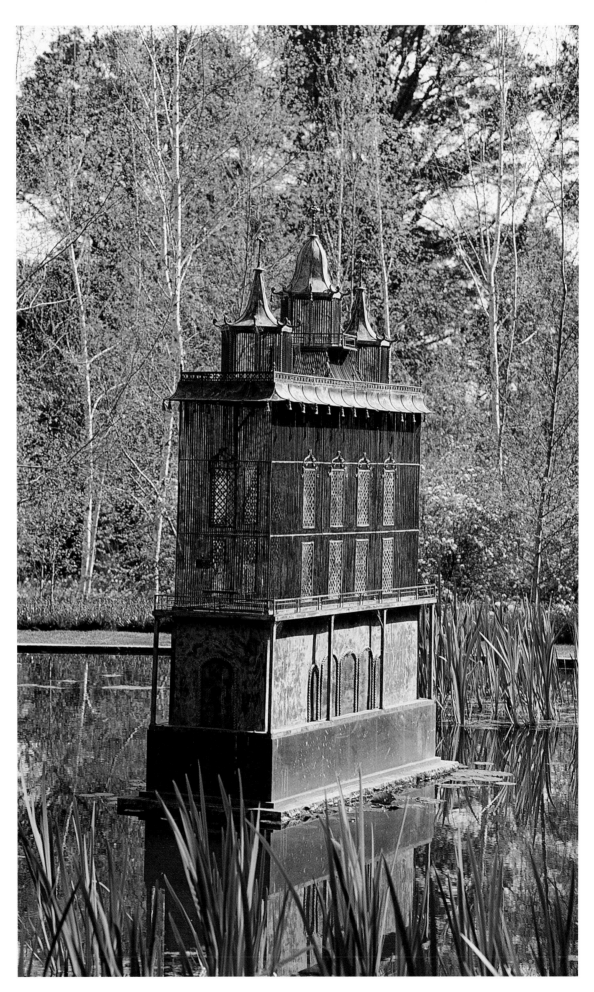

OPPOSITE, TOP Pattern, form and formality abound in this garden. Lining the gravel drive, behind a neat box parterre, is a pair of beautiful tiered double-'U' cordon apples that need careful training but are wonderfully productive. The zigzag of box has spring bedding of pansies and dwarf white snapdragons contained by a line of pinks along the drive, with candytuft, *Iberis grandiflorus*, behind.

OPPOSITE, BOTTOM Serried ranks of pompommed bay, *Laurus nobilis*, rise out of rings of clipped box. Interspersed with the topiary is the tall Darwin tulip 'Ivory Floradale'.

ABOVE, FROM TOP Leaves and blossom of pink ornamental cherries emerge in spring; the bulbous Dutch *Iris* 'Apollo'.

RIGHT The chinoiserie bird cage on the lake echoes a series of aviaries sited throughout the garden.

spring into summer

11

Cotswolds

Celia Haddon is a writer who aims, in her Cotswolds garden, to offset the imbalances in modern agricultural and horticultural practices by making a haven for as many forms of wildlife as she can entice to visit. The plot of 20 × 55 m (66 × 180 ft) attracts a wide range of butterflies, bees, wasps, grasshoppers, caterpillars, birds, mice and hedgehogs. This project shows that an ecologically sound garden need not require aesthetic compromise. Room has been found for a vegetable garden enclosed by beautiful drystone walls that also enfold wooden benches and compost heaps disguised as beehives. There is a circular maze of turf and brick and a hay meadow studded with cranesbill and ox-eye daisies. Provision has been made for many native berry- and nectar-bearing plants that will attract wildlife. This delightful garden sits in total harmony with the surrounding rural, if less ecologically sound, agricultural landscape.

RIGHT, TOP In Haddon's garden the brick-and-turf maze with its centre of cobbles forms a decorative link between the paved garden near the house and the lawn beyond, flanked by meadow beds.

RIGHT, BOTTOM Ox-eye daisies stand out amid the long grass.

OPPOSITE, TOP Beyond the gate in the hedge beside the vegetable garden, where potatoes and parsley grow, there is a view of the distant church spire.

OPPOSITE, BOTTOM LEFT One of the compost bins disguised as a beehive is backed by *Rosa rugosa* 'Roseraie de l'Haÿ' and foxgloves.

OPPOSITE, BOTTOM RIGHT In the areas set aside as meadow, ox-eye daisies are mixed with vetch and field cranesbill.

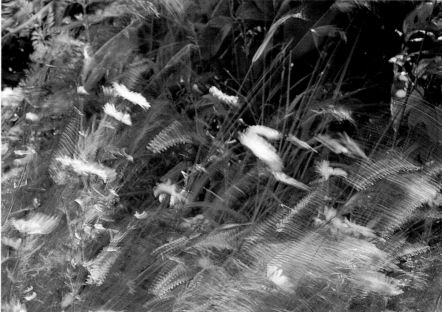

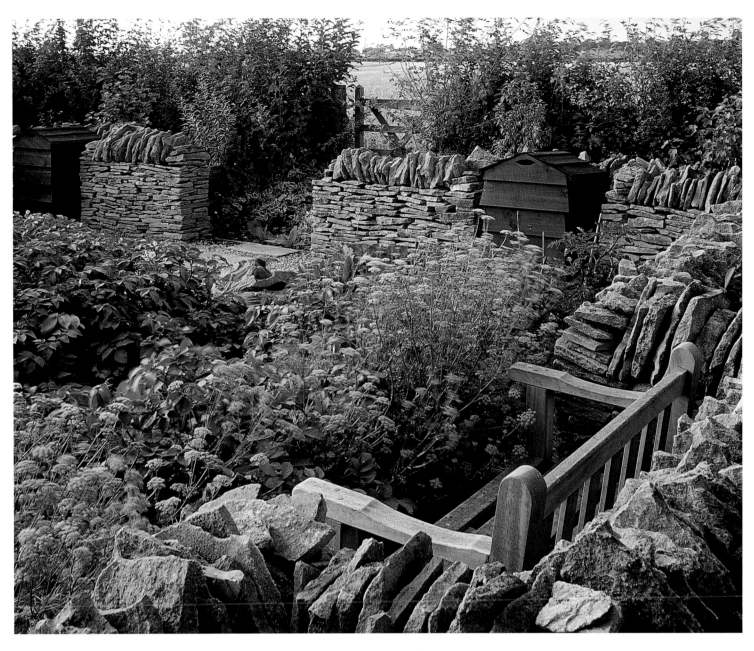

12

Manor Farm

The garden that Simon and Antonia Johnson created from bare fields at Manor Farm, Middle Chinnock, in Somerset showcased their different but complementary horticultural talents. Simon is a garden designer with a love of form, symmetry and perspective, and Antonia, a writer, likes to dream up planting combinations, grow vegetables and create wild areas in which to hide away with a book. The 8 hectares (20 acres) of farmland, of which 1.2 hectares (3 acres) is garden, gave the couple plenty of scope to combine their twin passions. The deep loam over clay is an excellent growing medium and allowed the garden to take on a look of age in its early days. The backbone planting of hedges and trees was quickly established to enhance the layout of paths, walls and terraces that was put in before the task of choosing plants and colour schemes began. By combining their areas of expertise the Johnsons made the garden a wonderful meeting of elegant design and exciting planting.

RIGHT, TOP An avenue of *Pyrus calleryana* 'Chanticleer' is underplanted with flowering cranesbill, *Geranium* × *magnificum*, and *Allium cristophii*.

RIGHT, BOTTOM The blossom of espaliered pear varieties, including *Pyrus* 'Merton's Pride' and *P.* 'Williams', appears with the grape hyacinths, *Muscari armeniacum*.

OPPOSITE The east-facing rear of the house, seen from the wild garden, with the pink flowers of self-sown lady's smock, *Cardamine pratensis*, in front of *Viburnum* × *burkwoodii* 'Park Farm Hybrid'.

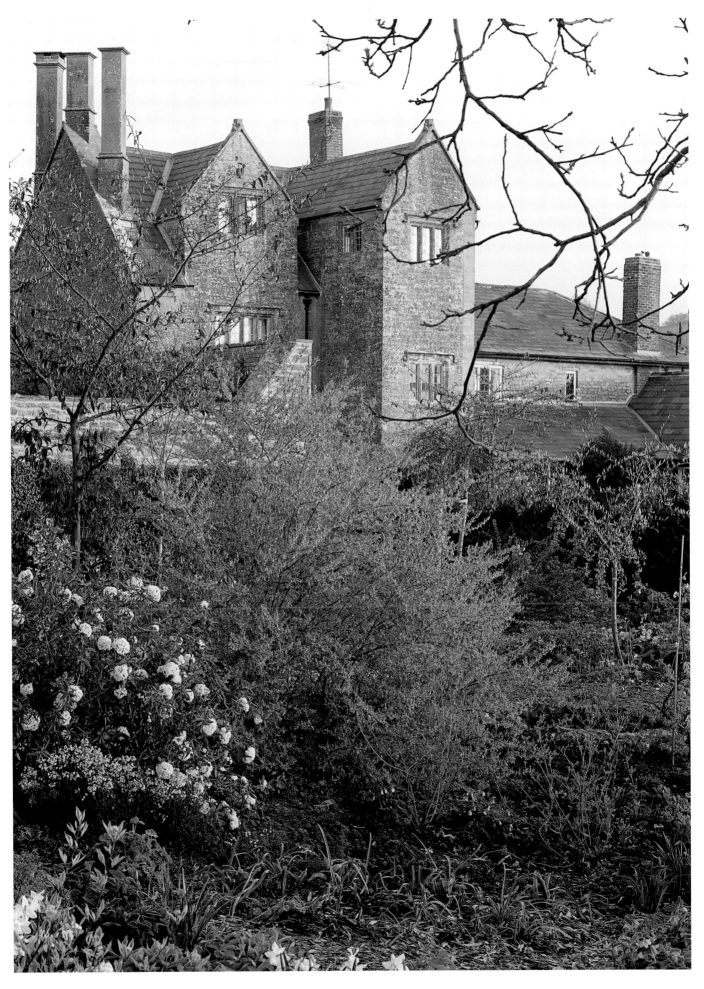

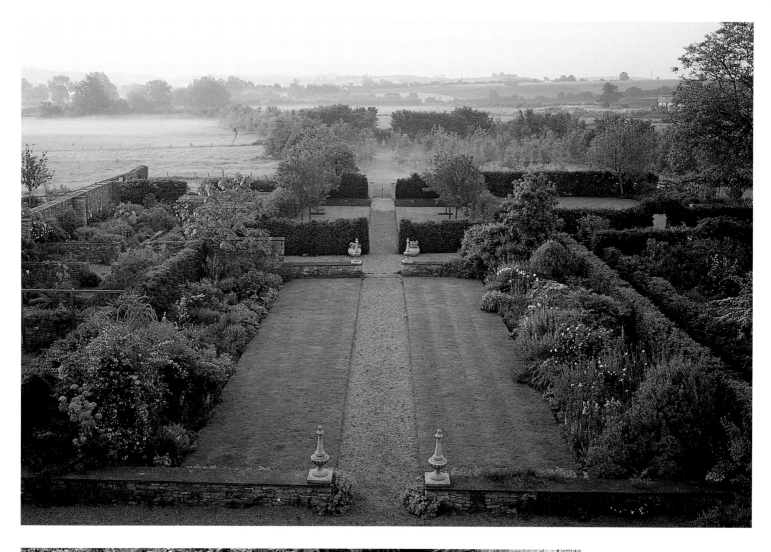

ABOVE The strong geometric layout of the garden and its succession of lawns, divided by paths, hedges and borders, is clear when seen from above.

LEFT A seat in the herb garden stands amid a mixture of purple sage, Hidcote lavender, borage, chives and mullein.

OPPOSITE, TOP LEFT *Buddleja alternifolia*, magenta rose 'De Rescht', blue goat's rue, *Galega orientalis*, and the perennial wallflower *Cheiranthus* 'Bowles's Mauve' are assembled in the herbaceous borders.

OPPOSITE, TOP RIGHT Box-edged squares with alternating blocks of bearded irises and *Tulipa* 'Elegant Lady' lie below standard *Viburnum carlcephalum*; at the end is *Prunus* 'Tai Haku'.

OPPOSITE, BOTTOM LEFT At the centre of the herb garden a copper planter filled with *Salvia microphylla* is surrounded by thyme and golden marjoram with *S. × sylvestris* 'Mainacht'.

OPPOSITE, BOTTOM RIGHT *Allium cristophii* and *Nepeta* 'Six Hills Giant' blend tones of mauve.

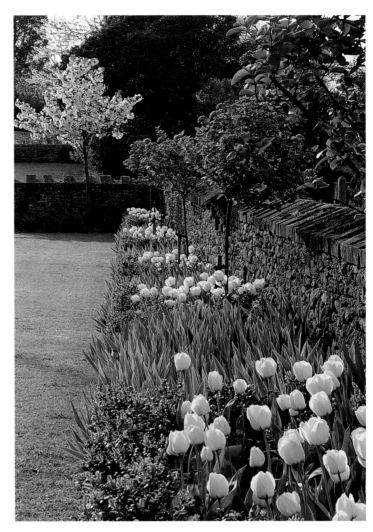

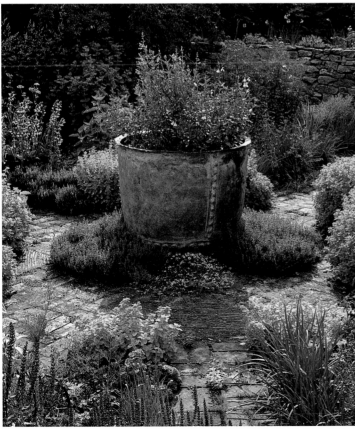

13

The Dower House, Morville Hall

Katherine Swift's work as a historian and writer is fused with her passion for plants and design in the garden she has created near Much Wenlock in Shropshire. The Dower House, and Morville Hall behind, were once part of a Benedictine priory, and Swift has made the garden into a sequence of areas dedicated to the characters who have occupied the house down the centuries. The geometry given to the garden by its walls and hedges was designed to draw you from one area to the next. You pass from the turf maze inspired by local Iron Age earthwork enclosures, through a medieval cloister garden and knot garden, through Victoriana to a modern-day ornamental fruit and vegetable garden. The planting is in strict keeping with the period represented but is planned to allow Swift to indulge her love of old-fashioned roses, striped auriculas and a sensational collection of feathered and flamed florists' tulips.

RIGHT A square raised bed of feathered and flamed English florists' tulips, including the raspberry-ripple-coloured 'Wakefield', stands beside a blossoming apple tree.

OPPOSITE, TOP In the knot garden, squares of old English lavender, *Lavandula × intermedia*, surround interwoven ribbons of rue, *Ruta graveolens*, and germander. Lining the central path is a double row of Seville oranges in terracotta pots.

OPPOSITE, BOTTOM A delight in spring is the apple and rose tunnel, where *Tulipa* 'Couleur Cardinale' and the daisy *Anthemis cupaniana* coincide with the apple blossom.

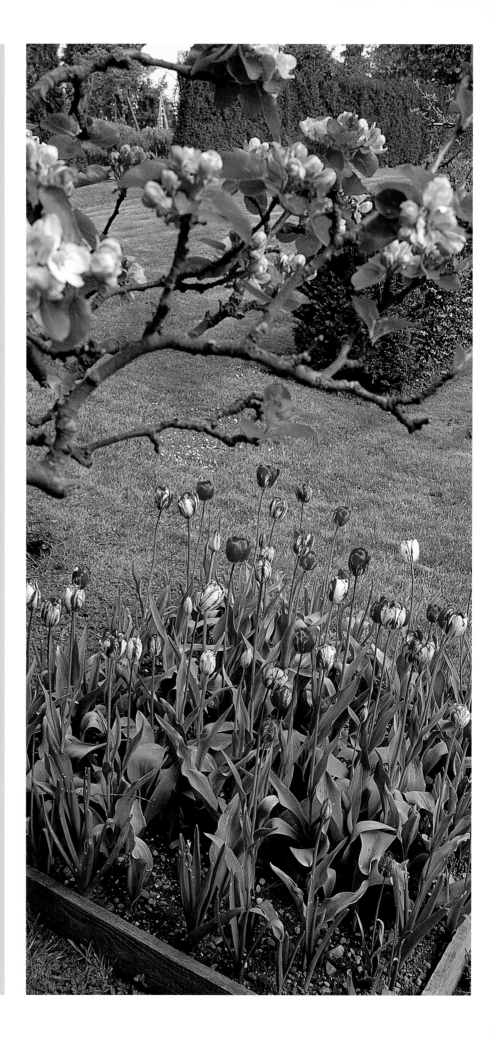

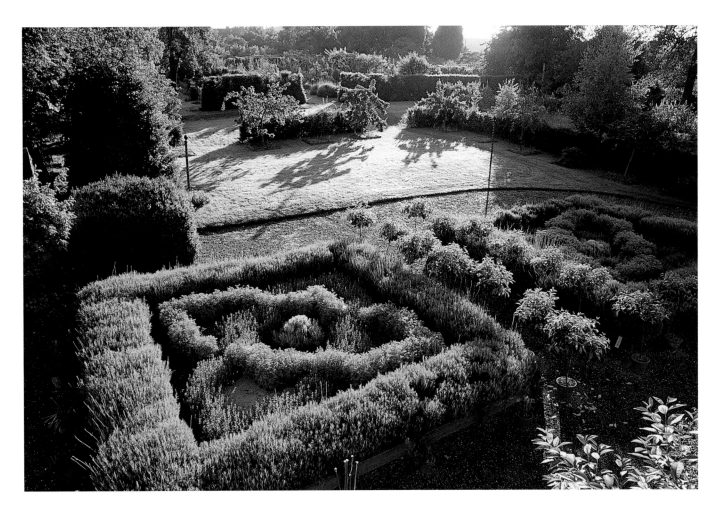

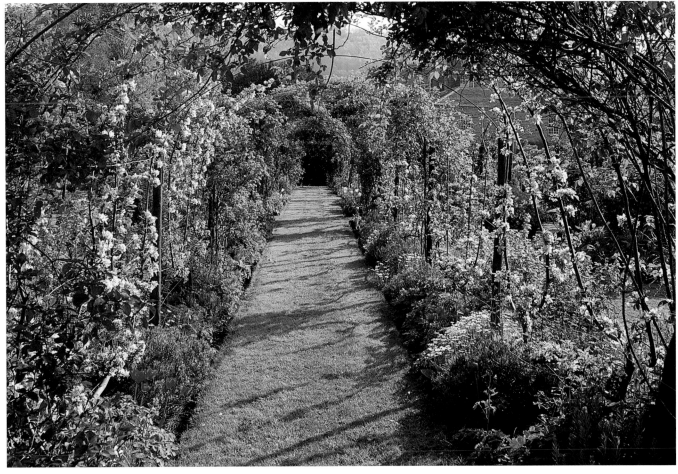

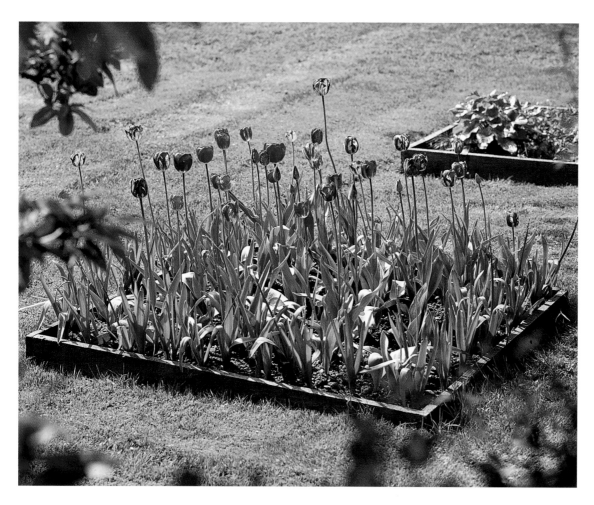

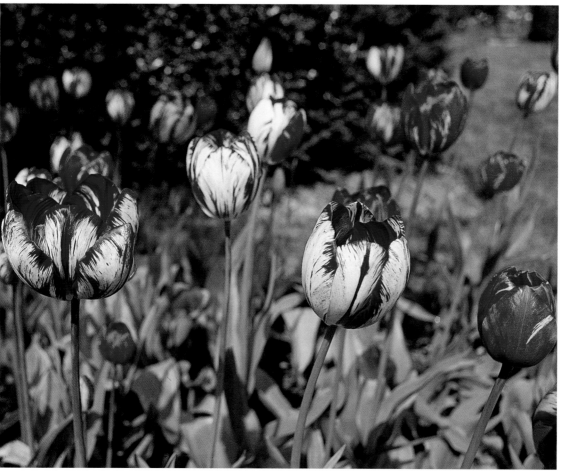

LEFT, TOP Multicoloured tulips in a raised bed soften the expanse of lawn.

LEFT, BOTTOM A bed of the English florists' tulip 'Juliet'.

BELOW *Tulipa acuminata*, the horned tulip.

OPPOSITE, TOP In the Dutch Garden tulips and narcissi are planted in a seventeenth-century manner, with no two of the same plants standing next to each other. In this *plate-bande* of late-season bulbs are the apricot, white, black, blue and flaming parrot tulips.

OPPOSITE, BOTTOM, FROM LEFT *Tulipa* 'Juliet'; 'Dr Hardy', an English florists' tulip that blends yellow and maroon; *Tulipa acuminata*.

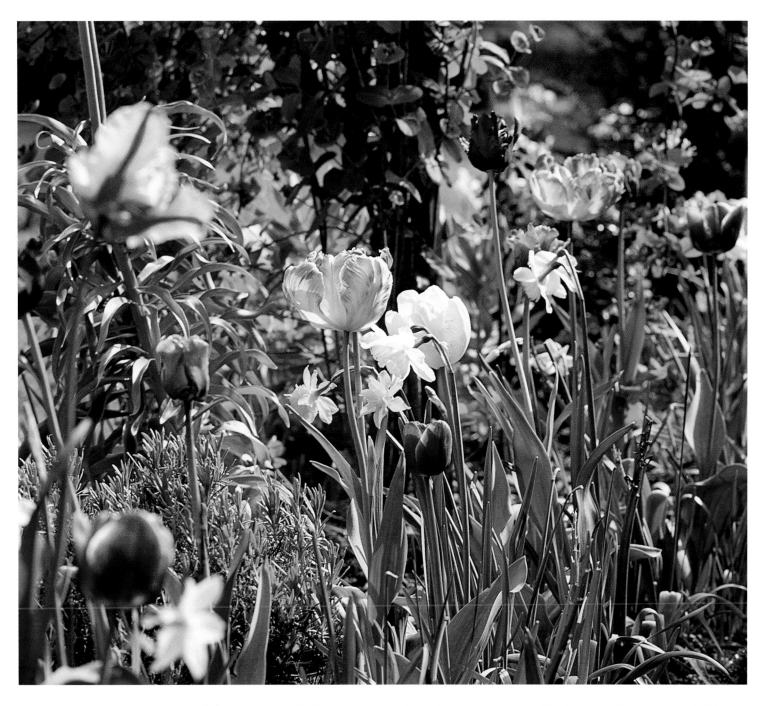

14

Conholt Park

The walled garden at Conholt Park in Hampshire was home to little more than a thicket of brambles when Caroline Tisdall embarked on its restoration a decade ago. Now the restored Edwardian glasshouses yield peaches, nectarines, apricots, grapes and figs. The original box hedges, their quirky forms bestowed by age, are joined by dramatic swaths of ornamental artichokes, providing year-round aesthetic interest in this large organic kitchen garden. A long rosemary hedge attracts early-pollinating bees, and in summer a section of the garden filled with campanulas, salvias and catmint does the same. The formal fountain is encircled by a bed planted with a ring of white tulips and narcissi for spring and a billowing mass of *Alchemilla mollis* in summer. Beyond the confines of the walled garden grazes Conholt Park's engaging herd of Highland cattle.

RIGHT Warm red-brick walls enclose the organic kitchen garden, which is decorated with a wide variety of ornamental plants to keep the area attractive in every season. Wide box hedges provide all-year structure, and garlands of rope are strung with climbing roses. In spring the fountain pool is circled with white tazetta narcissi and tulips such as the lily-flowered 'White Triumphator' and 'Spring Green'.

OPPOSITE, TOP A feature of the Rose Garden is a wirework gazebo with matching white-painted iron hoops as edging for the beds. Foxgloves flower during the first flush of the roses.

OPPOSITE, BOTTOM Ornamental cardoons, *Cynara cardunculus*, have almost year-round decorative effect and are planted extensively in the kitchen garden, where their lush spring growth is the perfect partner for tulips. The tunnels and wigwams are made of coppiced hazel.

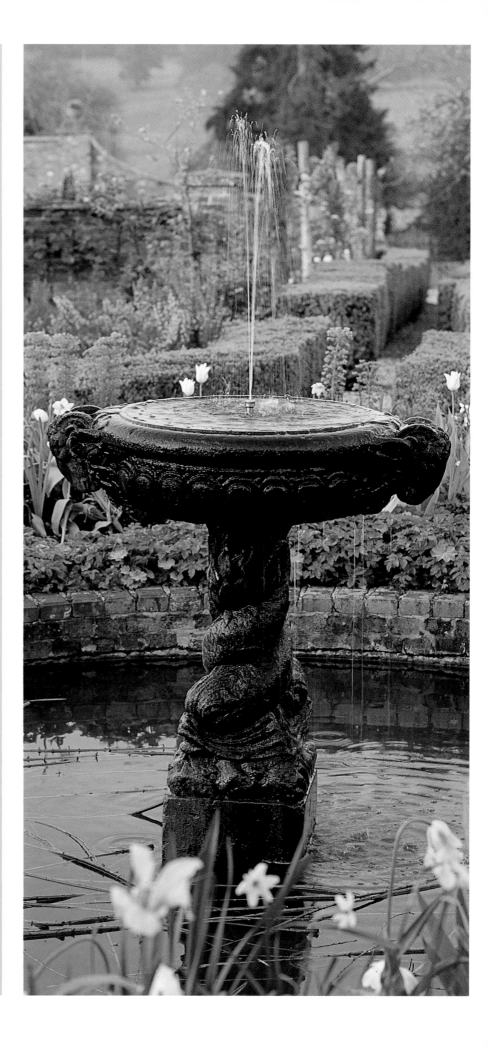

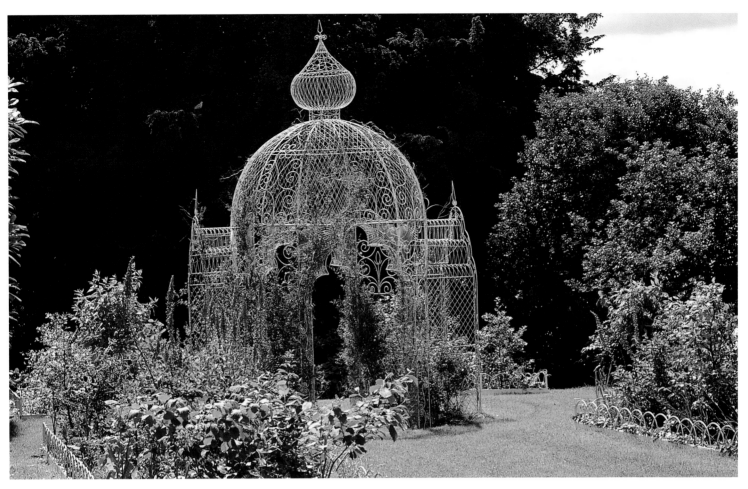

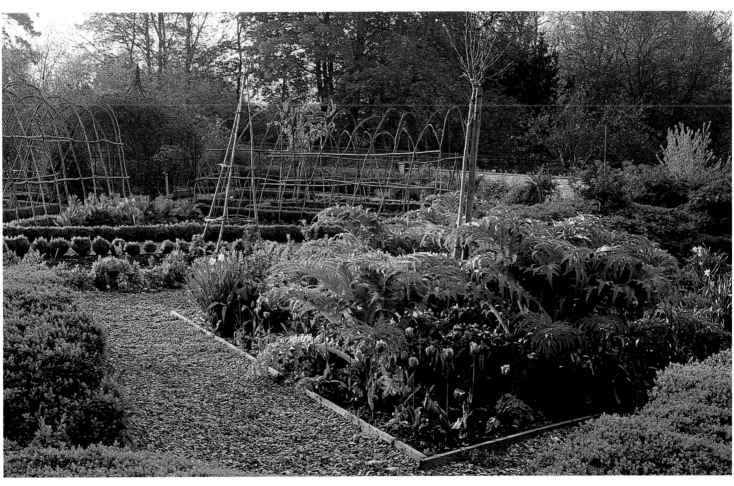

15

Villa Massei

When Paul Gervais and Gil Cohen swapped America for Tuscany in the 1980s the garden of Villa Massei, the 24-hectare (60-acre) property they bought near Lucca, was badly in need of restoration. In twenty years they have achieved something infinitely more rewarding than a mere spruce-up by bringing to life a garden rich in the tradition and atmosphere of idyllic Italian Renaissance gardens, and enhancing it with inventive modern planting. Rectangular beds in the Giardino all'italiana, one of the garden's many separate areas, are edged with box hedges clipped at 60 cm (24 in.), and filled with *Caryopteris* × *clandonensis*, whose silver-blue flowers billow above the rigid enclosures each autumn. Throughout the garden symmetry is softened by planting, both on a large scale and in the finer details. The cypresses that line the drive are backed by hybrid musk roses, a metal pergola drips with long-racemed white wisteria, and the mouth of a carved stone head spouts both water and a maidenhair fern.

The Orange Garden, with its neat, box-edged beds of mown grass and potted orange trees, can be enjoyed from the restored loggia. A metal pergola covered in the long-racemed *Wisteria floribunda* 'Alba' stretches from the house to the sixteenth-century grotto. On one side of the garden a magnificent camphor tree, *Cinnamomum camphora*, provides welcome shade for the large pots filled with oak-leaved hydrangeas, *Hydrangea quercifolia*.

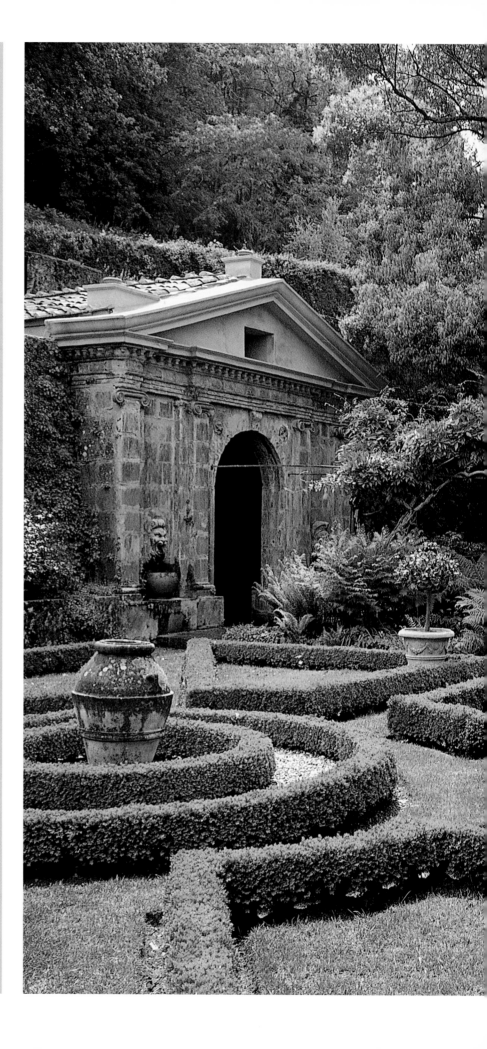

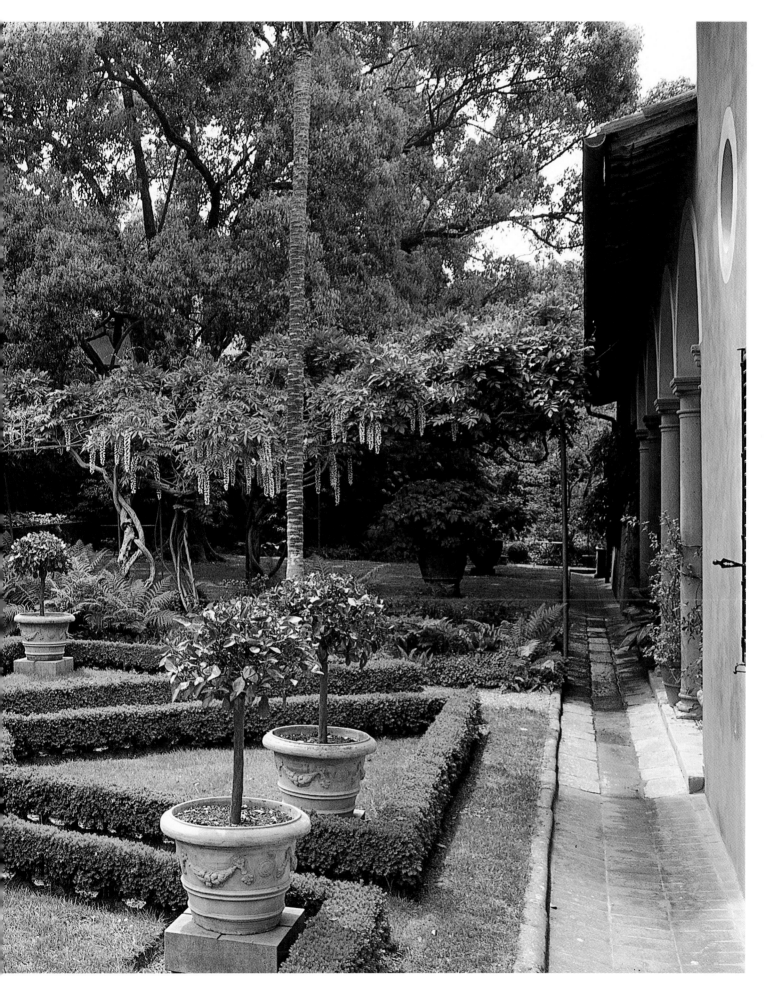

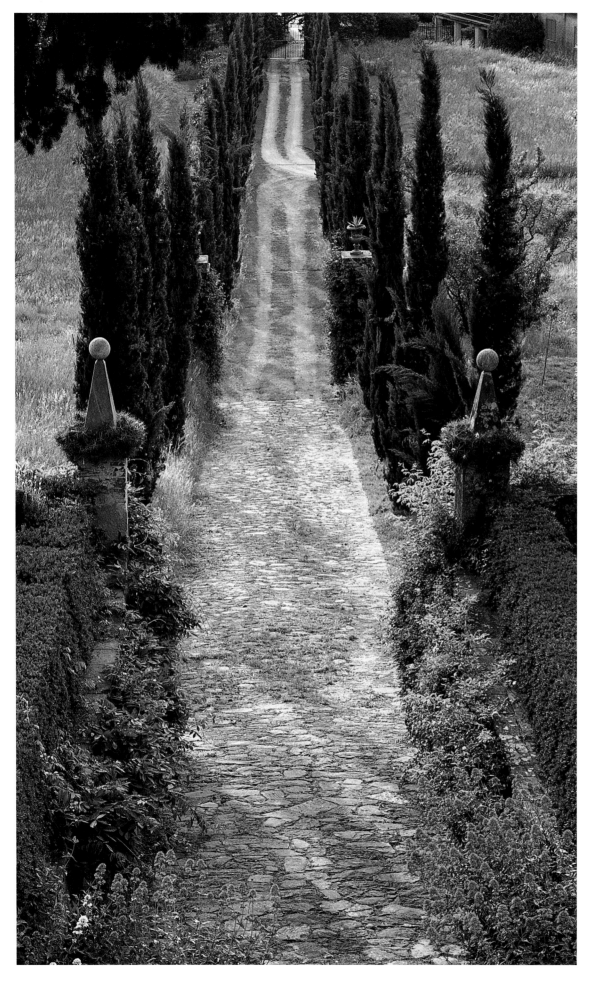

LEFT The *viale*, or drive, that runs up to the house is lined with an avenue of pencil cypresses. These stop at a pair of obelisks with ball finials set on square columns with a ruff of *Tillandsia argentea*. Tall box hedges continue the line up to the house, with flowering red valerian seeding itself in cracks in the paving.

ABOVE, FROM TOP A maidenhair fern grows out of the stone mouth from which water spouts into a fountain; the dolphin grotto, filled with potted ferns, is surrounded by walls clad in *Ficus pumila*.

OPPOSITE The pattern of the box-edged beds in the Giardino all'italiana was inspired by the eighteenth-century Giardino Buonaccorsi on the Adriatic. The L-shaped beds, 60 cm (24 in.) high, are filled with *Caryopteris × clandonensis*, which sends up cloud-like billows of soft blue flowers in late summer and autumn.

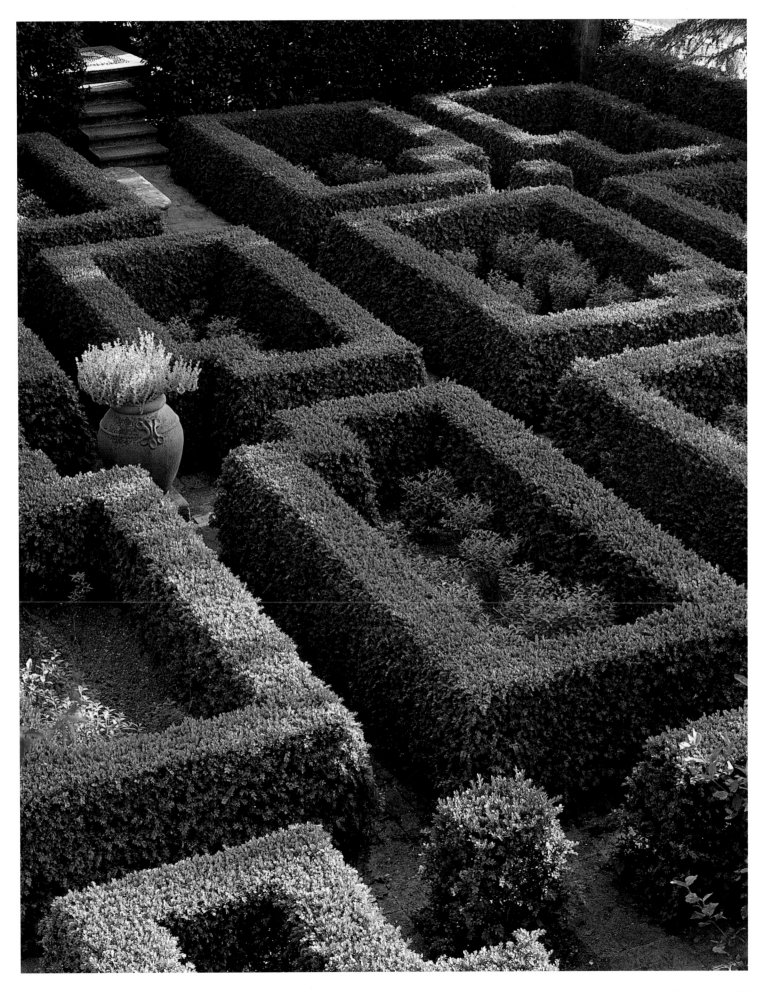

16

The Woodyard

When Terry Jones commissioned Ann Pearce to design his Dulwich garden the brief was simple: he wanted an uncluttered space that would aid contemplation. The result fits the bill to perfection but has the further benefit of extremely varied seasonal effects. While the house, a German prefabricated timber-and-glass Huf Haus, was assembled in a week, the garden took months of planning and construction. Levels were changed, a sophisticated filter was installed in the canal, and cables for the uplighting were laid underground. Creamy-coloured York stone was precision-cut specifically for the garden, and massive planting holes were dug for the large specimen *Cornus kousa* var. *chinensis* chosen *in situ* from a German nursery. The garden rises in subtle changes of level, each seeming to float above the one immediately. Rectangles of creamy gravel and bleached tree decking break up what would otherwise be a blinding expanse of stone. The water in the simple canal not only reflects the patterns of clouds but also ripples agreeably in the breeze, and has brought frogs and pond skippers for a very happy Terry Jones to contemplate when he relaxes on his plain bench in his uncluttered garden.

Multi-stemmed specimens of flowering dogwood, *Cornus kousa* var. *chinensis*, provide an upper storey of greenery above an evergreen lower level with clipped box balls.

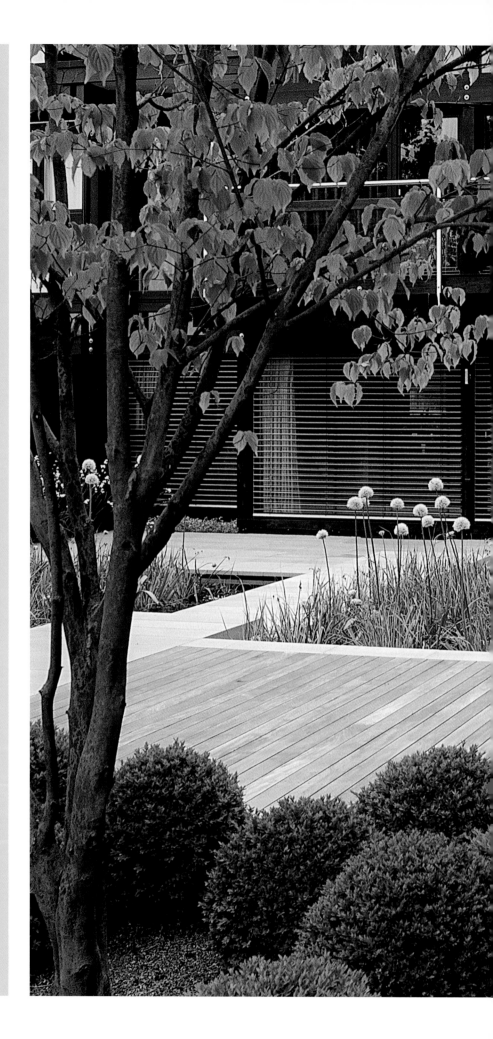

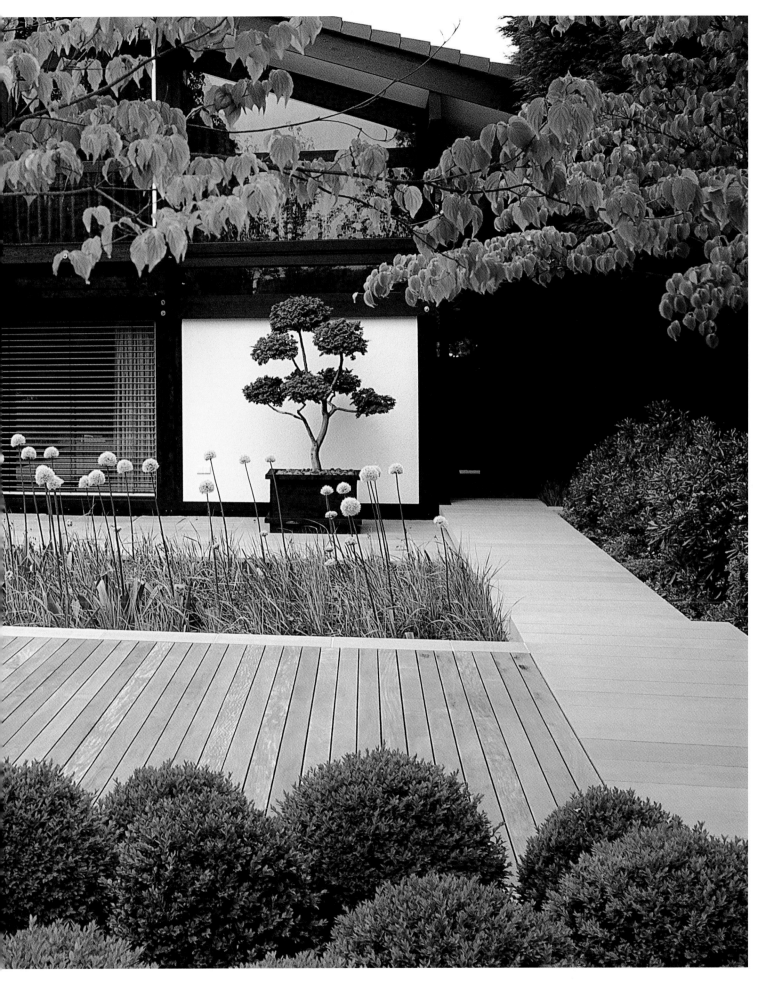

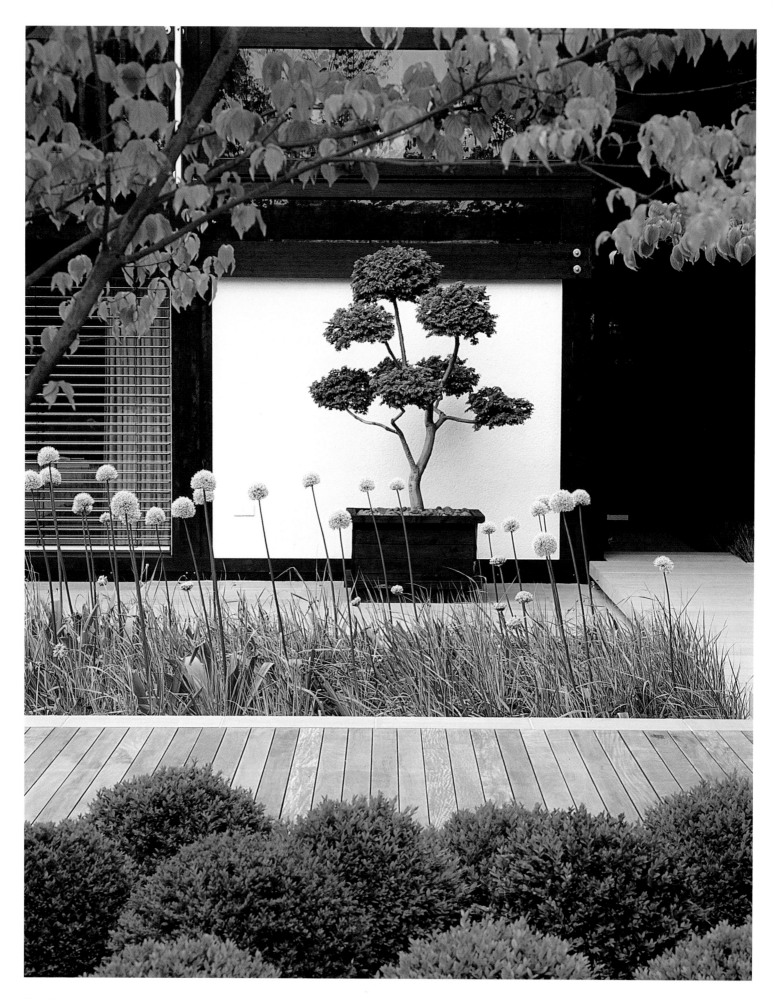

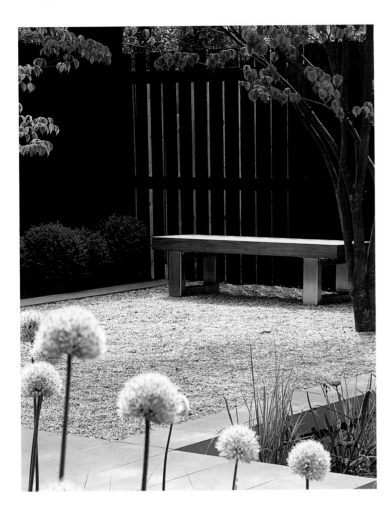

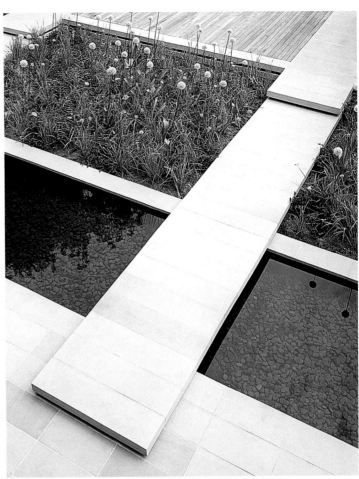

OPPOSITE A cloud-pruned *Ulmus* 'Jacqueline Hillier', growing in a mulch of pebbles in a black wooden tub set against a white-painted panel of the Huf Haus, resembles an outsize bonsai.

ABOVE, LEFT Black-painted boundary fences match the black house timbers and make a peaceful backdrop for the timber-and-stainless-steel bench.

ABOVE, RIGHT A bed of *Allium* 'Mount Everest' and the grass *Calamagrostis* × *acutiflora* 'Overdam' is crossed by a low bridge of precision-cut stone that, on the top level, separates the gravel area from decking.

RIGHT The sliding doors of the sitting-room open on to a York-stone terrace. The emphasis is on calm, horizontal lines, with a rectangular pool giving way to a narrow bed of alliums and grass, and the decked area and rows of closely clipped box beyond.

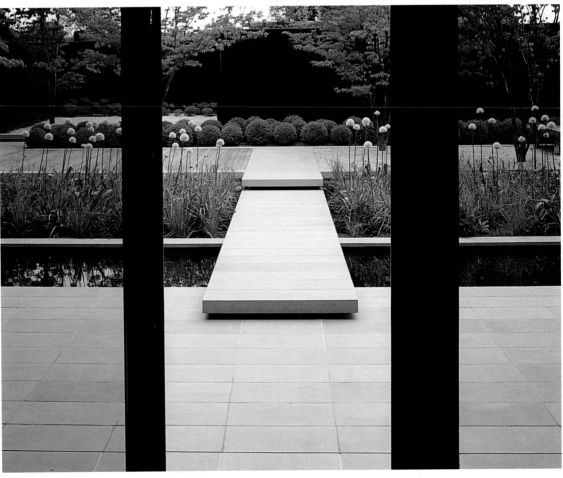

17

Westwell Manor

It is not only the turf-and-buttercup maze that is labyrinthine in this Cotswold garden. An exploration of Westwell Manor's garden takes you through myriad secret compartments that unravel as a sequence of spaces where mood is dictated by structure and planting. Anthea Gibson's reworking of the garden has kept much of its Arts and Crafts structure, as well as the yew and box hedges of the previous owners, but she is constantly improving it with imaginative twenty-first-century additions. The inky-black pool and narrow stone rills are recent but sit happily with the timeless atmosphere of the place. The water channels, built with the help of Anthony Archer-Wills, descend seven levels, each stone riser carved differently to change the note of the water as it falls. Sloping up and away from the house, the wide mixed borders contain an inspired blend of traditional stalwarts of the herbaceous border with modern cultivars.

RIGHT, TOP The maze displays strong textural contrast between the clipped turf and the longer, buttercup-studded grass.

RIGHT, BOTTOM The lush foliage of elephant's ears, bergenia, shines out against the dense matt green of box in a topiary parterre.

OPPOSITE This and a second seven-stepped rill run beside a pleached lime walk that Anthea Gibson designed with Anthony Archer-Wills.

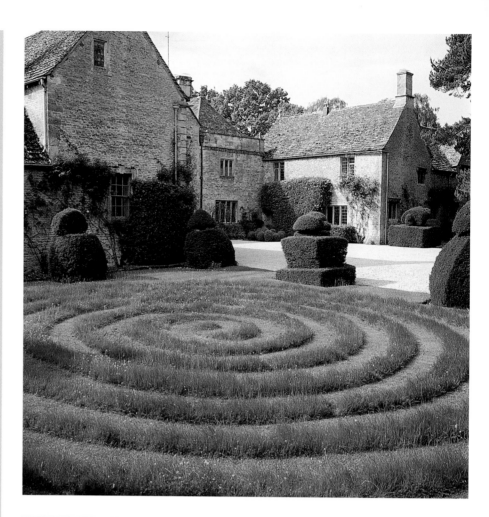

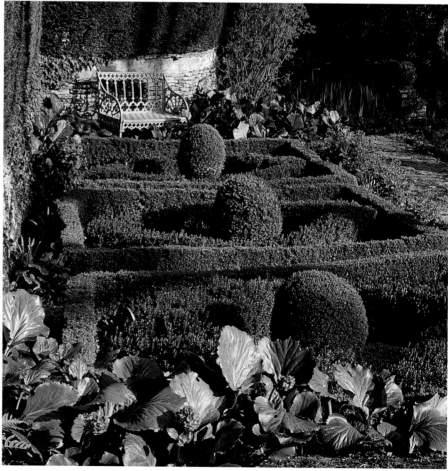

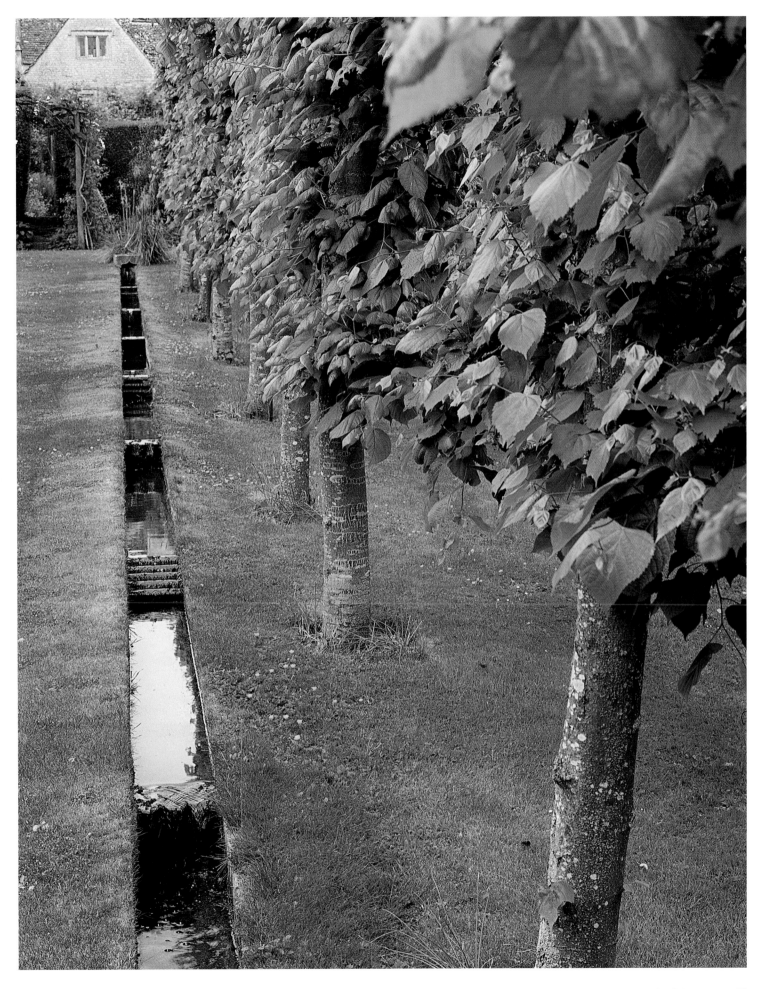

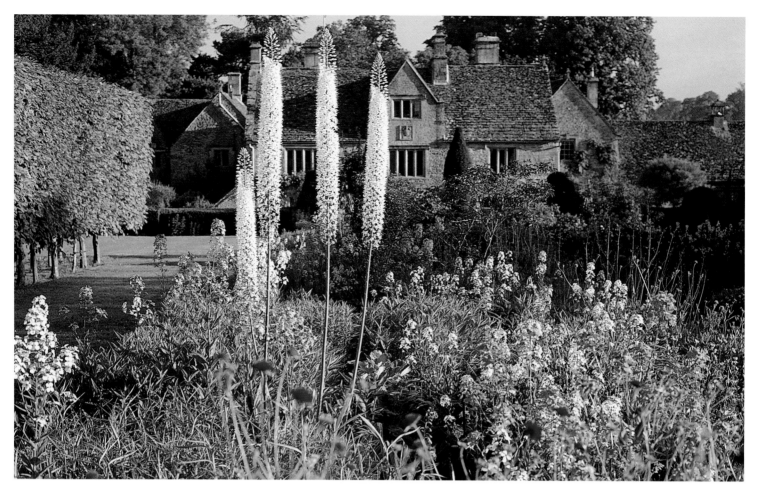

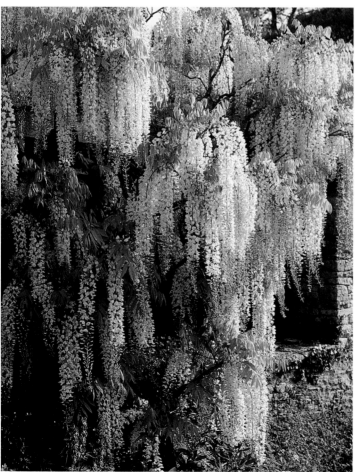

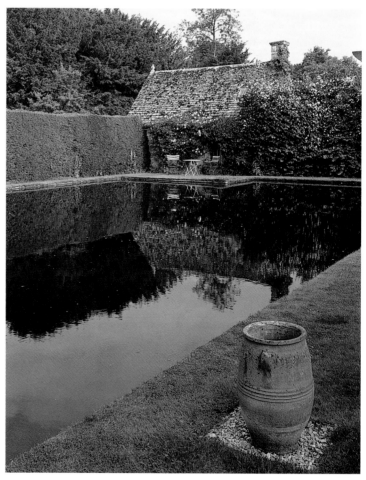

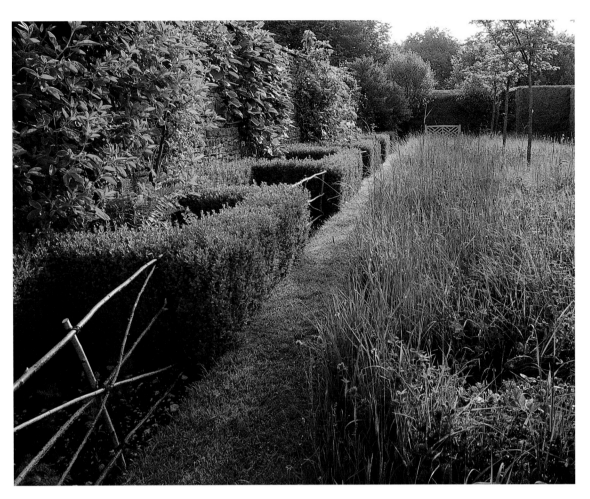

OPPOSITE, TOP The foxtail lily, *Eremurus himalaicus*, rises through a haze of sweet rocket, *Hesperis matronalis*, with *Knautia macedonica* in the herbaceous borders.

OPPOSITE, BOTTOM LEFT The long-racemed *Wisteria floribunda* 'Multijuga Alba'.

OPPOSITE, BOTTOM RIGHT Black pylam dye increases the pond's reflectiveness.

ABOVE Morning light streams through an arch with clipped yew beyond.

RIGHT Hazel hurdles protect young plants in the zigzag bays of box from deer.

BELOW Octagonal kiosks with gilded finials are changing-rooms for the pool.

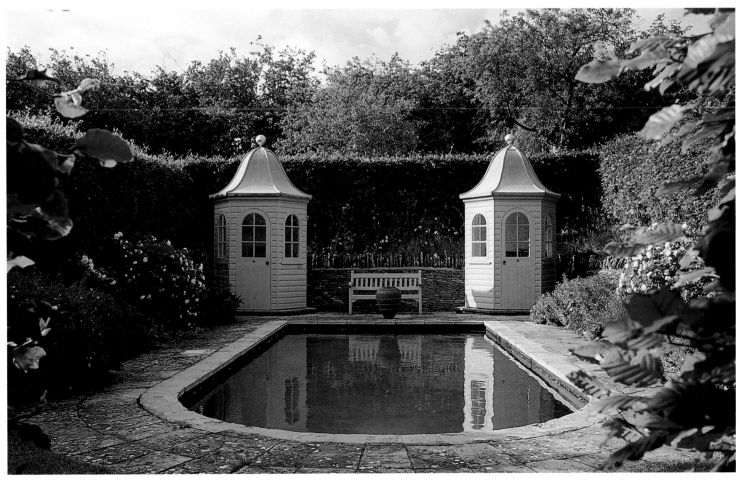

18

Caervallack

Matthew Robinson runs an architectural practice that takes on landscape and garden projects as well as houses. His wife, Louise McClary, is an artist. Between them they have created a garden filled with beautiful examples of various crafts. In such projects as metalwork arches, woven-willow structures, carved lettering on stone tables, statues, fountains and a new 12-m (40-ft) hydraulic timber bridge, their abundant creativity brings great energy and decoration to their garden. Their enthusiasm for cob-walled buildings derives not just from the fact that part of their seventeenth-century house in Cornwall is built from cob but also from the freedom of form the medium allows. They use a JCB to mix unbaked earth with straw, water and aggregate, then build the walls in layers 46 cm (18 in.) thick, leaving a week between applying each layer. Beneath a sound roof of thatch or tile, the buildings will still be standing, providing a warm-coloured backdrop to the couple's equally inspired plant combinations, long after the present owners' lifetime.

RIGHT The fluid circular forms made possible by building with cob are seen in the tile-topped wall behind giant fennel, *Ferula communis*, and *Camassia leichtlinii* 'Caerulea'.

OPPOSITE, TOP LEFT Stepping stones thread their way through the large pebbles among which the Robinsons have planted bamboo, ornamental grasses and *Sisyrinchium striatum*.

OPPOSITE, TOP RIGHT Violet *Camassia leichtlinii* subsp. *leichtlinii* rises behind *Tulipa* 'Queen of Night' and the large purple leaves of *Ligularia dentata* 'Desdemona'.

OPPOSITE, BOTTOM LEFT The tawny seed heads of *Nectaroscordum siculum* blend beautifully with the honey tones of the cob wall.

OPPOSITE, BOTTOM RIGHT The wall's sloped coping and ogee-arch window show the fluidity of form that can be achieved by building in cob.

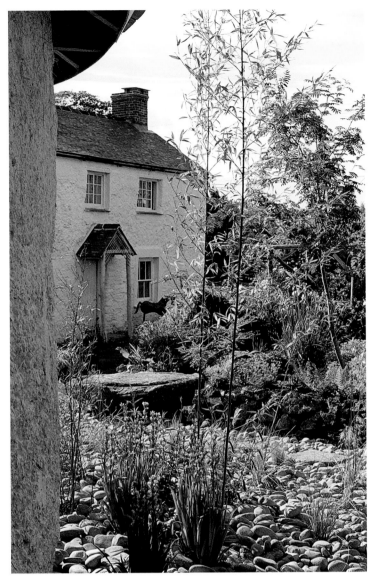

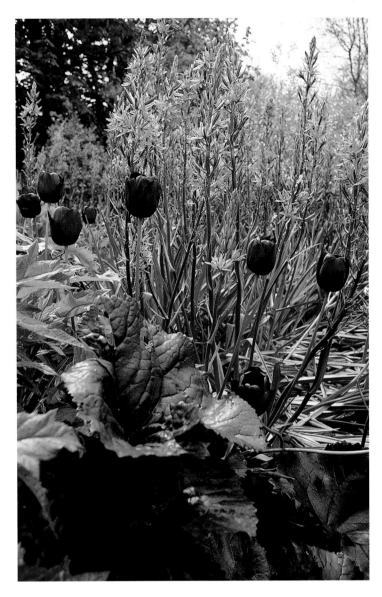

19

Iford Manor

Iford Manor sits in a valley by the River Frome in Somerset. Behind the house is a steep hill on which Harold Peto, in the early years of the twentieth century, created one of the most atmospheric gardens in England. Trained as an architect and passionate about the Italian Renaissance, he made a garden that is a masterful blend of architecture, scale, proportion and clever planting, now added to by Mrs Cartwright-Hignett. The garden ascends the hill in a series of terraces dotted with ponds, pools and rills fed by springs, and on each level stand pavilions, summer houses and seats. Peto's collection of architectural fragments has been carefully placed within the garden's overall scheme so that nowhere does it feel incongruous to be sitting in a pink-marble-columned casita or resting against a Byzantine well head. In 1907 the garden at Iford was described as a "haunt of ancient peace". Nothing has changed in a century.

The combination of box hedges, terracotta pots, topiary, statues and the elegant casita gives an intensely Italian feel to this courtyard garden, which in late spring is enlivened by the blossom of *Wisteria sinensis*. Like many of the garden buildings at Iford, the casita was reconstructed by craftsmen in Wiltshire from ruins that Harold Peto found in Italy. The central columns are of thirteenth-century marble from Verona.

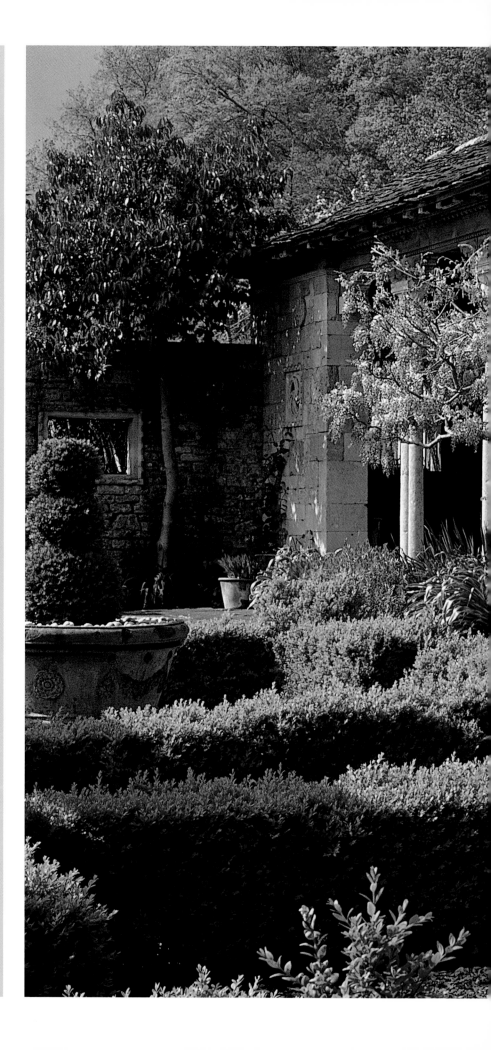

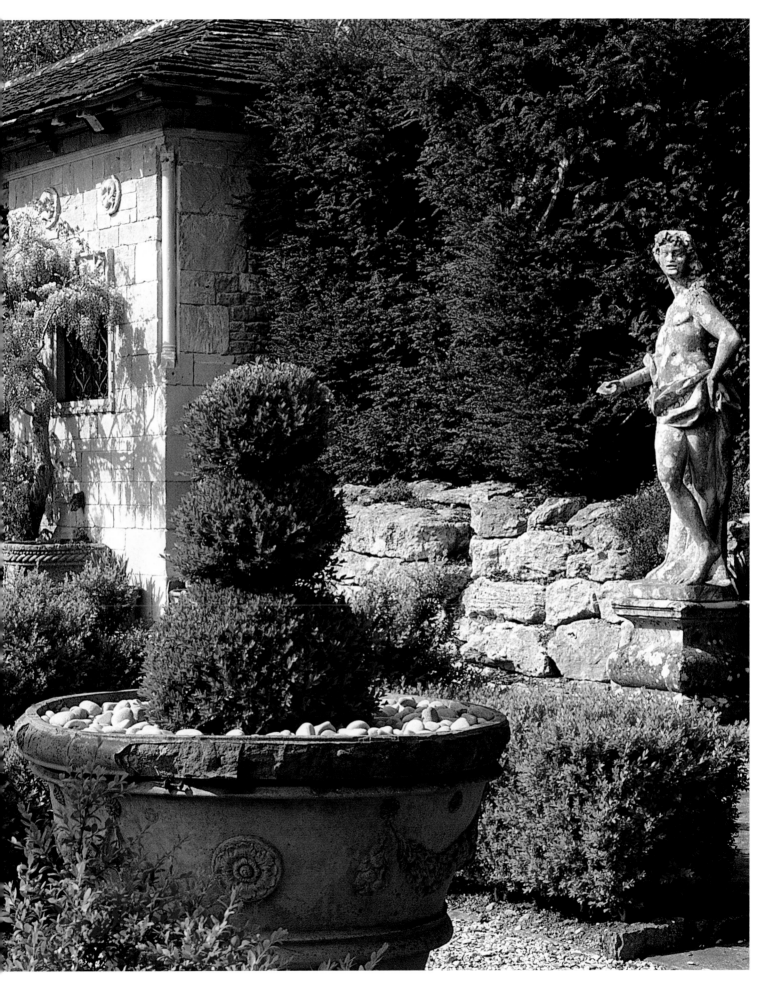

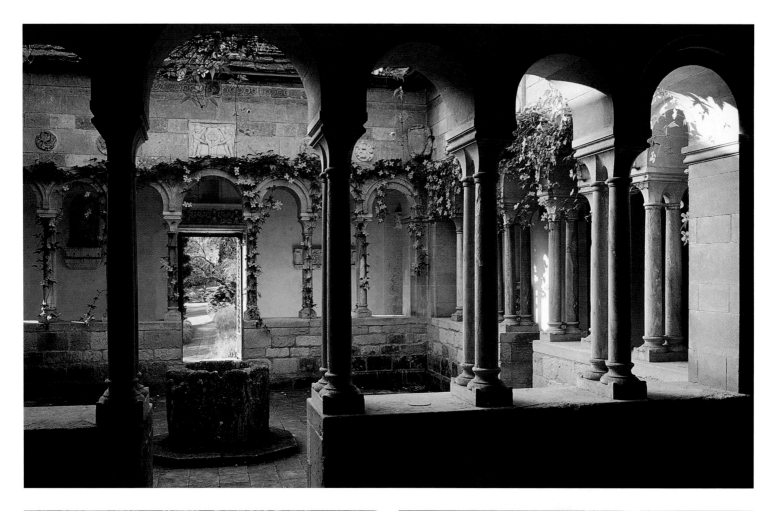

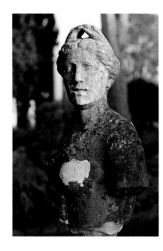

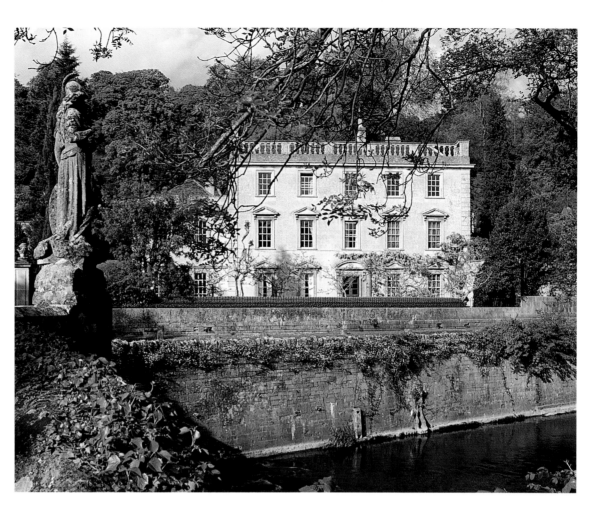

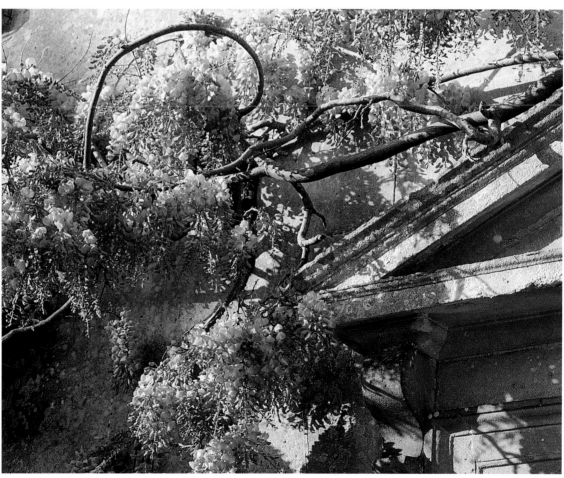

OPPOSITE, TOP *Clematis montana* var. *rubens* 'Tetrarose' weaves a delicate garland around the cloisters' pillars.

OPPOSITE, BOTTOM LEFT In the Japanese garden large stepping stones are laid over the water in a traditional Japanese crooked formation.

OPPOSITE, BOTTOM RIGHT Wild garlic carpets the slope on each side of the woodland steps leading to a stone column at the top of the garden. The column is dedicated to King Edward VII and his attempts to broker peace during the First World War.

ABOVE, FROM TOP Many busts on plinths adorn the garden; the pink flowers of *Clematis montana* var. *rubens* 'Tetrarose' contrast with the masonry of the cloisters.

RIGHT, TOP The handsome frontage of Iford Manor, framed by trees, can be seen from across the River Frome.

RIGHT, BOTTOM *Wisteria sinensis* twines about a window pediment on the façade of the manor house.

20

Shropshire

With this town garden, Mirabel Osler was faced
with a characterless long and narrow space. By
dividing the garden into a series of subtly defined
areas and filling it with generous planting and a
variety of decorative details, she packed it with
interest. A diamond-pattern brick-and-cobble path
links the separate areas and narrows at the far
end to increase the apparent length of the garden.
Lawn has been eschewed to allow for five seating
areas. The Cat House, designed by Richard
Craven, is a roofed gazebo providing shelter
from sun or rain. To add to the pleasure of eating
outdoors, a slate-topped metal table and eau-de-
Nil painted chairs are enclosed by clipped box,
lavender and willows. The shed makes an eye-
catching contribution to the garden with a *trompe
l'oeil* panel by Jessie Jones and a frothing canopy
of *Clematis montana*.

RIGHT, TOP A view over the garden shows
how a small space can be transformed
into varied compartments. The two
domed *Salix caprea* 'Kilmarnock' trees
are kept small and tight, while the rowan
on the left is pruned to remain tall but
cast little shadow.

RIGHT, BOTTOM A simple arrangement
of weathered pots decorates a wall
opposite a kitchen window.

OPPOSITE, LEFT, FROM TOP A metal chair
graces one of the garden's five seating
areas; a timber arch clad in *Lonicera
japonica* 'Halliana' frames the tapering
path; Richard Craven's Cat House gives
shelter in all weathers.

OPPOSITE, RIGHT On the front of the
garden shed is Jessie Jones's witty
mural depicting how the inside of an
orderly shed should look and a barn owl,
under a curtain of *Clematis montana* var.
rubens 'Tetrarose'.

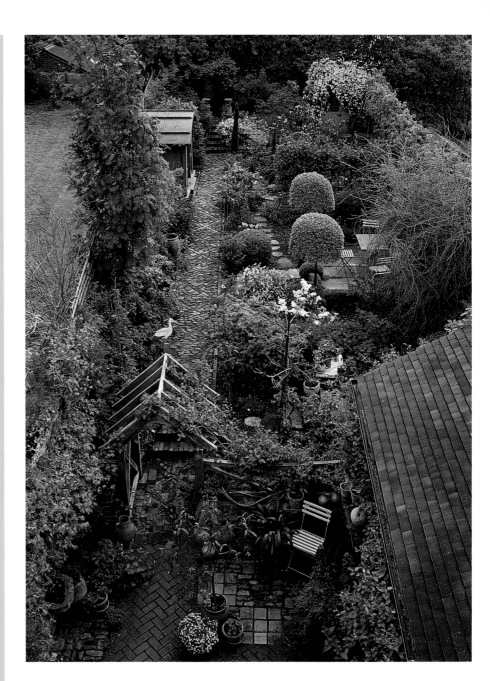

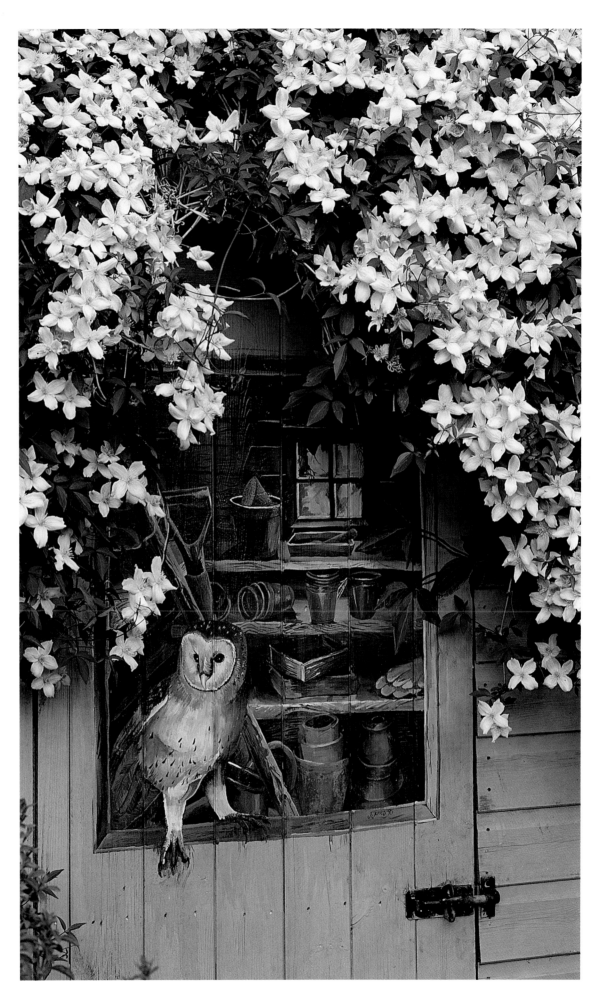

21

Titoki Point

A plant is included in the Colliers' richly composed New Zealand garden only after much thought. The vetted treasures are exceptional in form, texture or flower, and usually all three. An eye for a good plant is one thing, but the Colliers' plant associations are designed to highlight the best features of each plant through contrast. In the lush, damp area of the garden that we see here, the delicate forms of grasses are matched by sumptuous hostas, filigree tree ferns are partnered by giant gunneras, and sword-shaped iris leaves rise up around mossy tree trunks. Surrounding the peaty, hollow area of the water and bog gardens is a curtain of towering Californian redwoods, *Sequoia sempervirens*, the spongy, russet-coloured bark of which is an unexpected match for the trunks of the native New Zealand tree ferns, especially *Dicksonia fibrosa*, the wheki-ponga, with its distinctive skirt of dead fronds hanging beneath the fresh crowns.

RIGHT The glaucous leaves of *Hosta sieboldiana* var. *elegans* are partnered by *Gunnera manicata* and, in the background, a black tree fern, *Cyathea medullaris*.

OPPOSITE, TOP Wooden walkways wind past silver fern, *Cyathea dealbata*, and spiky *Cordyline australis* to the summer house, which is backed by the majestic trunks of American redwoods.

OPPOSITE, BOTTOM The flag iris, *I. pseudacorus* 'Variegata', is accompanied by large hostas, the plain green *Hosta* 'Hippo' and *H. tokudama* f. *flavocircinalis*, beside a platform over the pond at the end of the bog garden. Behind is an assortment of primulas and a fern-leaved elder, *Sambucus nigra* 'Laciniata'.

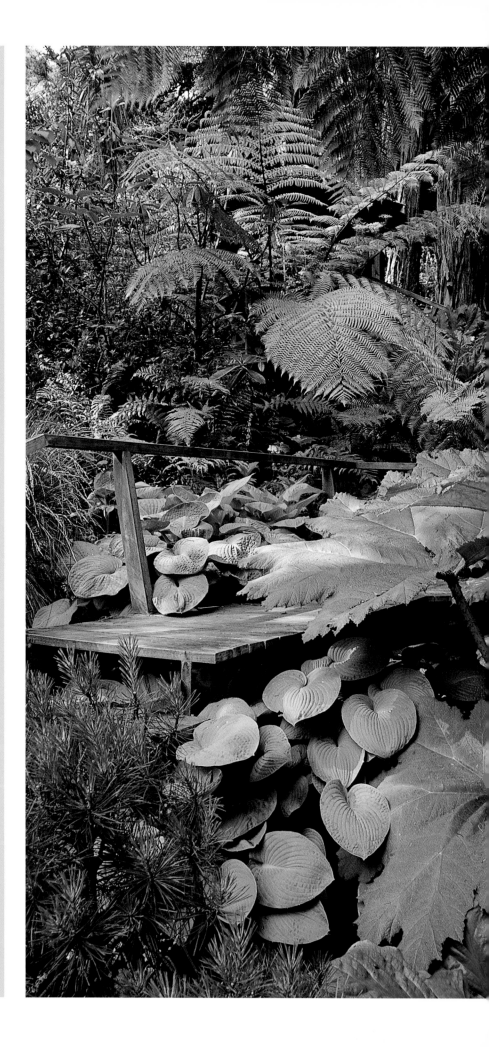

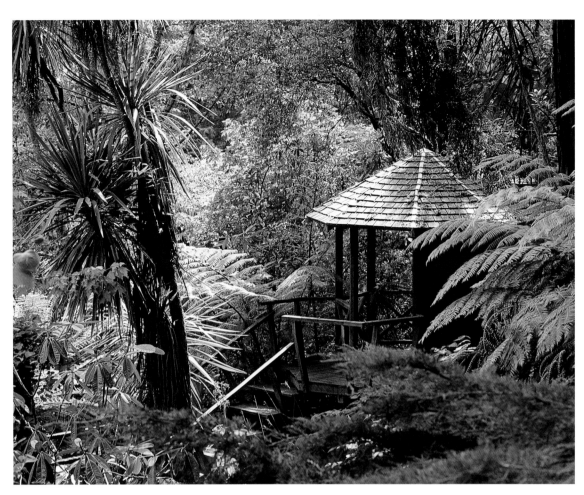

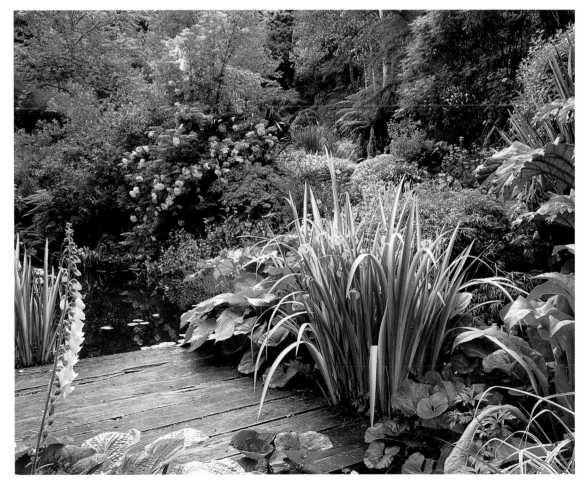

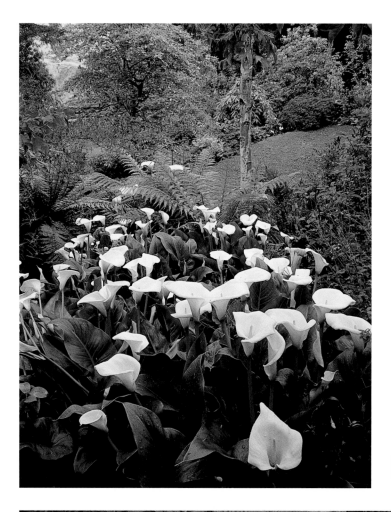

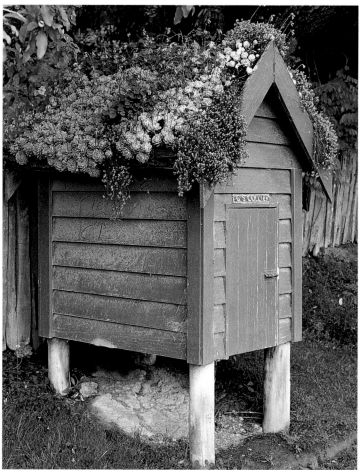

TOP LEFT A damp gully brims with arum lilies, *Zantedeschia aethiopica*.

TOP RIGHT The Colliers' mailbox is topped by a living roof of *Echeveria elegans*, crassula, and self-sown *Viola riviniana* Purpurea Group.

LEFT A rich tapestry of foliage is created by the combination of *Matteuccia struthiopteris*, the shuttlecock fern, with *Hosta undulata* var. *albomarginata*, *Rodgersia aesculifolia* and *Filipendula rubra* behind.

OPPOSITE, TOP LEFT Tree ferns flourish in the bog garden.

OPPOSITE, TOP RIGHT *Hosta* 'Snowden' surrounds *The Pioneers*, a sculpture made by David Anyon to commemorate the arrival of Gordon Collier's grandfather in New Zealand in 1889.

OPPOSITE, BOTTOM LEFT *Hakonechloa macra* 'Aureola' complements the purple filigree-leaved maple *Acer palmatum* 'Dissectum Atropurpureum'.

OPPOSITE, BOTTOM RIGHT *Iris japonica* thrives beside a rotting tree stump.

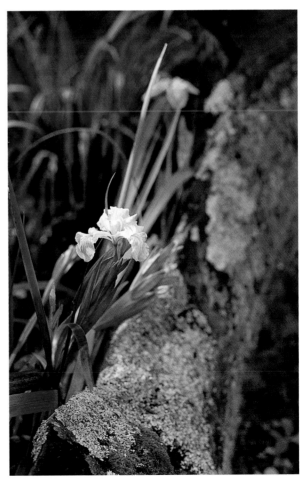

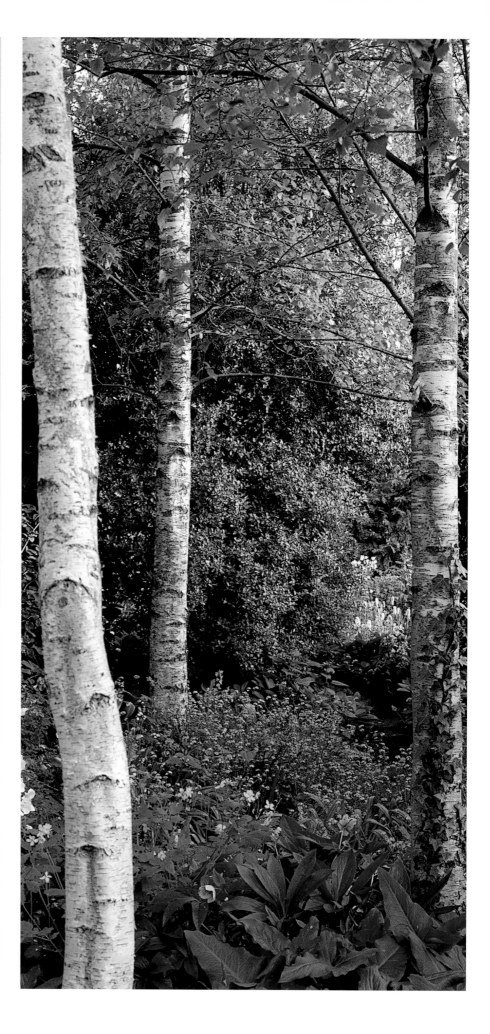

22

Rose Cottage

Timothy Walker is Director of the Oxford Botanic Garden and his wife, Jill, is a botanical historian. At Rose Cottage they have channelled their combined knowledge and transformed a plot of 0.08 hectare (⅕ acre) into a garden of many moods that satisfies their passion for plants and keeps open space for their children. A croquet lawn extends from the house and contrasts with a small woodland area that has been created under birch trees. Room has also been made for a gravel garden, a fernery and a mixed border. The border is cleverly orchestrated in both form and colour, passing from yellow and white flowers through shades of pink and ending with deep plum reds. Planting has been positioned strategically, to make the most of the sun as it moves around the garden as well as to maintain a sense of privacy.

RIGHT White-stemmed birches light up the woodland area and include the native *Betula pendula*, *B. utilis* var. *jacquemontii* and its cultivar 'Silver Shadow'.

OPPOSITE, TOP Through a veil of *Crambe cordifolia* and *Stipa gigantea*, a façade of Rose Cottage is seen across the croquet lawn. A hedge of Hidcote lavender runs along a terrace in front of the house.

OPPOSITE, BOTTOM Woodland planting under the birches includes the Welsh poppy, *Meconopsis cambrica*, an early single pale-yellow rose such as *Rosa primula*, forget-me-nots and the greater celandine, *Chelodonium majus* 'Flore Pleno', with hellebores.

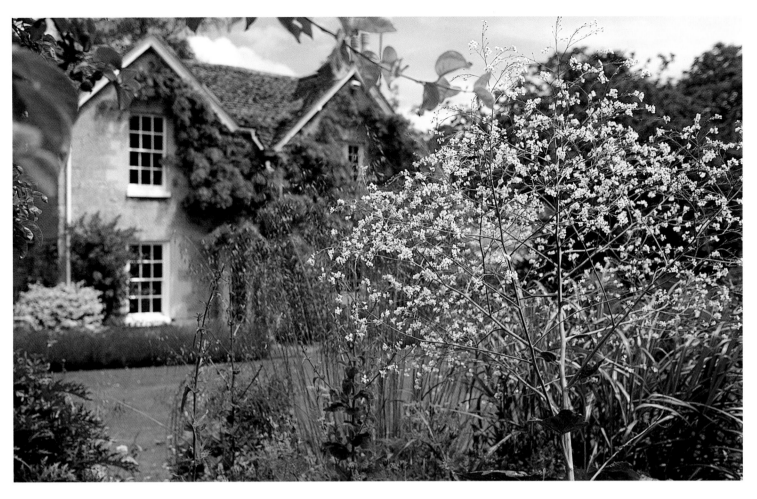

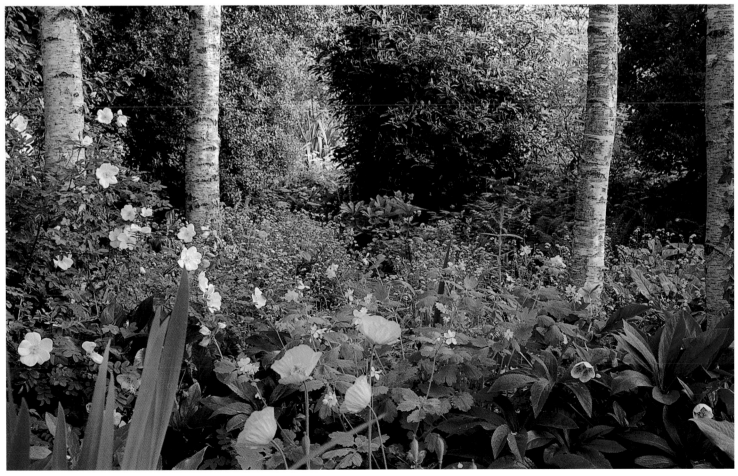

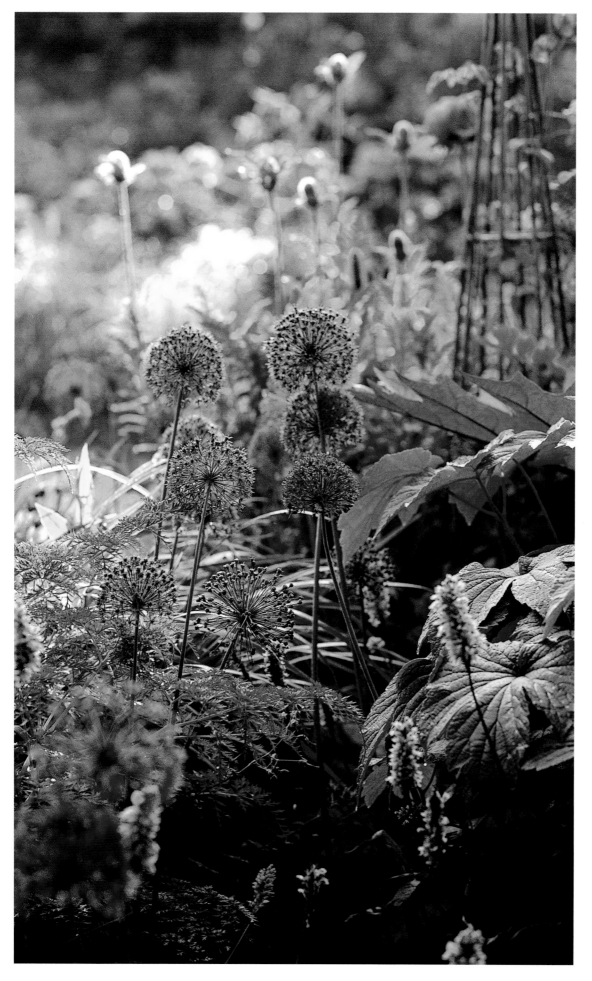

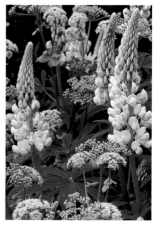

LEFT *Allium hollandicum* 'Purple Sensation' grows in the mixed border with *Persicaria bistorta* 'Superba', while behind are the buds of oriental poppies.

ABOVE, FROM TOP An unfurling bud of *Papaver orientale* 'Patty's Plum'; white lupins partnered with Alexanders, *Smyrnium olusatrum*.

OPPOSITE, TOP A stepping-stone path is bordered by the lush foliage of gunnera and the pink spires of *Persicaria bistorta* 'Superba'.

OPPOSITE, BOTTOM LEFT *Centaurea hypoleuca* 'John Coutts'.

OPPOSITE, BOTTOM RIGHT *Iris douglasiana*.

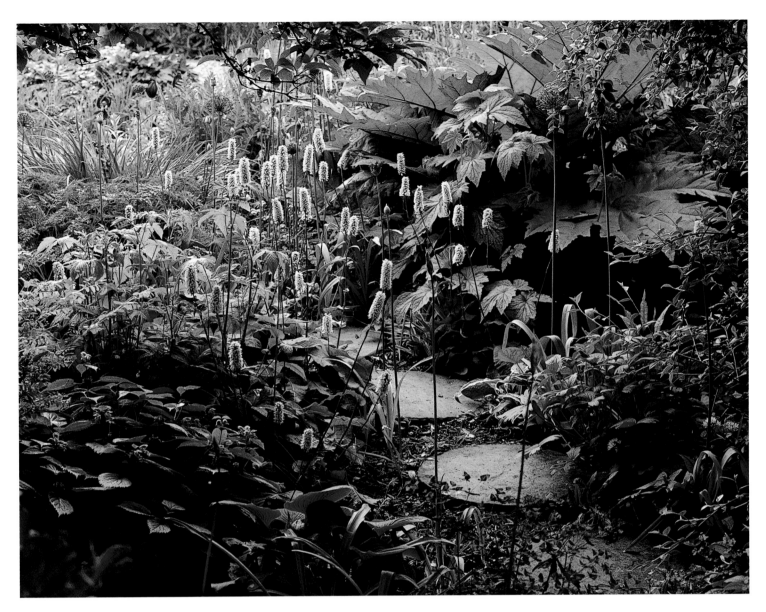

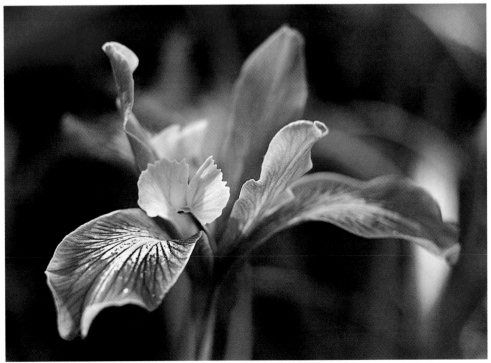

23

Home Farm

Home Farm in Northamptonshire was the 1.6-hectare (4-acre) country garden in which Dan Pearson, working with Frances Mossman, developed his increasingly naturalistic style. Pearson's aim to create a garden that remained true to the gentle spirit of the place while radically altering it was guided by the mantra of using the right plant in the right place. Bold repetition of a restricted palette of plants chosen to underline the mood and theme of each area gives a strong sense of both cohesion and balance. The thyme garden, stretching like a carpet of colour and texture from the house with hummocks of yew to bring volume as well as echo the distant hills, is a master-stroke by Pearson in a garden that brims with inspired planting. In the sunny barn garden the riotous concoction of oranges and reds crackles within tawny ironstone walls that also act as a perfect foil to the giant grasses.

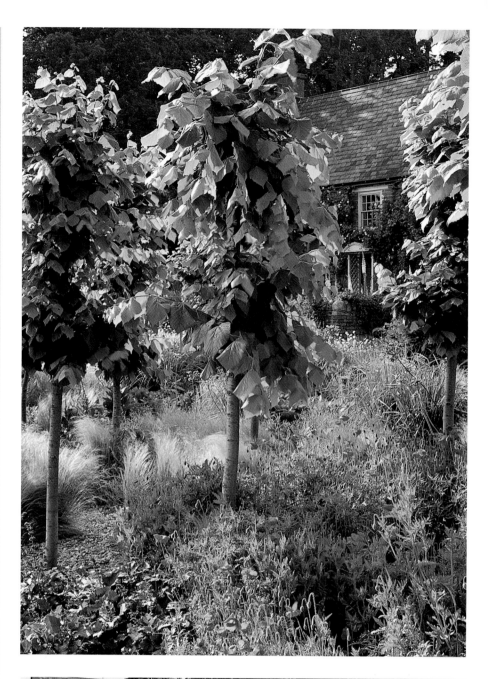

RIGHT, TOP Pillar-pruned, rather than pleached, *Tilia platyphyllos* 'Rubra' in the Lime Enclosure merge with naturalized drifts of *Stipa tenuissima* in the Grass Garden, along with field poppies and *Salvia verticillata* 'Purple Rain'.

RIGHT, BOTTOM A view towards the house across the flag-iris-rimmed pond and a meadow of ox-eye daisies reveals the gentle merging of distinct areas of the garden.

OPPOSITE The thymes 'Porlock' and 'Silver Posie' weave together as low shrubs and the ground-hugging *Thymus pseudolanuginosus* lines the path that leads to the front of the house, which is covered with *Rosa* 'Madame Alfred Carrière'. The loaf-like mound of yew has year-round impact. A froth of ox-eye daisies softens the low wall.

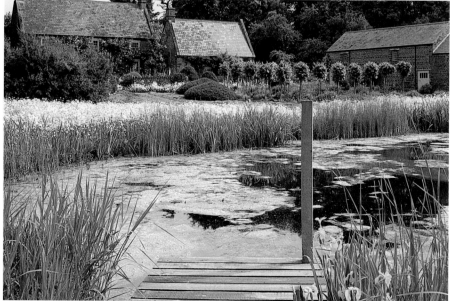

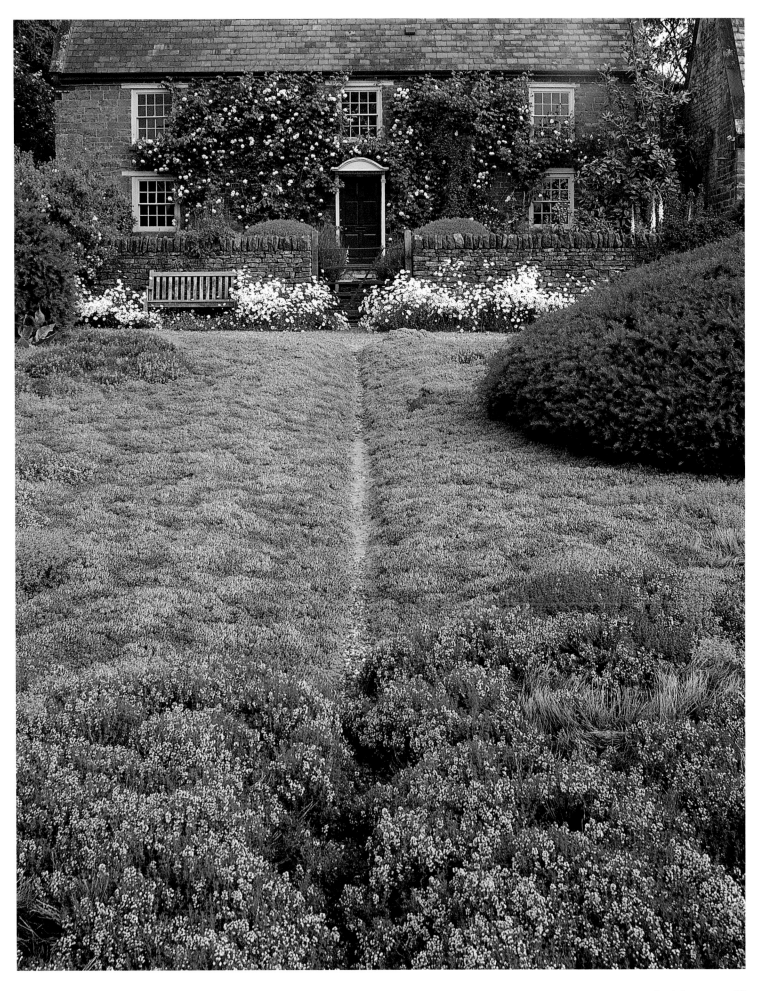

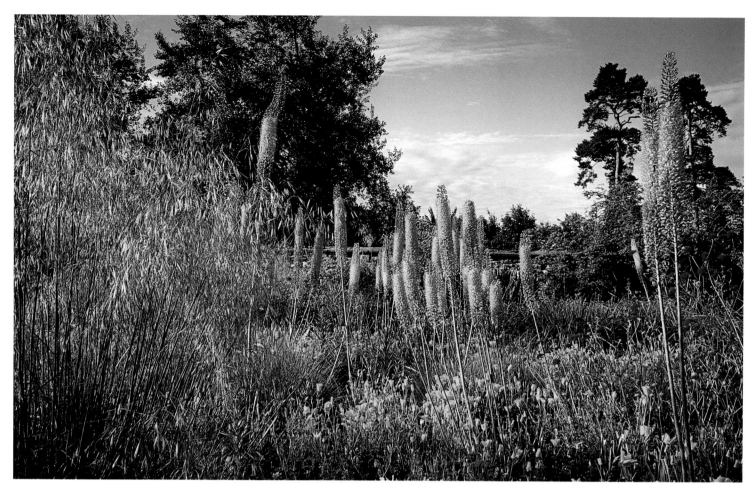

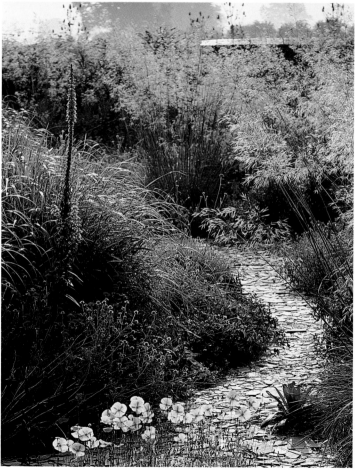

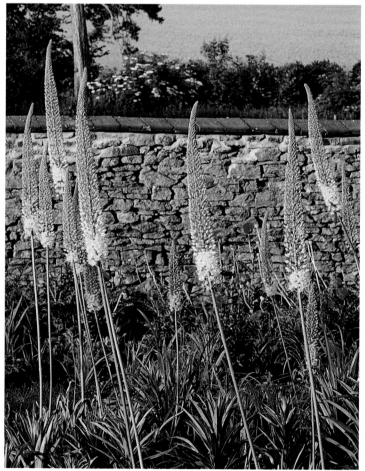

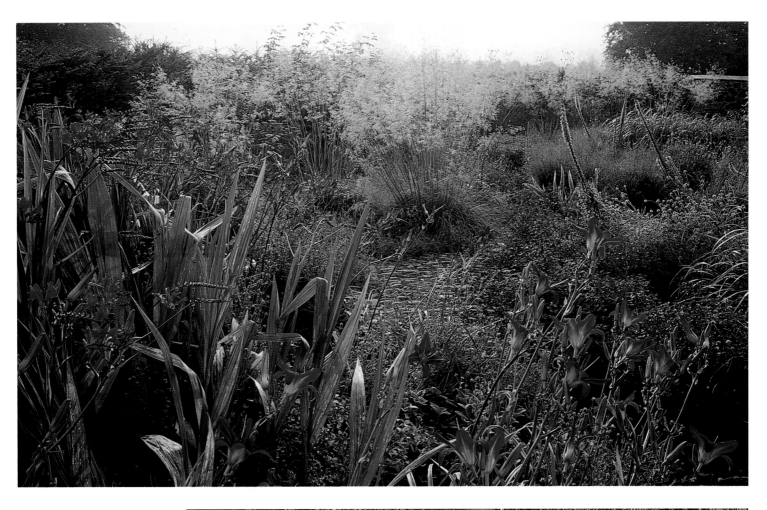

OPPOSITE, TOP In the Barn Garden in late June spires of *Eremurus* × *isabellinus* 'Cleopatra' rise out of the California poppy, *Eschscholzia californica* 'Orange Glow', with *Stipa gigantea*.

OPPOSITE, BOTTOM LEFT Golden oat grass, *Stipa gigantea*, harnesses sunlight and is seen here with *Digitalis ferruginea*, *Knautia macedonica* and a self-sown hybrid poppy.

OPPOSITE, BOTTOM RIGHT Tall, acid-yellow *Eremurus* 'Moneymaker' is partnered with orange *Eremurus* × *isabellinus* 'Cleopatra' and *Papaver orientale*.

ABOVE In later summer the oat grass continues to garner light, now in the company of *Crocosmia* 'Lucifer' and *Hemerocallis* 'Stafford'.

RIGHT In the grass garden such colonizing self-sowers as *Stipa tenuissima*, *Verbascum chaixii* 'Album' and *Eryngium giganteum* are held in check by judicious use of the hoe.

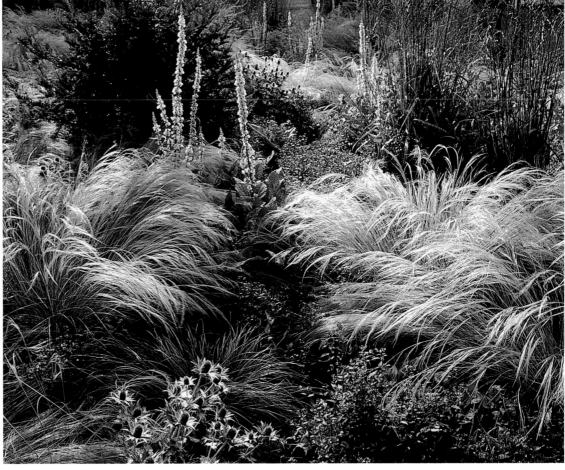

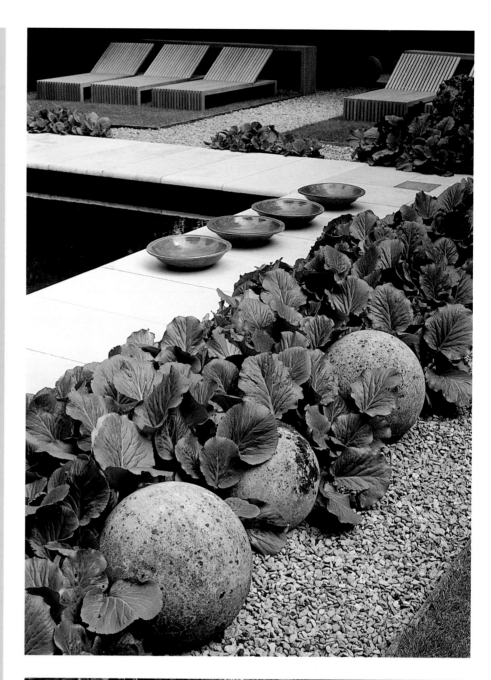

24

Cole Park

The elegant sense of proportion, clean structural lines and absence of fussy ornamentation in the Wiltshire country garden of Anouska Hempel (Lady Weinberg) make it both classical and minimalist. By adhering to a predominantly green palette, Lady Weinberg's plantings concentrate on volume, texture and contrast. In a parterre of subtle variation but great impact, two box squares are separated by simple bands of gravel and grass. Tall horse-chestnut hedges that line the drive have bare stilts, so shafts of light penetrate under the dark-green canopy and afford views over the bright-green fields beyond, while the designer's trademark mushroom-shaped domes of yew spill over the stone edge of the turning circle, emphasizing its rounded sweep. This is a garden where even the bergenia leaves look chic and tropical surrounding the dark-blue–green-tiled swimming pool.

RIGHT, TOP Bowls with a dark woad-blue glaze that matches the colour of the water decorate the swimming pool's edge. These contrast with the pool's shape, while the clean, angular lines of the bleached-iroko sunbeds echo its sharp contours. The pool's geometry is softened by an edging of lush bergenia leaves and stone balls.

RIGHT, BOTTOM A view through the pool garden shows the restful combination of water and abundant foliage.

OPPOSITE, TOP LEFT Two tall horse-chestnut hedges on stilts with a narrow but emphatic gap between them guide the eye towards the landscape beyond.

OPPOSITE, TOP RIGHT Domes of clipped box mushroom over the edge of the circular lawn that they adorn in the courtyard entrance to the Weinbergs' country garden.

OPPOSITE, BOTTOM The visual device of setting off angular edges against circles and spheres is seen again here at the entrance to the pool garden.

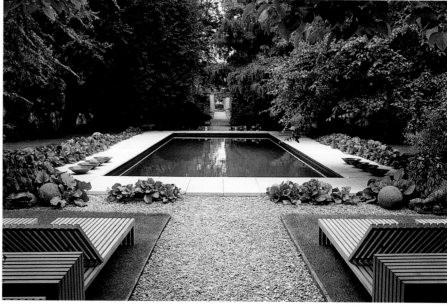

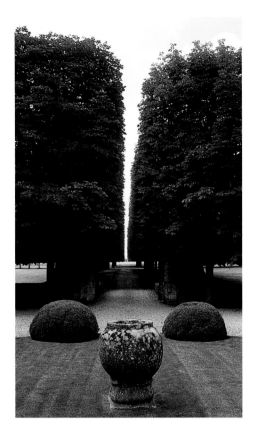

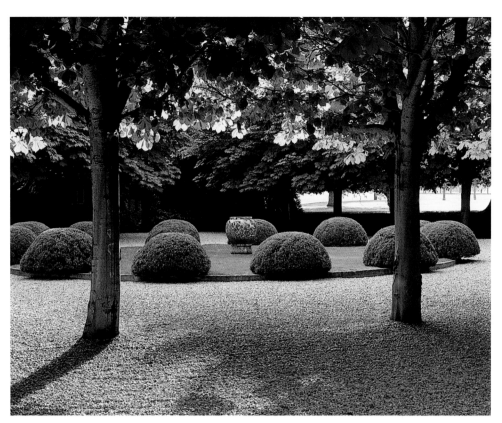

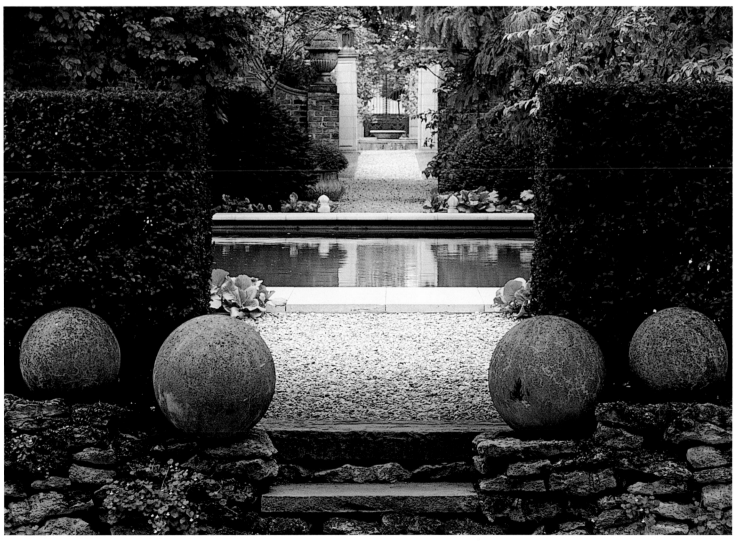

25

The Old Chapel

The previous owner of the Old Chapel at Chalford in Gloucestershire did not have gardeners in mind when he stipulated that the 0.4-hectare (1-acre) property perched on a steep escarpment in the Cotswolds could be sold only to artists. The terraced haven since created by John and Fiona Owen is just as indicative of their talents as designers and colourists as is their work on canvas and paper. The two aspects of the couple's creativity can be seen side by side at their annual midsummer celebration, when they exhibit their work at home. The garden brings together John's inspired feats of construction — he terraced the precipitous site, laid the paths and put up the buildings — and Fiona's skill in plant composition. There is a gentle sense of fluidity in the borders that results from her selection of generous self-seeders to meander among the permanent plantings. Columbine, forget-me-not, nigella and sweet rocket mingle with roses, catmint and cranesbill in romantic planting that expresses a great sense of harmony.

RIGHT The poached-salmon flower colour of *Papaver orientale* 'Mrs Perry' is mixed in this sloping border with apricot and white foxgloves and misty-mauve catmint. The white-painted Gothic seat acts as a bright focal point in what would otherwise be a dark and shady dead end.

OPPOSITE, TOP A sloping bank with shrub roses planted informally in the turf has a white-painted Gothic bird table. This and the half-moon seat were made by Freddy Gandy of Tetbury.

OPPOSITE, BOTTOM The terraced vegetable garden, with its neat brick paths, is decorated with functional lead cloches, a rhubarb forcing pot and an arch covered with the creamy-yellow climbing rose 'Alister Stella Gray', the blossom of which coincides with the wild elder in the hedgerow.

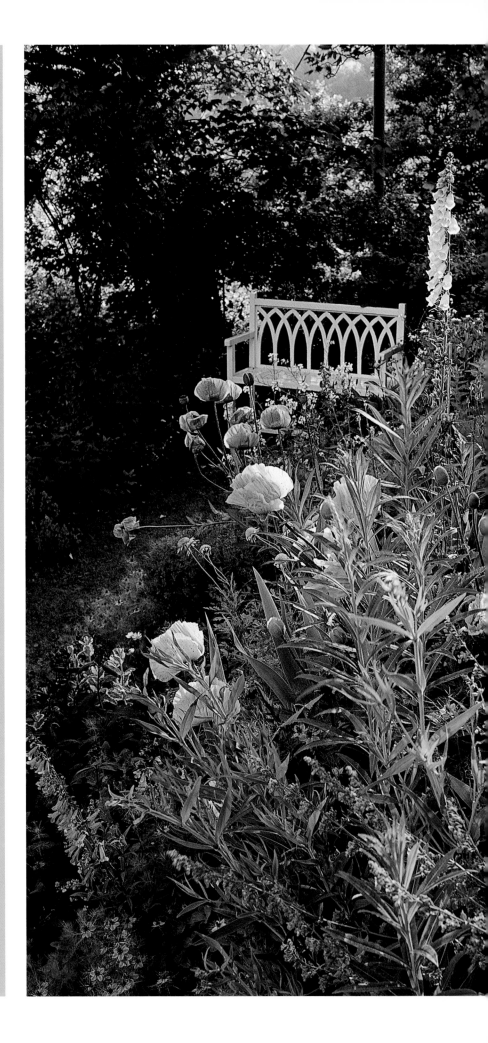

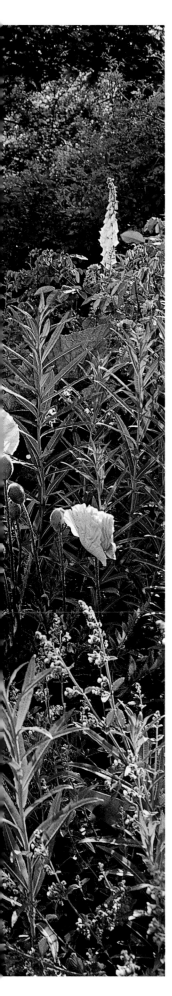

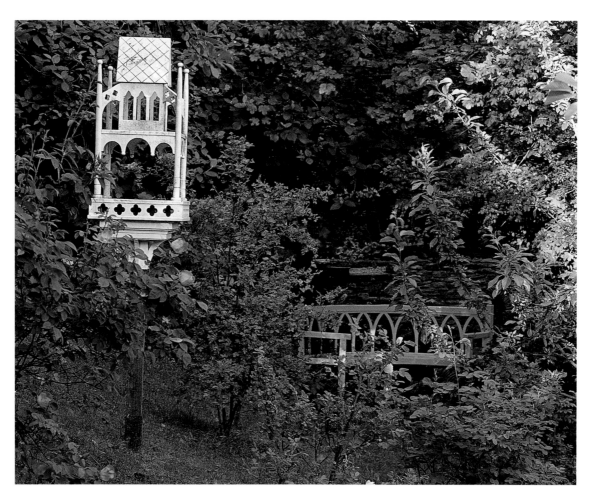

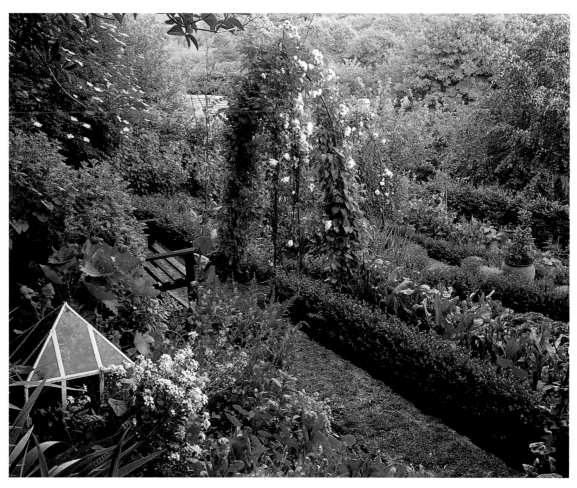

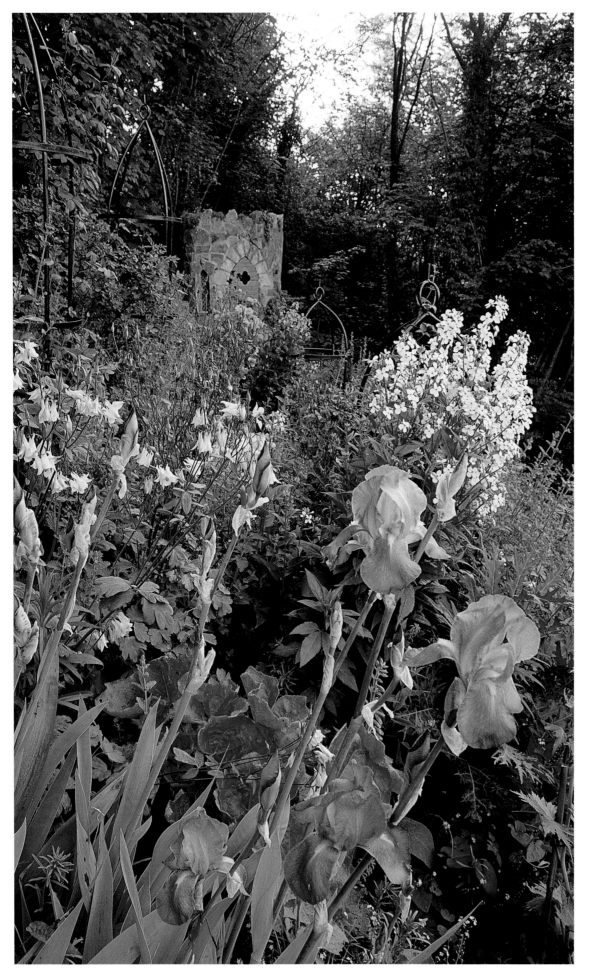

LEFT The white sweet rocket, *Hesperis matronalis* var. *albiflora*, seeds itself all around the garden, providing a link between the various areas and terraces, as do columbines in various colours, such as the pink and white aquilegias seen here with pale blue *Iris* 'Jane Phillips' in front of a stone tower folly built by John Owen.

ABOVE, FROM TOP The bird table with *Lavatera × clementii* 'Rosea'; *Dianthus* 'Doris' with love-in-a-mist, *Nigella damascena*.

OPPOSITE, TOP The Pond House, inspired by Arts and Crafts buildings at nearby Snowshill Manor, has a central dovecot and a Tibetan temple bell. The long Gothic wooden pew under the shelter of the Cotswold-stone roof was designed as a place in which to sit or lie in reflection overlooking the pond.

OPPOSITE, BOTTOM Freddy Gandy's half-moon seat stands on a circle of gravel and stone.

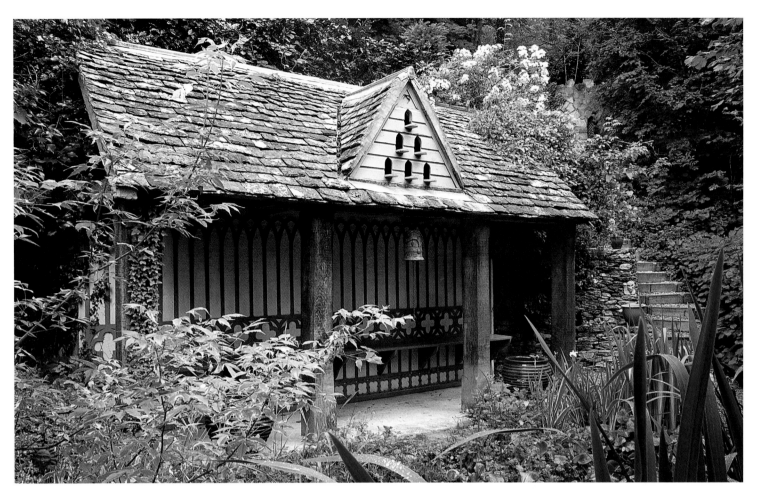

26

Nether Lypiatt Manor

The rigorous symmetry of this early eighteenth-century Cotswold house is perfectly matched by a garden of impeccable topiary. Simplicity of design and the use of grass and gravel around the tightly clipped forms of box create a sense of space and elegance. The shapes of the box both complement the restrained architecture of Nether Lypiatt Manor and lend the garden a modern edge. The parterre garden, with its central sundial in the lawn, is flanked by low hedges of lavender interspersed with columns of clipped Irish yew. This composition retains its style and structure throughout the year with a minimum of maintenance and would make a perfect garden for a large town house.

RIGHT AND OPPOSITE The repetition of pattern and motifs in the topiary lends a sense of rhythm and cohesion to the various parts of the garden. Pyramids of box set in box plinths not only guide you from the wrought-iron gates up to the front door (opposite) but also embellish each corner of the box-and-gravel beds in an adjacent garden. Here the rigid lines of diamond formations and pyramids are counterbalanced by perfectly spherical balls. Further contrast is provided by the lines of silver-leaved, dark-purple-flowered *Lavandula angustifolia* 'Hidcote' (right, bottom).

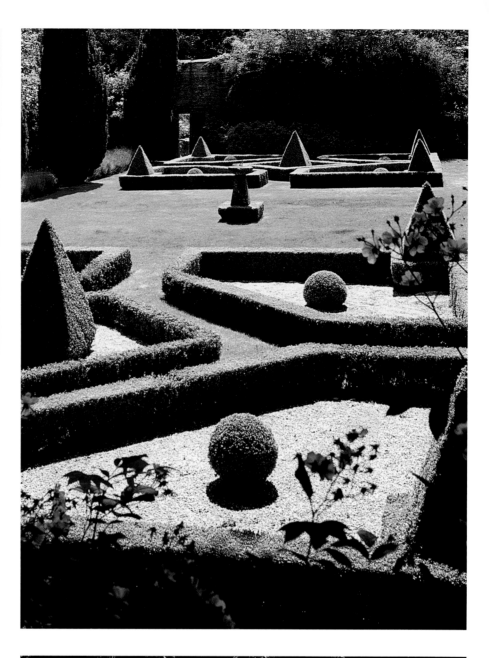

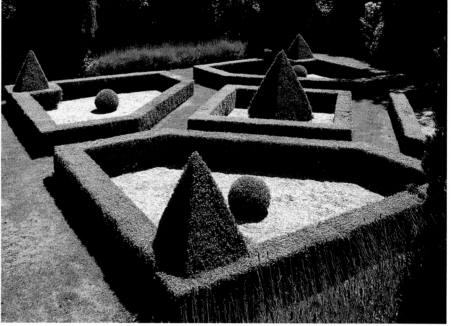

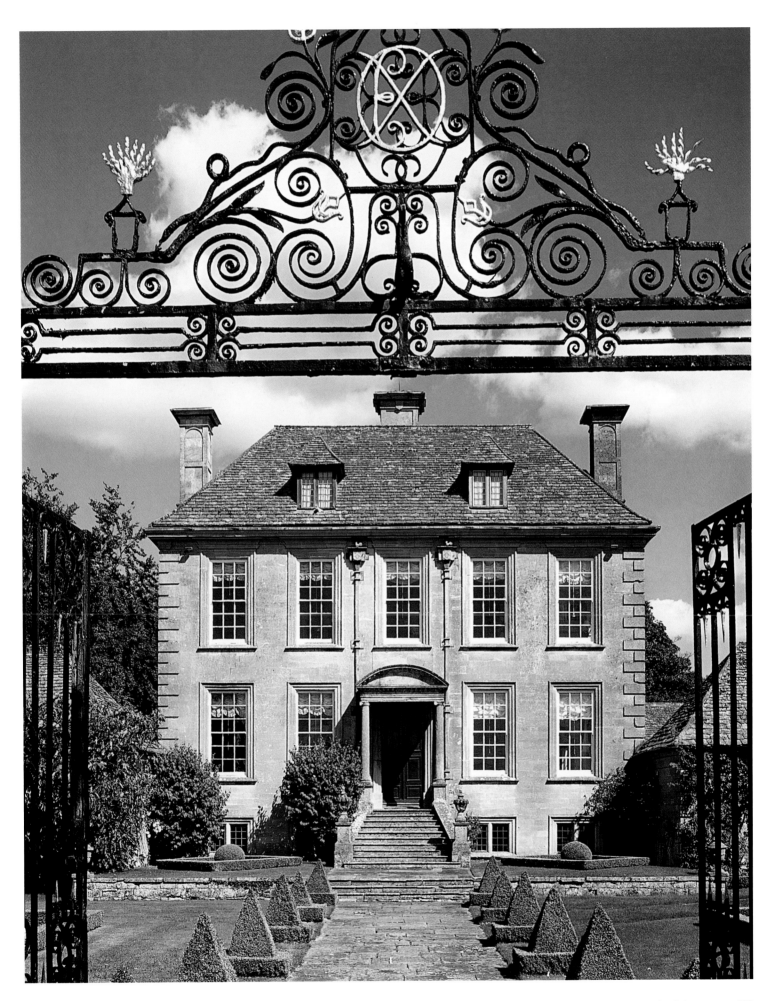

27

West Mill

A light touch was called for in the development of the terraces and garden around West Mill, positioned as it is in the fold of a Devon valley that runs down to the sea. For many years Andrew and Briony Lawson let West Mill be, and now a series of collaborative projects has resulted in apt and evocative additions that have left its harmony undisturbed. James Fraser and Ross Palmer helped build a terrace from local slate and stone; Dan Pearson pinpointed the planting that would best chime with the surrounding vegetation; Paul Anderson provided the driftwood garden seats; and Susie Lawson created the pebble mosaics. Twisted terrace railings made from oak branches found on the nearby woodland floor, bones washed up on the beach and arranged in decorative piles, and rams' horns from the coastal path further contribute to the strong sense of place that characterizes West Mill.

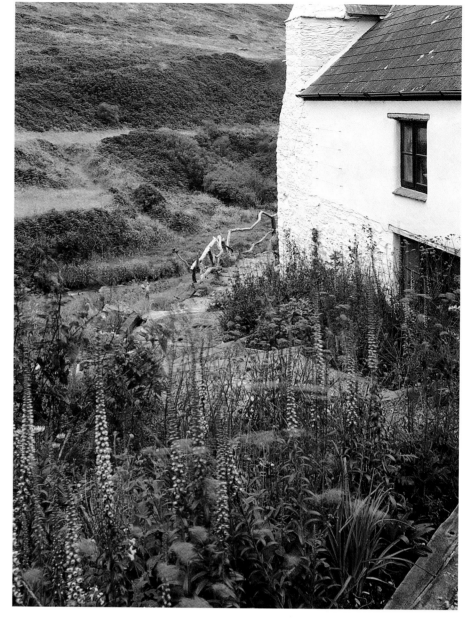

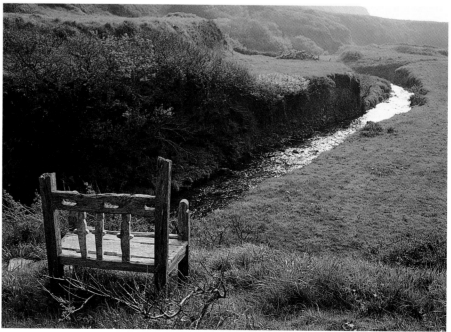

RIGHT, TOP Among Dan Pearson's planting suggestions, which show great sympathy with the garden, is a mixture of *Digitalis ferruginea, Knautia macedonica* and *Verbena bonariensis*.

RIGHT, BOTTOM One of Paul Anderson's characterful driftwood seats stands at a vantage point overlooking the Marsland stream as it meanders down to the sea.

OPPOSITE West Mill nestles in a gorse-filled valley between folds of cliffs that line the Devon coast.

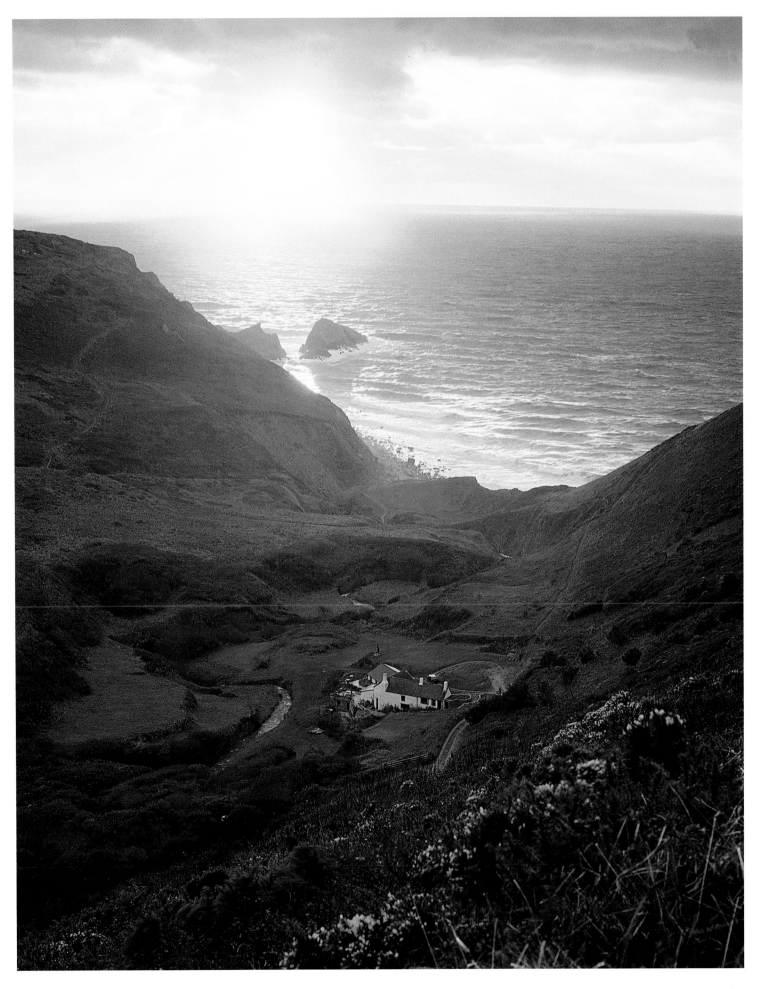

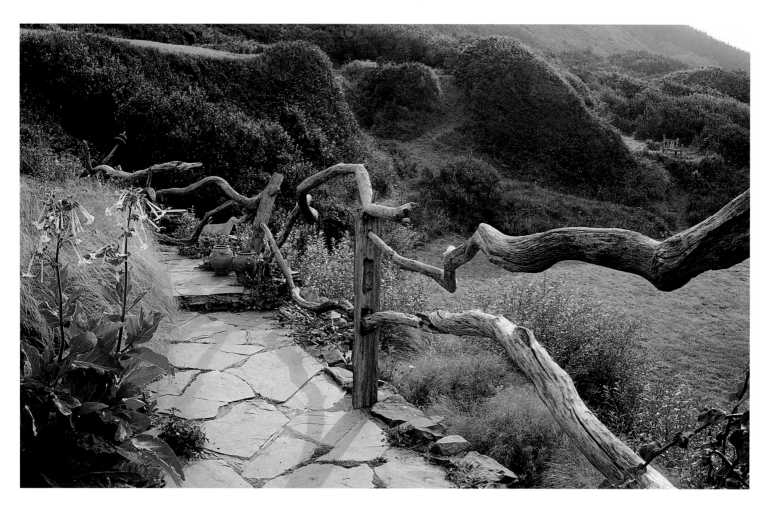

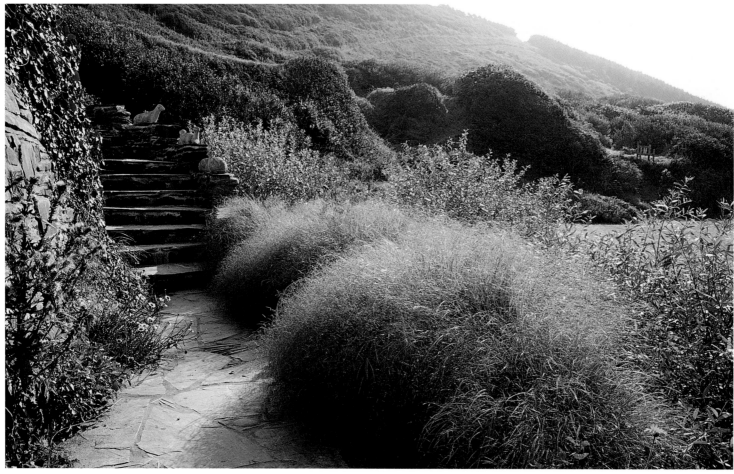

OPPOSITE, TOP The twisted railing that runs beside a garden path is made from fallen oak branches found in nearby woodland. *Nicotiana sylvestris* is planted out each year for its scented white flowers.

OPPOSITE, BOTTOM Fluffy, rufous mounds of *Anemanthele lessoniana* contrast with *Salix alba* var. *vitellina* 'Britzensis' along a path that leads to steps lined with sculptures by Briony Lawson.

ABOVE, FROM TOP Shards of pink brick in Susie Lawson's lobster mosaic are picked up in the russet tones of *Sedum telephium* 'Matrona'; a houseleek, *Sempervivum*, sits at the centre of a mill wheel that forms a table.

RIGHT A seat by Paul Anderson stands surrounded by *Verbena bonariensis* and *Digitalis ferruginea*.

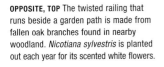

LEFT A silver-and-red spiral mosaic by Susie Lawson is matched by the hues and tones of surrounding planting, which includes *Sedum telephium* 'Matrona'.

ABOVE, FROM TOP A ram's horn found on a coastal walk and mounted on a stick decorates the garden; *Romneya coulteri* is planted with *Anemanthele lessoniana*.

OPPOSITE, TOP The valley that sweeps about the house is ablaze with foxgloves.

OPPOSITE, BOTTOM Weathered bones picked up locally congregate on a garden wall.

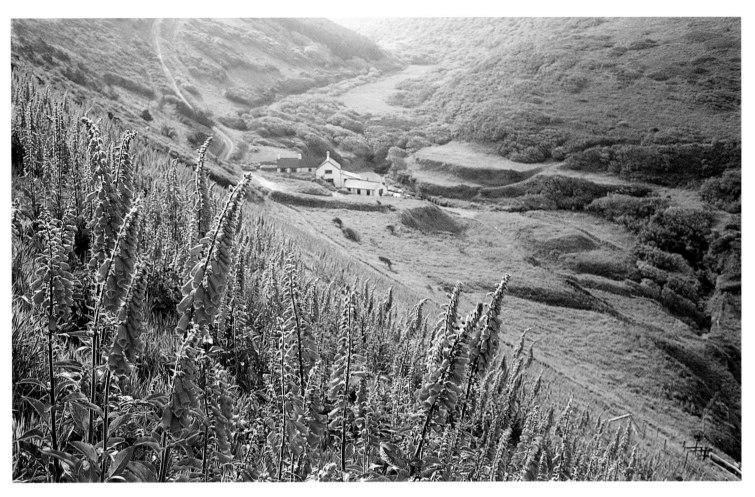

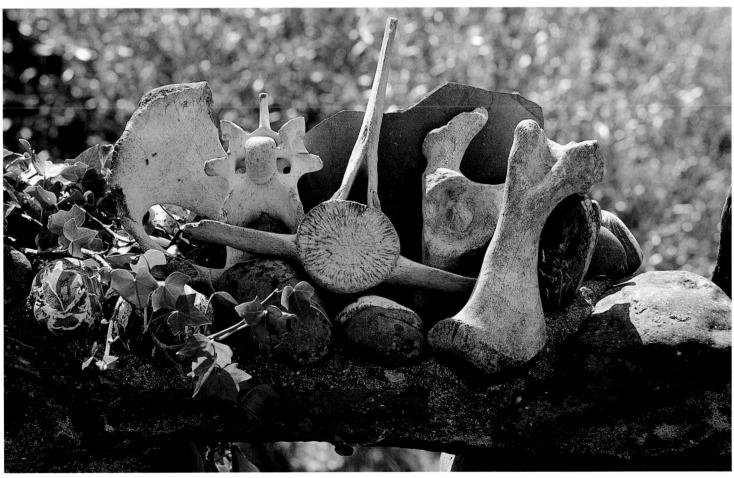

28

Guanock House

Arne Maynard designs classic gardens with a modern twist. At this 2-hectare (5-acre) Lincolnshire property shared with his partner, William Collinson, views stretch to the horizon in all directions. Following his maxim of always working with rather than against the surrounding landscape, Maynard divided the garden into a series of enclosures that conform to a grid of long axes. Brick walls and hedges of hornbeam, yew and box subdivide the site but in each area a small opening has been kept so as to offer a view to the horizon. This knack of making gardens appropriate to their setting makes Maynard the garden designer of choice for many interior decorators who also admire his love of structure, pattern and colour. His talent for balancing formal and informal elements in his gardens is expressed by laying down a rigid structure with hedges, pleached trees and clipped evergreens and counterbalancing this with a profusion of flowering plants in delicious colour compositions.

RIGHT, TOP An elegantly shaped lawn within a pleached lime walk is simple but decorative and draws the eye towards the ancient clipped yew in front of the house.

RIGHT, BOTTOM The terrace in front of the house is partially enclosed by a series of domed elaeagnus. Immaculate bands of lawn are edged by wide herbaceous borders and separated by a hedge of *Lavandula spica* that runs down the garden's main axis.

OPPOSITE, TOP Beside the pleached lime enclosure is the Physic Garden where eight clipped domes of *Quercus ilex* in squares of box stand sentinel beyond a circular pond with a fountain. The creamy, sword-shaped leaves of *Iris pallida* 'Argentea Variegata' make a striking contrast with the inky blackness of the water.

OPPOSITE, BOTTOM LEFT A clipped pyramid of copper beech topped with a neat spherical finial adds drama and structure to planting in the rose garden

OPPOSITE, BOTTOM RIGHT A secluded painted bench, designed by Chatsworth Carpenters, against the mellow brick of the house is enclosed by low hedges and clipped holly, *Ilex aquifolium* 'Myrtifolia'.

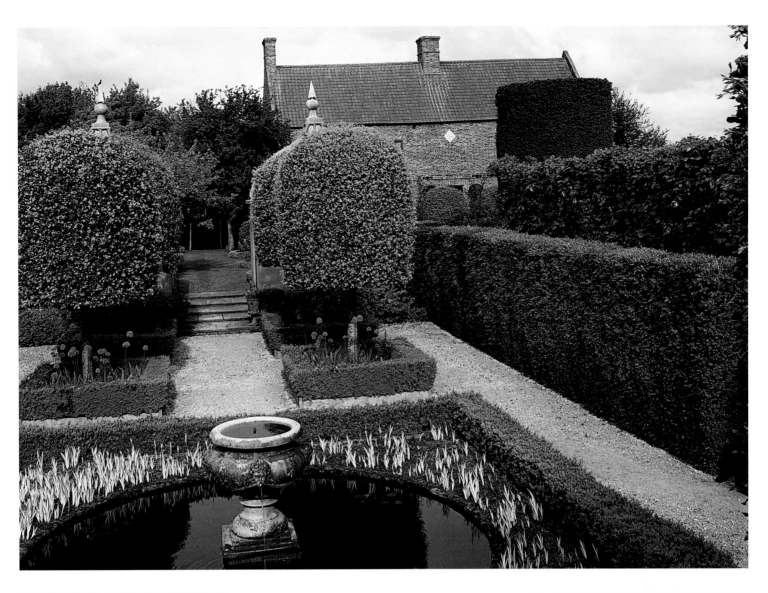

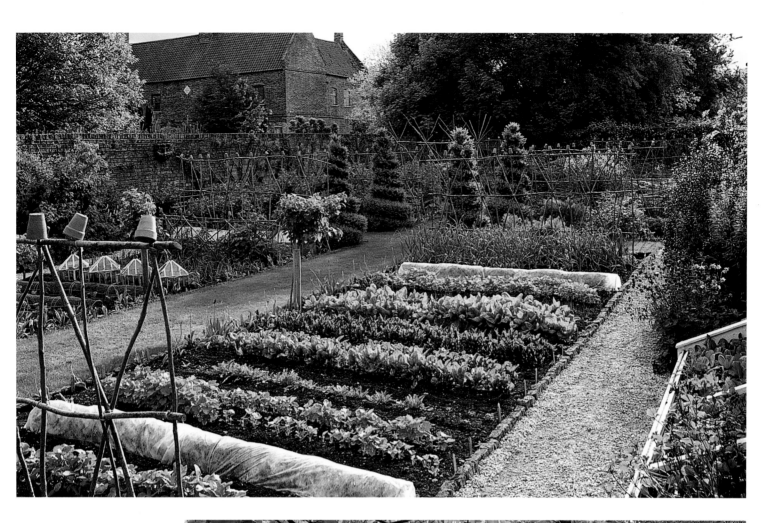

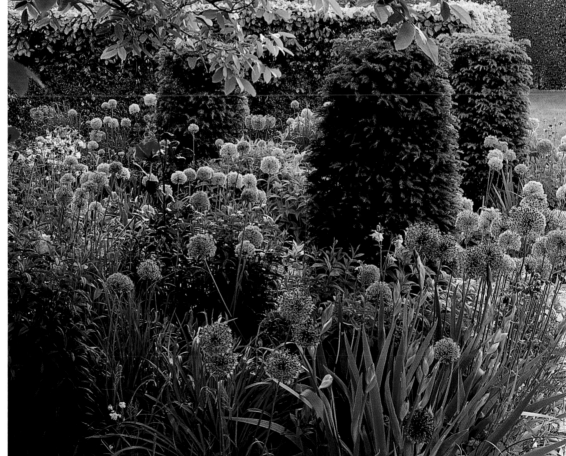

OPPOSITE Cow parsley grows in the orchard grass, which is left long until midsummer to benefit the accompanying carpet of spring bulbs.

ABOVE Four spiral columns of box at a junction of paths in the vegetable garden give year-round form and visual interest. The cultivated beds are of a practical width, easily reached from the paths on each side yet wide enough for a substantial crop.

BOTTOM In early summer the scarlet *Papaver orientale* 'Beauty of Livermere' adds accents of bright colour in an exuberant planting of *Allium aflatunense*. Short columns of yew provide evergreen colour and structure in this wide border.

No. 4 Coleshill

The garden that surrounds the picturesque stone cottage of Isabelle van Groeningen and Gabriella Pape is in Coleshill, an Oxfordshire village owned by the National Trust. In deference to the setting, the two garden designers have created a gentle and unselfconscious cottage garden that occasionally explodes into riotous planting combinations that one would expect from these early proponents of the New Perennial Movement. Plants are chosen as much for their winter silhouettes and seed heads as for their flowers, and the whole garden is given an annual cut-back in February. The path of shattered slate shards running up to the front door is overhung by a profusion of perennials and punctuated by wigwams of oak poles, bound together with twine, that are also used to support climbing beans in the vegetable garden. Behind the house a winding path leads through a large expanse of naturalistic planting that starts with the fiery reds and oranges of poppies, geums and achilleas and gradually fades to white roses and feverfew.

To preserve the atmosphere of a cottage garden, the planting in the front garden has been kept informal and without a rigid colour scheme. This joyous jumble of flowering colour and form includes (from left to right) *Phlomis tuberosa* 'Amazone', the deep-pink *Rosa* 'Gertrude Jekyll', tall yellow *Thalictrum flavum* subsp. *glaucum*, teasel, dark-purple *Rosa* 'Charles de Mills' and the tall white yarrow, *Achillea grandifolia*. The rose growing beside the building that once housed the village bakery is 'Albertine'.

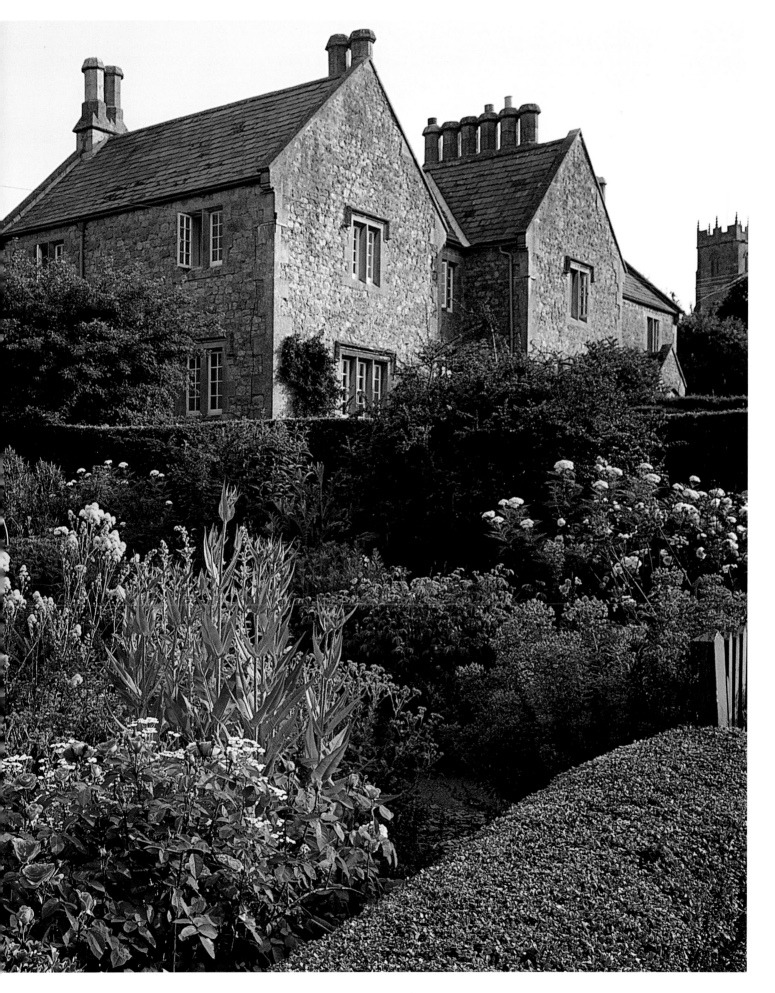

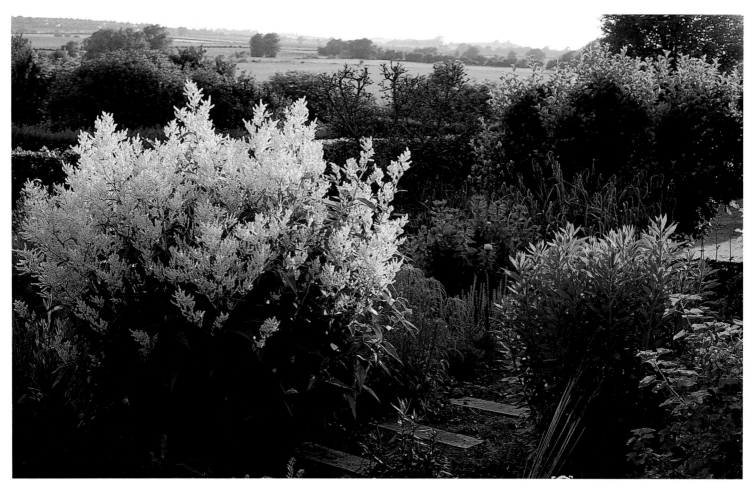

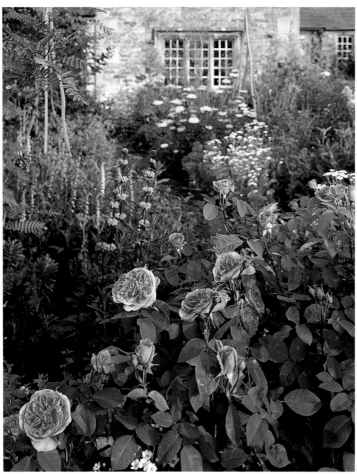

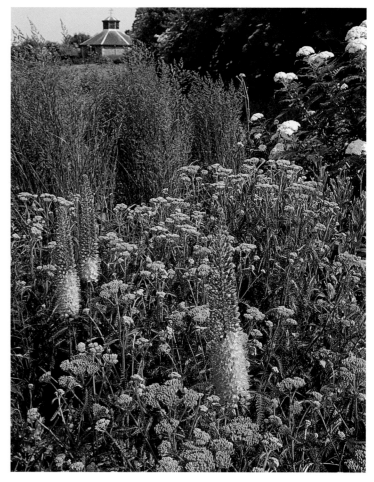

OPPOSITE, TOP The impressive giant perennial *Persicaria polymorpha*, with creamy-white plumes, grows beside a stepping-stone path in the back garden, from where there is a view across fields to distant hills.

OPPOSITE, BOTTOM LEFT *Rosa* 'Gertrude Jekyll' is combined with *Phlomis tuberosa* 'Amazone' and the perennial yellow foxglove, *Digitalis lutea*.

OPPOSITE, BOTTOM RIGHT *Eremurus × isabellinus* 'Cleopatra' works well with the rusty-orange yarrow *Achillea* 'Terracotta', *Calamagrostis × acutiflora* 'Karl Foerster' and *Achillea grandifolia*.

ABOVE, FROM TOP *Verbascum* 'Cotswold Queen' with bright-red Maltese cross, *Lychnis chalcedonica*; *Papaver orientale* 'Saffron'.

RIGHT In the vegetable garden climbing peas and beans are grown up these wigwams of five bendy green-oak canes gathered together with twine, seen here behind a row of broad beans.

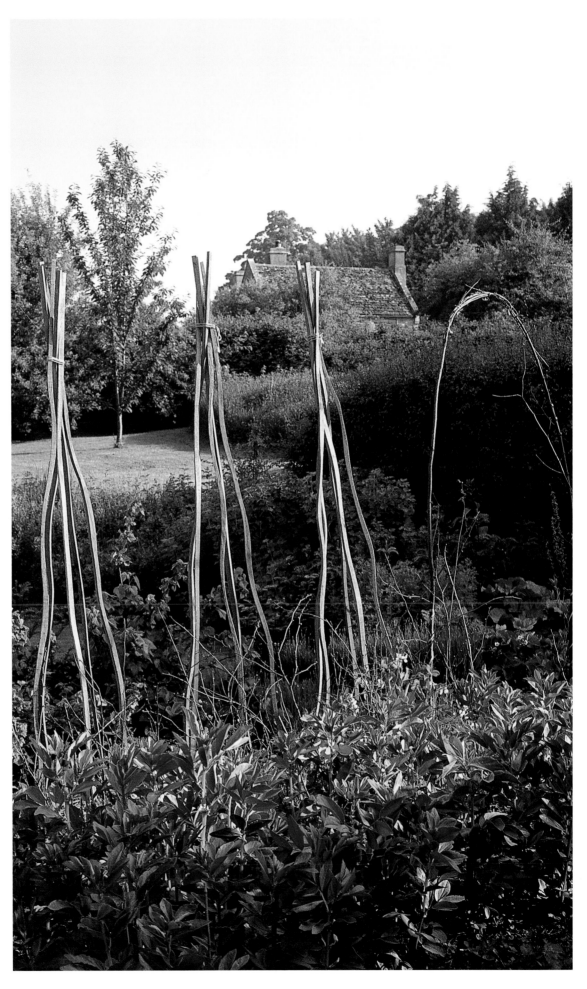

30

Melbourne

This courtyard garden in Melbourne is characteristic of the elegant and formally defined style of Paul Bangay. Water, topiary and statuary are all essential ingredients in this designer's work, and while some of his gardens are pared down to a minimalist appearance, the clients who commissioned this one favoured planting that would reflect the seasons. The recesses in the lime-rendered walls are filled with Virginia creeper, deep, shiny green most of the year but blazing with fiery tints in autumn. The focal point of the garden from both inside and outside the house is the simple and exquisitely lit water basin on its four-stepped plinth. The small change of level in the plot is subliminally exaggerated by the layering of evergreen hedges, so that a glance at the garden gives the impression of many levels. Another clever contrast is the difference in texture between the different types of box. The pattern of dark pebbles in pale limestone paving has the decorative appeal of a carpet when one looks down on to the garden from an upstairs window.

RIGHT The two-tier box hedging creates a textural contrast: a small, silvery-leaved box forms a low band around the taller, dark-green square of box that encloses planting. A ring of spiky-leaved cycads, *Cycas revoluta*, surrounds a large terracotta pot in which Meyer's lemon trees are being trained into the shape of a goblet.

OPPOSITE The apparent simplicity of this courtyard garden belies a great attention to detail. This warm, reddish-pink-sienna limewashed wall has a contrasting panel of *Parthenocissus* that is inset to heighten the effect. The limestone edging of the pond and the channel is juxtaposed with chippings of white marble, creating a change of texture. Uplighting passing through the water adds a soft and attractive glow.

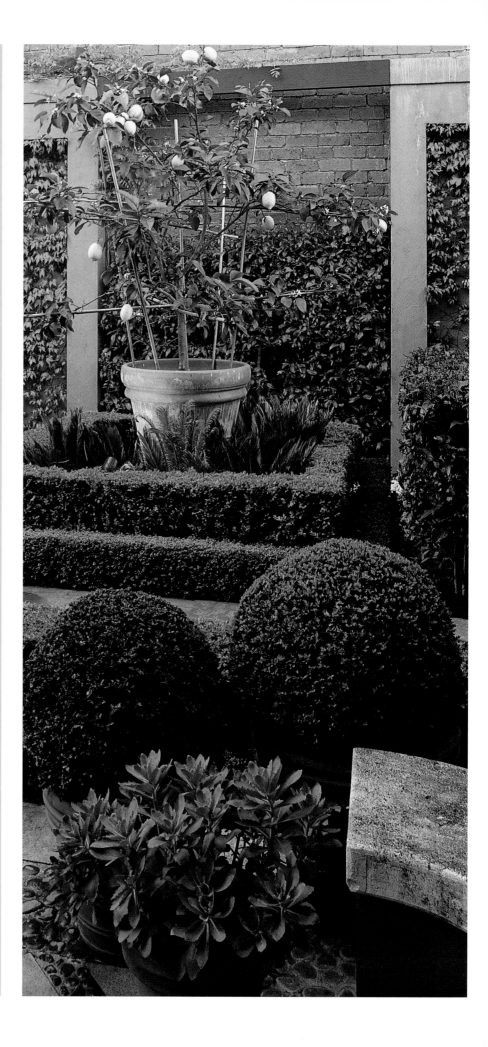

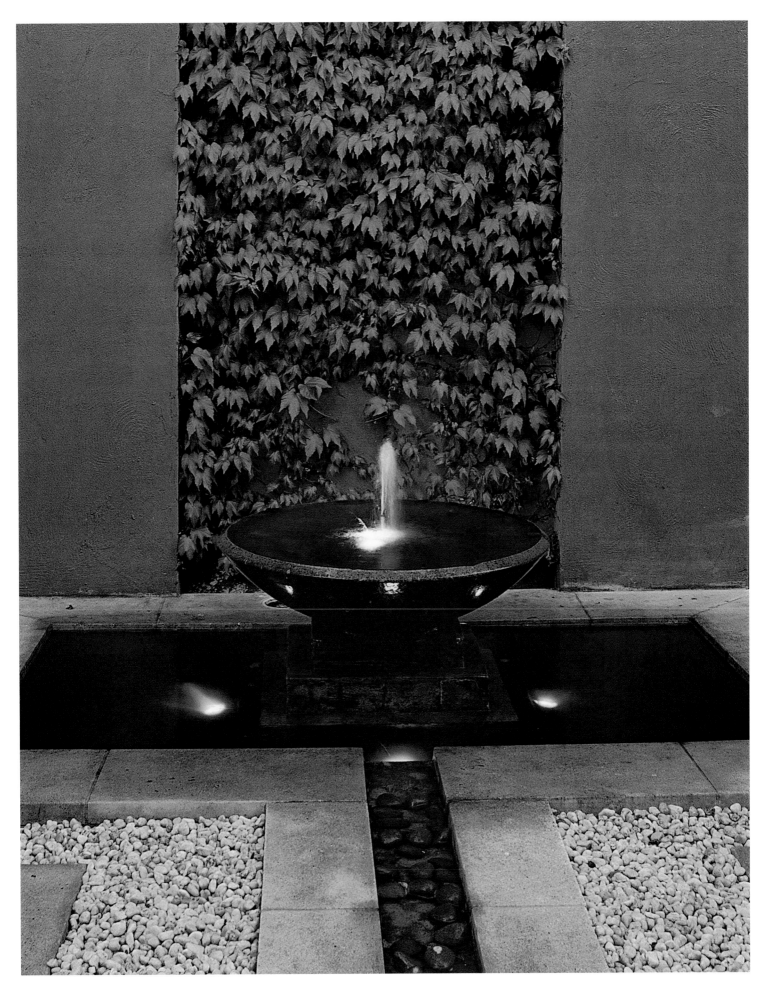

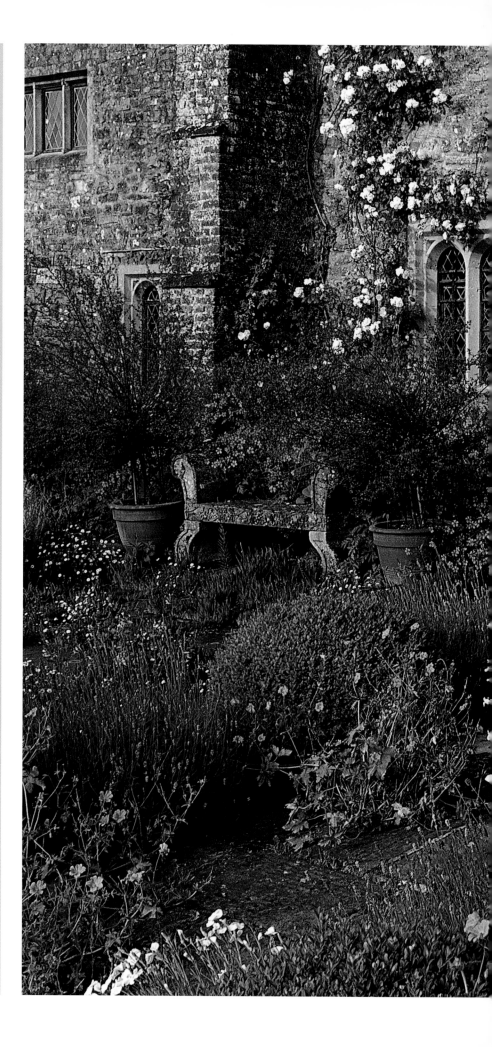

31

Cothay Manor

The outlines of much of the garden at Cothay Manor in Somerset were laid down in the 1920s by Colonel Reginald Cooper, but it is the energy and talents of the current owners, Mary-Anne and Alastair Robb, that have brought back to vibrant life what fifteen years ago was a tired and rather melancholy garden. There is a traditional garden layout of separate rooms, arranged with specific colours in mind, but it is not the garden alone that makes Cothay so special. The medieval manor house of soft, honey-coloured stone remains intact, with several additions, from when it was built in the 1480s. A strong sense of both continuity and tranquillity permeates the area the Robbs have created known as the Unicorn Garden, where a double row of mophead robinias has been underplanted with a simple and effective swath of smoky, mauve-flowered *Nepeta* 'Six Hills Giant'. Thousands of elegant, white, lily-flowered tulips enliven the walk in late spring.

The terrace that stretches from the west elevation of Cothay, said to be the most perfect example of a small classic medieval manor in England, has a sense of timelessness but was laid out and planted only after the Robbs bought the house in 1993. A framework of evergreen – domes of box and spikes of *Yucca filamentosa* 'Bright Edge' – provides winter structure that is embellished by a profusion of self-sowing summer-flowering plants. *Geranium palmatum* is a permanent fixture behind the stone bench, while the daisy *Erigeron karvinskianus* migrates around the cracks in the paving, competing for space with *Geranium* 'Claridge Druce', *Campanula persicifolia* and its white form 'Alba'. An unnamed rose with a long season of creamy-white flowers grows up the mellow, honey-coloured stone walls.

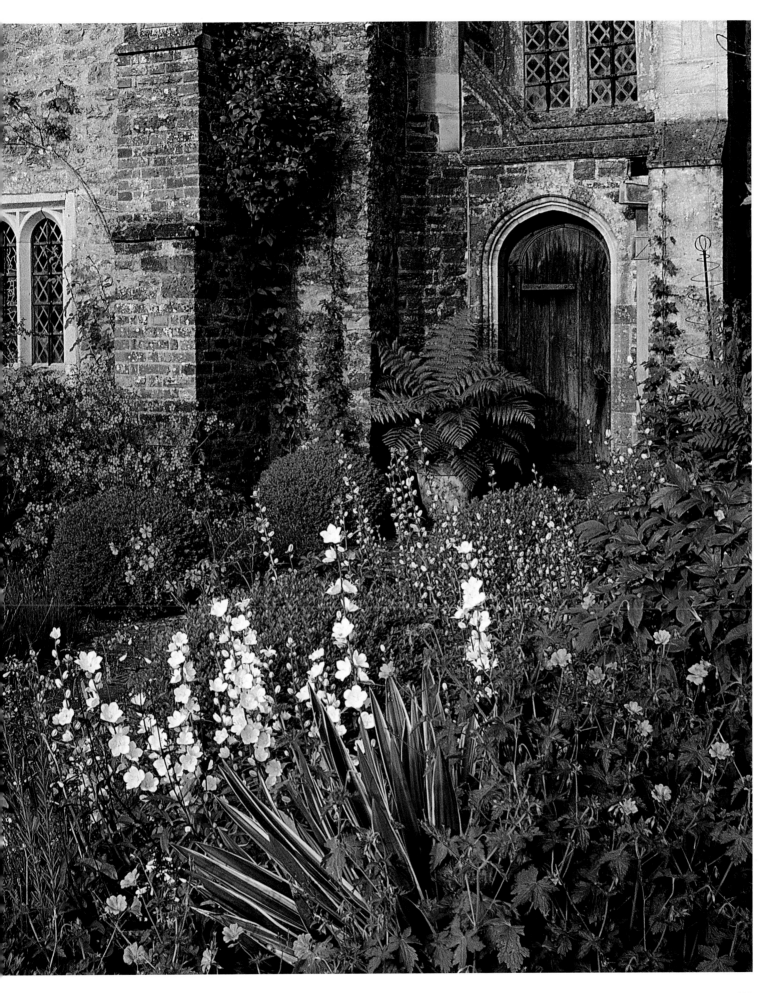

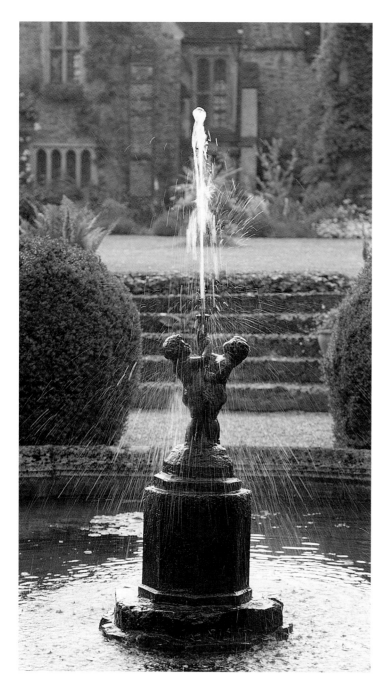

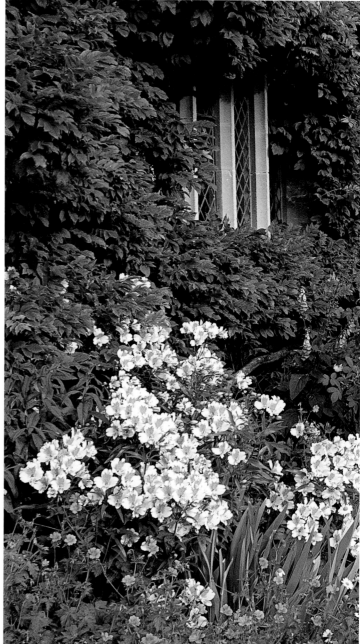

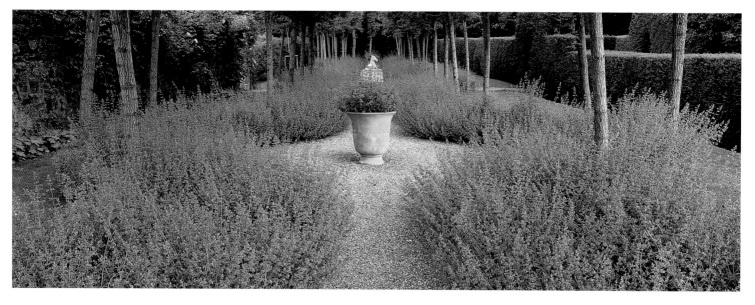

OPPOSITE, TOP LEFT An ornate fountain adorns the pond in the middle of the parterre.

OPPOSITE, TOP RIGHT *Alstroemeria pelegrina* 'Alba' with prominent yellow markings and *Geranium* 'Claridge Druce' grow in a border next to the house.

OPPOSITE, BOTTOM The Walk of the Unicorn is planted with a simple and effective sweep of *Nepeta* 'Six Hills Giant' beneath the spherical canopy of an avenue of *Robinia pseudoacacia* 'Umbraculifera'.

ABOVE, FROM TOP *Michauxia tchihatchewii*; *Papaver orientale* 'Beauty of Livermere' with *Allium hollandicum* 'Purple Sensation' and *A*. 'Globemaster'.

RIGHT A view through the medieval arch to the entrance courtyard embraces *Acanthus mollis*, sentinels of yew and a line of tall *Lavandula angustifolia* 'Hidcote Superior' flanking the path to the front door.

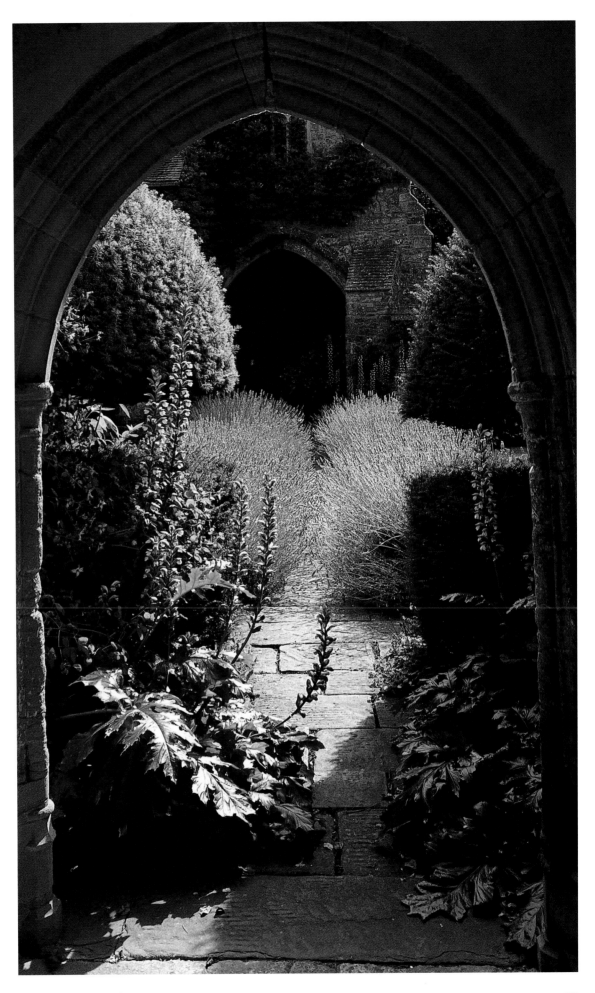

32

Chelsea Park Gardens

This front garden in London, created by James Aldridge, shows how a small space can be transformed by clever design and a handful of high-performance plants. Star jasmine, *Trachelospermum jasminoides*, a neat evergreen climber, frames the porch and its heavenly scent wafts through open windows in midsummer, enchanting visitors to the house. The small, stone-flagged courtyard is flanked by dramatic clumps of arum lilies and top-pruned olive trees that act as a delicate silvery veil to prevent people in the street or neighbours opposite seeing into upstairs windows. By varying the heights of the various box balls that elegantly echo the walls' round stone finials, and the volumes of their terracotta pots, Aldridge has subtly given the composition a further layer of interest. Needing only an annual trim and feed and occasional supervision of the timed watering system, this is a low-maintenance garden, and a very chic one at that.

RIGHT The front of the house is draped with sweet-smelling star jasmine, which is neatly trimmed up to the sills of the first-floor windows. Voluminous globes of box spilling over the rims of their terracotta pots provide a textural contrast with the wispy silver olives.

OPPOSITE, TOP The multi-stemmed olives are underplanted with lush, free-flowering, tropical-looking arum lilies, *Zantedeschia aethiopica*.

OPPOSITE, BOTTOM The impact of simple but elegant stone spheres is echoed by neatly clipped box balls.

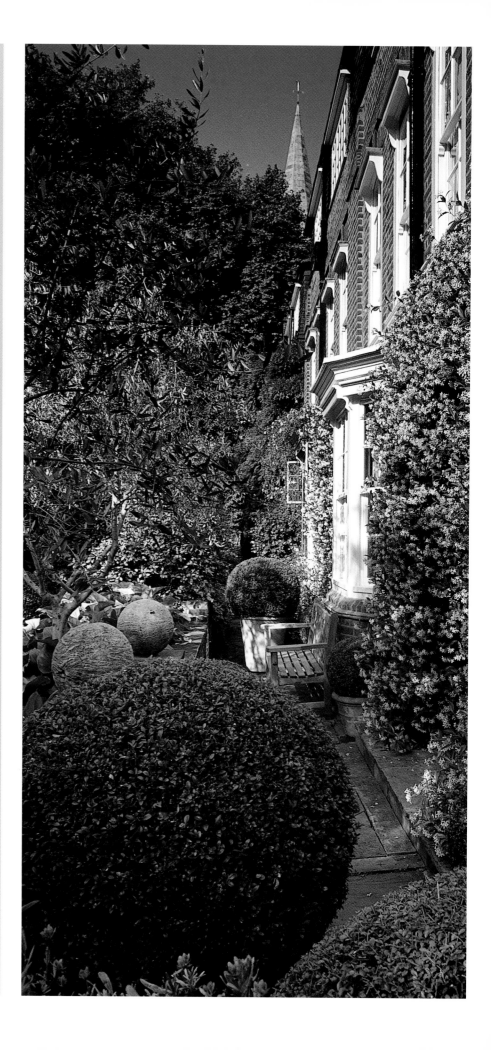

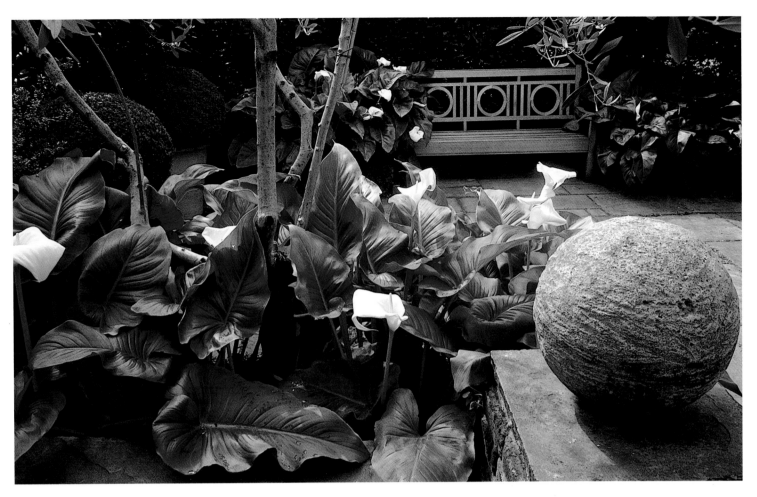

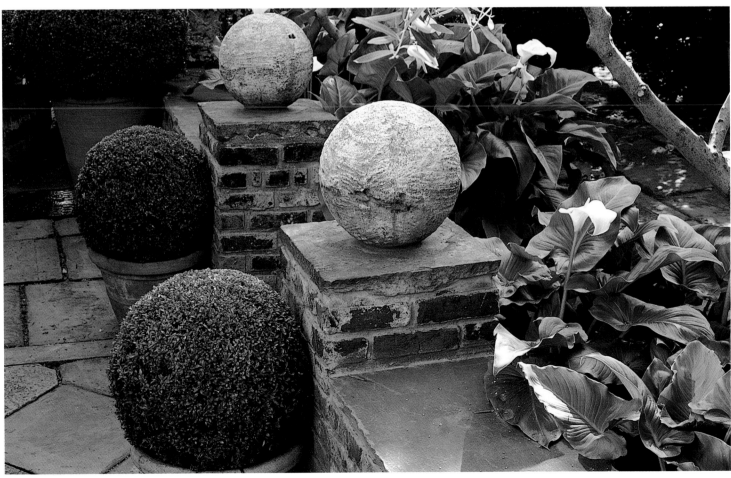

33

Gordon Ford

This Australian garden created by the late Gordon Ford was intended to have a resonance of the bush, and, despite being situated in a suburban area of Victoria, it is deeply evocative of an untamed environment. Rocks, trees and water were the essential ingredients of this garden designer's work. A lifetime's observation of how rocks become positioned in nature informed how he placed them harmoniously in gardens. Ford also planted trees extensively for both the vertical element they bring to a space and their usefulness in blurring boundaries. The colours and textures of the peeling bark of many Australasian trees were as important to his gardens as flowers are to other designers. Here, outside the front door, the semi-elliptical pool into which water cascades from massive basalt boulders is echoed in the calmer swimming pool with its jade-green water that enhances the natural appearance Ford strove so successfully to re-create.

RIGHT, TOP The house is approached along a narrow path beside an oval lily pool where the water is perpetually recycled over huge basalt boulders. The glass wall blurs the division between house and garden.

RIGHT, BOTTOM Among tree trunks in a woody part of the garden a seat made from reclaimed timber sits beside a path of bark chippings, surrounded by the hardy fern *Blechnum spicant*.

OPPOSITE The circular guest cottages, built from mud brick and with corrugated-iron roofs, nestle in a copse of tall trees.

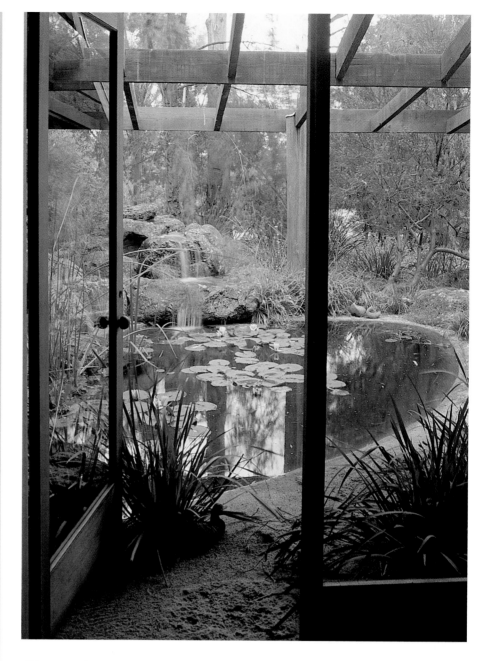

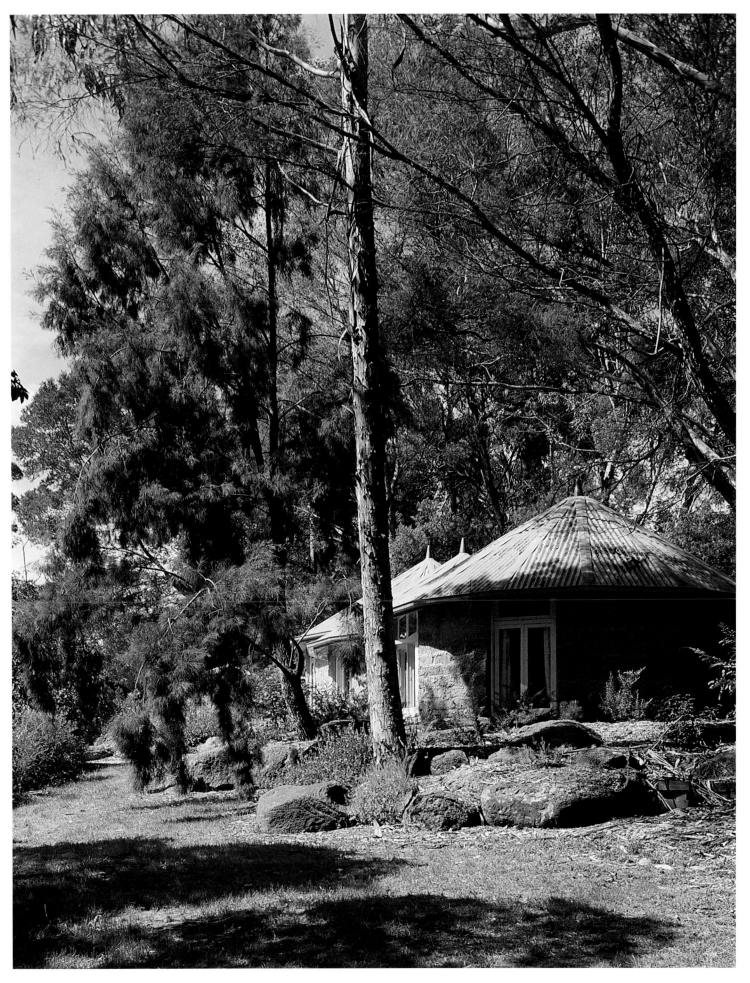

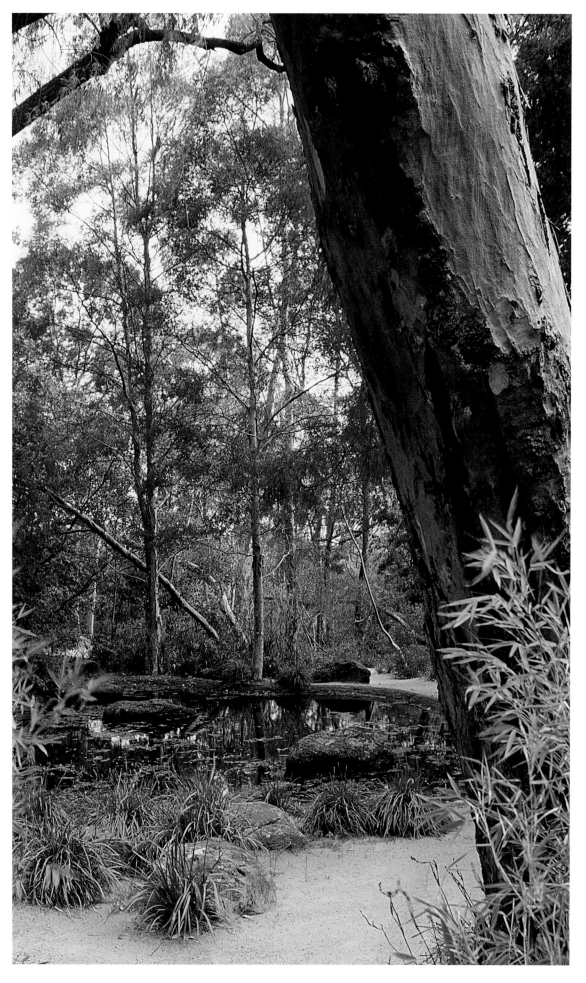

LEFT The sharply vertical thrust of gum trees is balanced by a calm horizontal expanse of water that brings light and life into the tree-filled garden. *Drepanostachyum falcatum* lines a path leading to the house.

ABOVE Among the trees chosen for this garden for the textural quality of their bark are (from top) the prickly paper-bark, *Melaleuca styphelioides*; a younger and possum-scratched specimen of the same tree; and *Allocasuarina torulosa*.

OPPOSITE This freshwater swimming pool is given the appearance of a natural pond by the boulders that line its rim and the jade-green colour of the water.

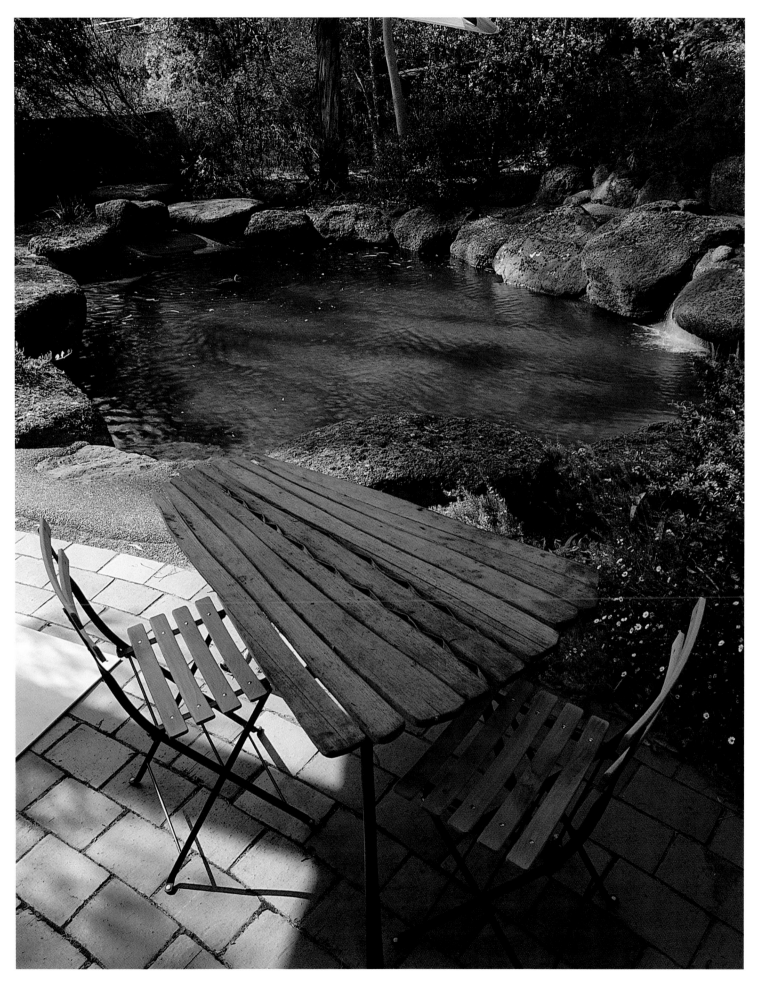

34

Norfolk

This garden of many moods is a collaboration between the owners, David and Eve Abbott, and the garden designer Arne Maynard. Unlike the many gardens where formal elements congregate around the house and the design becomes less restrained as you move farther away, here it is the rose-festooned millhouse itself, built over a stream that gushes through a sluice in the hall, that has a wild and enchanted appearance. *Rosa* 'New Dawn' and *R.* 'Albertine' scramble up tiles and over windows. On the far side of the lawn and enclosed by a picket fence is a Shaker-style vegetable and herb garden with raised beds and characterful giant fruit cloches, all constructed in oak. Lead-pineapple finials and galvanized chicken-wire detailing make the cloches uniquely decorative, while criss-crossing wands of willow act as elegant supports for climbing beans.

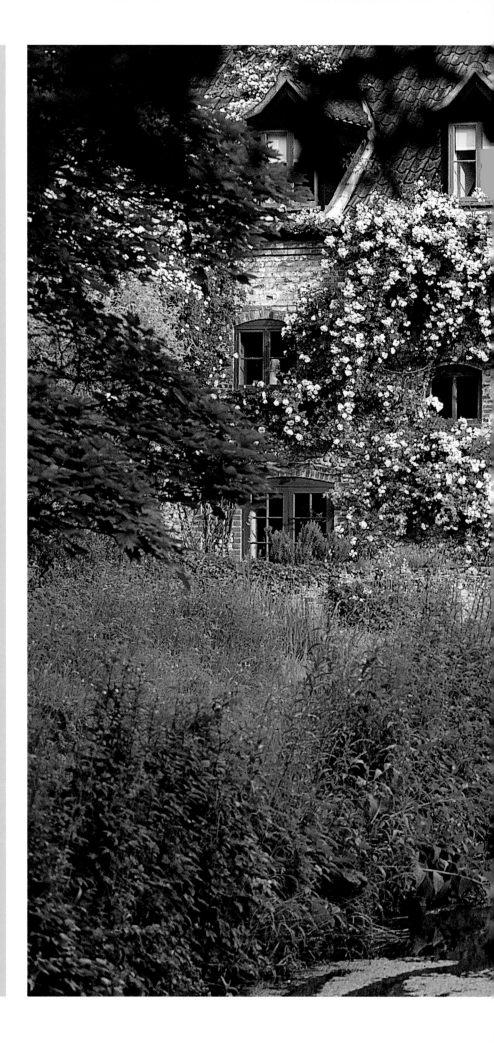

The river meanders through a wooded valley and gushes through the front hall before being channelled under the rear of the house, the wall of which is covered by the early peachy-pink rose 'Albertine' and the shell-pink, repeat-flowering 'New Dawn'. The water's effect is both stimulating and soothing, and this contrast is echoed in that between the wild planting on one bank and the smoothly mown grass dipping to the water's edge on the other. The impression of wildness is tempered a little by the formal cones and domes of box that line the narrow terrace.

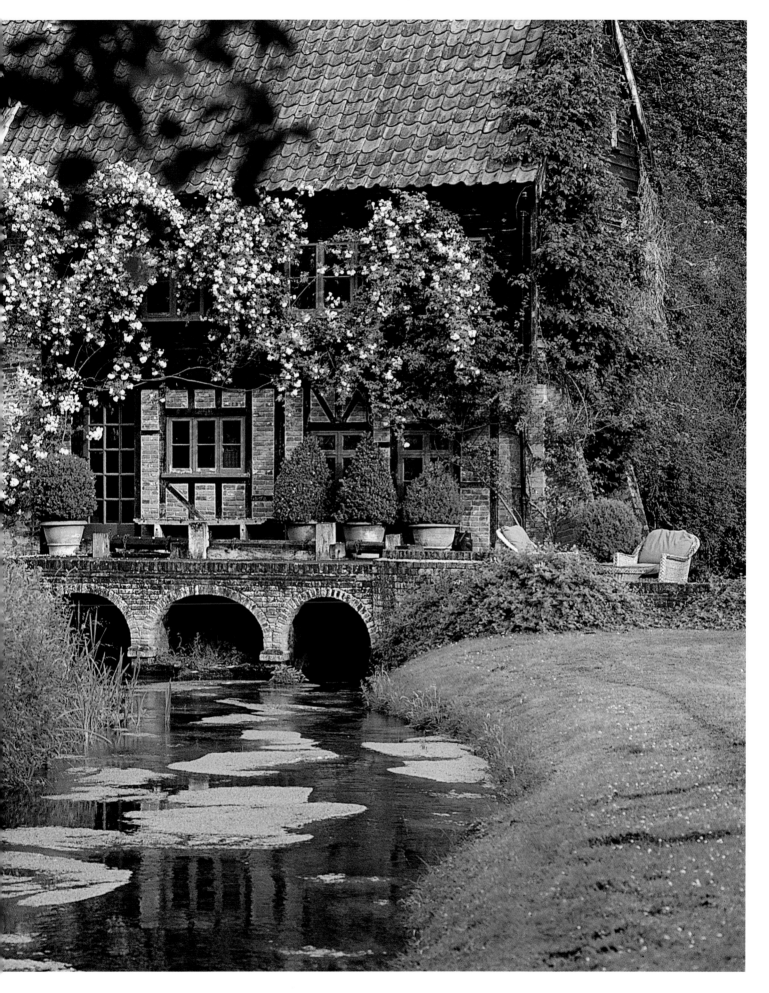

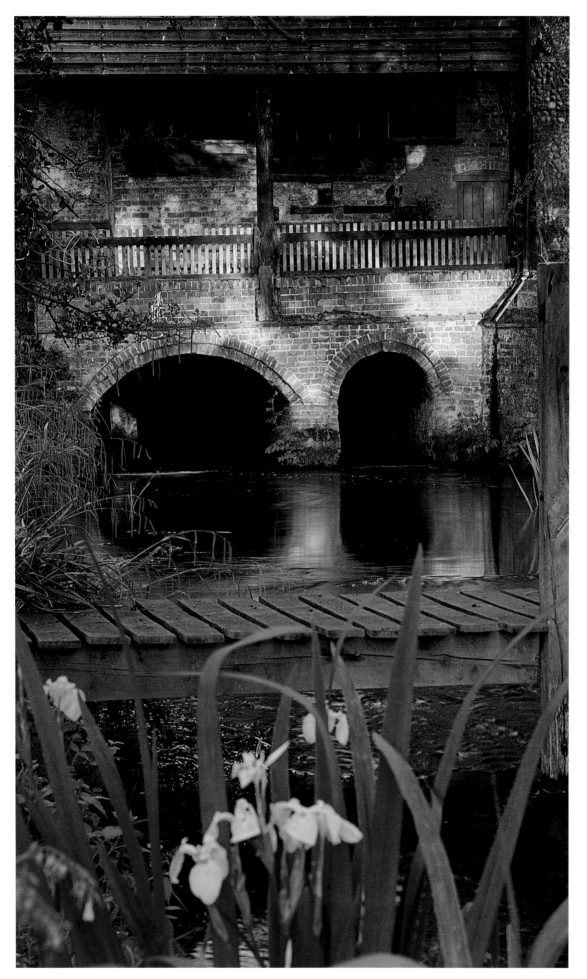

LEFT Native weeping sedge, *Carex pendula*, and naturalized flag iris, *I. pseudacorus*, line the river bank near the wooden footbridge.

ABOVE, FROM TOP A Lloyd Loom chair in a rustic shelter makes a tranquil retreat; gathered stems of rooted willow provide decoration and support for climbing beans and here are seen with mangetout, dwarf French beans and chives.

OPPOSITE, TOP Oak-edged beds in the courtyard garden contain a box knot and spirals of yew.

OPPOSITE, BOTTOM An oak picket fence surrounds the vegetable and herb garden, which is laid out as a series of oak-edged beds, some with decorative fruit cloches that protect strawberries and redcurrants. Set on lime chippings, each bed is easy to cultivate from all angles.

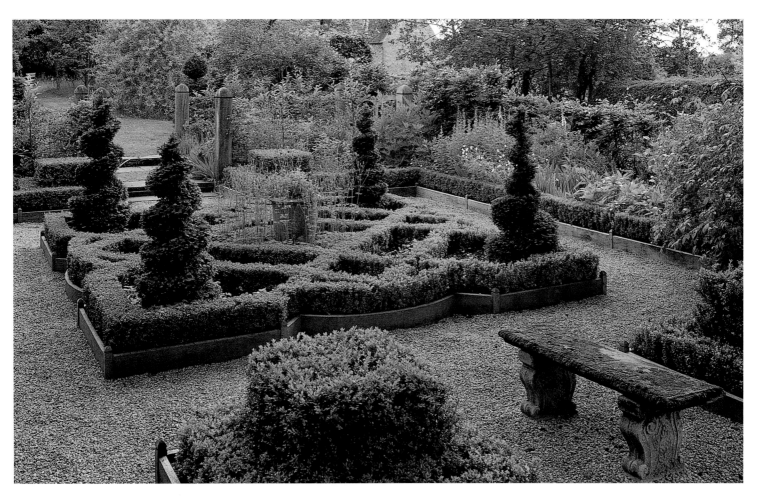

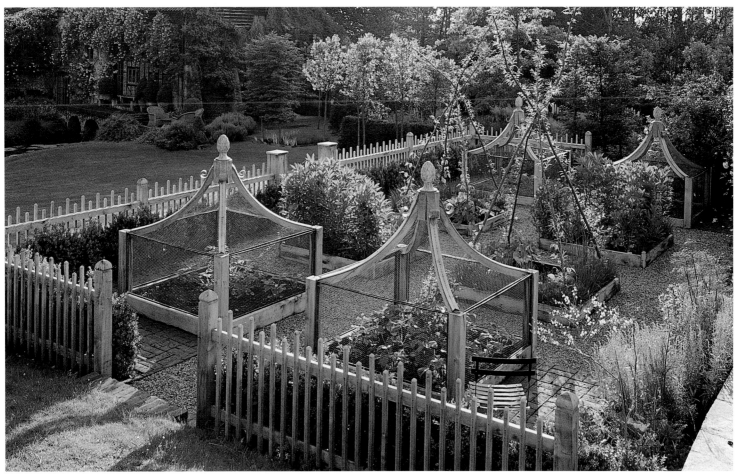

35

Chisenbury Priory

Several fascinating houses are hidden away in the villages that nestle in the folds of Salisbury Plain in Wiltshire. One such is Chisenbury Priory, which has a garden quite as interesting as the house. This is a varied garden with deep, floriferous borders flanking the elegant Georgian façade, streamside plantings lining the margins of the leat that meanders through the meadows, walled secret enclosures, orchards and vegetable gardens. However, Tessa and John Manser, the current owners, have added a new dimension to the garden with the sculptures and ironwork they have commissioned. A pergola designed by Paul Elliot resembles a skeleton of giant vertebrae formed like an ogee arch, while his bridge crossing the leat is decorated with scimitar shapes like the flares of a shooting star. A polished granite apple by Diane Maclean sits under an old apple tree, and a seat carved out of wood in the shape of a cupped hand is large enough to curl up in with a book.

RIGHT, TOP Chisenbury Priory's red-brick south-facing Georgian façade.

RIGHT, CENTRE The curvilinear bridge that spans the leat was embellished by its designer, Paul Elliot, with a scimitar-shaped motif.

RIGHT, BOTTOM Diane Maclean's polished granite apple is wittily juxtaposed with apple trees in the orchard.

OPPOSITE Paul Elliot's iron pergola is covered in climbing roses and underplanted with pale- and magenta-pink-flowered plants, including *Phuopsis stylosa* and *Geranium endressii*. In the foreground is a mixture of foxgloves, *Campanula persicifolia* and *Lathyrus rotundifolius*.

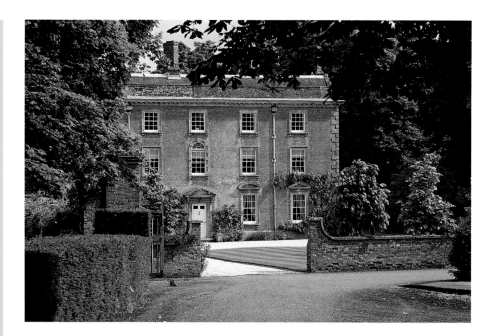

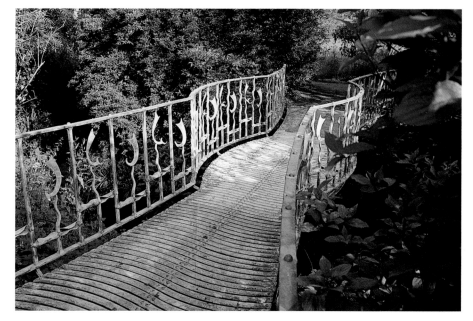

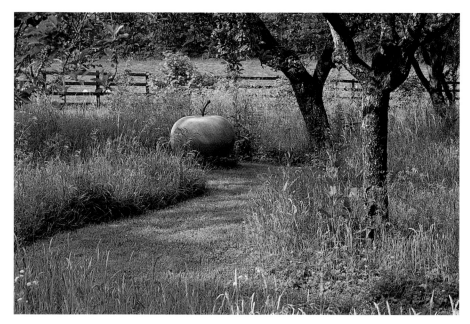

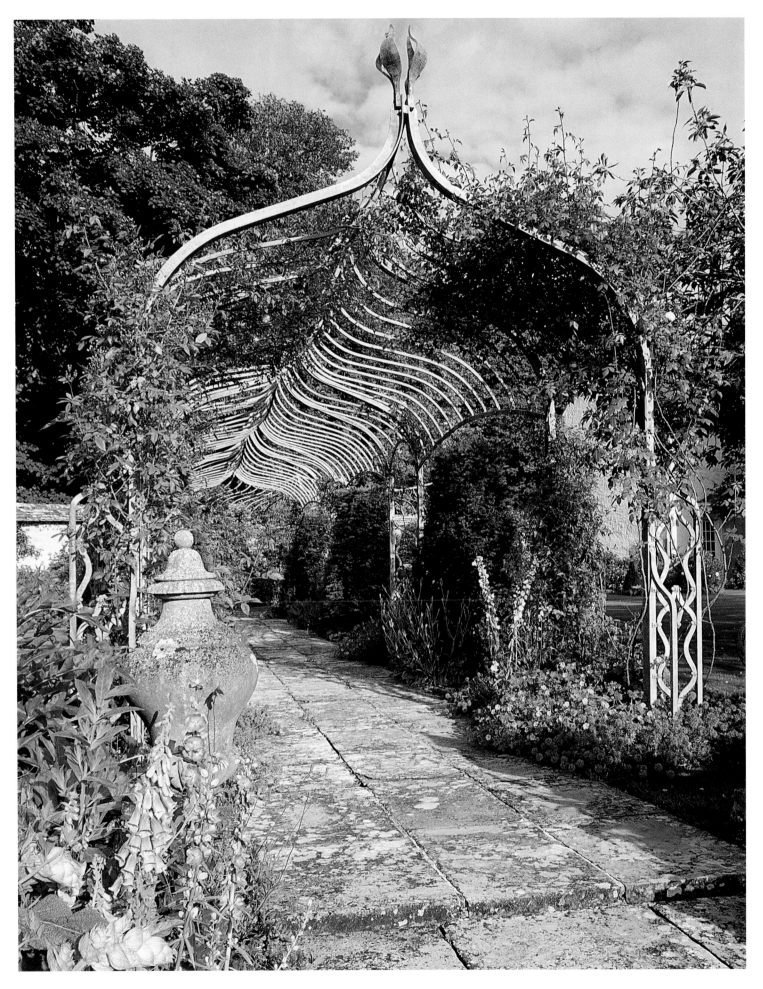

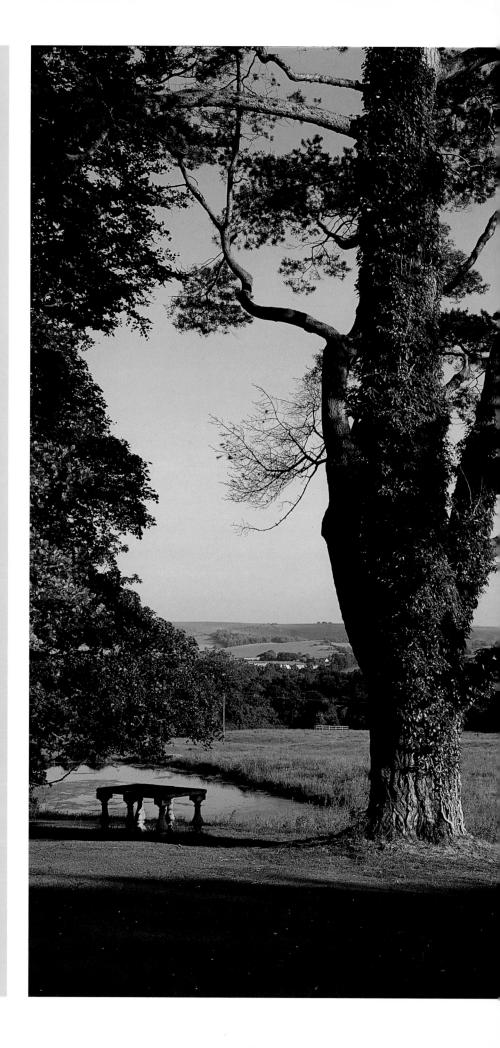

36

Shute House

John and Suzy Lewis's garden at Shute House in Dorset is considered the ideas laboratory of the great garden designer the late Sir Geoffrey Jellicoe. In collaboration with Michael and Anne Tree, Jellicoe created a garden of 1.2 hectares (3 acres) rich in allegory that harnesses the magical atmosphere pervading a site bubbling with the waters of a primeval spring. Water was taken in two directions to a bog garden, through a wooden channel and via his refashioned formal canal and iconic gravity-fed rill. Here the water rushes along, in contrast to the still canal, and produces harmonious chords as it cascades over a series of four steps studded with an increasing number of copper V's set in concrete. The top, narrow channel is mysteriously concealed by high, lush planting but opens out into a series of geometric-shaped pools set in gently sloping banks of grass. From still to rushing, from hidden to open, and from light to shade and back into light again: the perfect conjunction of art and nature.

A venerable Scots pine stands at the head of a series of recently dug lakes that were part of Sir Geoffrey Jellicoe's original masterplan for the garden. The lakes were intended to represent placid reflection upon infinity. In the distance is the chalk escarpment of Cranborne Chase.

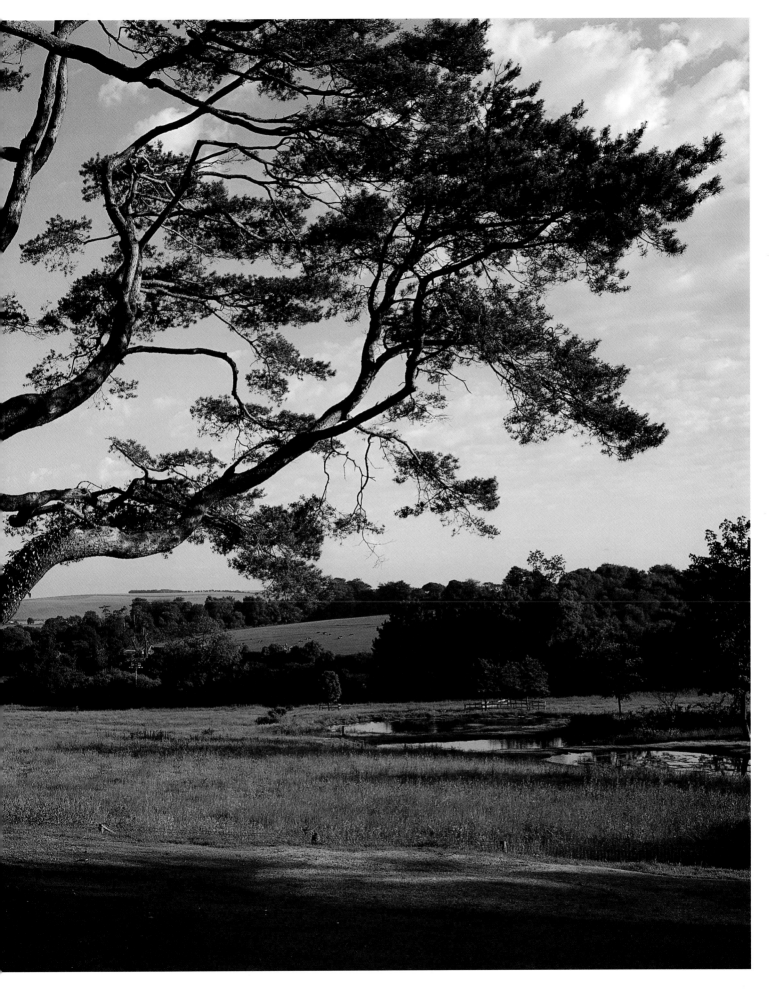

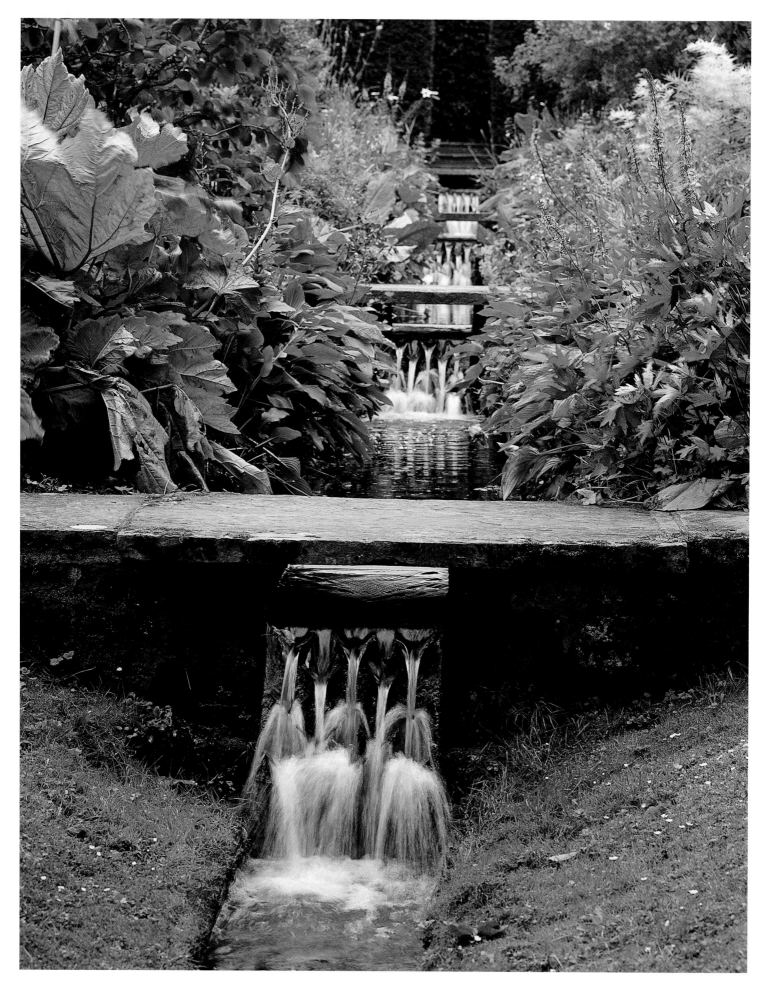

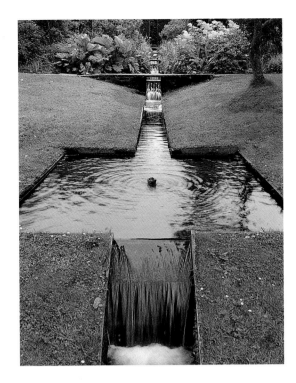

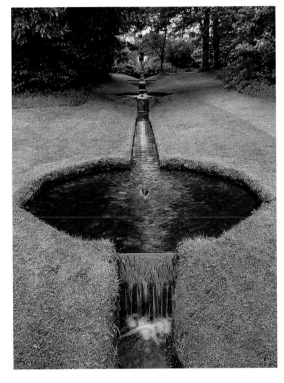

OPPOSITE A harmonic chord sounds as water passes over four copper chutes of varying heights. The rill's banks are planted with lush bog plants, such as *Gunnera manicata* and *Aruncus dioicus*.

TOP AND ABOVE Bubble fountains descend a gradient in a precisely straight line.

RIGHT, TOP Shute House, seen across a flower meadow and reflected in the pond.

RIGHT, BOTTOM At the head of the canal, arum lilies, *Zantedeschia aethiopica*, thrive in the spring water, and busts of Ovid, Virgil and Lucretius sit above wisteria.

37

Moss Green

With over 3 m (10 ft) of rain a year and protection from the surrounding bush-clad hills, Moss Green, near Wellington on New Zealand's North Island, has a climate conducive to growing a wide variety of plants. It was a situation that Bob and Jo Munro found hard to resist when in the 1980s they gave up their life as potters to create a plant paradise. The high water table and shallow soil over bedrock led them to establish ponds and many areas of damp-loving hostas, ferns, irises and primulas. The drier area around the house was devoted to silver-leaved plants with architectural forms. To counter summer droughts Bob came up with an ingenious misting device that he has turned into copper sculptures that release just the right amount of moisture to prevent plants from wilting in high summer, but also create magical icicle formations in the garden in winter.

RIGHT, TOP The silver planting near the house has as its centrepiece the architectural form of the ornamental artichoke, *Cynara cardunculus*, with *Brachyglottis* 'Sunshine' and the tall, drooping form of the purple-leaved *Pseudopanax ferox*.

RIGHT, BOTTOM Bob Munro's cone-shaped copper sculptures are both decorative and, owing to the mist they release into the atmosphere, beneficial. Here they are seen with *Kirengeshoma palmata* and the brown-leaved grass *Carex buchananii*.

OPPOSITE, TOP Circling the pond are groups of tree ferns, red rhododendrons and the arching form of the Toe Toe pampas grass, *Cortaderia richardii*.

OPPOSITE, BOTTOM, LEFT TO RIGHT A carved head doubles as a water spout; a feature is made of a saddle-shaped stone with *Geranium pratense* 'Mrs Kendall Clark' and *Stachys byzantina* behind it; inspired by oriental stone bridges, this turf and timber path zigzagging across the ponds is overhung by tall rhododendrons, tree ferns and glaucous hostas.

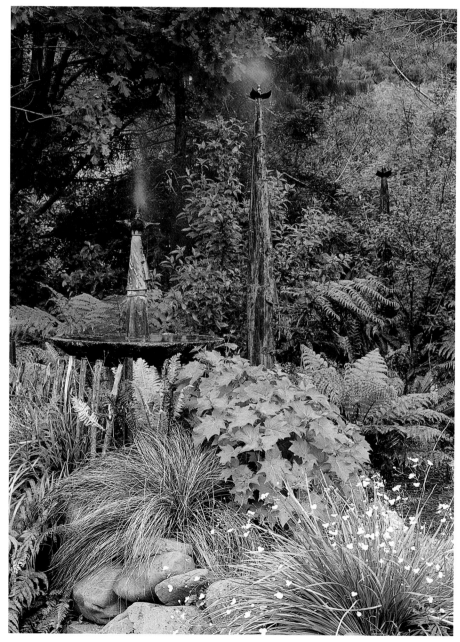

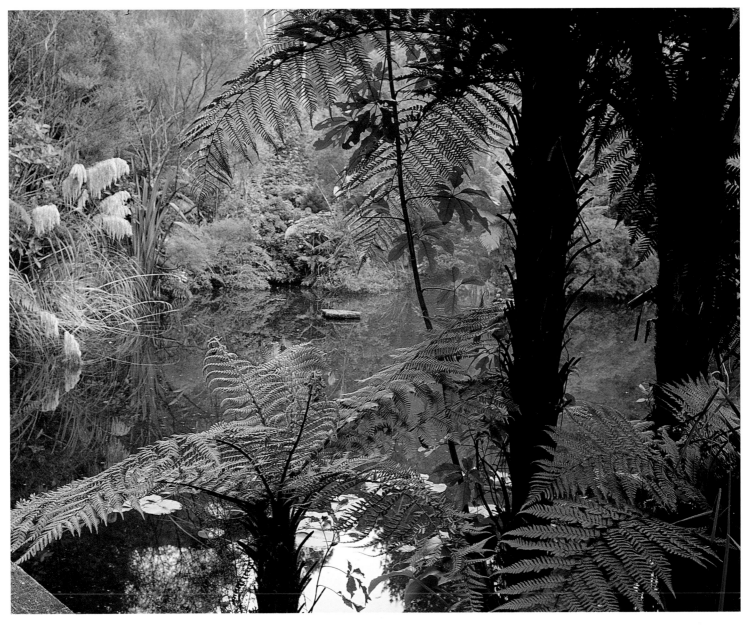

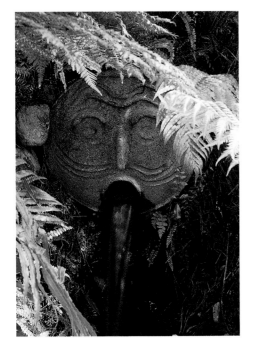

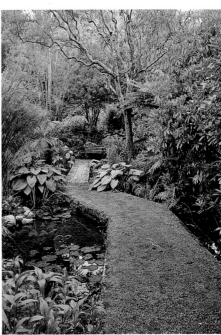

38

The Menagerie

The late Gervase Jackson-Stops spent twenty years transforming a dilapidated eighteenth-century banqueting house in Northamptonshire into a country house before concentrating on the garden. The creation of the garden and its follies was informed partly by the plans of Thomas Wright of Durham, who designed The Menagerie in the 1750s and who wrote books on arbours and grottos, but also by Jackson-Stops's own encyclopaedic knowledge of garden styles and sense of fun. The follies double as spare rooms and a chapel, and have contrasting façades on each side, so that a 'temple' with a Classical elevation, entered from a formal garden, leads out on to a wilderness through an opening in the façade of a rustic hermitage. There is no freezing-cold dunking pool in the grotto, but a sauna and jacuzzi. As well as the follies, a mound, formal fountains and lime avenues, there are rose gardens and elaborate borders, carefully tended meadows and a plant nursery; new areas are being added by the current owner, Alex Myers.

The spiral mount, built from the spoil that accumulated during the establishment of lime avenues and a *patte d'oie* formation of radiating paths at The Menagerie, has an ingenious covering of mat-forming *Acaena microphylla* on its sloping sides. This eliminates awkward mowing and creates a neat textural contrast. Topped by a stone obelisk, the mound also provides a viewing platform from which to see across the garden.

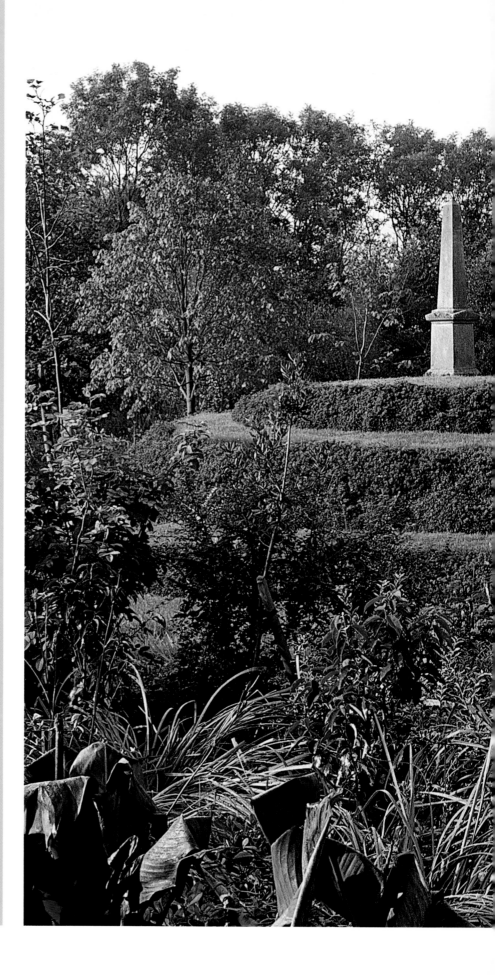

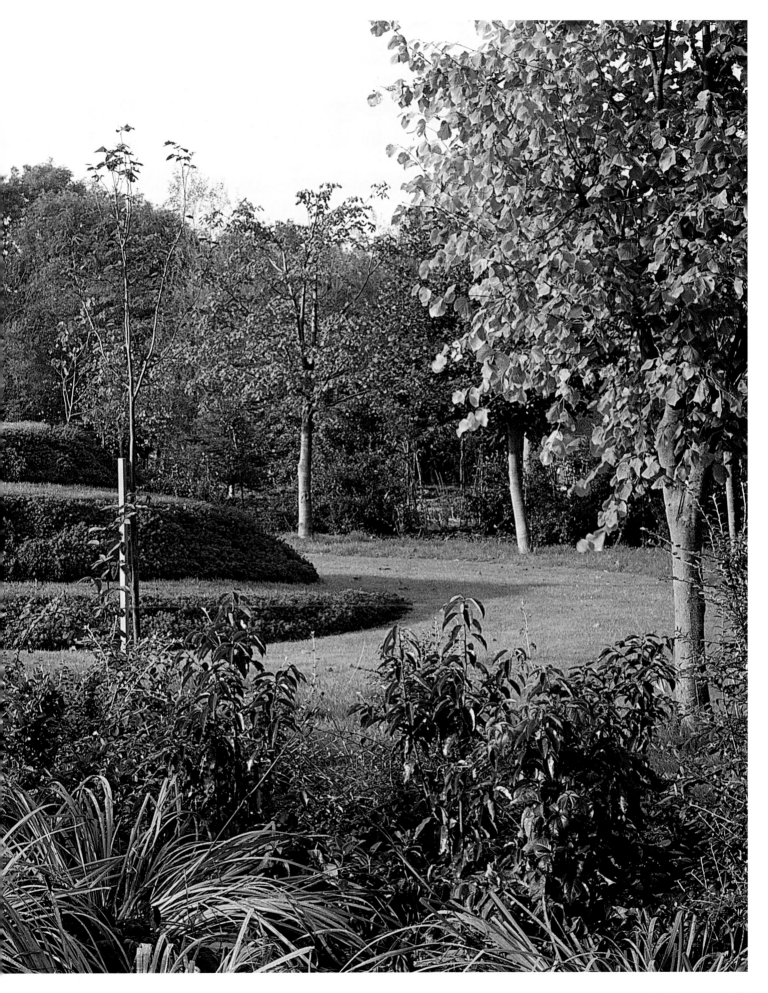

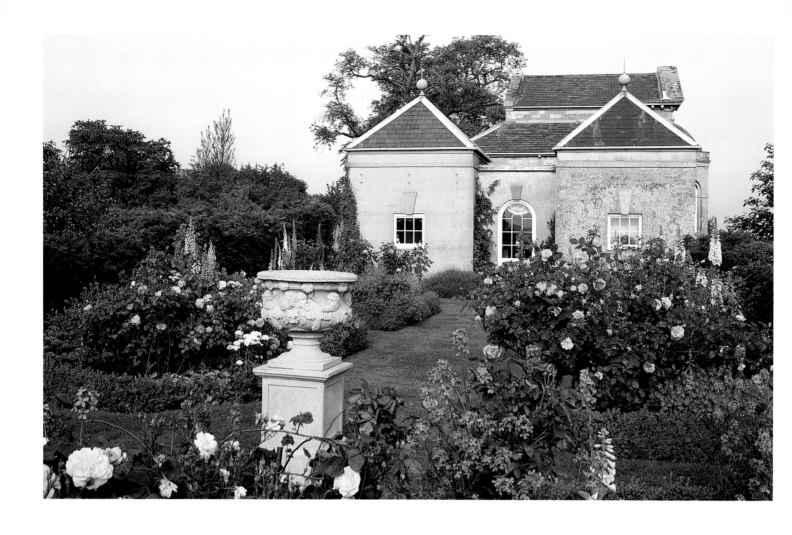

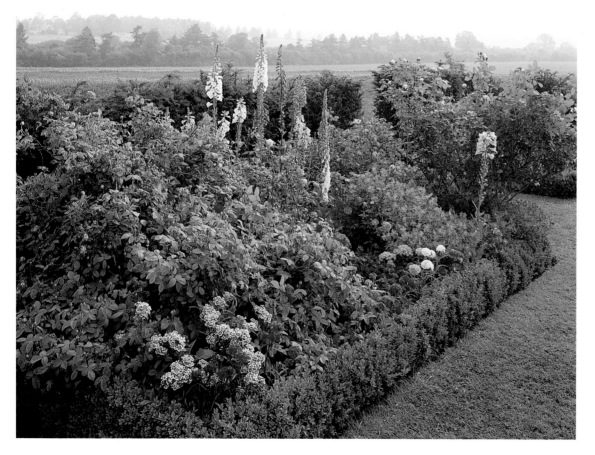

ABOVE The Rose Garden, designed in the late 1980s by Vernon Russell-Smith, has a purposely old-fashioned yet sumptuous planting of shrub roses with foxgloves, sweet rocket, *Hesperis matronalis*, and Jacob's ladder, *Polemonium caeruleum*, enclosed in box hedging.

LEFT Sweet Williams, foxgloves and *Geranium* 'Johnson's Blue' mingle with the striped *Rosa* 'Ferdinand Pichard' and the apothecary's rose, *R. gallica* var. *officinalis*.

OPPOSITE The two thatched follies designed by Charles Morris, one a circular Classical temple, the other a triangular rustic house, have three means of entry. The more formal façade of each building overlooks a similarly formal pool with a fountain, while another entrance gives on to an informal pond. A third doorway gives access to the house via serpentine paths.

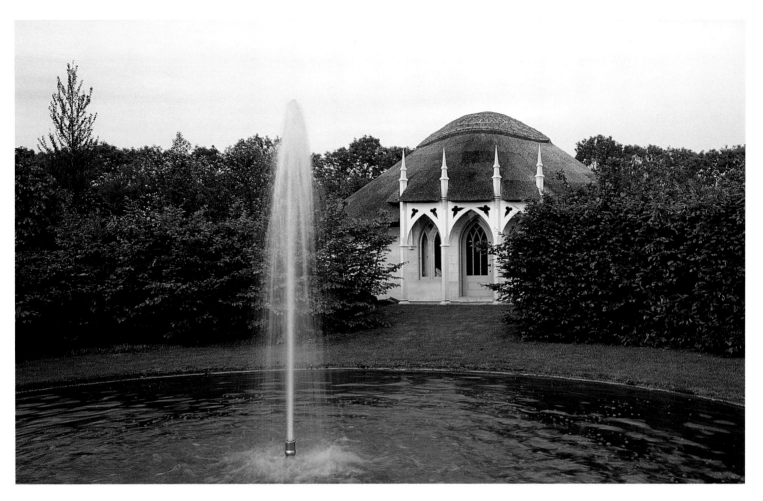

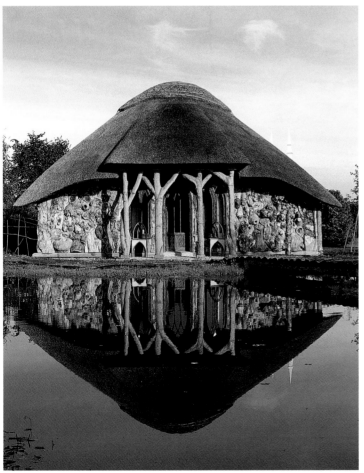

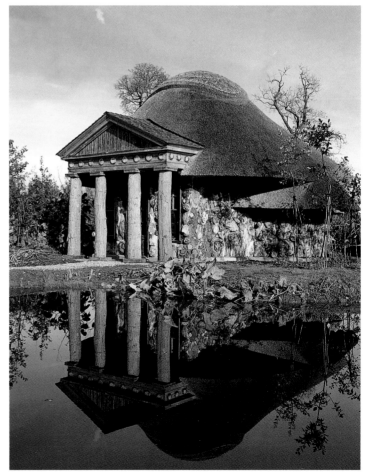

39

The Priory

Immaculately clipped topiary parterres and avenues of silver-leaved pears trained to resemble olives lend the garden of this Wiltshire priory a Gallic feel. Unsurprisingly, it was imbued with this character by its owner, the French garden designer Anita Pereire, and her talented gardener, Marcel Catoire, who accompanied her when she moved to the medieval stone house in Kington St Michael after the death of her husband. Madame Pereire's great love of roses is evident throughout the garden, from the edges of the picturesque shrubbery bordered by *Rosa rugosa* to the rose garden itself, where standards of pink *R.* 'Ballerina' are planted with matching low mounds of 'Ballerina' and white-flowered *R.* 'Kent'. To ensure a long flowering season and keep the frequently pruned evergreens, hedges and trees healthy, they are all given regular feeds, mulches and water. The looser planting in other areas of the garden is a fascinating blend of French and English styles, a horticultural *entente cordiale*.

RIGHT, TOP The neat, white-flowered groundcover rose 'Kent' is grown as a standard in the box parterre of Anita Pereire's Jardin à la française. An alternative to the blowsier 'Iceberg', 'Kent' bears abundant clusters of its small, brilliant-white flowers from summer until the first frosts. Another pest- and disease-resistant rose that will keep producing trusses of blooms until the onset of winter, pink-flowered 'Ballerina' is here both trained as a standard and pruned hard into a low carpet, doubling its decorative impact.

RIGHT, BOTTOM A regime of frequent clipping and feeding results in the healthy appearance of the beautifully trimmed box in the Jardin à la française and elsewhere throughout the garden.

OPPOSITE A window cut in trellis frames a view looking over the Jardin à la française to the fourteenth- and fifteenth-century stone priory. Covering the trellis is the rampant climbing rose 'Wedding Day', which has pale-apricot buds that open into flowers of creamy yellow fading to pure white.

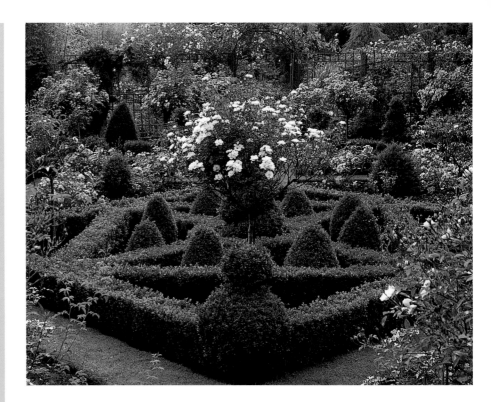

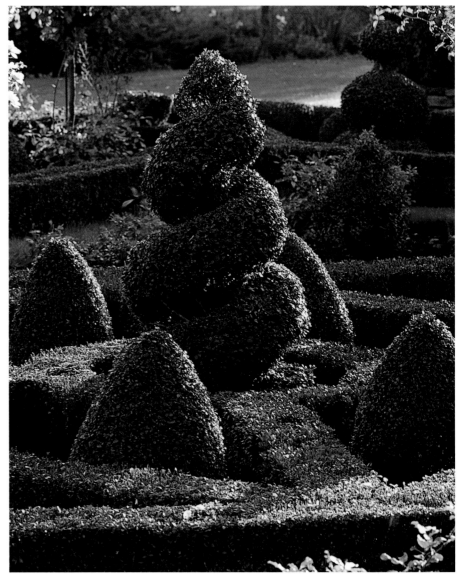

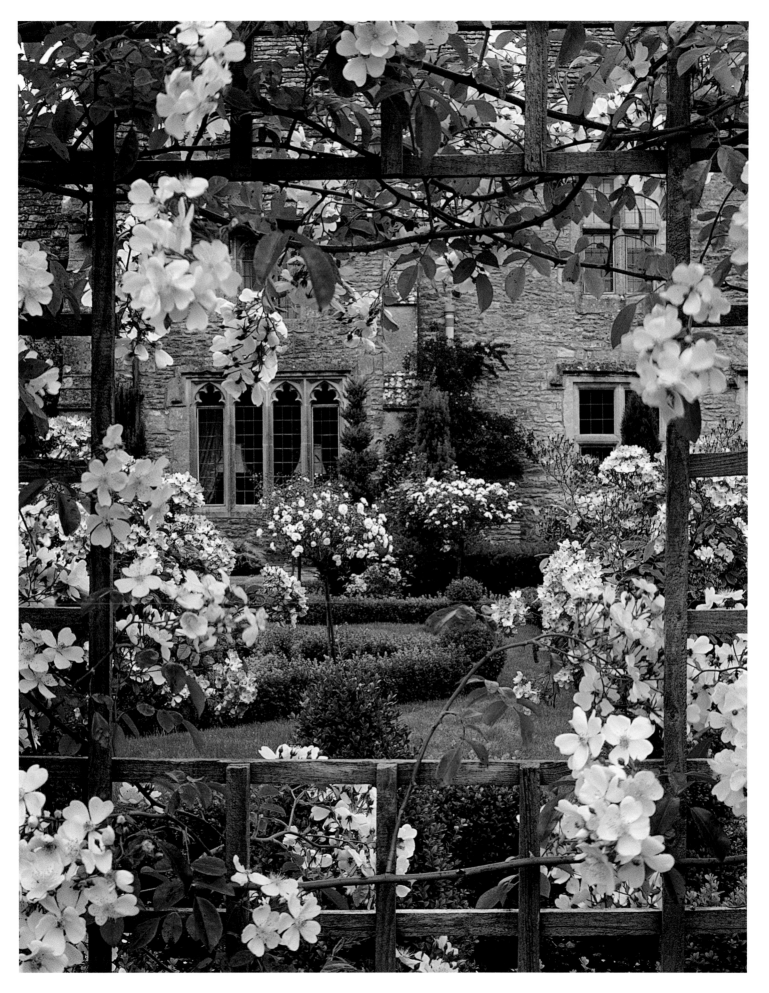

40

Little Sparta

Little Sparta is the garden of the late poet-philosopher-artist Ian Hamilton Finlay at Stonypath in the Pentland Hills near Edinburgh. Over many years more than 275 works of art in stone, wood and metal have been placed within a landscape that has been transformed from barren, windswept moorland into Britain's most thought-provoking garden. Here nature and art are fused with the aim of stirring body and soul. Hamilton Finlay's creation works on two levels. Immediately evident is his artistic manipulation of the landscape, with its careful diversion of streams, creation of ponds, lakes and watercourses and contrasts between areas of light and shade. Then, as we look more closely, the landscaper becomes the philosopher. Every seat, bridge, stile and stepping stone, every beehive, gate and water-spouting shell, is inscribed, so that the garden abounds with carved metaphors that inspire reflection on every walk within its bounds. Little Sparta offers an experience of a garden quite unlike any other we can have today.

RIGHT Stepping stones meander in a curve across the Middle Pond. On one of the rough slabs an inscription in smooth Roman letters reads: "Ripple n. A fold. A fluting of the liquid element." This is a characteristic Finlay device of adapting the dictionary form to give a poetic rather than a factual definition.

OPPOSITE, TOP Eleven huge, half-dressed blocks of stone lie in rows up on the heathery moor, with the Pentland Hills in view across the lake. The inscription "The present order is the disorder of the future Saint Just" refers to the condemnation of a corrupt society by the French Revolutionary Louis Antoine de St Just. By using separate stones for each word, Finlay implies that the stones could be rearranged to give the opposite meaning.

OPPOSITE, BOTTOM The names and numbers of Scottish fishing boats are written in blue paint on a line of three beehives placed beneath a grove of trees. The pastoral names of the boats – *Bountiful*, *Sweet Promise* and *Golden Gain* – emphasize the metaphor of honey as representing the harvest of the sea.

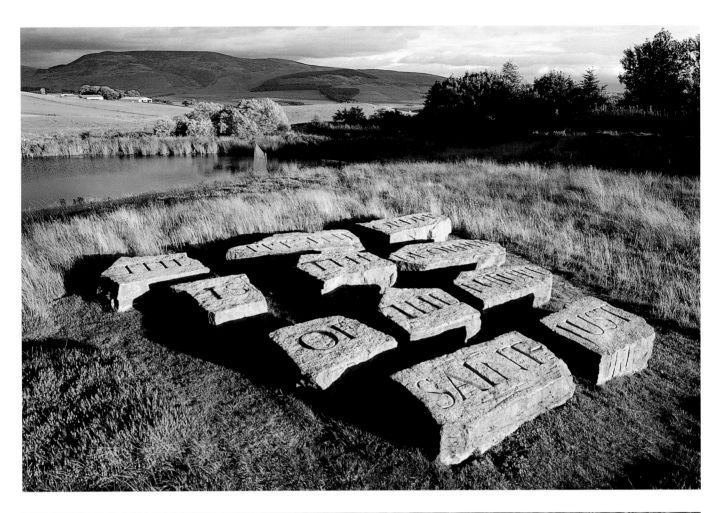

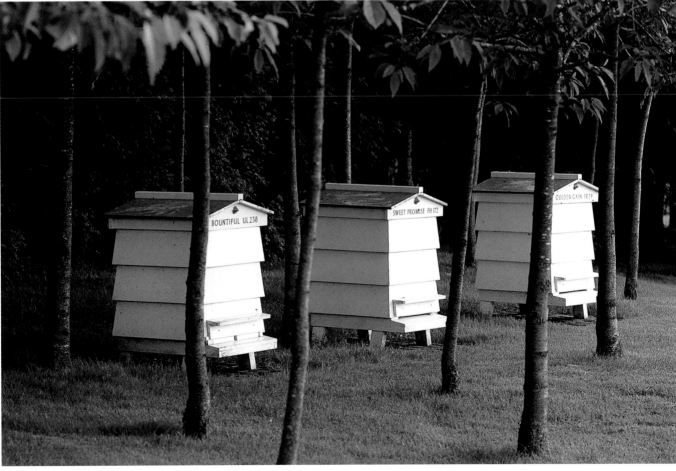

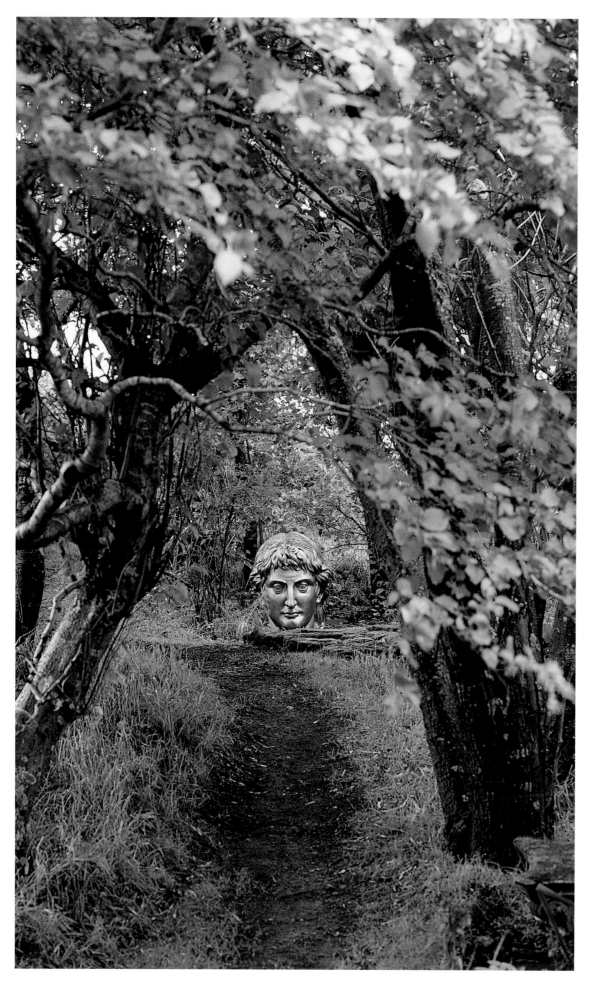

LEFT The spectacular gilded head of Apollo with "Apollon Terroriste" inscribed on his brow emerges from rough grass in a woodland setting. The French title for Apollo links him to the French Revolution and particularly to the Reign of Terror. Apollo was the god who maintained civilization, often by violent means.

ABOVE, FROM TOP A stile connecting the upper pond garden with the moorland is inscribed "Thesis fence Antithesis gate", with "Synthesis stile" on the reverse, after the philosopher Georg Wilhelm Friedrich Hegel. A gateway leading into the old front garden of Farm Cottage reads "A cottage. A field. A plough", with "There is happiness" on the reverse, another quotation from St Just, idealizing the simple way of life of French country people.

OPPOSITE, TOP Behind the marble sundial is a simple and effective mass planting of *Astrantia major* under trees.

OPPOSITE, BOTTOM The grotto, with its façade of undressed stone, has a smooth keystone engraved with the letters 'D' and 'A' separated by a lightning flash. The initials stand for Dido and Aeneas, who became lovers in a cave. The lightning flash signifies the disaster that befell them: Aeneas sailed away and Dido killed herself.

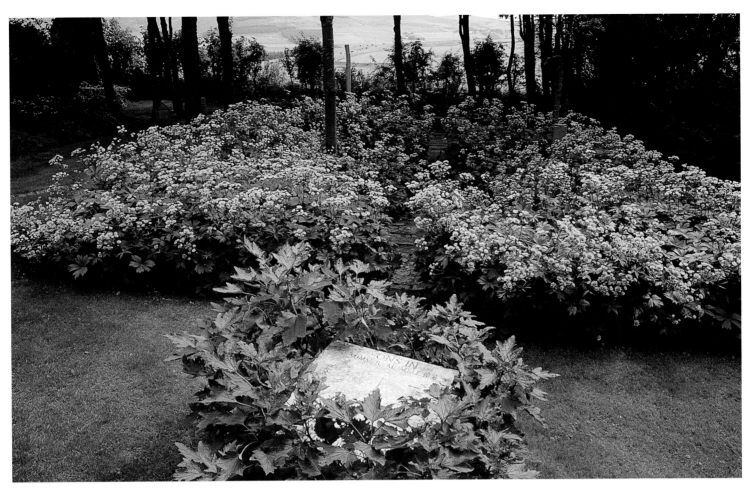

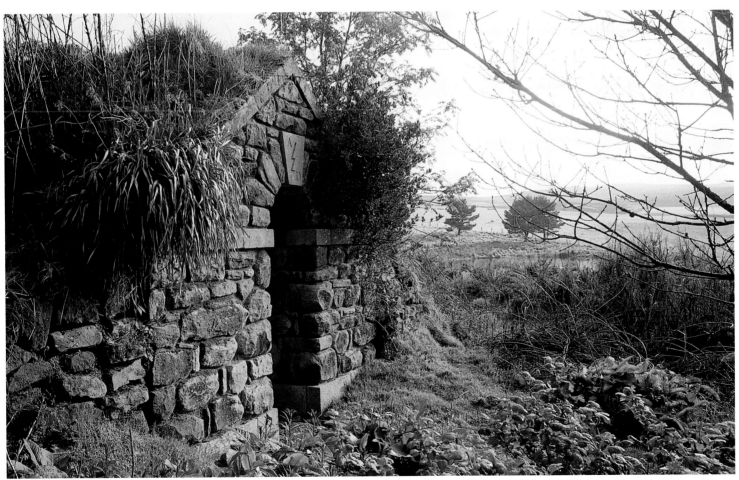

41

Cannwood Garden

The garden at Cannwood in Somerset reflects the ebullient personalities of its owners. The writer Polly Devlin and the inventor and engineer Andy Garnett have a wide circle of creative friends from whom they have commissioned bridges, follies, arbours and sculpture that combine function and fun. James Blunt's arbour and bench in the Secret Garden was created to provide a trysting place for the Garnetts' daughters. Ensuing grandchildren are bound to love playing in the Stumpery, built from diseased elms by Julian and Isabel Bannerman. Engineering and aesthetics come together in Richard La Trobe Bateman's bridges, where long, thin planks are cleverly suspended over the water. In the herb garden an enlarged outline of a computer's memory board is inscribed on a tall slab of polished black granite by Ben Jakober that stands between a pair of metal gates emblazoned with the spiral symbol of Père Ubu, the absurdist invention of the French playwright Alfred Jarry, who said that "laughter is born out of the discovery of the contradictory". At Cannwood the seemingly contradictory worlds of literature and science, lyricism and technology, come together joyfully.

RIGHT, TOP Pink *Rosa* 'Raubritter' is combined with taller *R. × alba* and gallica roses, such as the white 'Madame Hardy'.

RIGHT, BOTTOM An eighteenth-century stone urn by John Parsons of Bath encircled by marguerite daisies and lamb's ears is the centrepiece of the White Rose garden. Tall *Rosa × alba* 'Alba Semiplena' grows amid white foxgloves and *Clematis recta*.

OPPOSITE, TOP LEFT Leaning against a wall in the Herb Garden is a depiction in granite of a computer's memory board. The white metal spirals are symbols of the surrealist Collège de 'Pataphysique.

OPPOSITE, TOP RIGHT Isabel and Julian Bannerman's Stumpery is complete with an internal cast-iron stove.

OPPOSITE, BOTTOM LEFT Mock orange, *Philadelphus* 'Belle Etoile', and roses such as 'Rambling Rector' clamber over the arbour and seat by James Blunt.

OPPOSITE, BOTTOM RIGHT Sculptor Shane Barnard's *Urn at the end of its tether*.

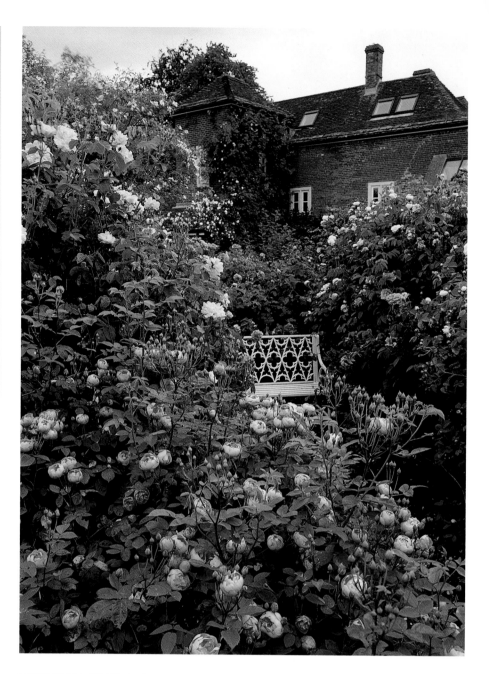

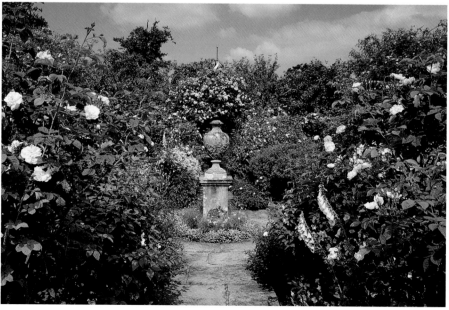

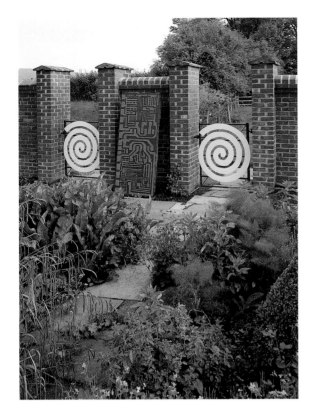

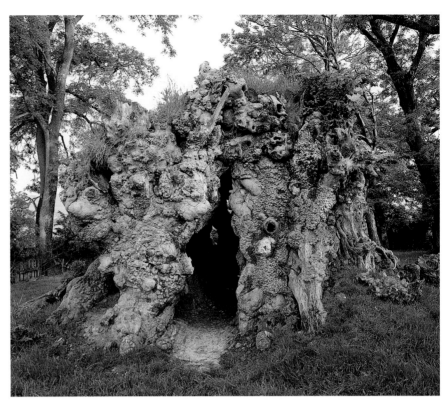

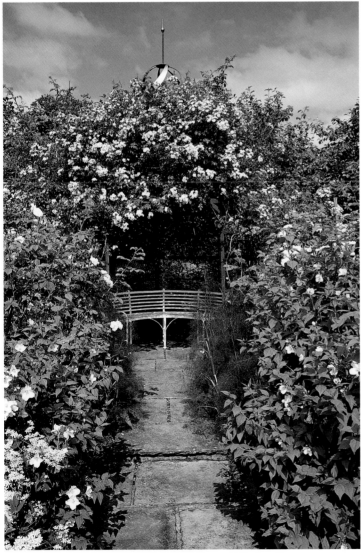

42

Gresgarth

The Italian-born landscape designer Arabella Lennox-Boyd and her husband Mark live their countryside life in Britain close to the Pennines in Lancashire. It is testament to her skills as a designer that a valley bottom in cold country has been transformed into a plantsman's paradise with a warm and exuberant atmosphere. It is here that she tries out new planting associations and indulges her passion for everything from meadow, woodland and vegetable gardening to experimenting with new perennials and filling formal parterres with old-fashioned roses and aromatic herbs. Gresgarth is a garden of many moods, with lakes and lawns, secret corners and a plethora of surprise details, from a topiary lion with a mane of shaggy golden yew to Mark's ingenious sundials. It manages to be both grand and cosy, enormously stylish and ever-changing, very much like its creator.

RIGHT This view across the lake from the wild garden in June shows the south-west front of the house rising above rose-filled terraces. Removing topsoil and so reducing the fertility of vigorous grasses made orchids and buttercups begin to flourish in the wild garden. Here the variable common spotted orchid, *Dactylorhiza fuchsii*, has built up into a sizeable colony of differing heights and colours interspersed with the bright-yellow meadow buttercup, *Ranunculus acris*. To give the orchids a chance to seed and spread, the grass will not be cut until August.

OPPOSITE, TOP The lion motif is found in various parts of the garden. Here the shaggy mane of unkempt golden yew, *Taxus baccata* Aurea Group, stands out against the neatly clipped body and legs.

OPPOSITE, BOTTOM Tall blue delphiniums are partnered by the yellow meadow rue, *Thalictrum flavum* subsp. *glaucum*, and ornamental cardoon, *Cynara cardunculus*.

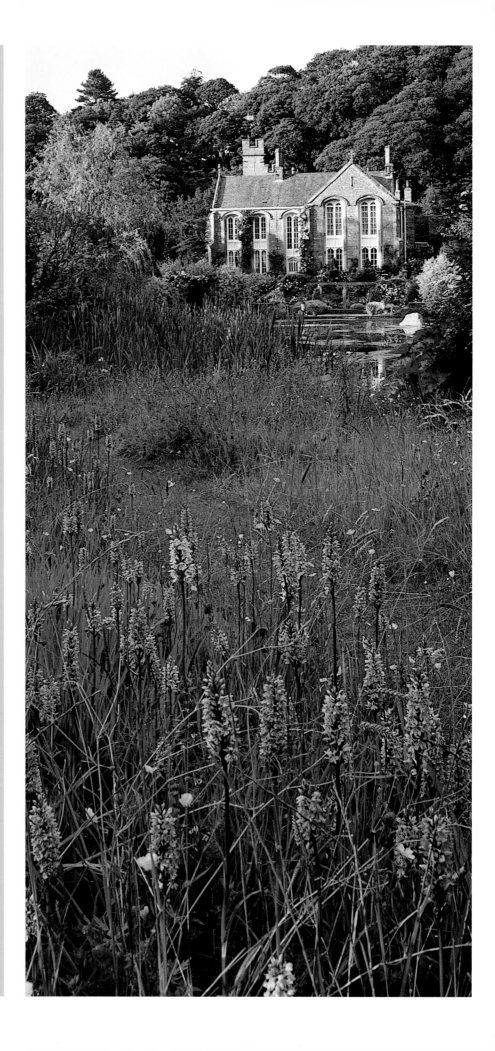

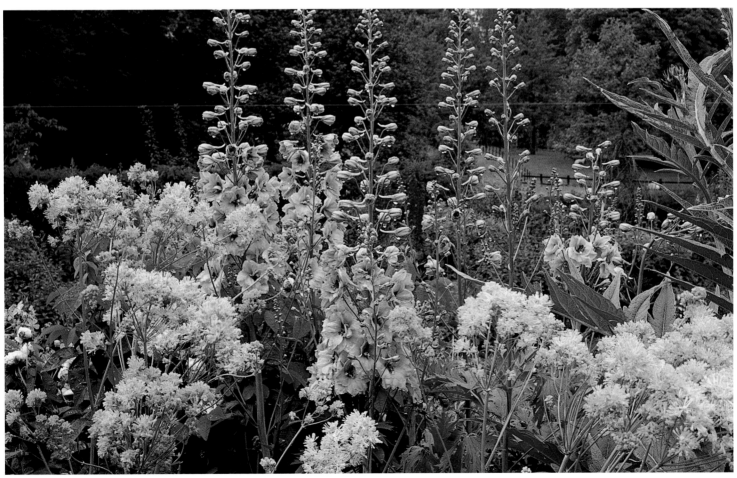

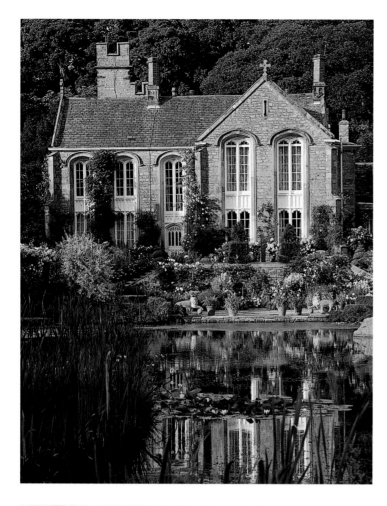

RIGHT Skilful repeat planting in the lush herbaceous borders extends the plants' season of interest. Cranesbill, *Nepeta* and *Sedum* 'Autumn Glow' are planted in front of progressively taller plants. These range in height from the magenta cranesbill, *Geranium psilostemon*, and the yellow spurge, *Euphorbia schillingii*, to tall *Campanula lactiflora*, *Veronicastrum* and *Thalictrum delavayi*.

TOP The Victorian sandstone house, with its fairy-tale Gothic windows, is reflected in the glassy lake.

BOTTOM A stone lion relaxes amid the rough grass and flowers in the meadow.

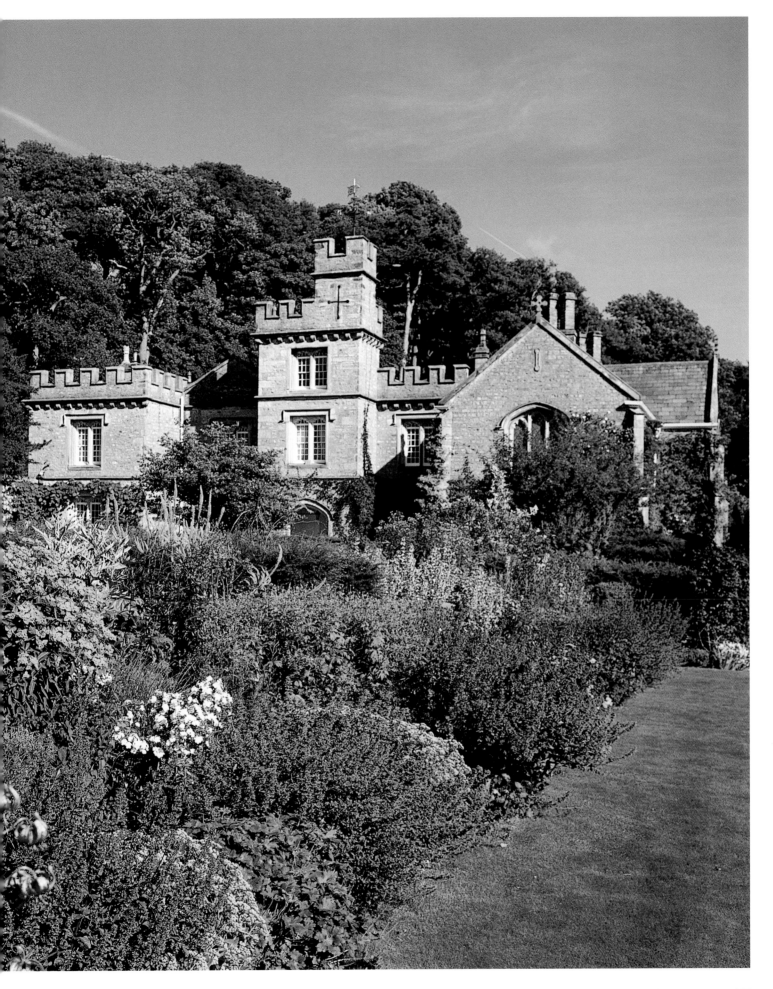

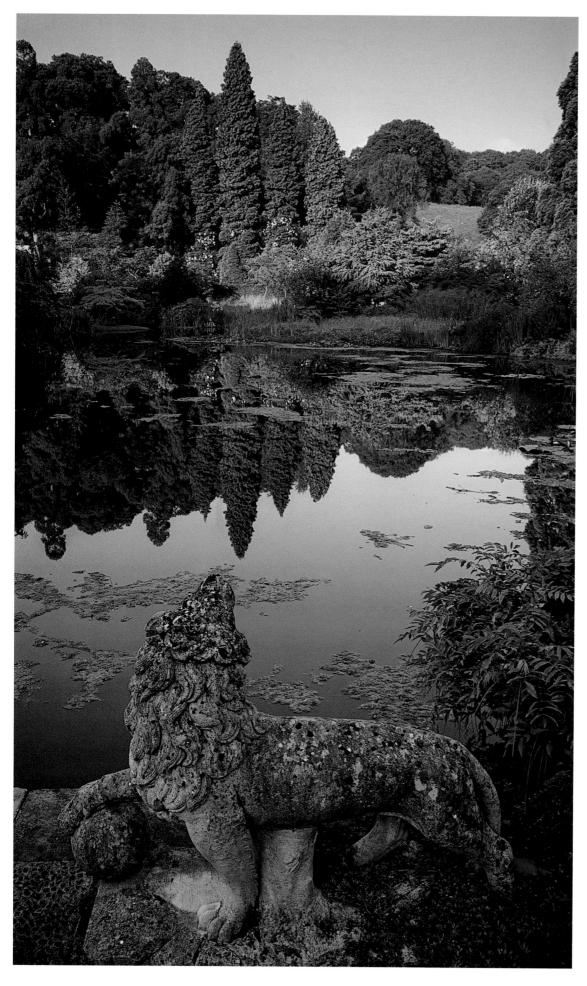

LEFT Towering columns of conifers and the sky are mirrored in the still waters of the lake, where a pair of stone lions guards the landing stage.

ABOVE, FROM TOP In shallow water at the head of the lake a pebble-bejewelled frog 1 m (3 ft) long is in full leap. This swirling pattern is one of many pebble designs the Lennox-Boyds have commissioned from Maggy Howarth.

OPPOSITE, TOP LEFT The roses that cascade over the terraces and the silver of a weeping pear soften the areas nearest the house.

OPPOSITE, TOP RIGHT The tall and striking feathery panicles of *Astilbe × arendsii* 'Venus'.

OPPOSITE, BOTTOM Roses, including the red-and-white-striped *R. gallica* 'Versicolor', are planted all around the terrace outside the kitchen. A box square with rectangular divisions is filled with seasonal planting. This impressive display of *Allium cristophii* follows earlier spring bulbs and tulips and will be replaced by summer bedding.

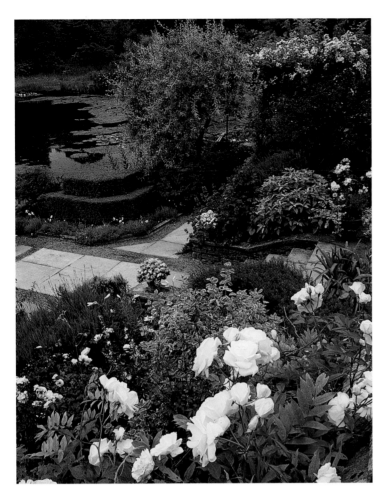

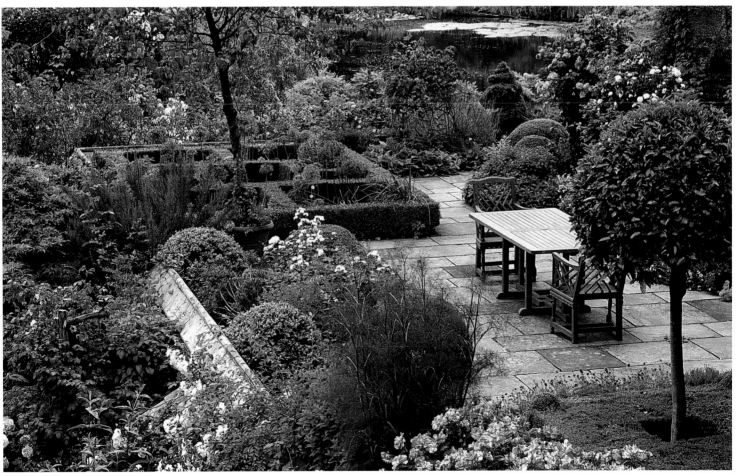

43

Everards Farm

The owners of this Somerset garden designed by
Dan Pearson asked him to produce something
wild and free. They wanted the farmyard to retain
an atmosphere of its ancient past despite being
deep in modern concrete and slurry. Pearson's
inspired solution was to use elders as the top-
storey shrub and to put in the centre a trough-like
raised pool surrounded by gravel into which ox-
eye daisies, *Alchemilla mollis* and tree lupins were
encourage to self-sow. Wide beds by the front
door were filled with decorative relations of
hedgerow plants, purple-leaved cow parsley,
Anthriscus sylvestris 'Raven's Wing', jostling for
space with *Astrantia* 'Hadspen Blood'. Throughout
the garden, plants were encouraged to spill over
the edges of flower beds and in some places
were planted outside these, in paths, gravel and
grass, to soften rigid edges and to introduce a
migratory element that would keep the garden
in constant flux.

RIGHT Honeysuckle climbs around the
front door, and on both sides wide beds
are filled with ruby-coloured *Astrantia
major* 'Hadspen Blood' and *Anthriscus
sylvestris* 'Ravenswing'.

OPPOSITE, TOP In the courtyard of the
farmhouse sharp edges are blurred with
planting that is wild and free: ox-eye
daisies and tree lupins, *Lupinus arboreus*,
are encouraged to self-sow in the gravel.
The narrow-leaved bulrush, *Typha
angustifolia*, rises out of the rectangular,
stone-edged pond.

OPPOSITE, BOTTOM This mixed planting
brings together *Knautia macedonica*,
Eryngium giganteum 'Miss Willmott's
Ghost', the bright-orange Californian
poppy, *Eschscholzia californica*, and
the towering oat grass *Stipa gigantea*.

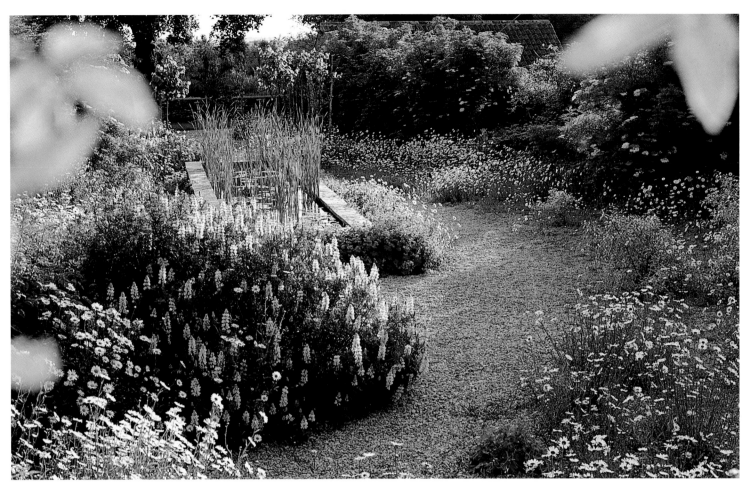

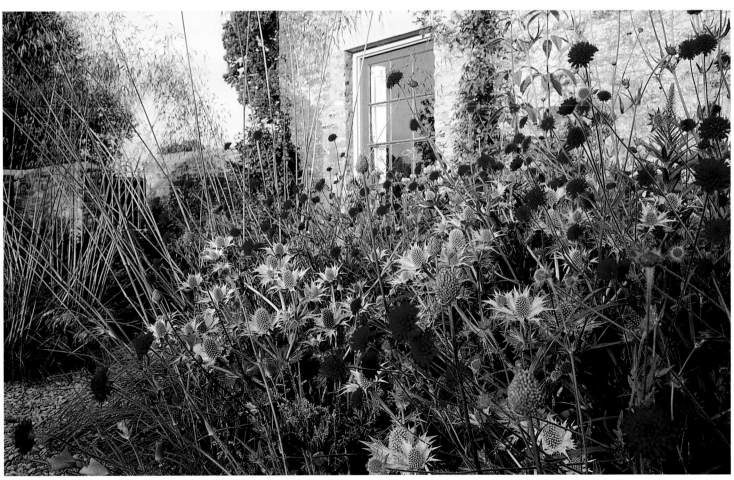

44

Wigandia

With the rolling grassland of the high sleeping volcano Mount Noorat, in western Victoria, for background scenery, William Martin decided he wanted to make a garden that was in harmony with the noble, tree-scattered hills. In this part of Australia the horticultural tradition is to use Northern Hemisphere plants in imitation of Western gardens. At Wigandia, however, the few Northern plants gain inclusion only if their form or texture chimes with the other plants, predominantly from the Cape and New Zealand. The garden was planned as a single canvas rather than a number of distinct areas, and any subdivisions are almost subliminal. The pace is set by the planting, which consists of three interconnected groups: the permanent structural plants, infill or short-lived plants, and self-seeders. Water is scarce, so a high proportion of succulents and semi-desert plants, with their typically architectural forms, make up the permanent element.

RIGHT, TOP The path that leads up to the front door is flanked by *Echium candicans*, *Cistus albidus*, a pair of tall, single-stemmed Three Kings cabbage palms, *Cordyline kaspar*, and the South African honey bush, *Melianthus major*.

RIGHT, BOTTOM Succulents grouped beside a seat include *Crassula ovata*, the purple-leaved *Aeonium* 'Zwartkop' and *Cotyledon orbiculata*.

OPPOSITE, TOP Planting is arranged to keep views of the sleeping volcano Mount Noorat clad in native *Eucalyptus viminalis* and *Pinus radiata*. At the centre of the composition, dwarf purple-leaved *Cordyline pumilio* is planted beside trimmed cones of *Juniperus chinensis* 'Spartan' on each side of a large clump of *Melianthus major*. *Yucca recurvifolia* is grouped under a cabbage palm.

OPPOSITE, BOTTOM The dark-red plumes of *Melianthus major* rise above its serrated, glaucous foliage, with *Phormium tenax* and Mount Noorat behind.

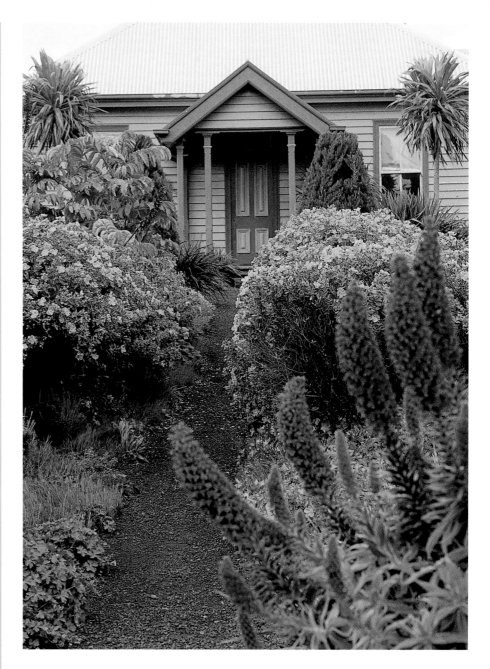

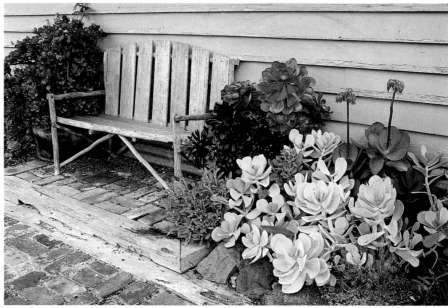

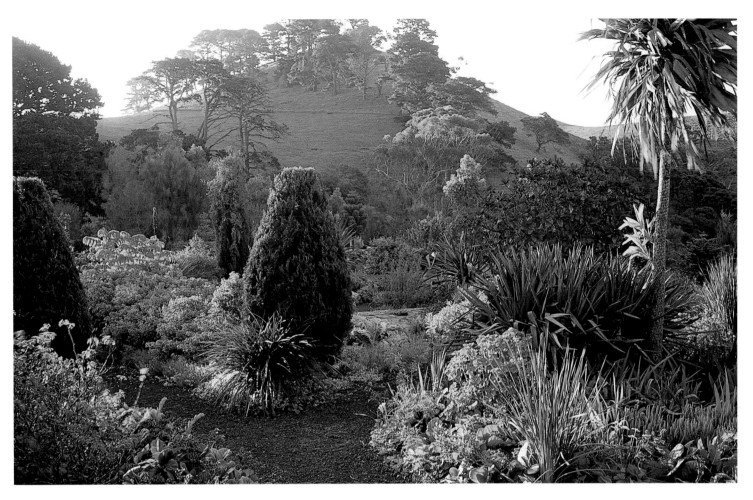

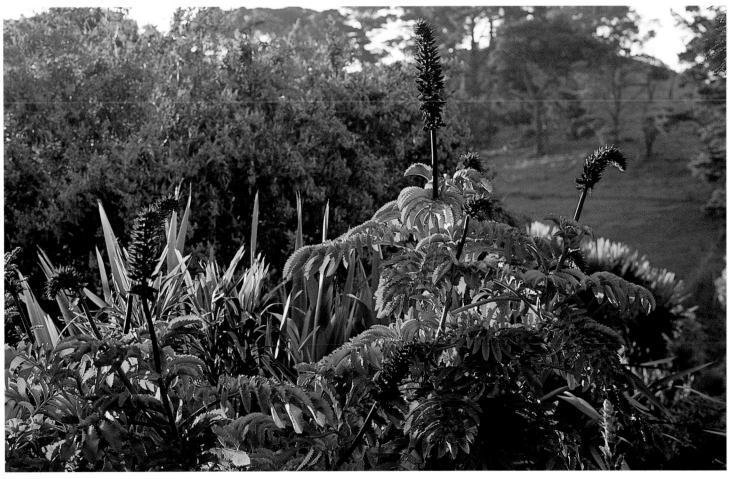

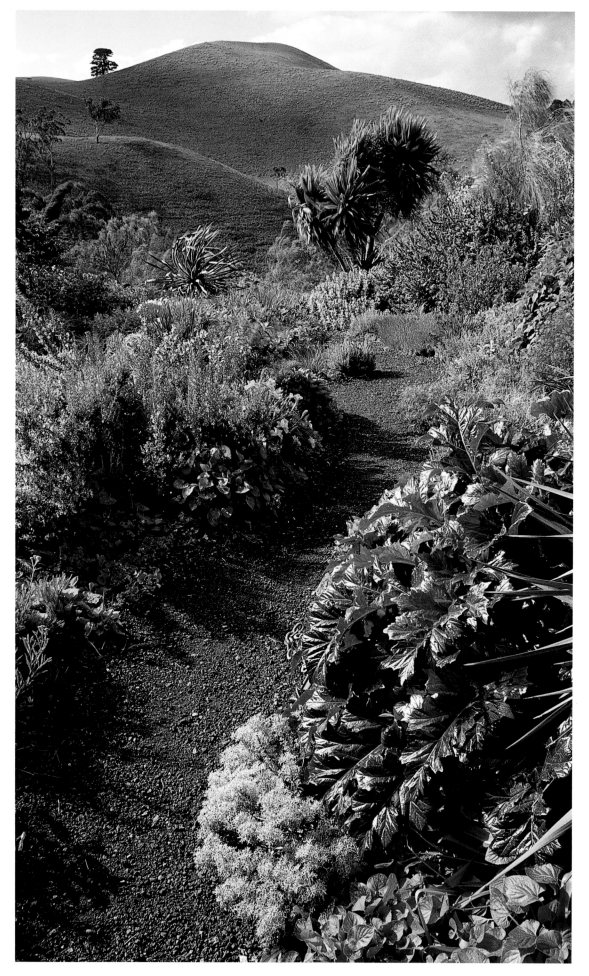

LEFT A collection of European and native New Zealand drought-tolerant plants lines a path made of scoria (crushed volcanic cinders). The plants include grey-leaved *Artemisia alba* 'Canescens', *Acanthus mollis* and rosemary, with yellow and blue forms of *Iris innominata*. A multi-stemmed *Cordyline indivisa* occupies the middle distance.

ABOVE, FROM TOP *Cotyledon orbiculata*; *Agave ferox* with *Aloe maculata*.

OPPOSITE, TOP The garden slopes away from the house, a former groom's cottage that William Martin saved from demolition. Situated on top of a ridge, the house is flanked by a distinctive band of *Eucalyptus cladocalyx*.

OPPOSITE, BOTTOM *Echium candicans* thrives at Wigandia.

45

Rockcliffe

Each year Emma Keswick embellishes her garden in the heart of the Cotswolds with a new project. This young garden, tended by a dedicated team of four, including Keswick (a designer who is also a hands-on gardener), already has a feeling of maturity that many gardens take decades to acquire. At Rockcliffe there are many areas with intricate borders, but what is exceptional is the way that she has married the pretty, honey-coloured manor house to the surrounding landscape. The box patterns on the wide stone terrace at the front of the house are cut in rounded shapes that look as though they have been squeezed out of a cook's piping bag. From the terrace there extends a magnificent sweep of lawn punctuated at each side by rows of pyramid-shaped hornbeam. This is a Gloucestershire garden with a decidedly French flavour.

Rockcliffe's generous terrace is in perfect proportion to its mellow, honey-coloured front, but the expanse of stone is cleverly broken up by low box in star and circle patterns. Lady's mantle, *Alchemilla mollis*, and *Geranium renardii* are allowed to seed into cracks in the paving. The two wings of the house are clothed in the repeat-flowering rose 'Madame Alfred Carrière', and at the base of the wall is a line of purple sage, *Salvia officinalis* 'Purpurascens'.

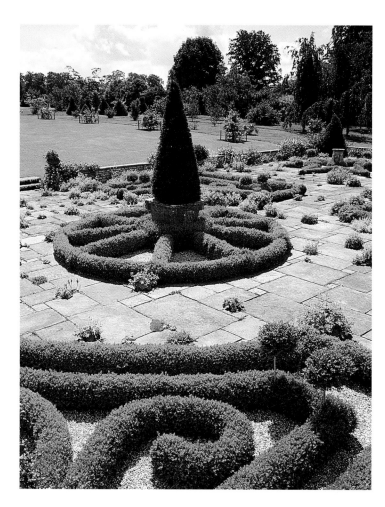

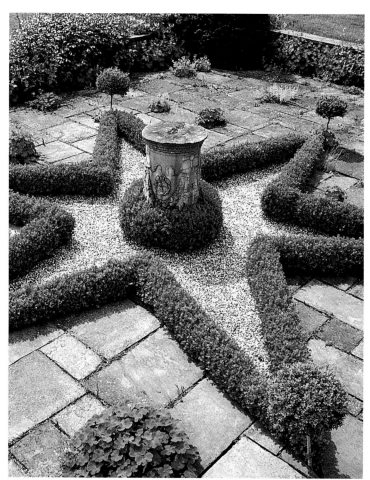

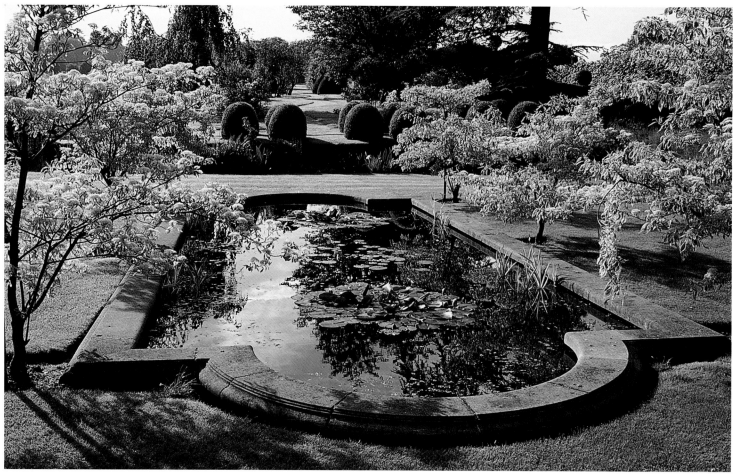

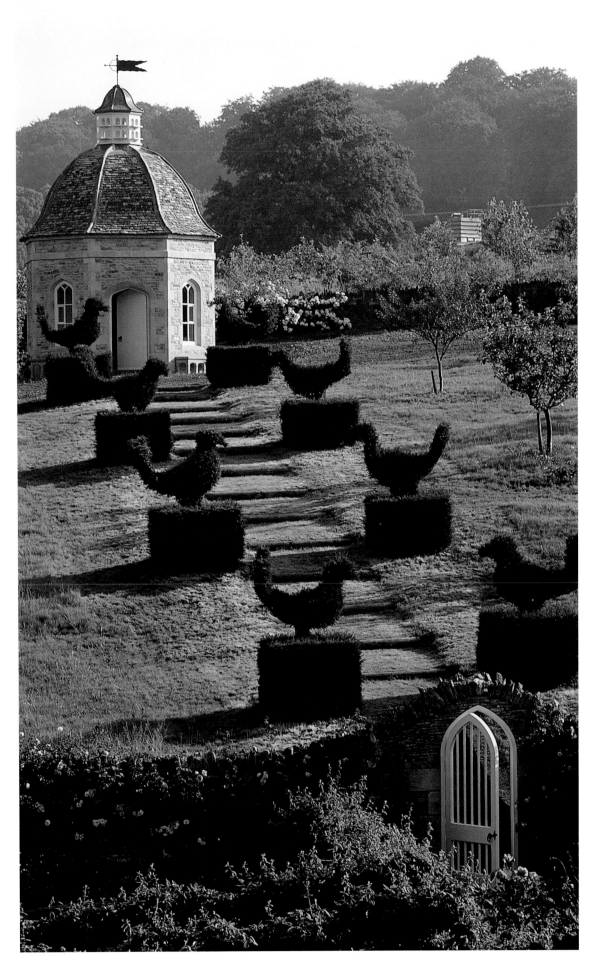

OPPOSITE, TOP LEFT The piping-bag effect of clipping the box hedges into rounded shapes lends itself to the wheel and circle shapes of the parterre. Behind is the young avenue of trees that leads out from the house.

OPPOSITE, TOP RIGHT A mound of *Geranium renardii* grows beside a gravel-filled star of box.

OPPOSITE, BOTTOM A trio of *Cornus controversa* 'Variegata' lining either side of the lily pond produces horizontal tiers of creamy yellow.

ABOVE, FROM TOP White-flowered lavender, *Lavandula angustifolia* 'Nana Alba', surrounds a sundial; *Viola cornuta* is combined with the Welsh poppy, *Meconopsis cambrica*, and white lupin, *Lupinus* 'Noble Maiden'.

RIGHT Topiary birds perch on cubes of yew in an avenue of birds that joins the kitchen garden to the octagonal folly at the top of the orchard.

The Coach House, Bettiscombe

The writer and designer Penelope Hobhouse has converted a coach house and cow byre into a light-filled home with many walls of glass, so you do not have to step outside to feel that you are in the garden. The house forms a division between the two contrasting aspects of the garden, which on one side is expansive and open, with a panoramic backdrop of rolling Dorset downland, and on the other is enclosed by warm walls. This garden was designed with retirement in mind. When the workload needs to be reduced, all the infill planting can be swept away, to leave a magical outline of evergreen topiary, hedges, trees and shrubs requiring the minimum of maintenance. But, for the time being, the stainless-steel-rimmed pond and arches, *allées* of clipped hornbeam, sugar-loaf spires of yew, and clipped domes of phillyrea, olearia and box are accompanied by a profusion of flowering plants.

RIGHT In this summer view from the open large door of the Garden Room into the enclosed back garden, the central path, with its small reflective pool, is engulfed by a profusion of bright planting. Spurge-green euphorbias and the bright-yellow flowers of *Phlomis fruticosa* and mulleins are joined by tree lupins and the creamy tones of a *Cornus controversa* 'Variegata' in the distance.

OPPOSITE, TOP The Garden Room's central door is aligned with Bettiscombe's front door, giving a view through the house. The outline of the sugarloaf-shaped yews that form the backbone of the planting can be seen here among the mainly yellow-flowered summer display.

OPPOSITE, BOTTOM The stainless-steel-edged pond acts as a mirror to the sky and the surrounding planting. At the far end of the pond a contrast is created by the juxtaposition of the thin-leaved bulrush, *Typha angustifolia*, and the giant *Gunnera manicata*.

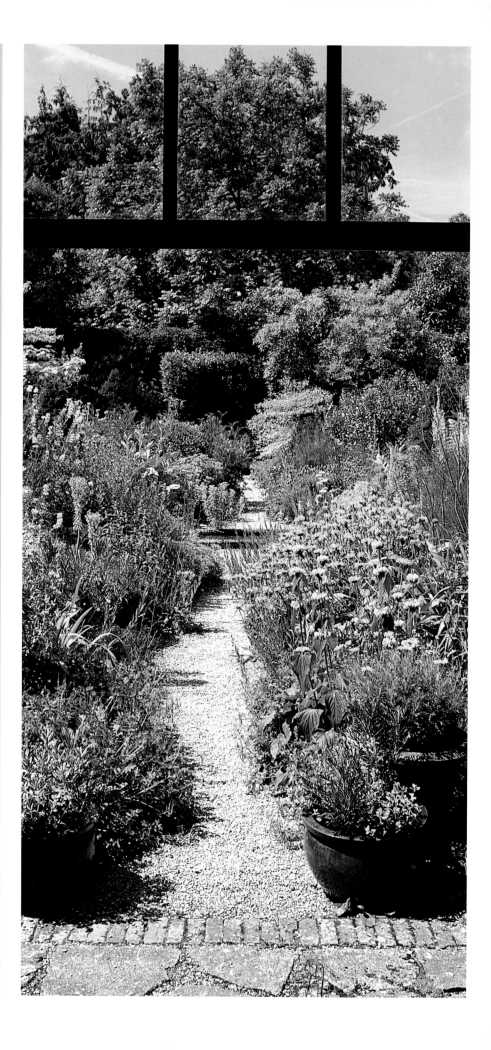

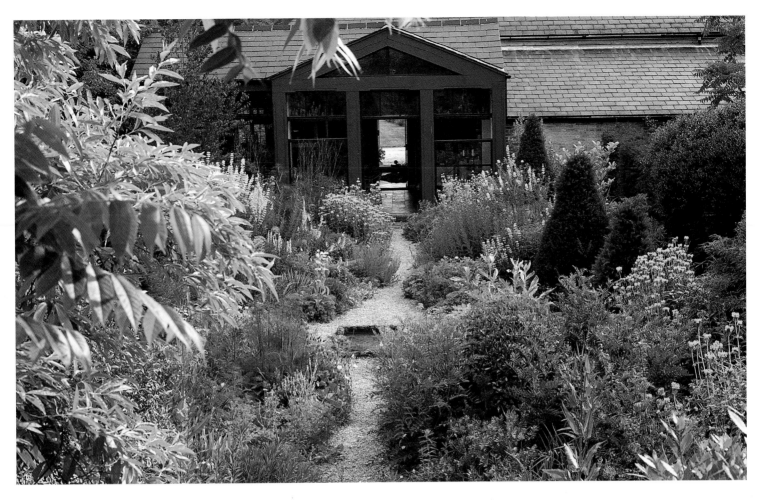

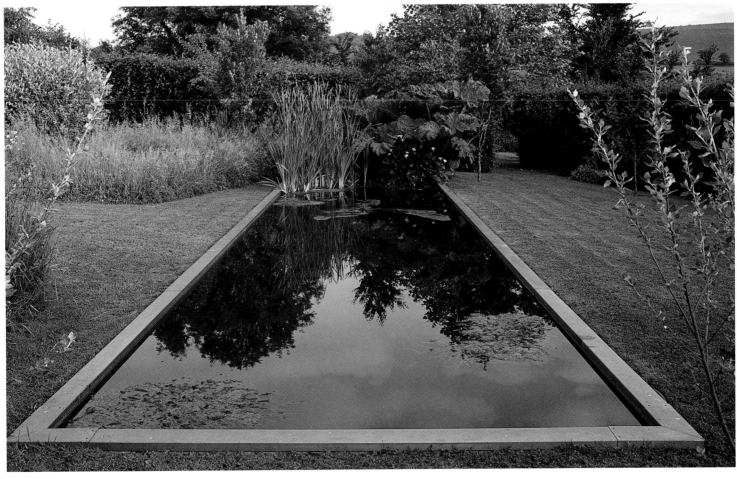

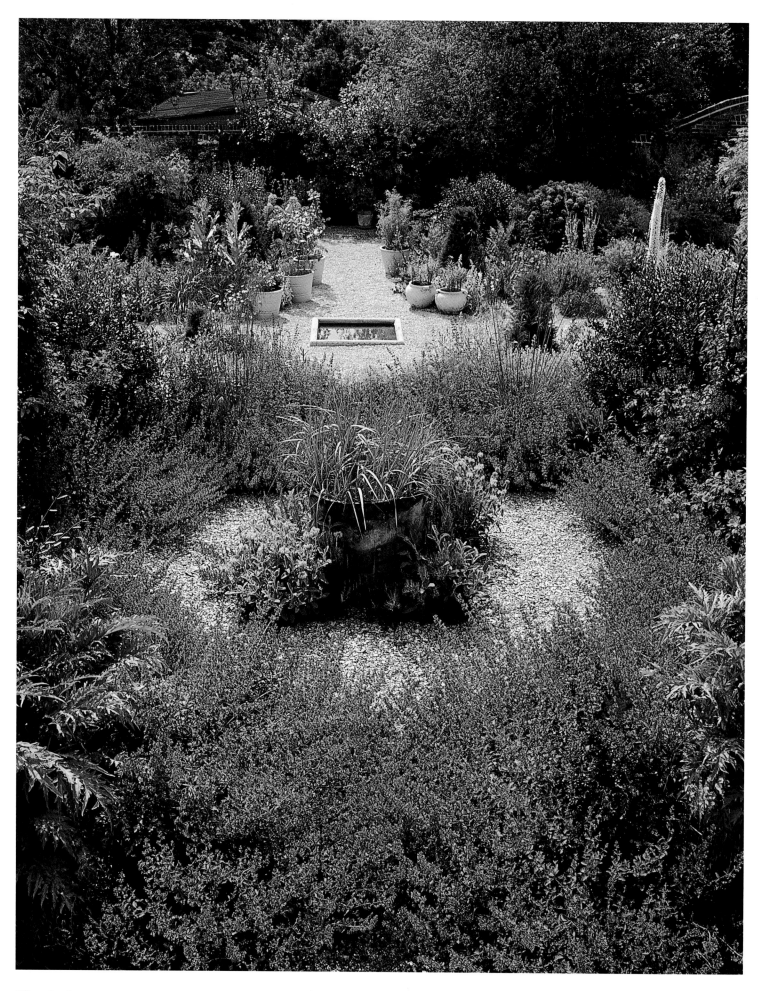

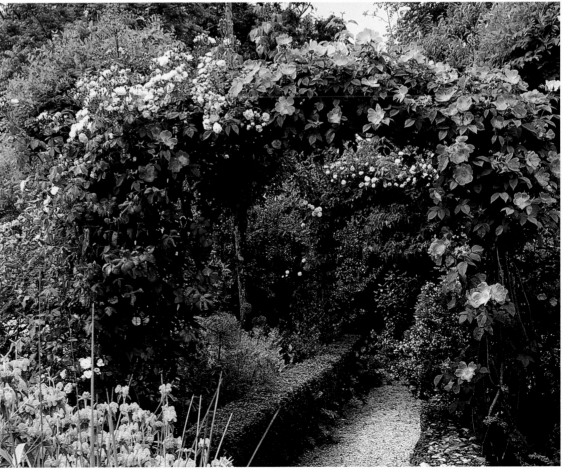

OPPOSITE The lower garden with its pool is seen here from the top terrace, where a soft ring of *Nepeta* 'Six Hills Giant' blurs hard edges. The large central copper bowl with *Phlomis fruticosa* at its base is filled with *Leymus arenarius*.

TOP Roses festooning the arches on the top terrace include the double white-flowered rambler 'Adélaïde d'Orléans' and the smoky-mauve 'Veilchenblau'.

ABOVE *Phlomis fruticosa* with white valerian, *Centranthus ruber* 'Albus'.

RIGHT The large, single-flowered pink *Rosa* 'Complicata' and pale-pink 'Félicité Perpétue', through which twines the pinky-red *Clematis viticella*.

47

Oxfordshire

Being as much a hands-on gardener as a designer, Tom Stuart-Smith finds that his commissions are endlessly varied. At this Oxfordshire property he has made a lush waterside garden and a flower-filled meadow of epic proportions, and renovated the walled kitchen garden in a quasi-traditional manner yet with plenty of contemporary twists. Neat rows of fruit and vegetables with arches of apples fill half the space while the other half is divided in two. In early summer the flower garden, with its quirky, randomly positioned topiary, contains a nostalgic blend of roses, catmint and alliums. White foxgloves are echoed by the rocketing spires of white foxtail lilies. Semicircular seats under sheltering bowers of woven willow occupy each corner of this section. In the remaining quarter of the garden the serpentine form of the tunnels of living willow tells you that here tradition has been firmly put aside. These woven tunnels separate massive beds of tall, purple-plumed *Miscanthus sinensis* 'Malepartus'.

TOP This exquisite meadow of grasses and ox-eye daisies overlooking Otmoor feels wondrously remote but is only a few miles from the city of Oxford.

BOTTOM The walled garden is divided into four enclosures: a water garden, a vegetable garden, a maze planted with large blocks of *Miscanthus sinensis* 'Malepartus', and a rose garden where slender white *Eremurus* 'Joanna' rises above *Nepeta racemosa* 'Walker's Low'.

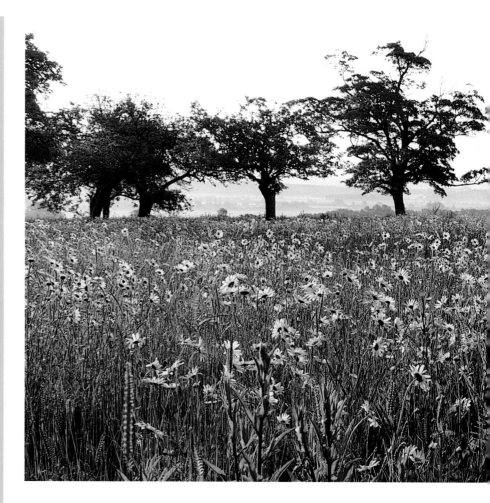

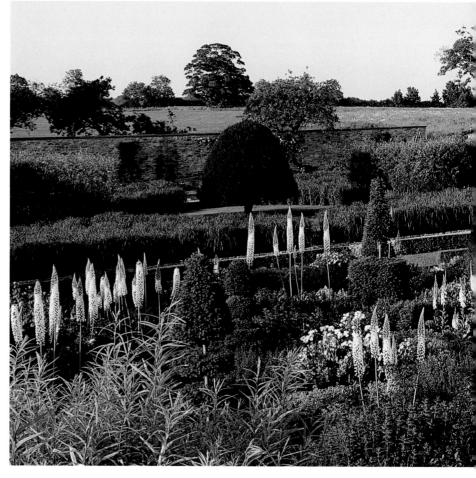

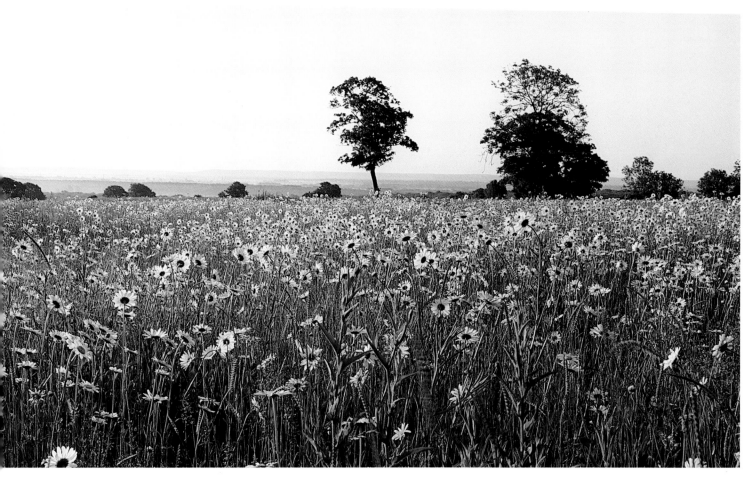

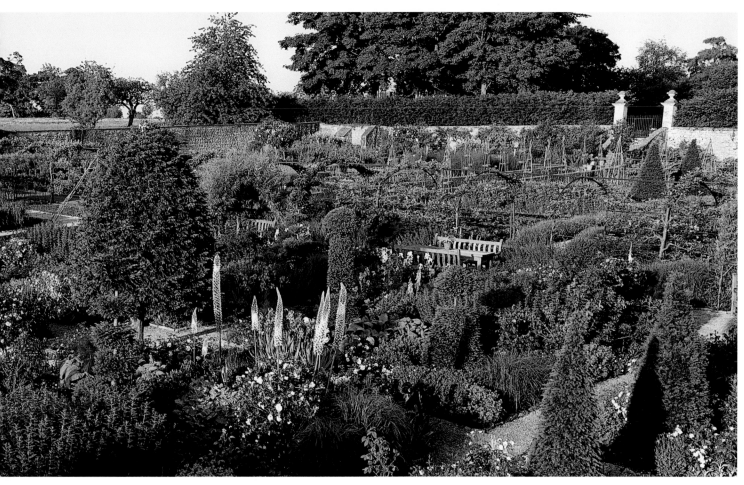

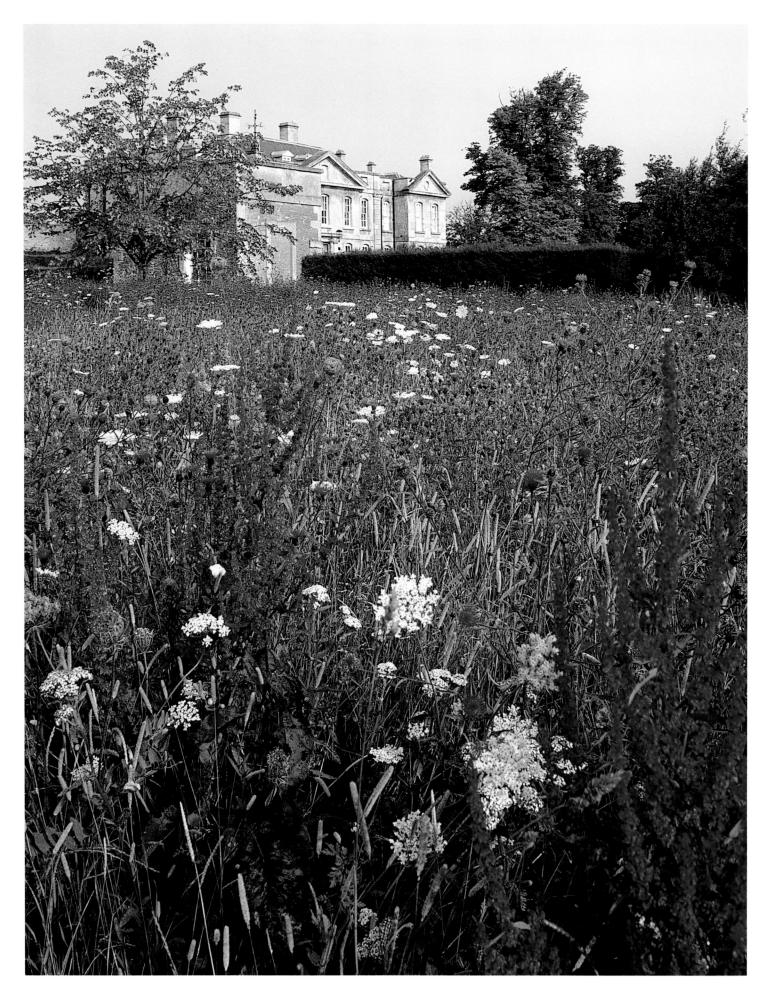

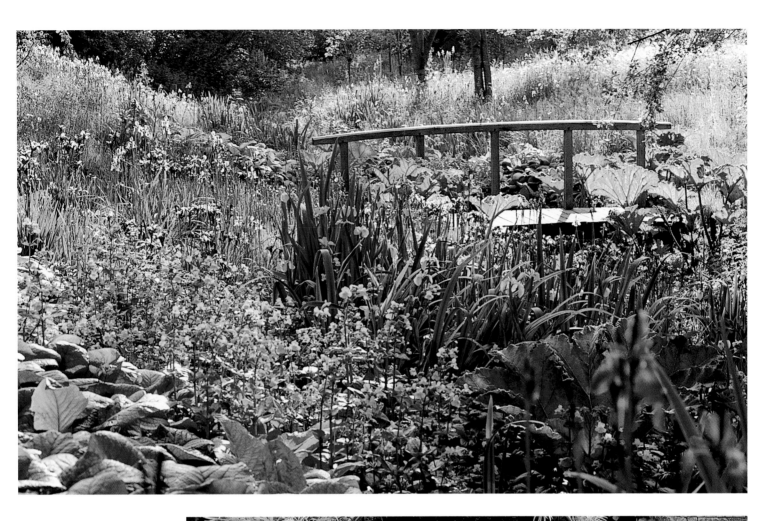

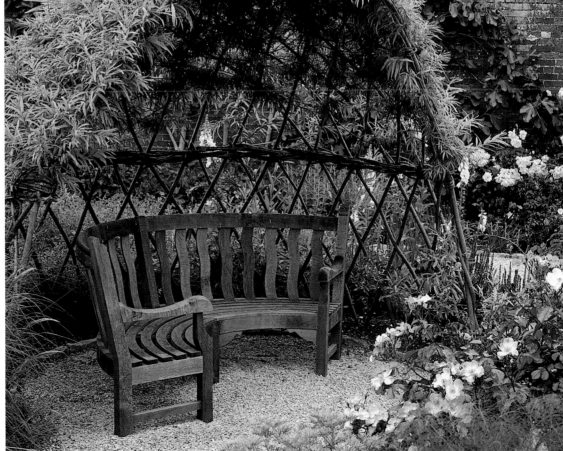

OPPOSITE Docks, wild carrot and greater knapweed, *Centaurea scabiosa*, decorate the meadow in midsummer.

ABOVE The banks of a stream that runs through the arboretum have drifts of moisture-loving perennials, including yellow flag iris and mimulus, blue *Iris sibirica* cultivars and *Gunnera manicata*.

RIGHT A woven-willow arbour in the rose garden has had its lower criss-crossing stems stripped bare so that the pattern remains visible but the canopy becomes dense by midsummer.

48

Lawhead Croft

Three hundred metres (1000 ft) above sea level in the Lanarkshire Moors of Scotland is a garden that has grown with glorious disregard for bad weather. Instead, Susannah and Hector Riddell make the most of the extra summer day length that helps their perennials to grow to twice the size they would in the south. They select plants that revel in the rich moist soil and they welcome the marauding moss that seems to grow up and over every surface that is left to face the elements. These committed gardeners cultivate a wide range of plants with great inventiveness. Running down the centre of the main garden is a tunnel of larches, each clipped back very hard, with wide gaps between them so that the adjoining borders are not robbed of light but dramatic shadows are cast on the grass path below. Quirky sculptures and seats fashioned from rhododendron branches are fitted in among alpine plants and evergreens that give structure during the long Scottish winter.

RIGHT, TOP In front of the garden's ingenious tunnel of larches is *Eryngium giganteum* 'Miss Willmott's Ghost'.

RIGHT A rustic seat made from a tree stump and a plank of wood has a mat of *Acaena novae-zelandiae* at its base and spires of *Digitalis ferruginea* near it.

FAR RIGHT Moss has been encouraged to cover this stone sculpture of a head with hair and a beard.

OPPOSITE TOP *Viola cornuta* 'Alba' lines a path in a mossy glade of trees and ferns.

OPPOSITE BOTTOM An abundant bed of multicoloured delphiniums is edged with *Nepeta* 'Six Hills Giant'.

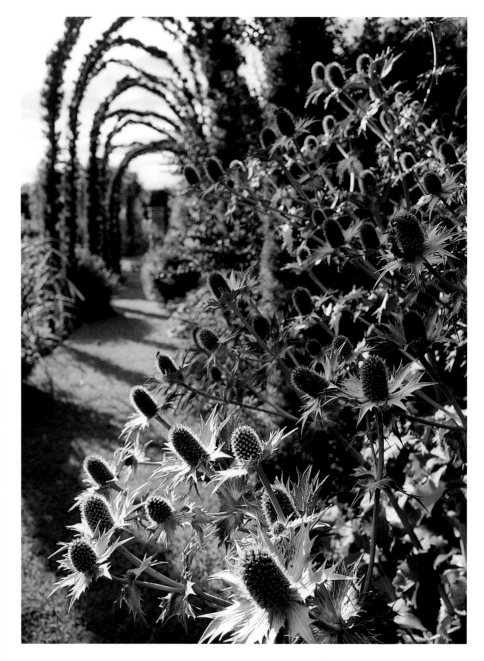

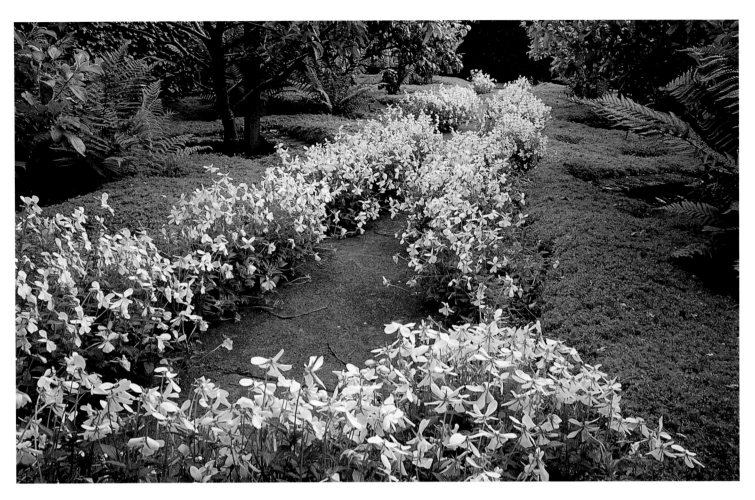

49

Las Navas

On a hill overlooking the dry and dusty plains around Toledo in Spain, Arabella Lennox-Boyd has created an oasis in an unpropitious setting. There is an obvious contrast between the garden and its surrounding landscape, but the transition from one to the other has been cleverly handled by the strategic planting of olive trees, which are used formally in the garden and grown as groves as you step out into the countryside. The formal areas of the garden are laid out as a series of geometric walled and hedged enclosures with robust planting to cope with the baking summers and hard winters. Descending the garden's main, sloped axis is a magnificent cascade that takes its inspiration from the Villa Lante near Rome. The use of clipped box running down alongside the water to represent the fish-like stone shapes at the Villa Lante is a softening stroke of genius in what would otherwise be a harshly silver composition of olives and cobbles set in concrete.

RIGHT The spire of a pencil cypress, *Cupressus sempervirens*, acts like a beacon to distinguish the garden from the arid Spanish plain and distant hills. An olive grove forms a softening link between garden and landscape. Self-sowing red and white valerian, *Centranthus ruber* and *C. ruber* 'Albus', and a billowing cherry-pink rose, 'Zéphirine Drouhin', create an informal atmosphere around the cypress.

OPPOSITE, TOP Water that feeds the cascade flows from a cruciform lily pond set in the cobbled paving of the White Garden. Box-edged beds are filled with 'Iceberg' roses and silver-leaved shrubs such as *Salvia lavandulifolia*, *Ballota pseudodictamnus* and *Potentilla* 'Abbotswood'.

OPPOSITE, BOTTOM LEFT The house overlooks a lawn punctuated by blocks of clipped evergreens and spires of pencil cypress. *Iris germanica* blooms in early summer.

OPPOSITE, BOTTOM RIGHT An octagonal fountain stands among bearded iris 'Headlines' in an avenue of cypresses that is given lighter colour by white valerian and yellow *Phlomis fruticosa*.

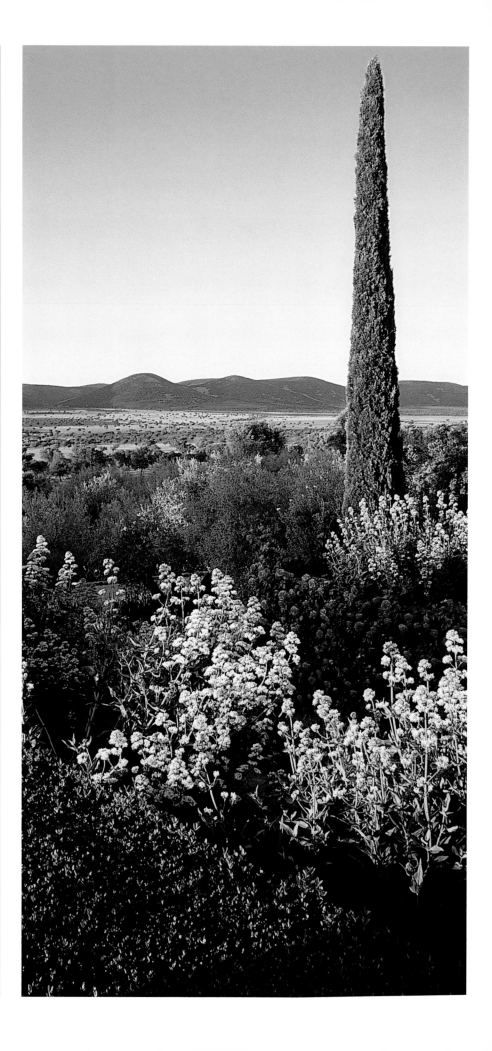

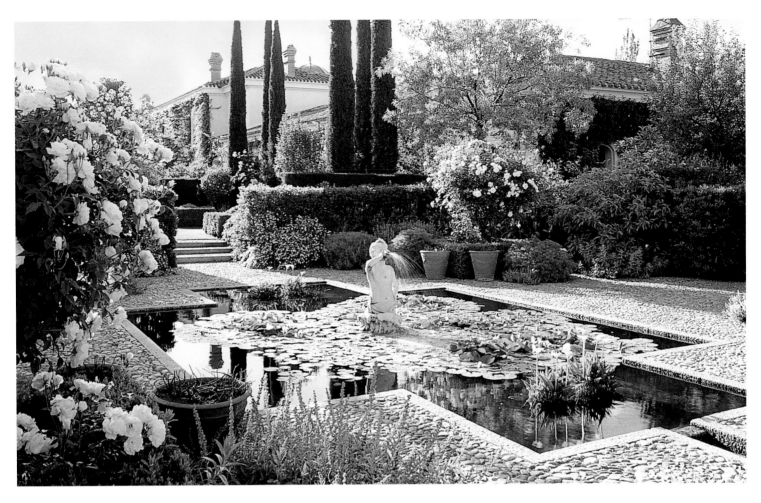

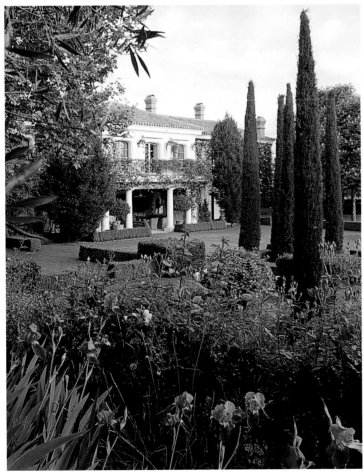

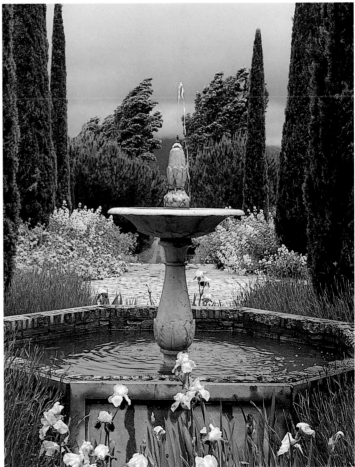

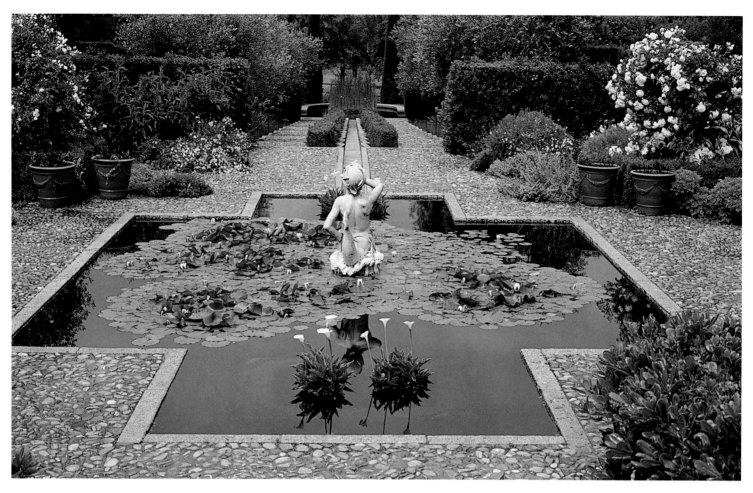

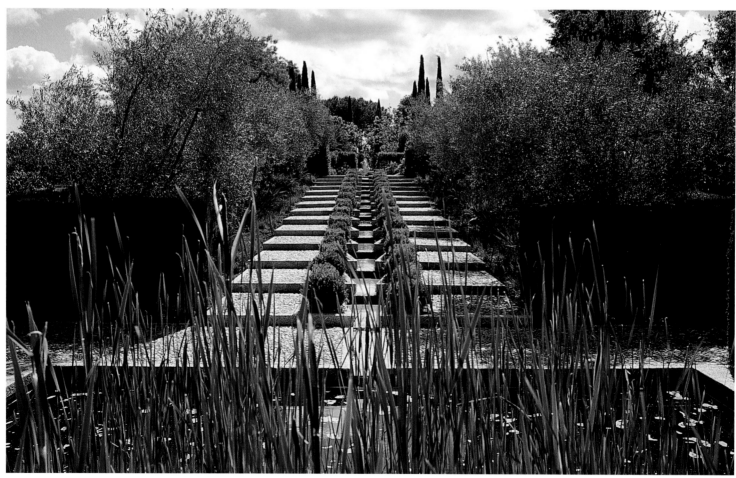

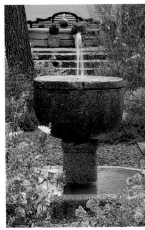

OPPOSITE, TOP White water lilies and *Zantedeschia aethiopica* flower in the calm cruciform fountain from which water flows down the cascade. White iceberg lilies and silver-leaved shrubs fill the surrounding beds.

OPPOSITE, BOTTOM The cascade, lined by undulating box hedges that are set in wide cobble steps themselves fringed by a double row of olive trees, ends in a shallow pool with a line of thin-leaved bulrush, *Typha angustifolia*. Under the olives are planted *Rosa* 'Scharlachglut', *Iris germanica* and lavender.

ABOVE, FROM TOP Among the garden's many fountains is this stone bubble spout; an old stone font has also been transformed into a water feature.

RIGHT The shadows cast by this simple spiral sculpture interplay with those produced by neighbouring trees.

50

Bloxworth House

A monastery once lay in the tranquil hollow surrounded by gentle hills in Dorset where Bloxworth House now stands. The sense of timelessness around the Jacobean house remains intact despite a complete overhaul of the surrounding 3.6 hectares (9 acres) of garden over the past ten years. Terraces, walled gardens, flower meadows, an inconspicuous swimming pool and a long, water-lily-filled canal are all recent additions. To Martin Lane Fox, a garden designer and butterfly enthusiast, the relationship of a building to its setting is key to retaining harmony and a sense of place. A rustic octagonal summer house overlooks the flower meadow with its masses of ox-eye daisies, a carpet of bee-attracting lavender is laid out in front of a barn on stilts, and the majestic, mainly seventeenth-century elevation of the house is reflected in the canal's still waters and framed by a double row of stone pines, *Pinus pinea*.

RIGHT, TOP The octagonal summer house is a vantage point from which to enjoy the wild-flower meadow full of ox-eye daisies.

RIGHT, BOTTOM A tiled barn stands in a meadow of lavender that was planted to attract butterflies.

OPPOSITE, TOP A long, formal canal has been laid out in front of the mainly Jacobean house with an avenue of stone pines, *Pinus pinea*, on either side.

OPPOSITE, BOTTOM LEFT Generous stone urns and a variety of plants soften the swimming pool, with its blue-grey water.

OPPOSITE, BOTTOM RIGHT The pool is disguised as an ornamental pond, into which water flows from under an urn. The damask moss rose 'Nuits de Young' is partnered by the plum-coloured thistle *Cirsium rivulare* 'Atropurpureum'.

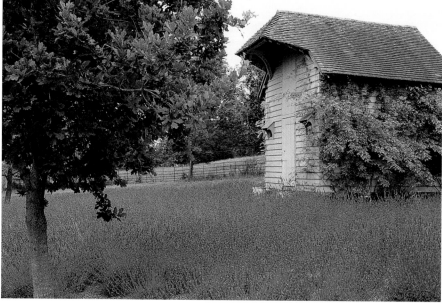

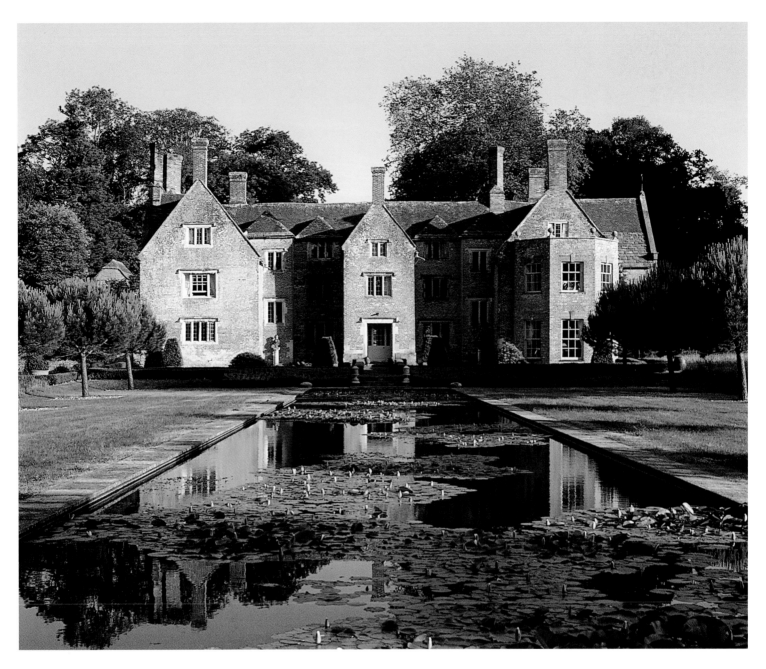

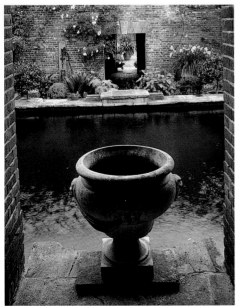

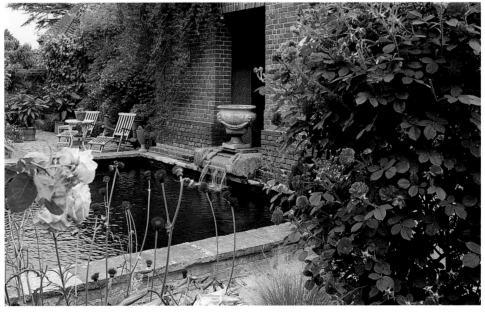

51

Wollerton Old Hall

The garden at Wollerton Old Hall in Shropshire began as a hobby for Lesley and John Jenkins with a string of island beds in front of their sixteenth-century timber-framed house. Lesley's background as an art teacher, however, instilled in her not only a love of form and a finely tuned eye for colour but also the importance of setting each picture in the right frame, and she soon realized that the island beds had to go. Since then the garden has been transformed into a series of fourteen elegant themed gardens within a complex framework of hedges that is an artwork in its own right. But the density of planting adds another dimension. Imaginative juxtapositions of perennials – not in the current pared-down, prairie-obsessed manner but full of luscious delphiniums, phloxes, asters and campanulas – are set off by calmer areas of trees, water and grass.

RIGHT Delphiniums feature strongly in the planting of many areas of the 1.2-hectare (3-acre) garden. In the herbaceous borders, with a blue-painted gazebo in the background covered with *Rosa* 'New Dawn' and *R.* 'Paul's Himalayan Musk', is the intensely blue *Delphinium* 'Faust', with red and white valerian, apricot roses and hollyhocks.

OPPOSITE, TOP An assemblage of roses old and new typifies the planting, which is planned to extend over a long season. The old-fashioned deep-red *Rosa* 'Zigeunerknabe' is seen with white willowherb, *Chamerion angustifolium* 'Album', *Clematis* 'Etoile Rose' and the creamy rambler *R.* 'Wedding Day' near the half-timbered gable end of the house.

OPPOSITE, BOTTOM *Hakonechloa macra* 'Aureola' is paired stylishly with blue-painted garden chairs.

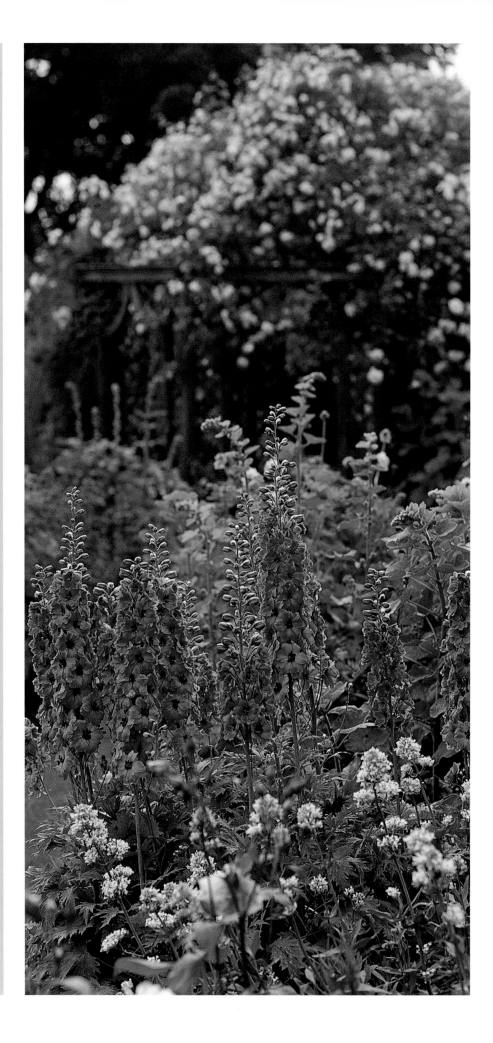

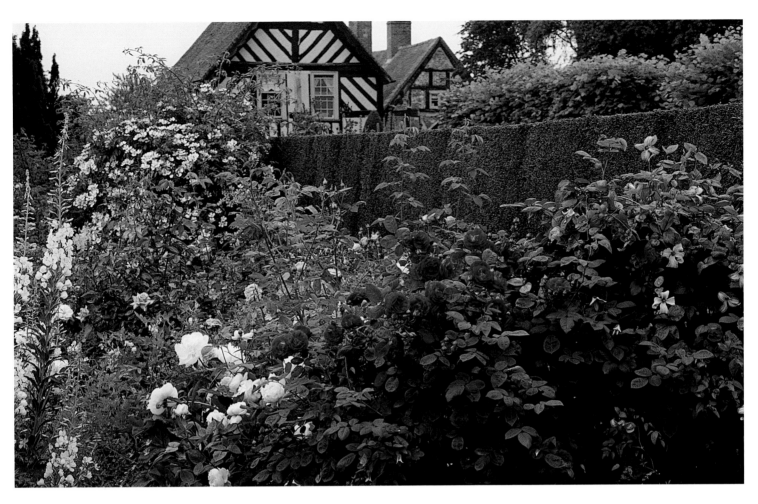

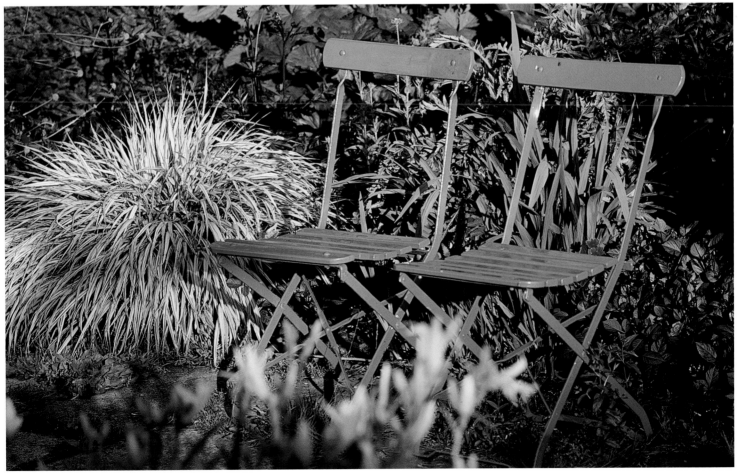

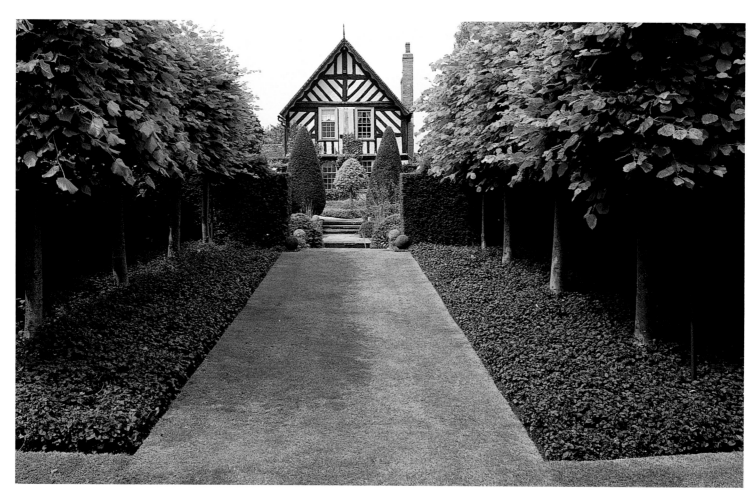

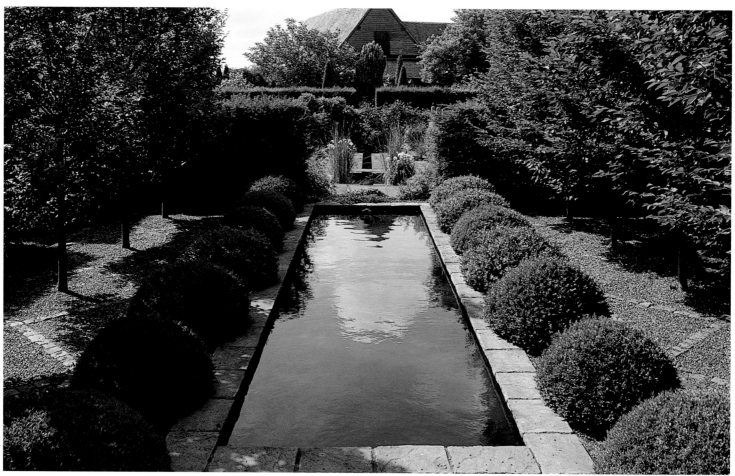

OPPOSITE, TOP The Lime Walk is one of Wollerton's soothing areas of restrained planting, a contrast to the exuberance of the richly planted borders. Under the red-stemmed *Tilia platyphyllos* 'Rubra' is a simple planting of *Viola riviniana* Purpurea Group, which is embellished in spring by *Tulipa* 'Queen of Night'.

OPPOSITE, BOTTOM Another cool and calm area is the Rill Garden, which in one half has a wide canal with a narrow rill on a lower level beyond it. Clipped domes of box spill over the edge of the stone pond within a neat double row of fastigiate hornbeam, *Carpinus betulus* 'Fastigiata'.

ABOVE, FROM TOP *Rosa* 'Raubritter' with *Clematis* 'Etoile Violette'; *Delphinium* 'Pink Ruffles'.

RIGHT At the far end of the Upper Rill canal is a gazebo that hosts honeysuckle and *Rosa* 'Champneys' Pink Cluster'.

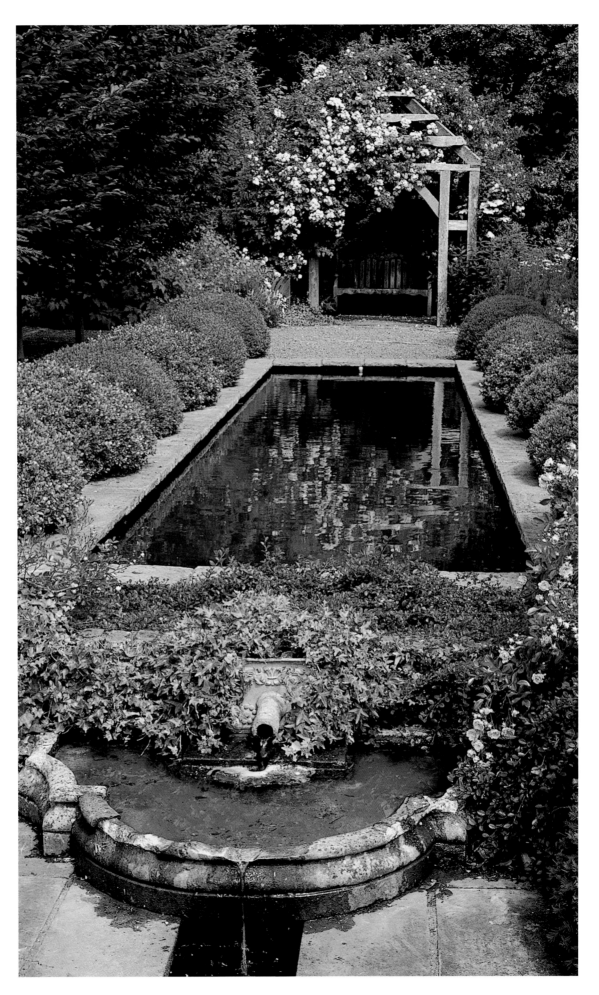

52

Fulham, London

The former London garden of the actor turned garden designer Anthony Noel is an example of an imaginative outdoor space packed with both seasonal and year-round interest despite being very small. He conceived the garden as a unity in terms of evergreens and structure, trelliswork, paths and lawn, but each wall, corner or vista also works as a *mise-en-scène*, decorative in its own right. There is a dramatic focal point on all four sides: lion's-head fountains spout water into troughs on the main, opposing walls and large urns give a monumental sense of scale. Terracotta pots, plain or painted with decorative stripes, are filled with topiary and a succession of bedding plants. By regularly changing the incidental planting – spring bulbs are replaced by lilies and winter-flowering pansies by marguerites; tulips give way to ivy-leaved pelargoniums – Noel lends the garden a continuous and engaging sense of renewal.

Even in summer, when this small garden is at its most lush, the important contribution of evergreen structure is clear. The end wall is draped with the large-leaved ivy *Hedera colchica* 'Dentata Variegata' and an assortment of pots is filled with clipped topiary. The architectural impact of such perennial plants as the large, glaucous-leaved *Hosta sieboldiana* var. *elegans* at the end of the path is as integral to the overall composition as the large urns and fountains that are out of view behind the standard marguerite. Restricting the palette to green, white and silver produces a unifying effect, enlivened by splashes of yellow from the twining golden hop, *Humulus lupulus* 'Aureus', and black from the pansy *Viola* 'Molly Sanderson'.

53

Herterton House

The farmstead at Herterton House had not been lived in since 1709 when Frank and Marjorie Lawley took on a repairing lease from the National Trust. The house was resuscitated and so too the scrappy muck yard, a patch of land of 0.4 hectare (1 acre) in the windswept moors of Northumberland that is now a jewel box of a garden. The Lawleys erected stout stone walls to divide the site into a series of enclosures of different sizes, each of which has been given a theme. There is a formal garden, a physic garden and a flower garden. Each has a firm architectural framework within which plants are placed that relate to the narrative of each area. In the flower garden, where four stone troughs mark the central axis, flower colour follows the movements of the sun and the moon. Dawn's soft pinks and creams give way to midday-sun yellows, and blues symbolic of the sky become the plum colour of dusk, all within a neat rectangle of box.

A firm framework of rectangular beds, clipped box and sentinel yews in the Flower Garden is accompanied by a kaleidoscopic display of plants that charts the course of the day. Dawn is represented by the soft creams and pinks of veronicastrums, daisies and pale-pink yarrow. Yarrows form a thread throughout the garden, with *Achillea filipendulina* 'Gold Plate' in the area that depicts the sun, the creamy *A. taygetea* for the moon, *A.* 'Lachsschönheit' for dawn and the fiery-red *A.* 'Fanal' for dusk.

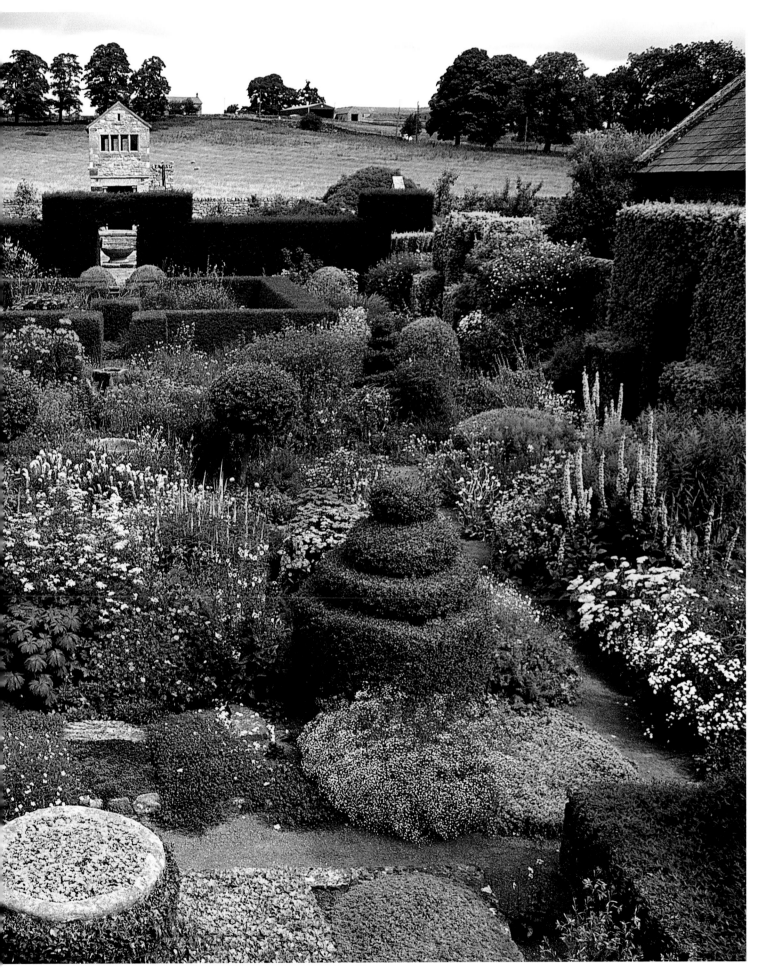

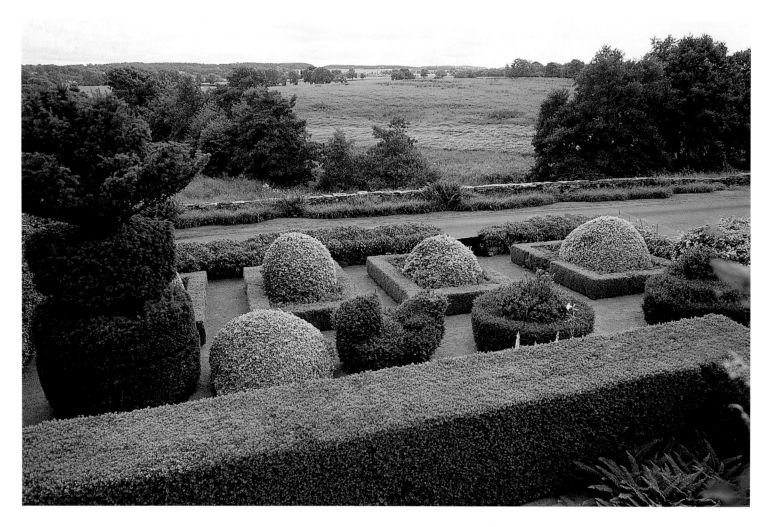

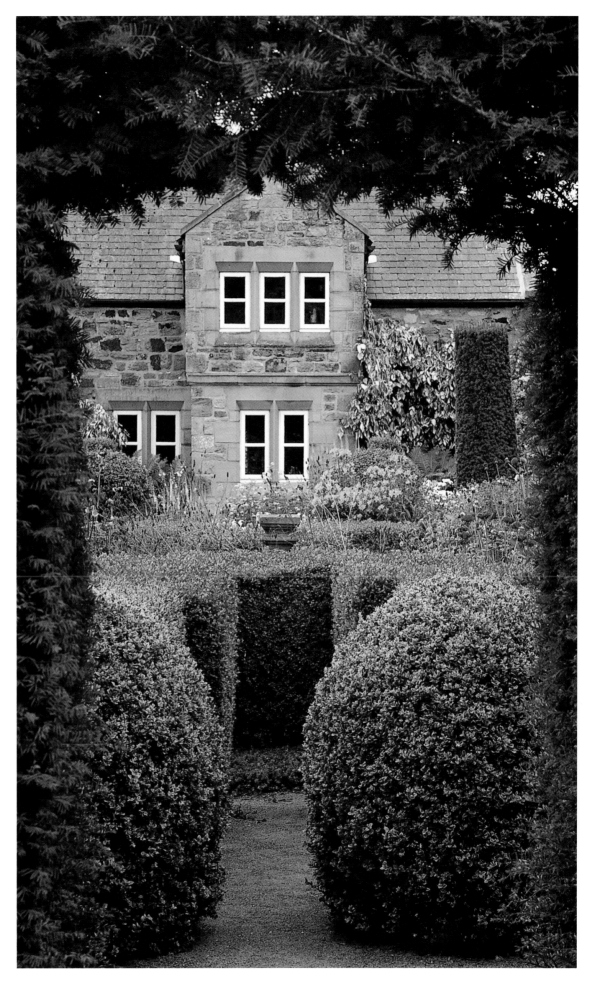

OPPOSITE, TOP The untamed Northumbrian landscape contrasts dramatically with the topiary garden, which abuts the road.

OPPOSITE, BOTTOM LEFT Long-spurred columbine, *Aquilegia* 'Olympia Red and Gold', combines vividly with the Icelandic poppy, *Papaver croceum*.

OPPOSITE, BOTTOM RIGHT One of the four stone troughs in the Flower Garden is surrounded by a carpet of low-growing plants. The pompoms of sea pink, *Armeria* 'Bees' Ruby', are echoed in those of a chrysanthemum planted behind with *Geranium clarkei* 'Kashmir White'.

ABOVE, FROM TOP *Pilosella aurantiaca*; *Achillea* 'Fanal'.

RIGHT The vibrant red and orange flowers that represent dusk rise from an architectural framework of clipped evergreens and include *Alstroemeria aurea*, *Lychnis chalcedonica* and *Sanguisorba officinalis*. Growing up the house is *Hedera colchica* 'Sulphur Heart'.

54

Coughton Court

When the owner of Coughton Court, Clare Throckmorton, and her daughter, garden designer Christina Williams, undertook the restoration of this Warwickshire garden fifteen years ago, they decided to keep the landscape around the house understated and simple but let the horticultural fireworks go off in the walled kitchen garden. As a result, the house rises from a serene backdrop of green lawns framed by yew hedges and pleached limes, while in the restored kitchen garden more than two hundred roses and an ever-changing array of perennials fire off throughout summer and autumn. This is where Williams has developed an oasis of traditional planting with a twist, the soft colours of roses and catmint given an edge by bright-orange foxtail lilies. Acid yellows bite through soft pastels. There is another surprise in the layout: at first view it appears to follow conventional lines, but once you step off the central path you are in a labyrinth of sensuous planting.

RIGHT, TOP The west-facing façade of Coughton Court.

RIGHT, BOTTOM An arch festooned with the roses 'Sander's White Rambler' and 'Debutante' is surrounded by *Campanula lactiflora* 'Loddon Anna', *Geranium* 'Patricia' and *Lavandula* 'Hidcote Blue', while behind is the pale lemon-yellow giant scabious, *Cephalaria gigantea*.

OPPOSITE, TOP St Peter's church and the towering chimneys of Coughton Court are seen from the rose garden, where bands of *Lavandula angustifolia* 'Hidcote' and orange spires of *Eremurus bungei* are planted among a profusion of roses that includes *Rosa* 'Félicité Perpétue' in the centre.

OPPOSITE, BOTTOM A central gravel path in the rose garden leads under an arch of the rambling roses 'Adélaïde d'Orléans' and 'Félicité Perpétue'.

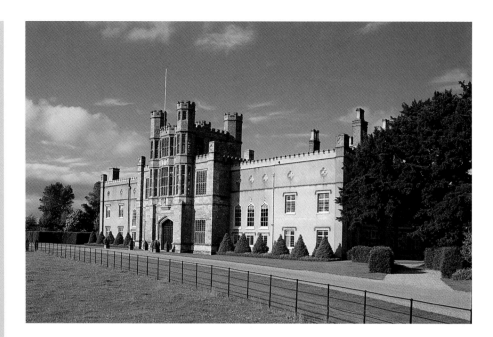

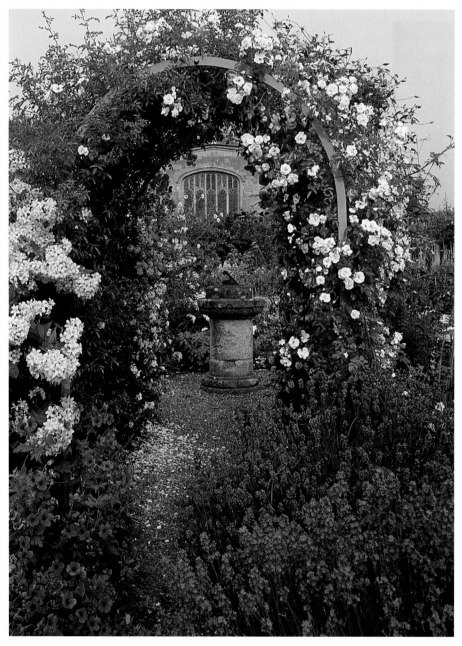

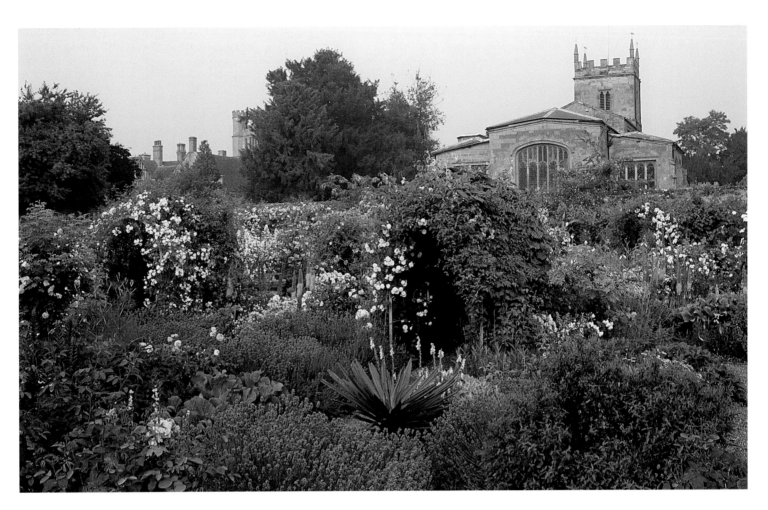

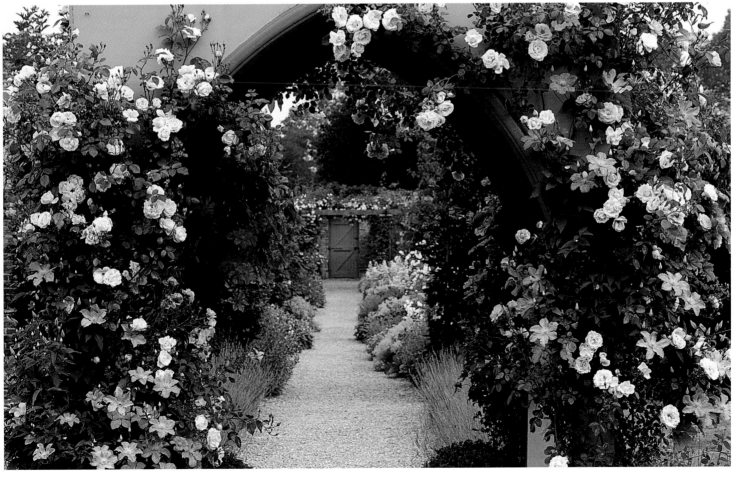

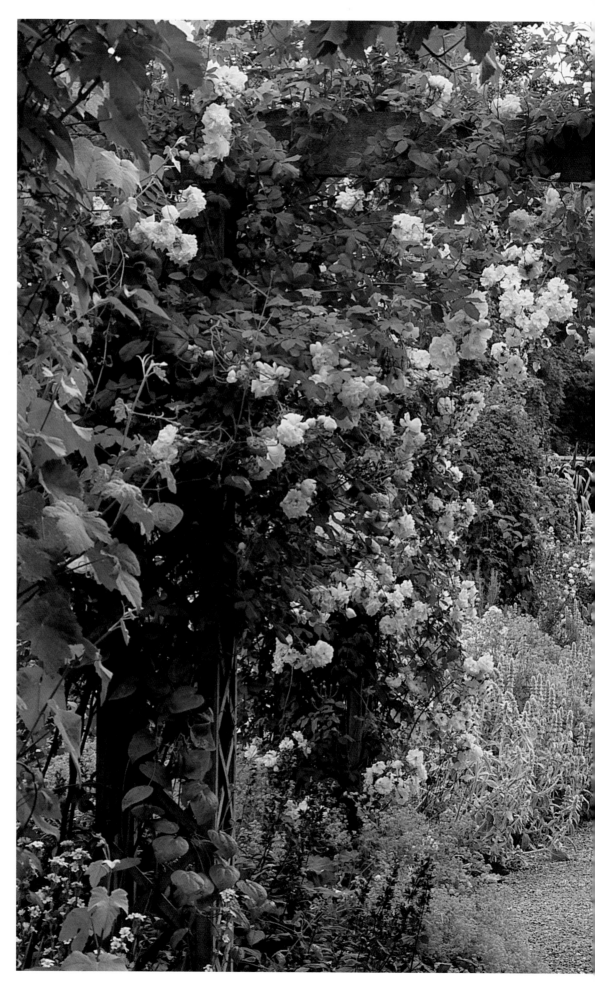

ABOVE, FROM TOP A green-painted bench in a sunny spot is flanked by pots of ivy-leaved pelargoniums; an *Allium schubertii*.

RIGHT The gravel path through the rose garden leads to a gazebo with *R.* 'New Dawn' and *Clematis* 'Hagley Hybrid'. Lining the path are alternate groupings of *Stachys byzantina*, *Alchemilla mollis* and purple sage, *Salvia officinalis* 'Purpurascens'.

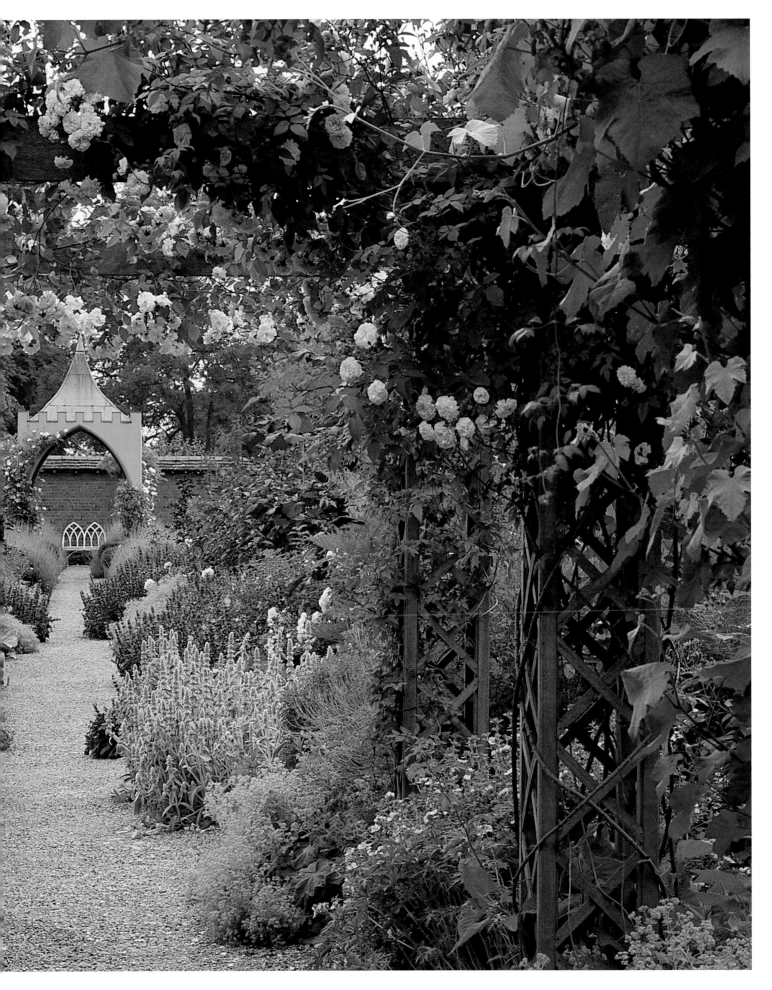

55

Les Quatre Vents

One hundred kilometres (60 miles) north-east of Quebec City is a garden of 8 hectares (20 acres) filled with fantastical garden buildings, elegant vistas and horticultural splendours that say much about the dynamic and stimulating owners. More than thirty smaller gardens lie within the boundaries of Les Quatre Vents, each reflecting the many passions of Anne and Frank Cabot. The potager and the bread-oven garden reflect a love of family, friends and food. The rope bridge over the 'Himalayan' ravine was inspired by a trek in Nepal. Buildings and plantings evoke oriental garden art, with a tea house, a painted bridge and swaths of irises and primulas. The dovecote, mirrored by a canal and a string of gently descending reflective pools, has a European sensibility. There are temples, follies, whimsy and wit, but the whole is tied together by a striking use of native trees and shrubs that connect or divide the garden's many worlds. This is a garden born out of geographical and intellectual wanderings and charged with the double mission, as the owners say, "to soothe and stimulate the spirit".

RIGHT A narrow reflecting pool enclosed by a triple avenue of trees produces a mirror image of the four-storey pigeonnier. An arch at ground level guides the eye to the landscape beyond.

OPPOSITE, TOP *Actaea racemosa*, *Achillea ptarmica* 'The Pearl', lilies, larkspur and potentilla are ingredients of the white garden near the house. White poppies, peonies, lilac and philadelphus bloom here earlier in the season.

OPPOSITE, BOTTOM Steps and lawns are a feature of one of the more formal areas of the garden. Astilbe and bergenias flank the granite steps in the foreground, and the white garden is seen behind.

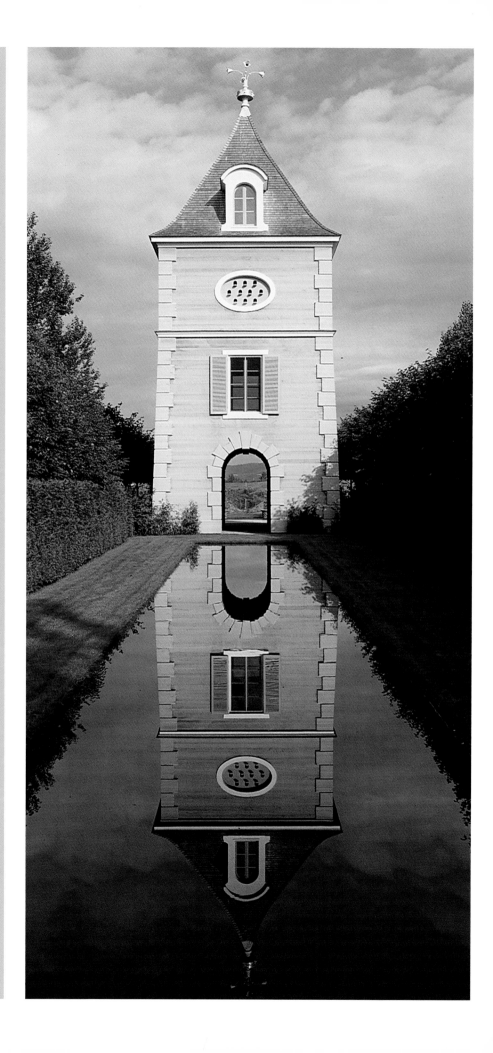

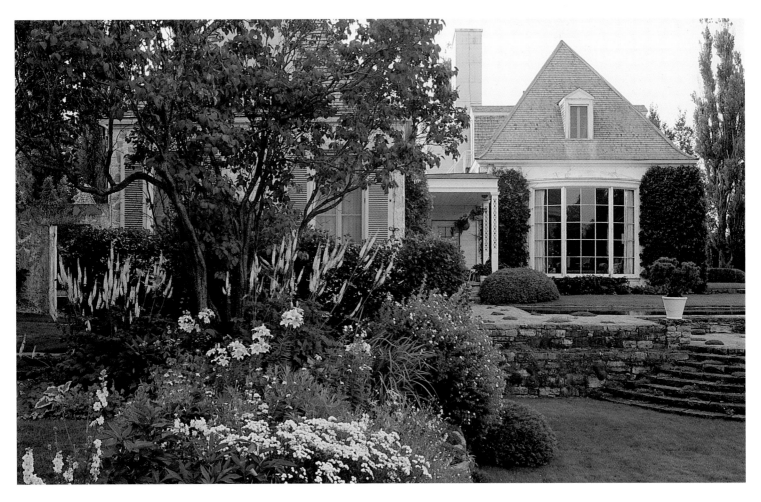

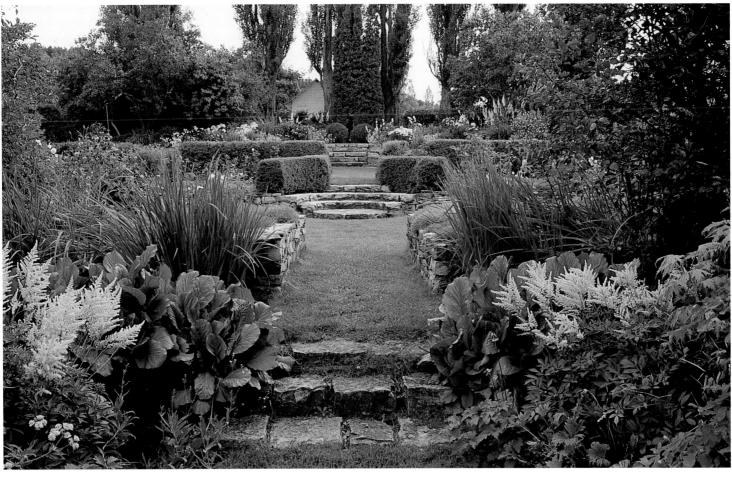

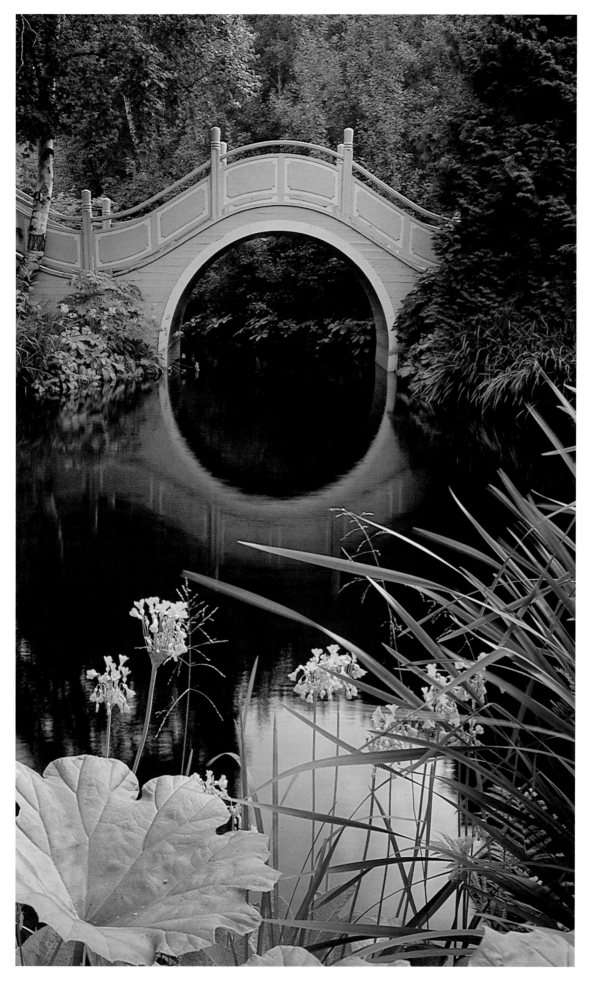

LEFT The humpback Chinese moon bridge and its reflection make a harmonious oval in the water. Irises, rodgersias, petasites and *Primula florindae* lie in large, lush drifts around the bridge.

ABOVE, FROM TOP A rope bridge crosses the 'Himalayan' ravine; *Rodgersia podophylla* lines curving timber steps in the woodland garden.

OPPOSITE A watercourse spills down a series of terraced, lily-studded pools and rills into the lake, with neatly clipped columns of cypress on either side.

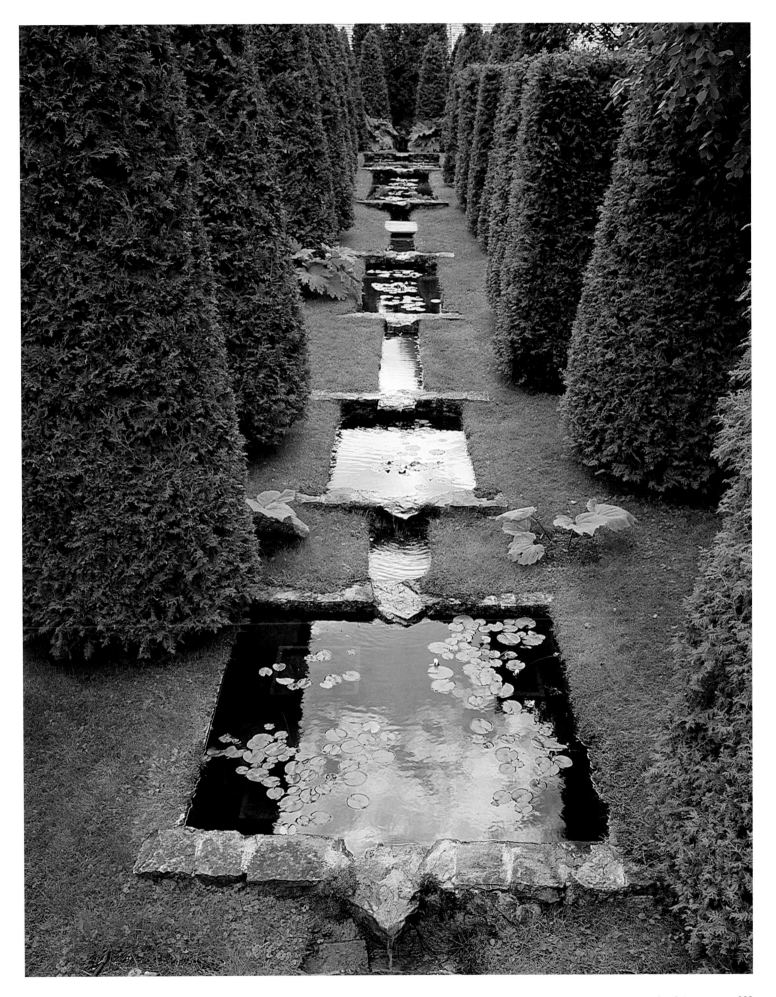

Chilcombe

The artist John Hubbard, with his wife, Caryl, has created a garden near the sea in Dorset that is the horticultural equivalent of shabby chic: relaxed, understated and with a deliciously comfortable atmosphere. Good bones are the backdrop to planting that looks effortless but is rich and layered with form and colour, like John's powerfully evocative abstract oil paintings. The garden at Chilcombe combines the best elements of a cottage garden: effusive but unpretentious planting held together within the cohesive structure of a formal garden, beautifully laid paths, neat definitions and well-clipped hedges. It is made up of a series of enclosures where the hedges and walls filter wind from the coast, creating a mild maritime microclimate. Half-hardy plants have a very long season, and the vegetable garden, where bare earth and rows of green are the norm, is brilliantly decorated with penstemons, diascias, salvias and felicias. Harmonious colouring that suits the soft landscape is vivified by the occasional injection of contrasting colour.

RIGHT The house can be seen from the kitchen garden, which is surrounded by protective trees and hedges, such as the tapestry hedge, a mixture of holly, hornbeam and copper beech. This is as much a flower garden as a productive garden, because the Hubbards grow rows of vegetables, herbs and salads among penstemons, scarlet salvias, wigwams of sweet peas and *Diascia rigescens*.

OPPOSITE An interesting combination of well-known and unusual garden plants creates a cottage-garden effect in this part of the garden. *Gillenia trifoliata* with yellow Welsh poppies, *Meconopsis cambrica*, in the foreground, *Salvia microphylla* and *S. nemorosa* with towering foxgloves congregate around a pot by Rupert Spira.

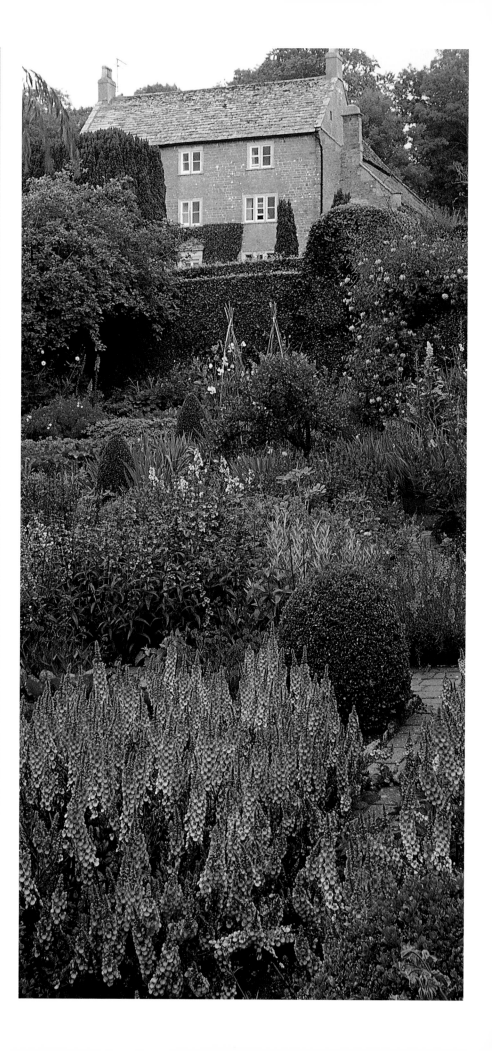

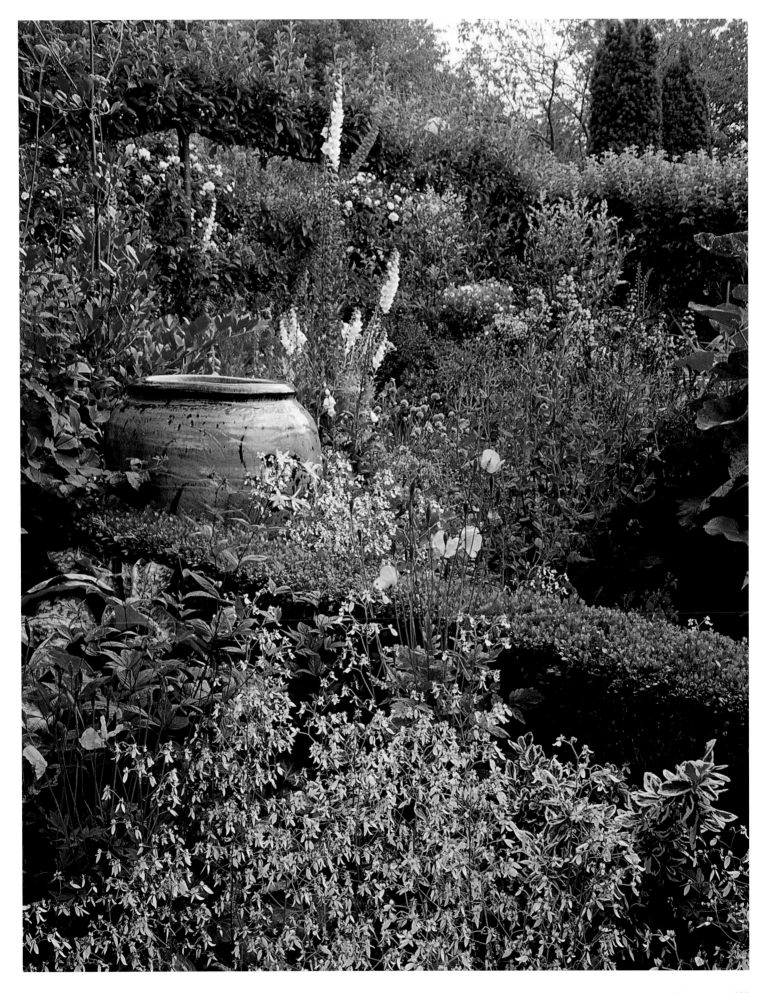

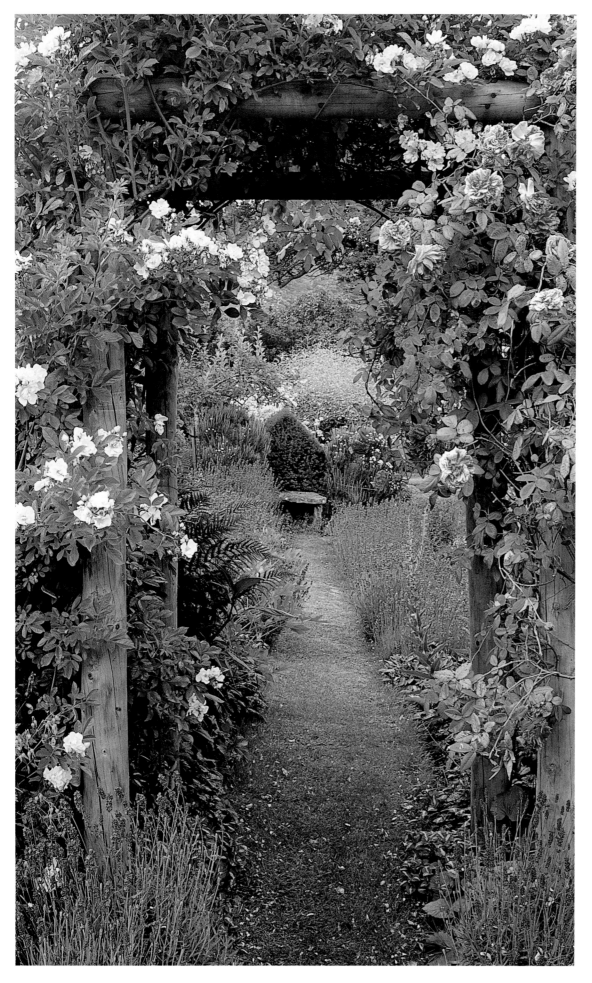

LEFT A rustic wooden arch over which *Rosa* 'Rambling Rector' and dark-pink *R.* 'Zéphirine Drouhin' are trained defines the transition from one section of the garden to another. In addition, it frames the view of a lavender hedge that leads to a stone seat backed by a triangle of clipped box with a frothy cloud of *Crambe cordifolia* behind.

ABOVE, FROM TOP *Lilium regale* 'Album' with lamb's ears, *Stachys byzantina*, and salvia; *Salvia sclarea* var. *turkestanica*.

OPPOSITE The South African *Diascia rigescens* gives an impressive display of flowers from early to late summer. It survives winter in mild gardens but is half-hardy in cold areas. Here it thrives in the free-draining, loamy soil, with a neat mound of box, gentian-blue borage, *Borago officinalis*, and the taller *Salvia candelabrum* behind.

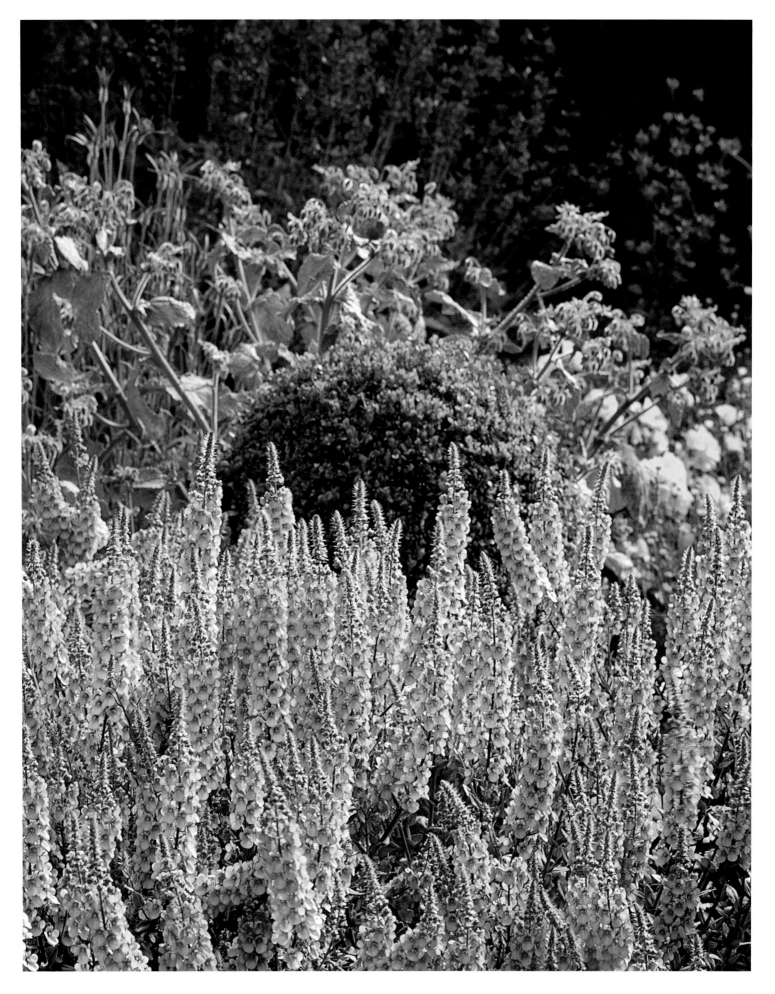

Prospect Cottage

The late film director, writer and poet Derek Jarman created, amid the shingle along the shore at Dungeness in Kent, a garden of elegiac beauty that matured as he became progressively weakened by Aids, from which he died in 1994. Within view of a nuclear power station and set in a barren wilderness with no boundaries, the garden became an oasis of stones, symmetry and sympathetic planting. The horned poppies, sea kale and sea peas that spontaneously grew out of the shingle were Jarman's starting point. In an effort to protect them from rabbits and from the wind and rain that blasted horizontally across the terrain, he inserted beachcombed pieces of twisted metal or wooden poles into the shingle and topped them with interestingly formed shells or flints. Gradually 'beds' were outlined in geometric patterns of pebbles and flints, and although planting became more complex and sophisticated, nothing was added unless it was right for the site. It is the aim of most garden creators to tap into and remain true to the spirit of a place. At Prospect Cottage Jarman unwittingly did exactly that and created one of the late twentieth century's most iconic gardens.

The garden had to look after itself when the filmmaker was away, so only plants that thrived even when blasted by harsh, salty winds, driving rain or blistering sun were placed among the sculptures he created from the gnarled metal and timber he found while beachcombing. Sea kale, *Crambe maritima*, artemisias, cotton lavender, cistus, roses, sages and *Teucrium fruticans* have all been fashioned into compact forms by the elements.

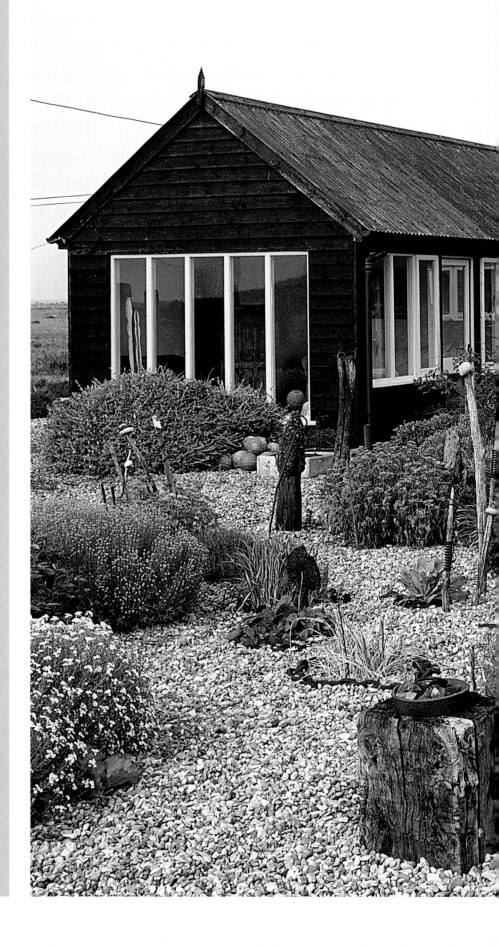

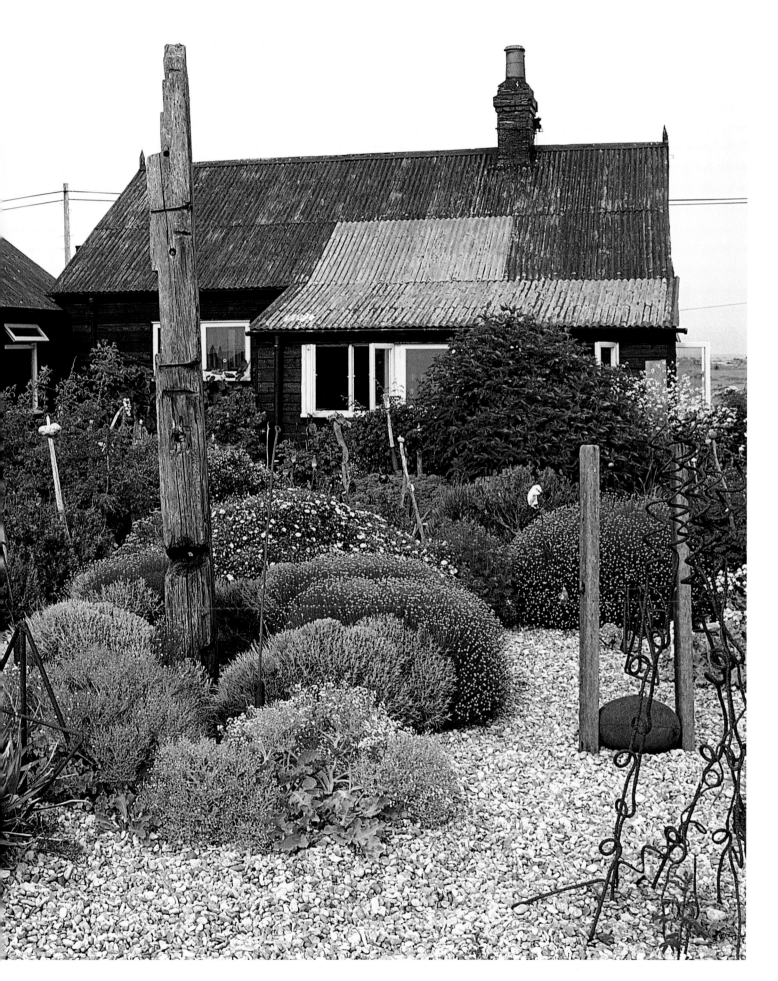

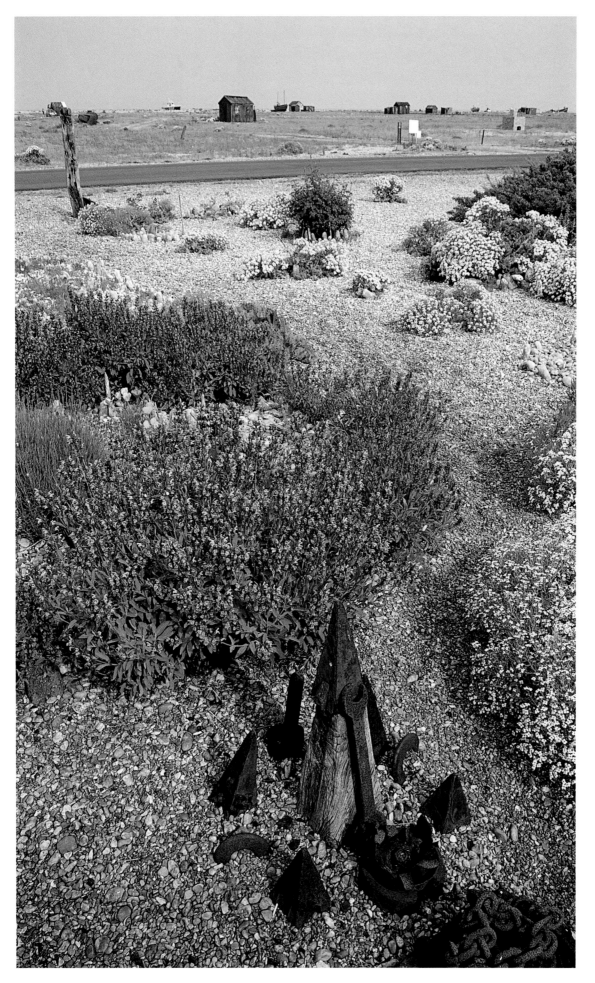

LEFT Random planting and strategic weeding create an impression of plants in their natural habitat. This shingle beach is home for some natives, such as the honey-scented, white-flowered sea kale, but these conditions are also perfect for herbs such as Mediterranean sage, *Salvia officinalis*.

ABOVE, FROM TOP Rings of pebbles and sticks placed around young plants have a twofold effect of protecting young plants from grazing and creating little decorative shrines; retrieved from the shore, a rusted metal girder circled by a heavy chain offsets a purple foxglove.

OPPOSITE Pebbles, stones and gravel of varying shapes and colours are used to define symmetrical zones of planting. In front of the cottage a stone circle contains Californian poppy, *Eschscholzia californica*, while behind this sages, lavender, sea kale and valerian thrive.

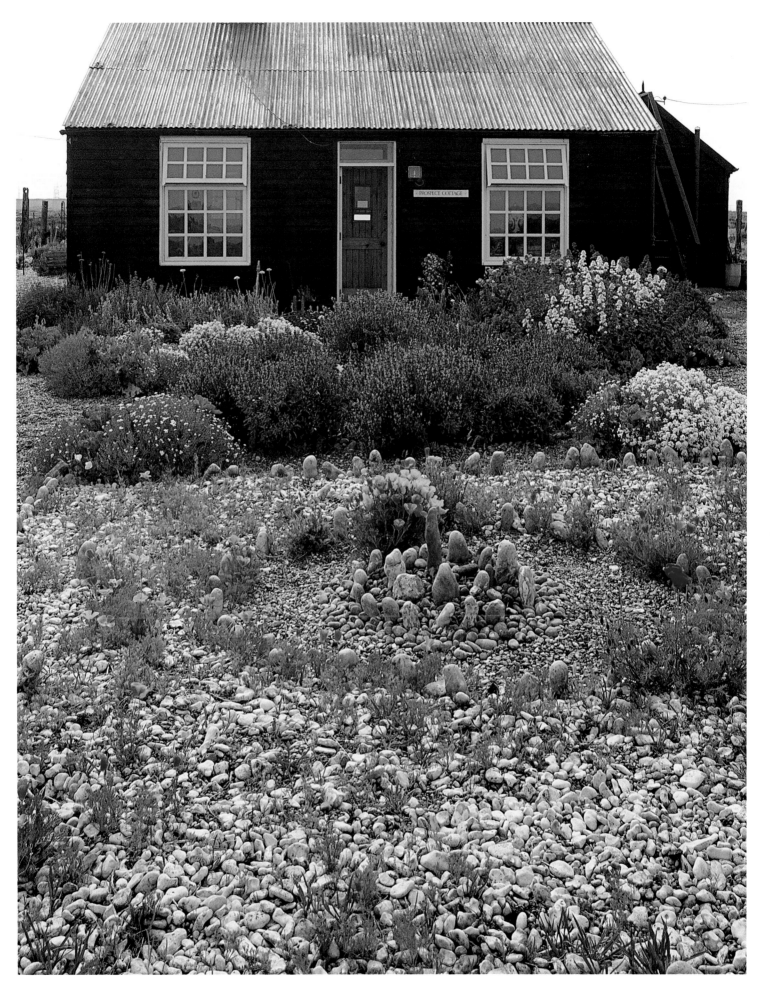

58

Wartnaby Gardens

Isabel King is passionate about old-fashioned roses, and the garden she has created at Wartnaby in Leicestershire brims with them in summer. Realizing that one of their shortcomings is a somewhat brief season of splendour, she has mingled her rose collection with a strong framework of evergreens and accompanied them with a wide array of low perennials. The garden is made up of several enclosures, each following a different theme: the parterre garden has mainly white-flowered plants, roses such as 'Madame Hardy', the pillar rose 'Madame Plantier' and the long-flowering *Viola cornuta* 'Alba'. A covered lime arch cut along strong horizontal lines provides shade for hellebores and hostas. On the terrace outside the house many of Lady King's favourite pale-pink roses congregate with silver-leaved hebes, rock roses and flowering cranesbills.

RIGHT, TOP At the end of a lime avenue, an urn on a pedestal draws the eye to the unspoilt Leicestershire countryside.

RIGHT, BOTTOM For year-round effect the knot garden near the house has box hedging and topiary interplanted with the flesh-pink repeat-flowering moss rose 'Mousseline'. Climbing over the wall near the gate is *Rosa* 'Iceberg', with 'Madame Plantier' on top of the wall in the corner.

OPPOSITE, TOP Borders flanking the steps that lead from the terrace to the lawn are filled with roses, including 'Raubritter' against the window, palest pink 'Fantin-Latour' and darker pink 'Constance Spry'.

OPPOSITE, BOTTOM A vista cutting through the garden is lined with the vigorous and floriferous modern shrub rose 'Bonica', underplanted with a sweep of *Nepeta racemosa* 'Walker's Low'.

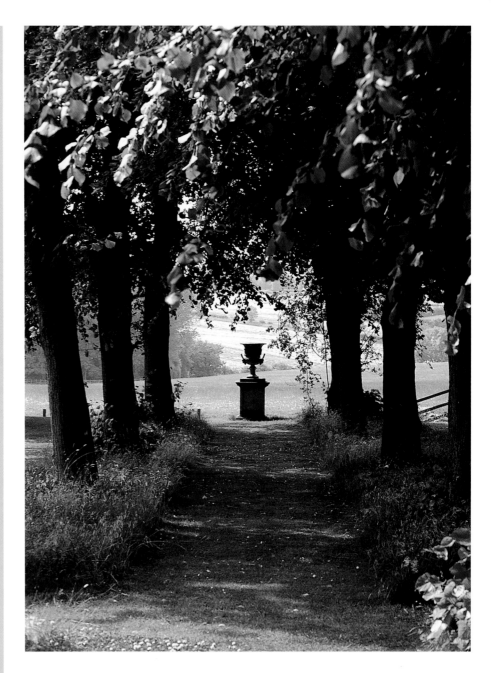

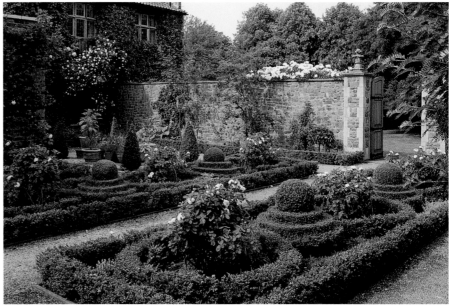

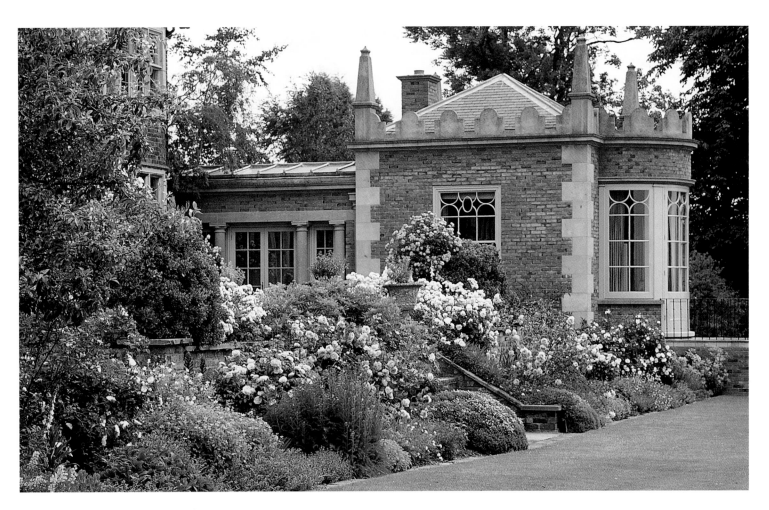

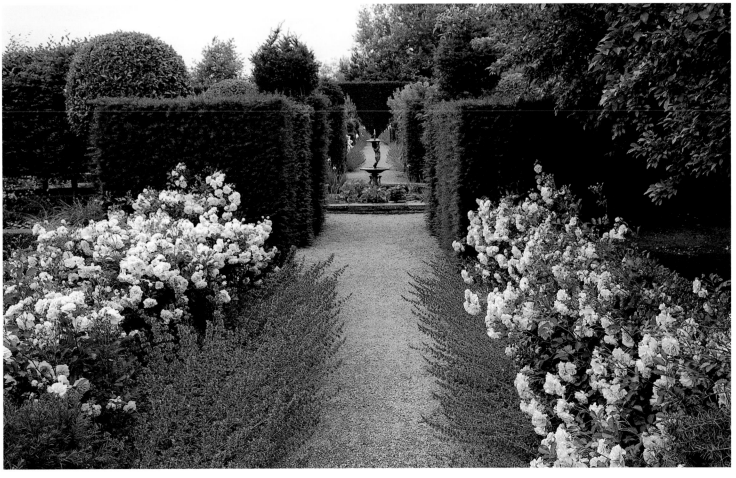

59

Broughton Grange

This Oxfordshire garden designed by Tom Stuart-Smith is a walled garden with a twist. Although it is in part dedicated to fruit and vegetables, it is predominantly a highly decorative pleasure garden. Nor is it entirely walled: there are views over rolling countryside on two sides yet the space retains an impression of enclosure. This is largely to do with Stuart-Smith's planting skills. The division of space, the beautiful stone-and-brick wall, the stepped terracing and maze of paths are all cleverly orchestrated, but the bold and masterly planting takes your breath away. An asymmetrical matrix of fastigiate yews, topiary beech and box hedging provides a backbone around which perennials change in waves through the seasons. With such a large area dedicated to perennials, there are highlights for each month of the year, and each season has a salient colour and texture: waves of blue and yellow in early summer and tawny red, brown and coral in autumn.

An overview of the planting in summer shows how certain prominent plants weave through the composition in the top terrace border with its spires of clipped Irish yew. These include *Phlomis russeliana*, the hooded, pale-yellow flowers of which are borne from late spring to early autumn; the silver-leaved carpeting *Stachys byzantina* 'Big Ears'; the indigo *Salvia* × *sylvestris* 'Blauhügel'; the russet-flowering grass *Anemanthele lessoniana*; and domes of the spurge *Euphorbia seguieriana* subsp. *niciciana*.

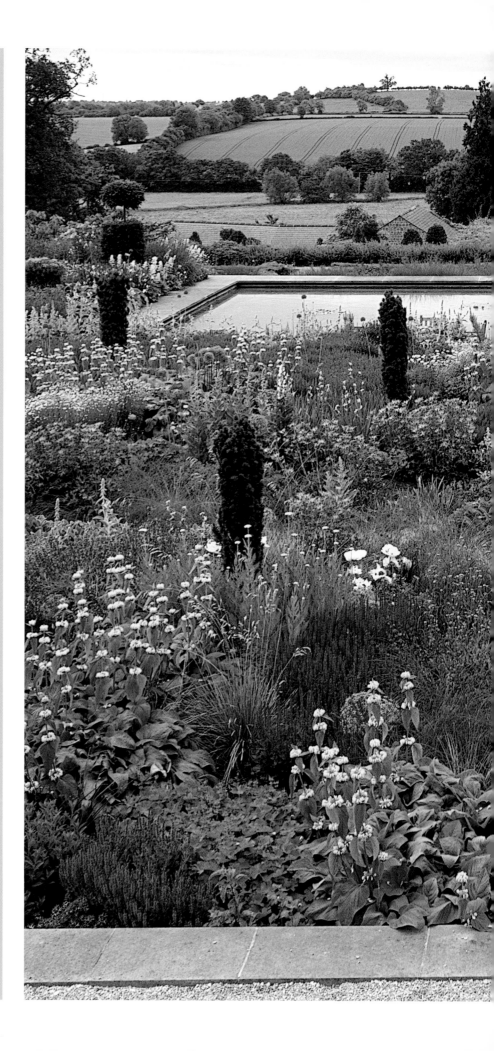

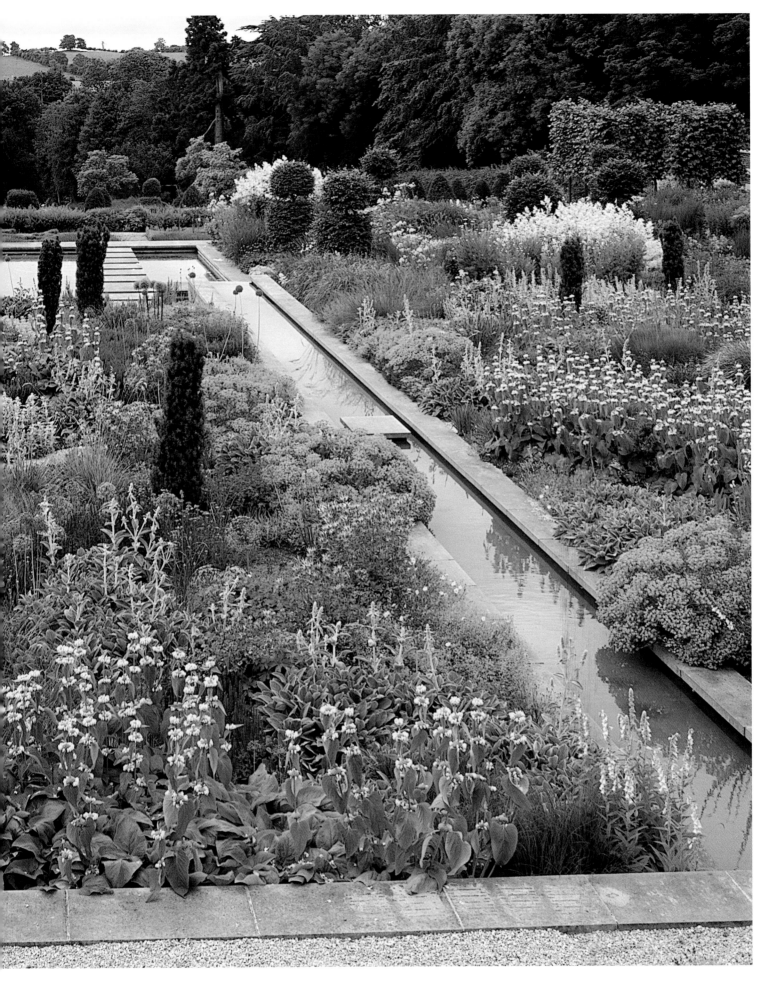

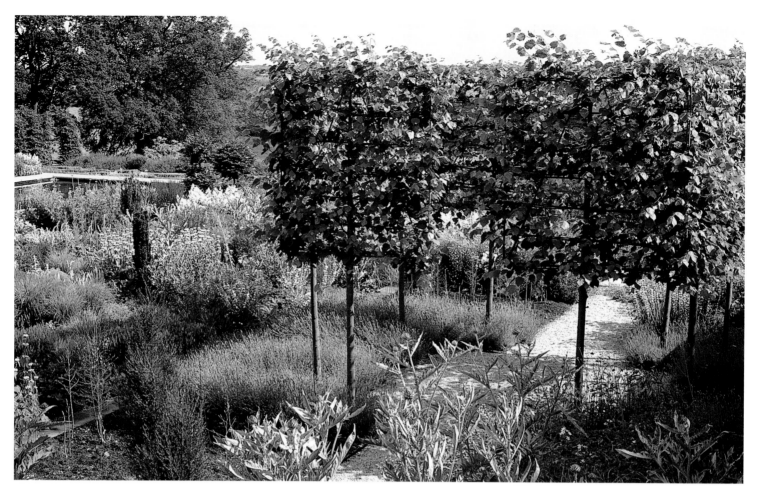

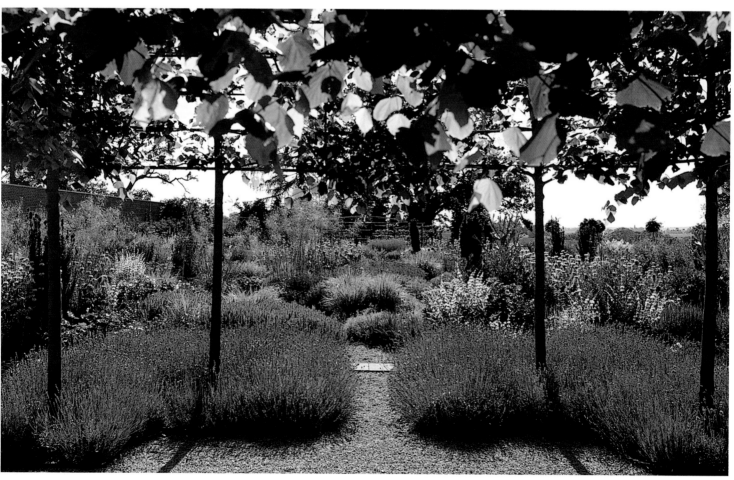

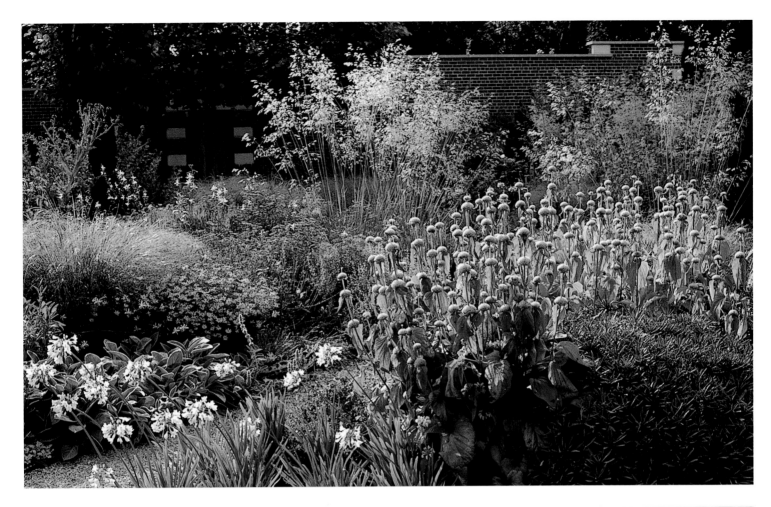

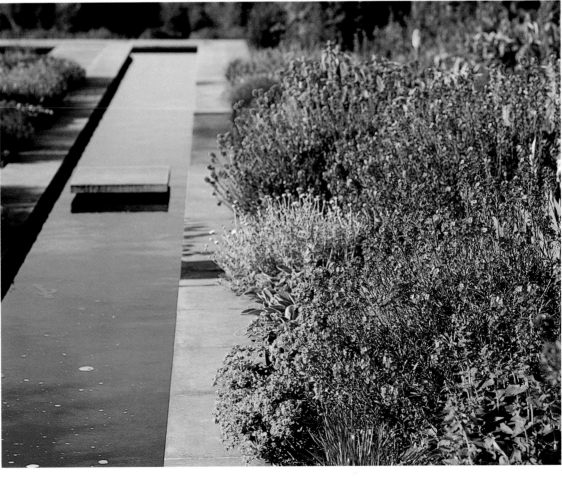

OPPOSITE A cube of pleached limes stands at each entrance to the garden via the brick-and-stone wall, while a row of giant cardoons frames an asparagus bed (top). Each cube is underplanted with *Lavandula angustifolia* 'Munstead' and behind are *Salvia nemorosa*, *S. argentea* and *Stipa gigantea* (bottom).

TOP A late-summer mix of giant oats, *Stipa gigantea*, *Phlomis russeliana*, white agapanthus and *Anemanthele lessoniana*.

ABOVE *Aconitum* 'Stainless Steel' blends softly with *Persicaria polymorpha*.

RIGHT *Erysimum* 'Bowles's Mauve' and *Euphorbia seguieriana* edge the rill with its cleverly placed stepping stone on the middle terrace.

Suffolk

Arabella Lennox-Boyd has designed a series of elegant enclosed gardens around this moated Jacobean house to contrast with the more expansive atmosphere of the orchard and park beyond the moat. Near the house there is an emphasis on formality and winter structure. For example, the herb garden outside the kitchen has four triangular outer beds with box cones that converge on a central square of nine herb-filled box compartments. Throughout the garden roses have been planted in abundance: an octagonal yew enclosure is devoted to heavily scented old-fashioned varieties, and elsewhere roses are trained over archways, the bridges that span the moat, and a steep-roofed boathouse. Built with the spoil from the construction of a swimming pool, a turf maze provides a focal point in the park and is a great vantage point from which to look out over the well-proportioned arrangement of paths that cut through the long meadow grass.

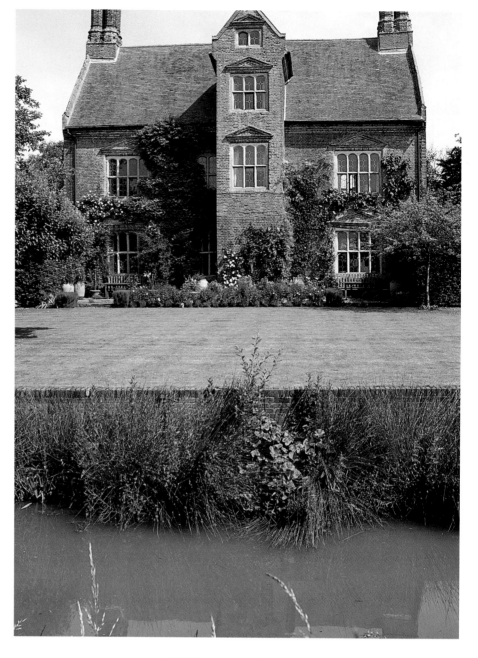

RIGHT, TOP The Jacobean brick Hall is separated from the moat by a planted terrace and a simple expanse of lawn.

RIGHT, BOTTOM Paths radiate from the top of a mound sited in a park of young trees that includes a walk of alternate ash and beech. Some mature trees were brought in to give height, but most were planted as whips.

OPPOSITE, TOP The uprights of the bridge that crosses the moat are festooned with rambling roses.

OPPOSITE, BOTTOM The box pattern at the centre of the herb garden provides structure in winter and individual compartments for annual and perennial herbs. A row of hybrid musk roses in the background includes white 'Prosperity' and pink 'Felicia'.

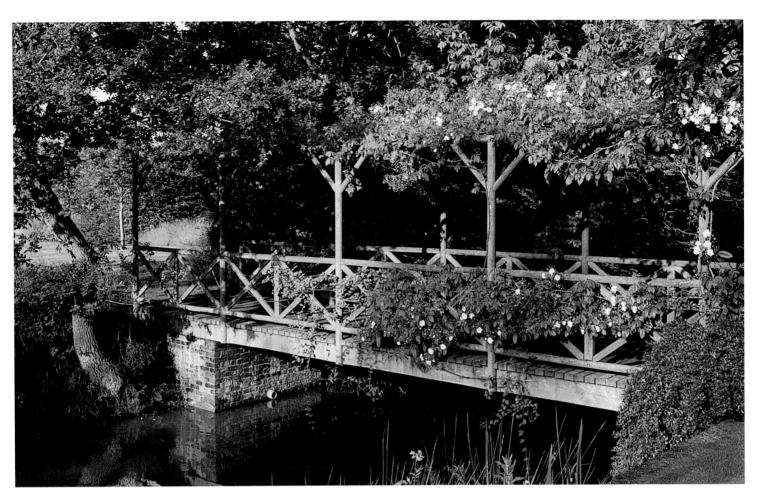

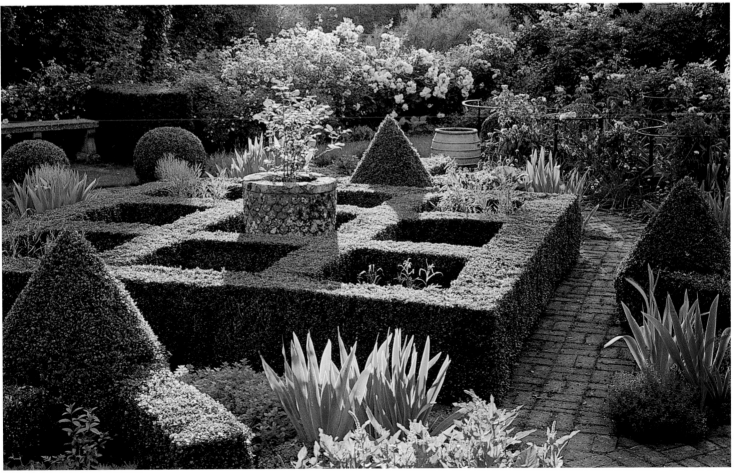

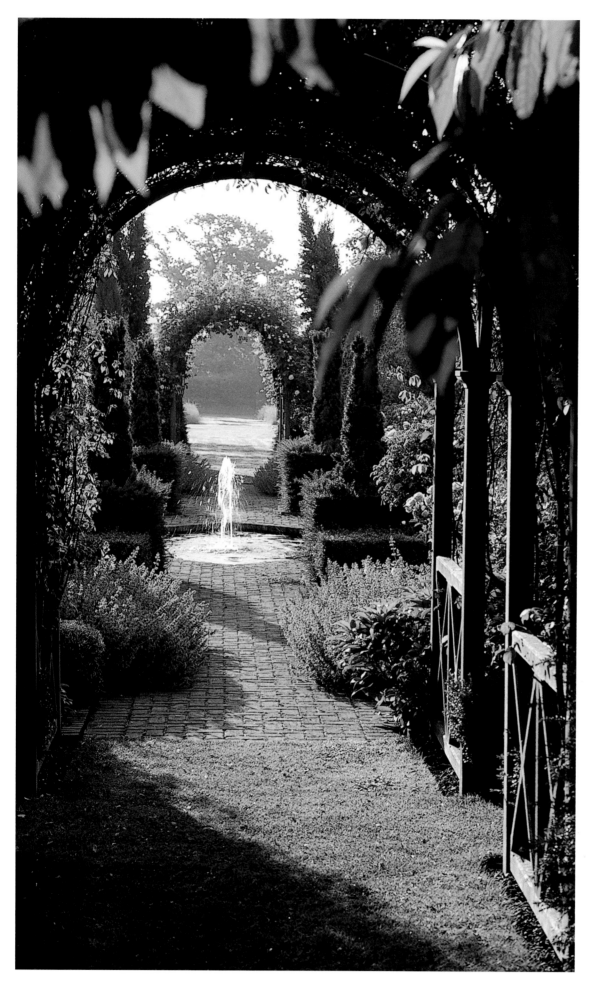

LEFT The fountain at the centre of the octagonal rose garden is seen here through one of the four rose-covered arches that provide openings in the surrounding yew hedge. Internal yew platforms with tall spires rising from them are a permanent feature when the roses and lavender are over.

ABOVE, FROM TOP A naturalized bee orchid in the meadow; the deep-red moss rose 'Nuits de Young'.

OPPOSITE, TOP LEFT A deep-pink old-fashioned rose glows in evening sunlight.

OPPOSITE, TOP RIGHT *Rosa* 'Climbing Cécile Brünner' adorns the arch, above dark-pink *R.* 'Duc de Guiche' and pale-pink *R. gallica* 'Duchesse de Montebello'.

OPPOSITE, BOTTOM A circle of copper-beech trees surrounds the mound that rises like a closely mown sculpture from the long grass, speckled with ox-eye daisies, in the meadow.

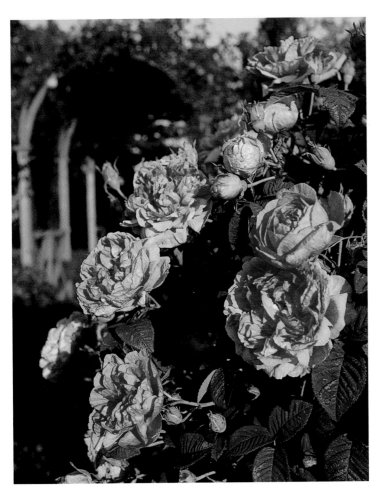

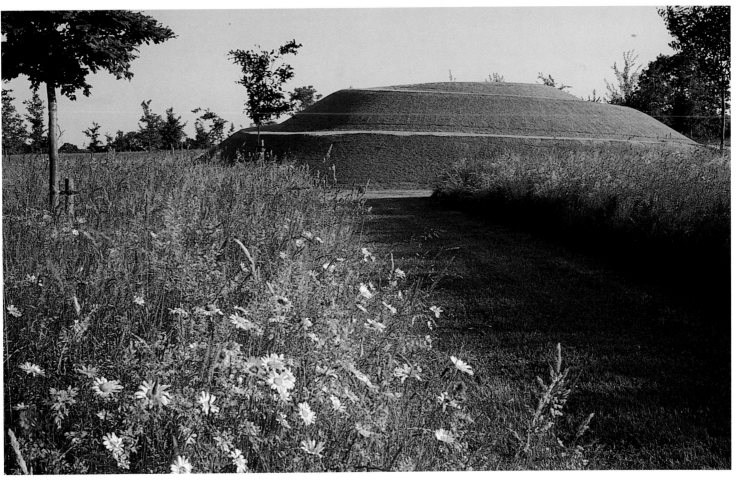

...ic Garden

...bourne artist Margaret Knox, who had ...und in landscape design, loathed mosaic ..., but an idle project involving her children, ... pile of broken tiles and some gloopy concrete mix changed her prejudice into passion. Her reservations were mainly to do with the siting of mosaic works and their incompatibility with their surroundings, so to create a sense of unity she covered the garden's brick walls as well. Fountains, boulders, urns and amorphous forms presented like a blank canvas by her son, who works in special effects, became covered with the shattered spoils of tiles that were destined to be builder's rubble. Knox developed a preference for the richer colours of old tiles with lead glazes and tracked down her materials through demolition companies. Bold foliage plants, such as yuccas, aloes and cacti, were planted to complement the mosaic's pronounced textural effect in this exotic and eccentric garden.

RIGHT, TOP Wavy bands of mosaic tiles in complementary colours, punctuated with circular discs of different colours, cover the walls that abut a gravelled area of the garden. *Agave attenuata* grows out of the gravel behind 'rocks' that Knox made from concrete reinforced with coat hangers and then decorated with mosaic.

RIGHT, BOTTOM In the foreground is the starfish-like rim of a giant pot that houses a swan's-neck agave, *A. attenuata*. Knox's son made the pot for the plant and she then decorated it with tiles.

OPPOSITE, TOP Seen from this angle, the lip of the pot seems to be opening like an unfolding flower.

OPPOSITE, BOTTOM, LEFT TO RIGHT Tulip and carnation Iznik-style tiles were broken up to make the centre of this mosaic circle, which is surrounded by a Victorian design in creams and browns; a bird fountain spouts water from its beak; this mosaic sofa inspired Knox to use the medium in garden design.

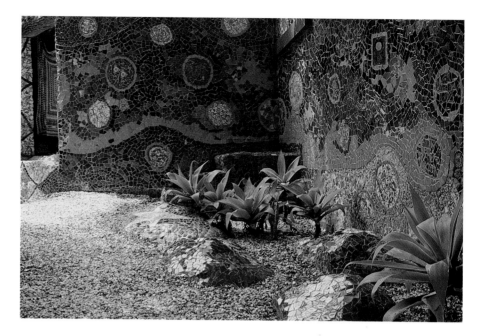

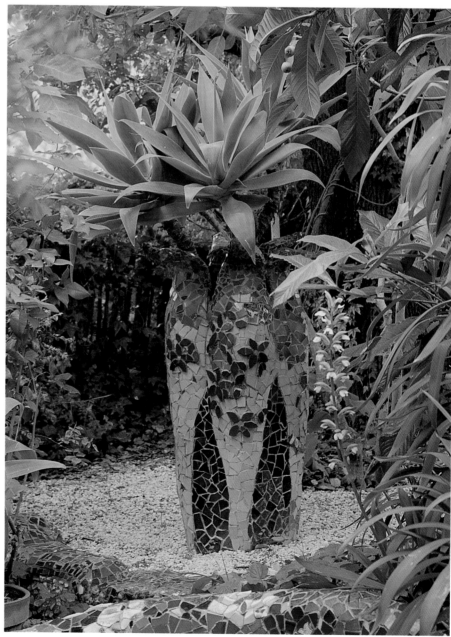

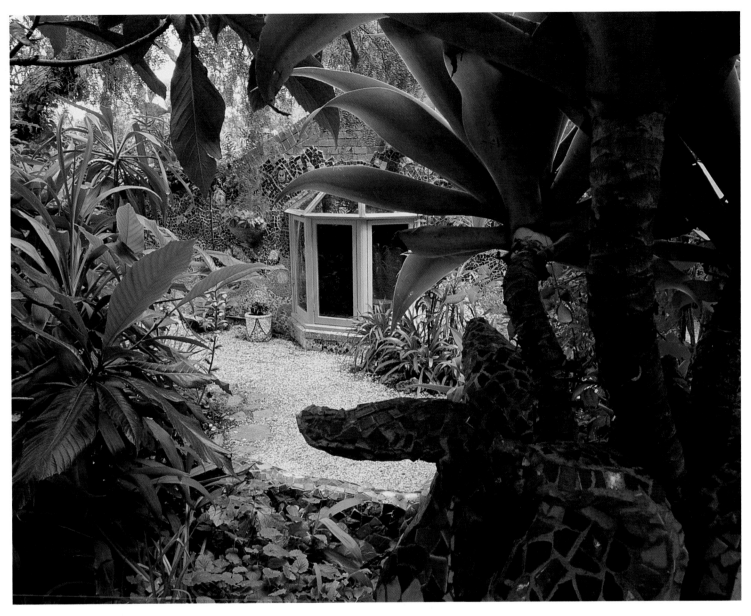

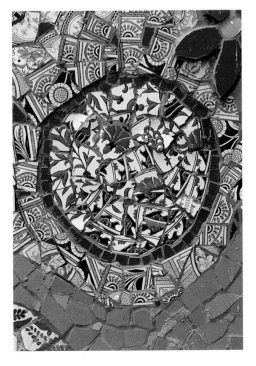

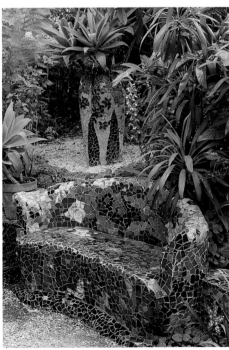

Sticky Wicket

The Dorset garden of Pam and the late Peter
Lewis, Sticky Wicket, is one that regularly changes
its appearance but never ceases to inspire. Pam
Lewis is an environmentalist and artist whose
melding of native plants in a bold and painterly
way is expressly designed to create a haven for
wildlife. In the Round Garden concentric circles
of planting that start tight and low in the centre
become looser and more random the closer they
are to the edges. For each season the planting has
a predominant wash of colour, and key ingredients
in various shades of mauve, pink and purple are
repeated around the circles. Early-summer carpets
of thyme studded by the rusty fuzz of hair grass
and *Hordeum jubatum* is a partnership inspired by
nature but given centre stage in the garden. In her
wild-flower meadows she has used native plants
to benefit wildlife, proving that there is no need to
compromise artistic vision to achieve this goal.

The Round Garden, designed as a nectar
garden for insects, has concentric
circular beds radiating from the centre
that are broken by gravel paths. In the
central circle a static carpet of mauve-
flowered thyme is contrasted by feathery
grasses that sway with every puff of
wind. A reddish haze of hair grass, *Aira
elegantissima*, is accompanied by the
broad, nodding panicles of squirrel-tail
grass, *Hordeum jubatum*. The two
grasses are planted randomly to mimic
the tapestry-like way that plants grow
in wild communities; their seeds
provide valuable food for birds and
small mammals.

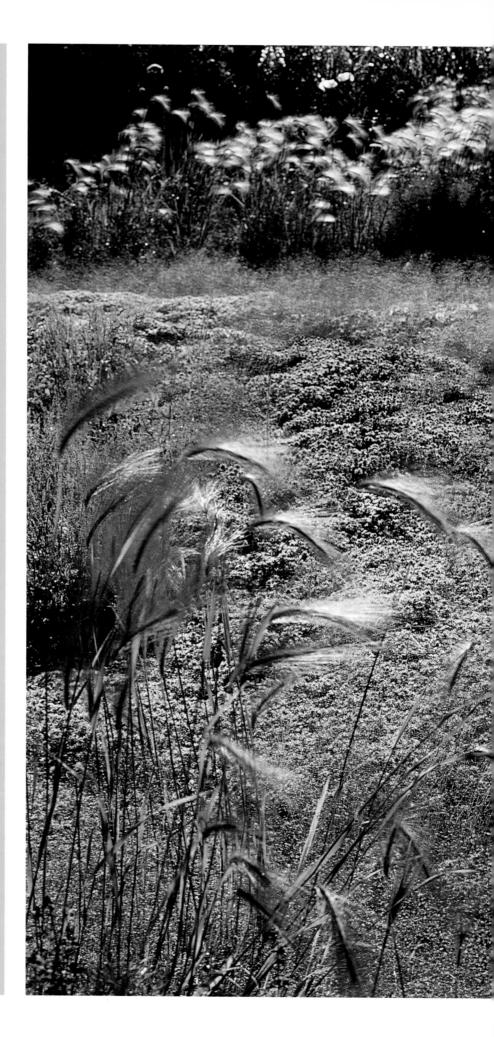

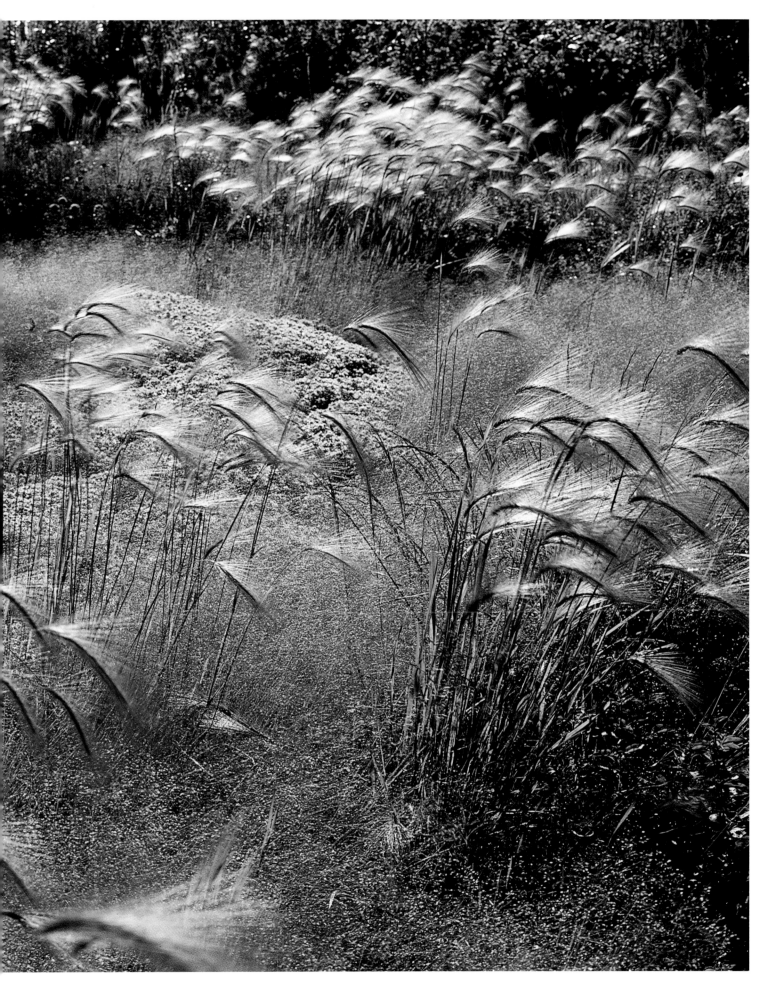

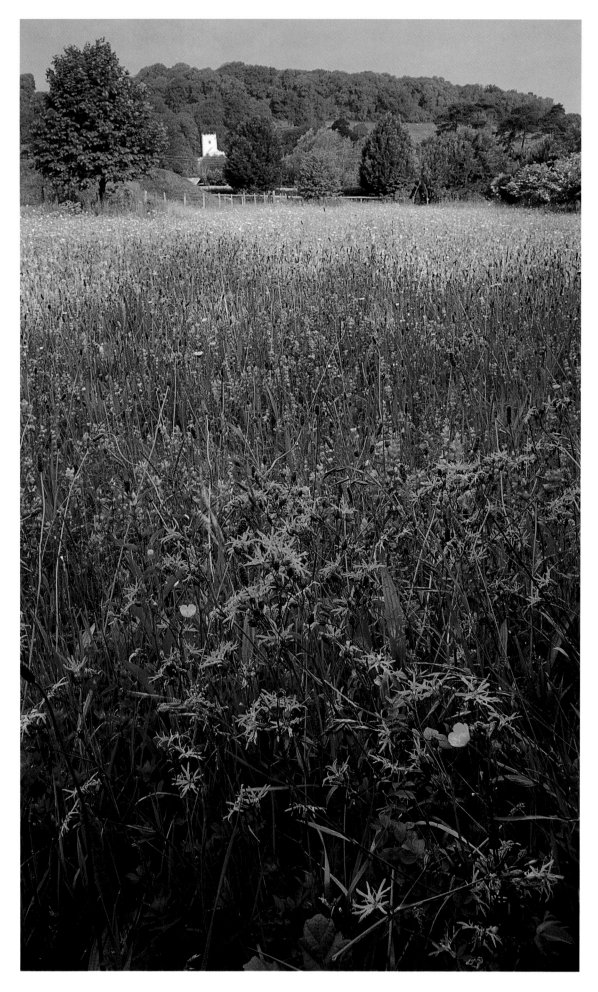

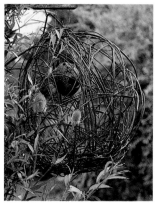

LEFT Changing conditions can alter the balance of flowering in the meadow from year to year. Here ragged robin, *Lychnis flos-cuculi*, and yellow rattle, *Rhinanthus*, predominate.

ABOVE, FROM TOP *Catananche caerulea* and *Thalictrum delavayi*; *Cosmos atrosanguineus* and *Angelica sylvestris* 'Purpurea'; a woven-willow bird feeder.

OPPOSITE An early-morning scene in the Round Garden (top) shows how the light contrasts with the light in the evening (pp. 224–25) and at midday (bottom), when the grasses take on tawny tones and the mauves and pinks of flowering leeks, *Phlox paniculata* 'Franz Schubert' and *Achillea* come to the fore.

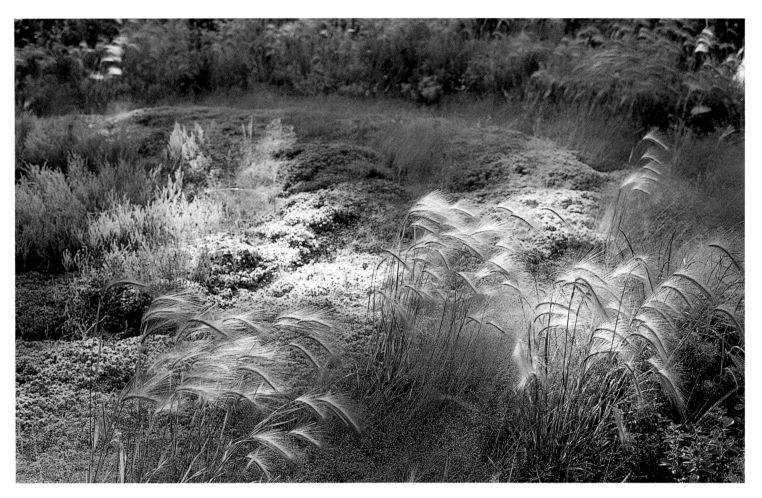

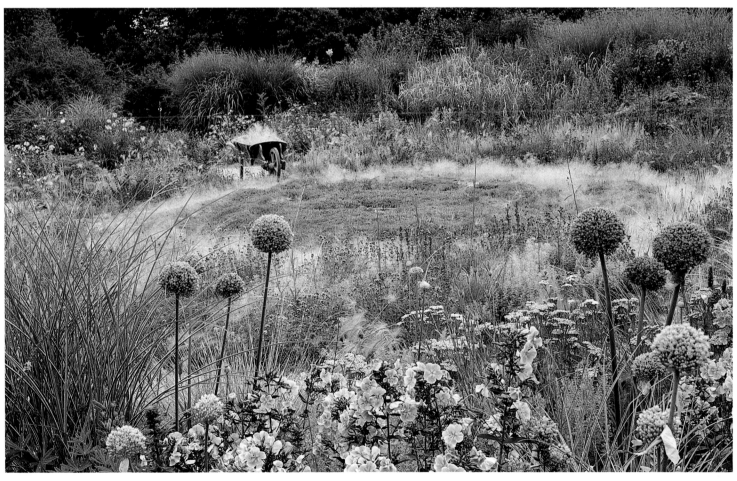

63

The Dillon Garden

The Dublin garden of Helen Dillon is an exquisite example of plantsmanship joining hands with clever design. At 45 Sandford Road, Ranelagh, within less than 0.4 hectare (1 acre), the horticultural journalist and broadcaster has created a series of gardens ranging from the intimate and enclosed to the flamboyantly theatrical. At the heart of the garden, bisecting it cleanly, is a sleek, reflective canal set within polished limestone paving. The tranquil horizontal plane created by this space contrasts starkly with the flanking borders, which brim with texture and colour throughout the year. A riot of fiery reds on one side of the canal faces a concoction of cool blues opposite. Dillon likens her garden to an ever-evolving stage set where the main players are under constant threat of removal if they are not performing at their best. Permanent structure is provided by an assortment of geometric box shapes, arbours, tunnels and statuary.

The canal, set in limestone and flanked by polished limestone paving, bisects the red-and-blue-themed borders. A yellow-leaved honey locust tree, *Gleditsia triacanthos* 'Sunburst', contrasts with the plum, scarlet and vermilion assemblage of *Heuchera* 'Palace Purple', *Potentilla* 'Gibson's Scarlet', *Geum* 'Mrs Bradshaw', *Rosa glauca*, *R.* 'Frensham' and *Cytisus* 'Killiney Red'.

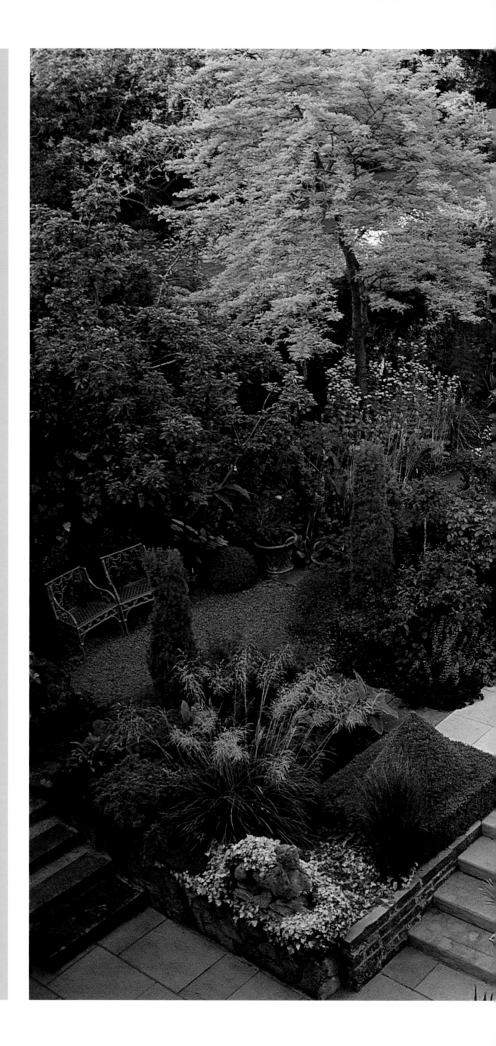

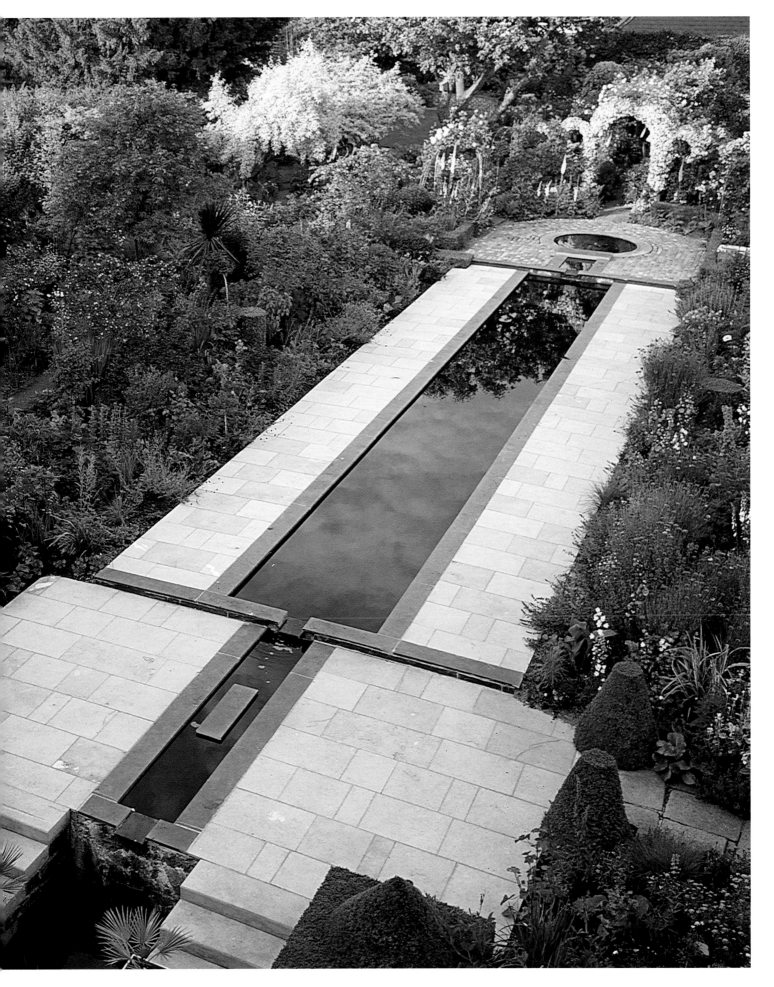

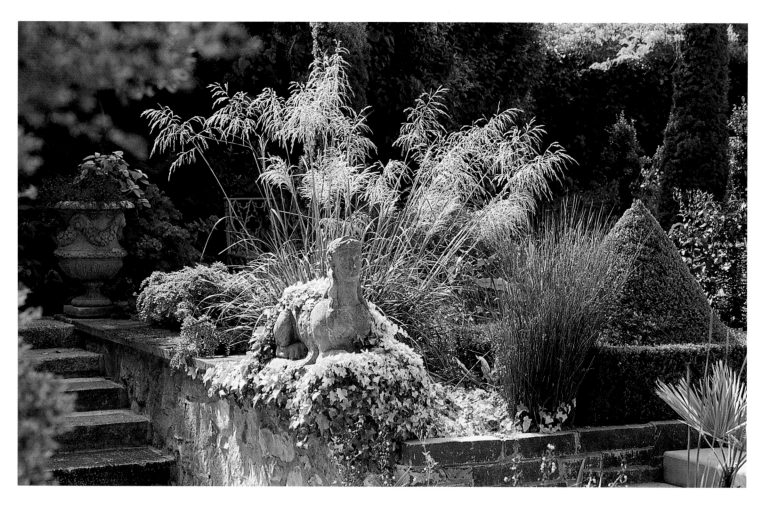

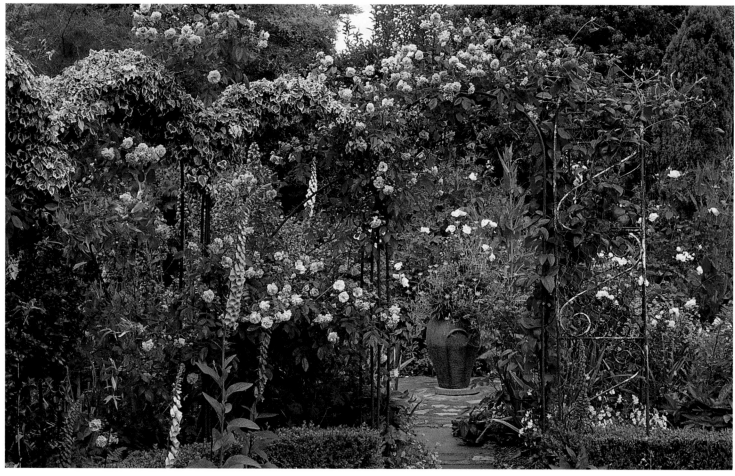

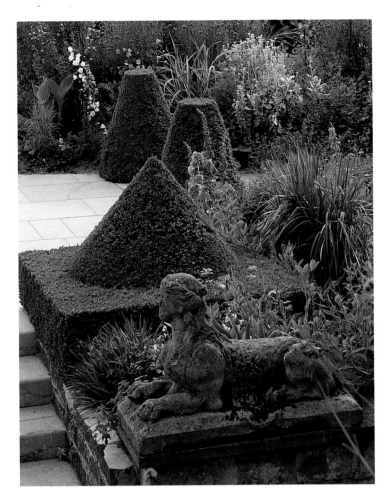

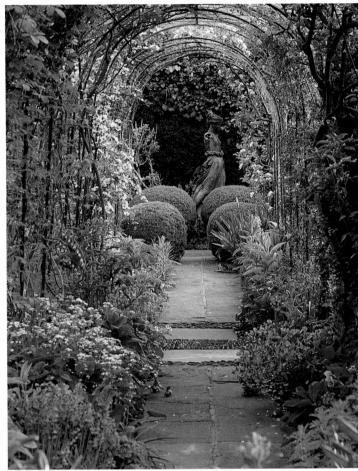

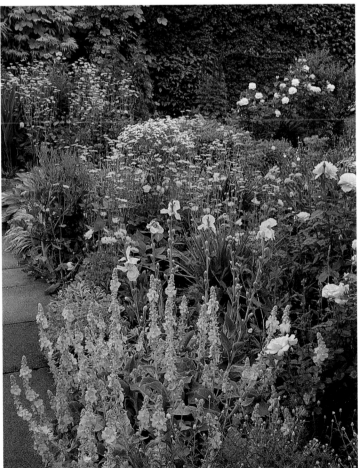

OPPOSITE, TOP At the house end of the canal, *Hedera helix* 'Buttercup' laps one of a pair of stone sphinxes that flank the steps leading up to the terrace.

OPPOSITE, BOTTOM The rose arbour that frames the end of the canal is covered in *Rosa* 'Cornelia' and cream variegated ivy. At its base grow foxgloves, delphiniums and the dark-pink *Gladiolus communis* subsp. *byzantinus*.

TOP LEFT A sphinx sits beside neatly clipped topiary that evokes a pyramid.

TOP RIGHT A statue of a fleeing nymph is placed at the end of a rose tunnel underplanted with bluebells and white *Brunnera macrophylla* 'Betty Bowring'.

BOTTOM LEFT A bright summer border is packed with *Papaver spicatum*, *Doronicum pardalianches* and the apricot poppy *Papaver pilosum* subsp. *spicatum*, with deep-orange Welsh poppies in the background. *Verbascum* 'Frosted Gold' spills over on to the path.

BOTTOM RIGHT, FROM TOP *Clematis fusca*; *Rosa* 'Souvenir du Docteur Jamain'.

summer into autumn

64

London

Despite appearing every inch a country garden, this expansive, flower-filled haven is in the heart of Notting Hill. The owner of the 0.8-hectare (2-acre) site wanted a picturesque setting for the historic house, which was built on the site of a spring that still gurgles up through ancient well heads in the cellar. As well as the deep borders in blue, pink and silver, gravel walks and mature trees, the garden is remarkable for its wild-flower meadow. As this garden is believed to be one of the few remnants of unimproved grassland in central London, its preservation and enhancement were key objectives for Todd Longstaffe-Gowan and Tom Stuart-Smith when they recently refurbished it. In addition to the existing bent grasses, yarrow and self-heal, the meadow is now also filled with ox-eye daisies, meadow buttercups and the bright-yellow pea flowers of bird's-foot trefoil, *Lotus corniculatus*.

RIGHT In a border in front of the restored Victorian greenhouse *Salvia* × *superba* grows with *Rosa* × *odorata* 'Mutabilis'. Behind these stand the towering stems of the silver thistle, *Onopordum acanthium*.

OPPOSITE, TOP The planting in this border abutting the meadow has been kept soft and naturalistic so that the two gently merge. To achieve this, *Gaura lindheimeri* was planted with *Calamagrostis brachytricha*, meadow cranesbill and *Anthemis tinctoria* 'Sauce Hollandaise', which echoes the ox-eye daisy.

OPPOSITE, BOTTOM Early-morning sun lights up the silhouettes of *Onopordum acanthium* and the buds of *Verbena bonariensis* in front of *Geranium* 'Brookside', peach-coloured *Alstroemeria ligtu* hybrids and *Geranium clarkei* 'Kashmir White'.

65

Tapeley Park

Tapeley Park's sheltered, south-facing aspect and proximity to the Devon coast allow a wide range of plants to flourish in an exotic garden, originally designed by Sir John Belcher, that covers more than 8 hectares (20 acres). The main garden descends from the house in a series of three ornamental Italianate terraces that have borders commissioned by the owner, Hector Christie, from Mary Keen and Carol Klein. The cool yellows and pale blues and whites of Keen''s 'moonlight' border contrast with the inky blues, purples and reds Klein used in hers to create an illusion of depth. This modern planting augments a nineteenth-century layout of steps, walls and lawns punctuated by magnificent trees and topiary. Fuchsia hedges stretch the length of the terraces' retaining walls, while the air of exoticism is even more apparent around the palm trees, where echiums and *Geranium palmatum* rampantly self-seed.

RIGHT, TOP Tapeley Park is idyllically situated among terraced gardens overlooking the tidal River Torridge where it meets the sea at Bideford.

RIGHT, BOTTOM A beech hedge and spinning tops of clipped yew mark the southern perimeter of the lower terrace.

OPPOSITE Tall pines veiled by a sea mist add a sense of magnificent scale to this garden scene of a tall retaining wall backed by palm trees and topped with Russian sage, *Perovskia atriplicifolia*. The narrow border in front of the wall has a large crimson bottlebrush, *Callistemon citrinus* 'Splendens', the tall *Nepeta subsessilis*, *Allium sphaerocephalum* and *Verbena bonariensis*.

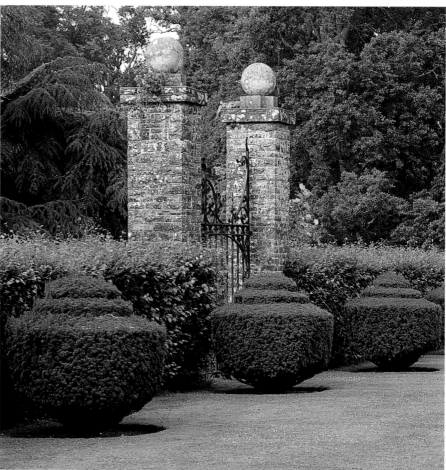

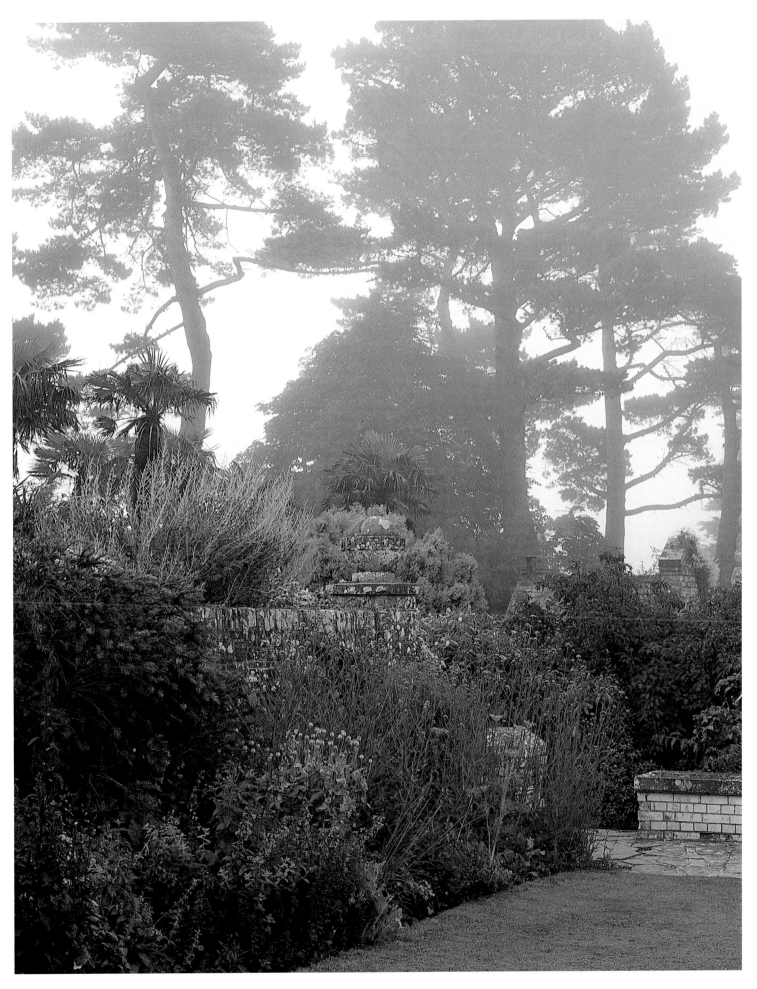

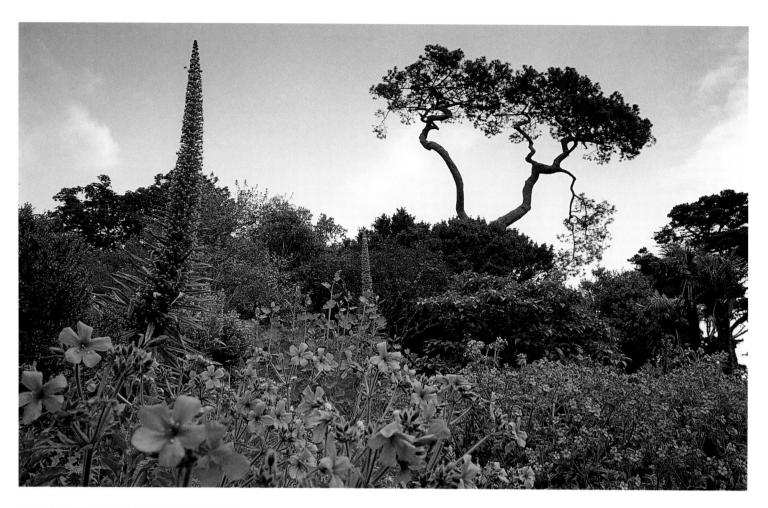

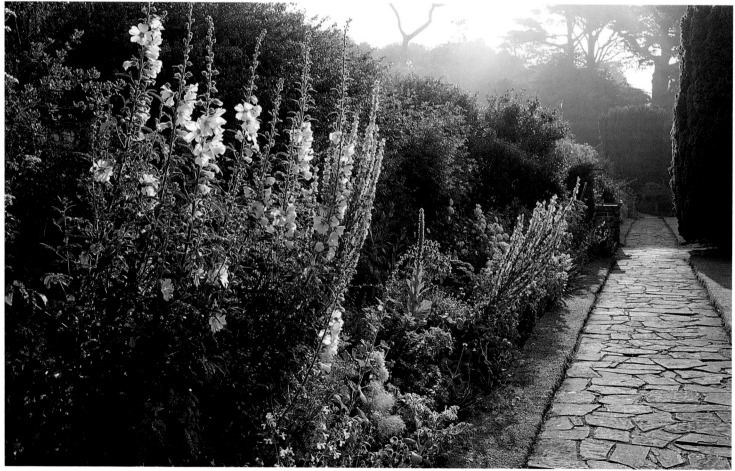

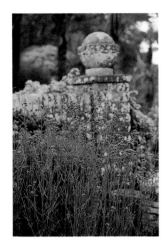

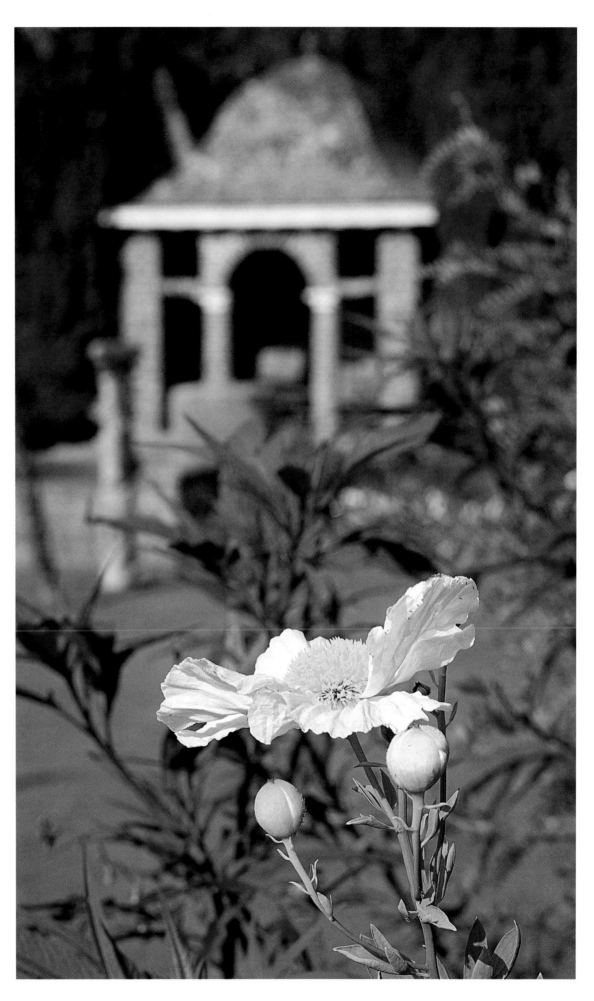

OPPOSITE, TOP Among a carpet of *Geranium palmatum* in the foreground stands a spike of *Echium pininana*, while a forked pine stands out against the sky.

OPPOSITE, BOTTOM Beneath a hedge of crimson fuchsia, the middle terrace border, designed by Mary Keen and Kirsty Macdonald, is a 'moonlight' composition of pale yellows and cool blues. *Alcea rugosa*, a primrose-yellow hollyhock, and *Verbascum bombyciferum* accompany sea holly and borage.

ABOVE, FROM TOP *Verbena bonariensis*; *Rehmannia elata* with *Geranium* 'Ann Folkard' and *Eryngium × tripartitum*.

RIGHT Behind a tree poppy, *Romneya coulteri* 'White Cloud', with its papery bloom and tumescent buds, stands an elegant summer house.

Elizabeth Street, London

In this imaginative design for an outdoor living area James Aldridge has turned an unprepossessing flat roof space into an easily maintained extra room. Because it is situated over the building there is no soil for planting, but this problem has been overcome by using judiciously chosen pots and plants that chime with the overall colour scheme of creamy white and grey. The canopies of six white-stemmed birches, *Betula utilis* var. *jacquemontii*, in cuboid planters help to disguise the strong vertical thrust of the stark London-brick walls, which are further softened by plastered and painted wood panels. The tarmac roof covering is concealed by timber decking of a colour to match the weathered-oak table. Spiky, silver-leaved astelias placed in tall, cylindrical pots with a top dressing of white gravel and tightly clipped pots of lavender need feeding and watering just once a week. The dank basement void has been brought to life by a tree fern and a cycad.

RIGHT A bridge of metal and timber over a light well that helps to illuminate the basement takes you from this house to its roof garden. Two Philippe Starck 'Bubble Club' chairs and a polished zinc cube form a sitting area. The iroko boards used for the floor were allowed to weather naturally.

OPPOSITE, TOP A view through the stems of *Lavandula* × *intermedia* 'Grosso' shows a series of taupe-coloured clay pots that line a second, lower level of the roof terrace. Multi-stemmed *Betula utilis* var. *jacquemontii* in grey terrazzo containers provides shelter and privacy in summer and unites the two levels.

OPPOSITE, BOTTOM LEFT A mulch of black pebbles is an effective way to retain moisture and makes a smart finishing touch. At night discreet low-voltage lighting illuminates the roof garden.

OPPOSITE, BOTTOM RIGHT The teak table and Jasper Morrison 'Air' chairs make a dining area at the far end of the terrace. The wall plaques were made by Boldstone Sculpture and the white terrazzo pots are planted with *Astelia banksii*.

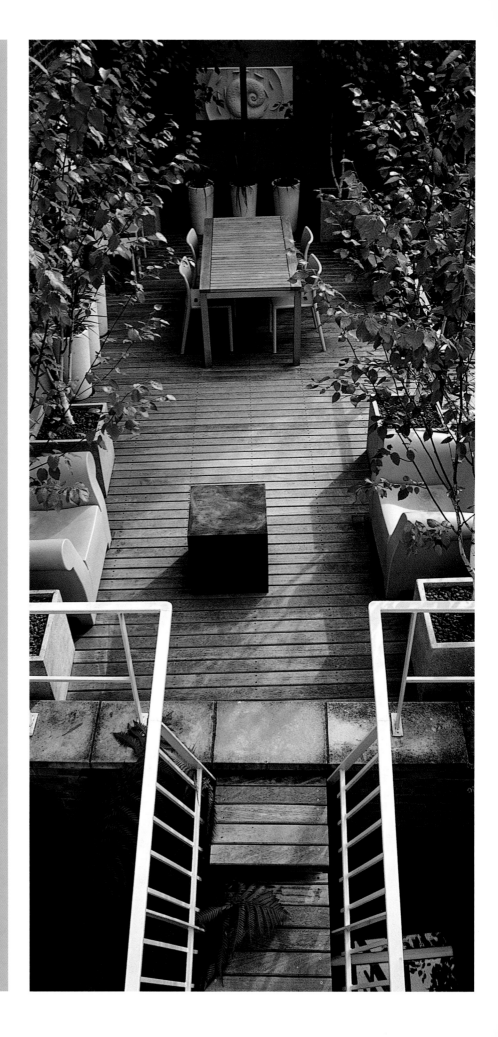

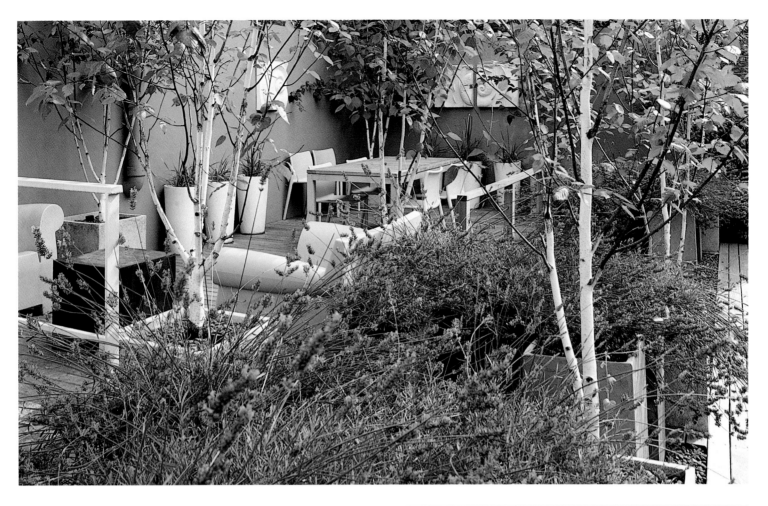

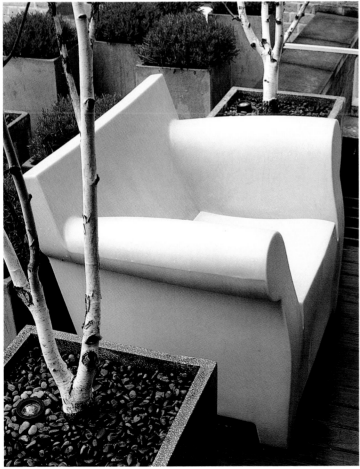

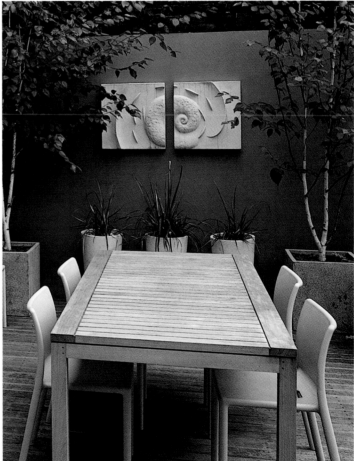

67

The Garden House

On the southern edge of Dartmoor in Devon is a garden blessed with a sublime situation. Views to the medieval church of Buckland Monachorum and the distant Cornish hills are framed across folding meadows by ancient copses, while within the sheltered walled garden are the ruins of an ecclesiastical settlement with a crumbling stone gatehouse and thatched barn. Superimposed on this setting is a series of gardens of great distinction. The 0.8-hectare (2-acre) walled garden was developed over many years by the late Lionel and Katherine Fortescue and filled with a notable collection of plants. After the Fortescues died Keith and Ros Wiley embarked on an ambitious plan at The Garden House, expanding the garden's boundaries and concocting exquisite naturalistic plantings inspired by their observation of plant communities in the wild. The resulting Cretan cottage garden is a pan-European wild-flower meadow that melds seamlessly with the surrounding landscape.

A slate wall, topped with succulent sedums and sempervivums and with a line of catmint in front of it, marks the boundary of the Cottage Garden. Beyond the wall there is an exuberant medley of magenta *Lychnis coronaria*, white feverfew, *Tanacetum parthenium*, wild carrot, *Daucus carota*, *Verbena bonariensis* and *Verbascum* 'Cotswold Beauty'. The village of Buckland Monachorum is glimpsed in the middle distance, with the Cornish hills beyond.

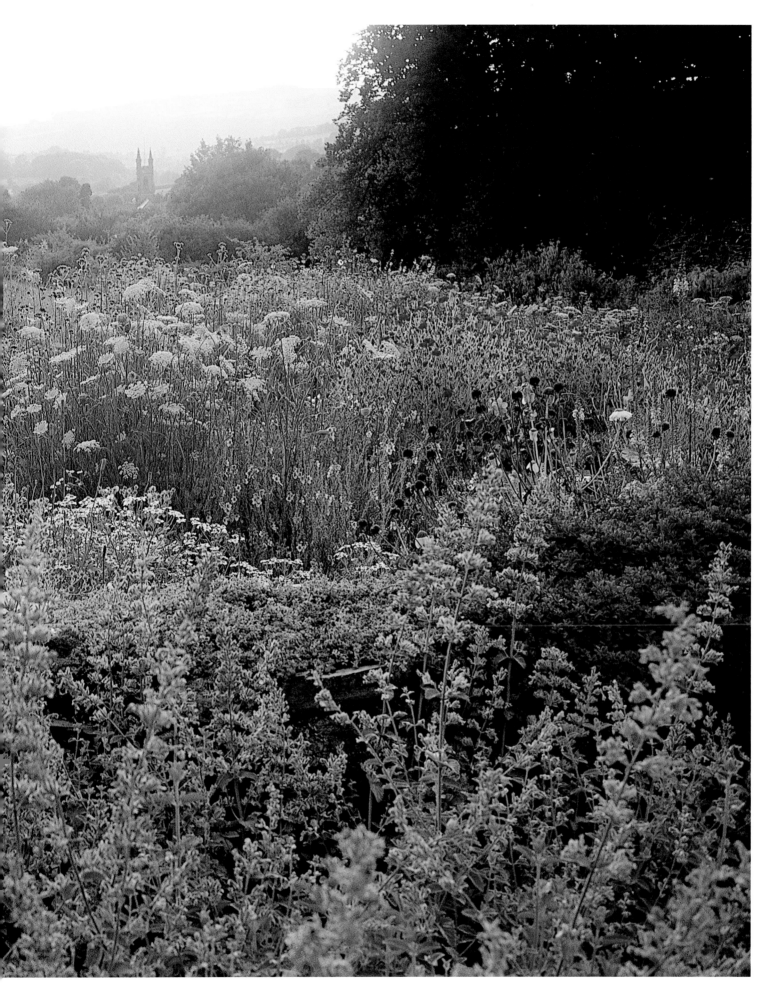

OPPOSITE A young paper-bark maple, *Acer griseum*, with its bark peeling, stands among *Rodgersia aesculifolia*, *Crocosmia* 'Lucifer' and pale *Campanula lactiflora* 'White Pouffe'.

TOP The drooping, waxy, white, scented bells of *Styrax japonica* 'Pendula' mingle with *Kalmia latifolia* and vivid-orange *Papaver orientale* behind an impressive colony of *Dactylorhiza foliosa*.

ABOVE *Astrantia* 'Buckland'.

RIGHT The red-hot poker *Kniphofia* 'Wrexham Buttercup', which goes from green buds to citrus-yellow flowers, contrasts with *Agapanthus campanulatus*.

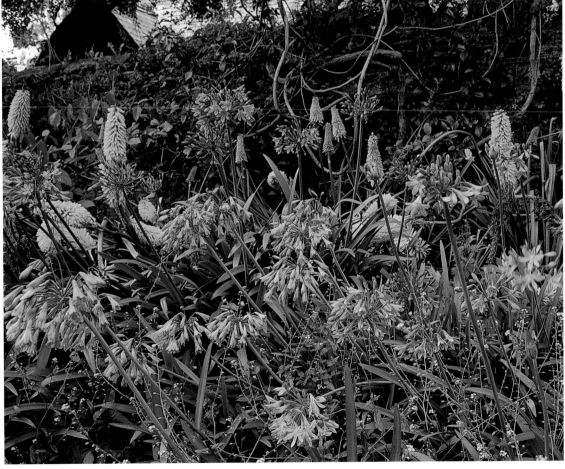

68

Casa Tania

At Casa Tania in Andalusia Arabella Lennox-Boyd has created a new garden that harks back in style to the Moorish gardens of the region. The exquisite craftsmanship of the intricate pebble patterns that decorate many of the paths, and the rill cascading between steps and bubbling fountains, give the garden an immediate sense of place and age. All the essential ingredients of a Mediterranean garden are here – a backdrop of magnificent pines, tall columns of pencil cypress, olives and citrus trees – but the lush tropical planting brings the garden up to date. A pergola with stone columns is festooned with the tender climber *Thunbergia grandiflora*. Flanking the cascade steps that descend to the pool garden is a row of intoxicating white angels' trumpets, *Brugmansia × candida*. Many varieties of jasmine scattered throughout the garden also scent the air both day and night throughout the summer.

The elegant layout of this garden, with its geometrical mosaic carpet of pebbles in dark and pale grey, has three sections. The central square is wide and expansive, while the two smaller areas have wider beds and cooling bubble fountains of marble. Box hedging accentuates the symmetrical layout of the gardens, which are filled with citrus trees, agapanthus and crinum lilies. Pale-pink ivy-leaved pelargoniums, which flower from late spring until winter, cascade over large terracotta pots.

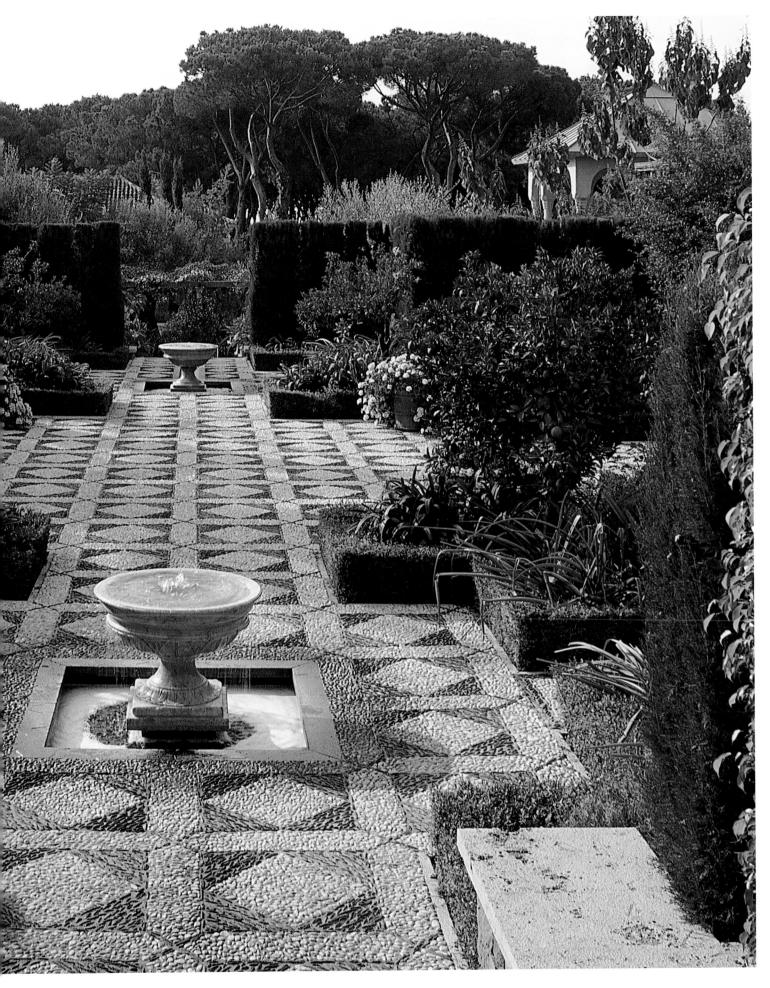

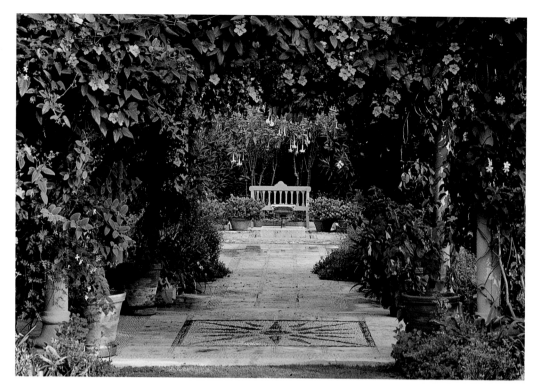

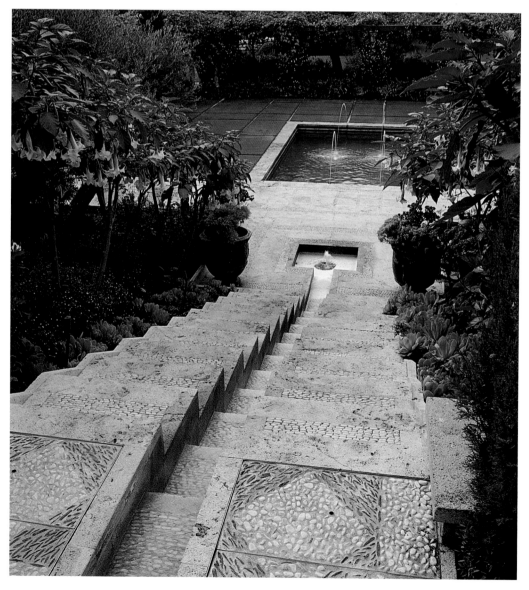

LEFT, TOP A blue seat is reached by passing below a pergola covered in jasmine, bougainvillea and *Thunbergia grandiflora*.

LEFT, BOTTOM The cooling cascade that runs down the centre of the steps leading to the pool is flanked by an avenue of white angel's trumpets, *Brugmansia × candida*, underplanted with the daisy *Erigeron karvinskianus* and echeverias.

ABOVE The blue trumpet vine, *Thunbergia grandiflora*, is backed by bougainvillea.

OPPOSITE Mature pencil cypress echo the columns of the two-storey pool house.

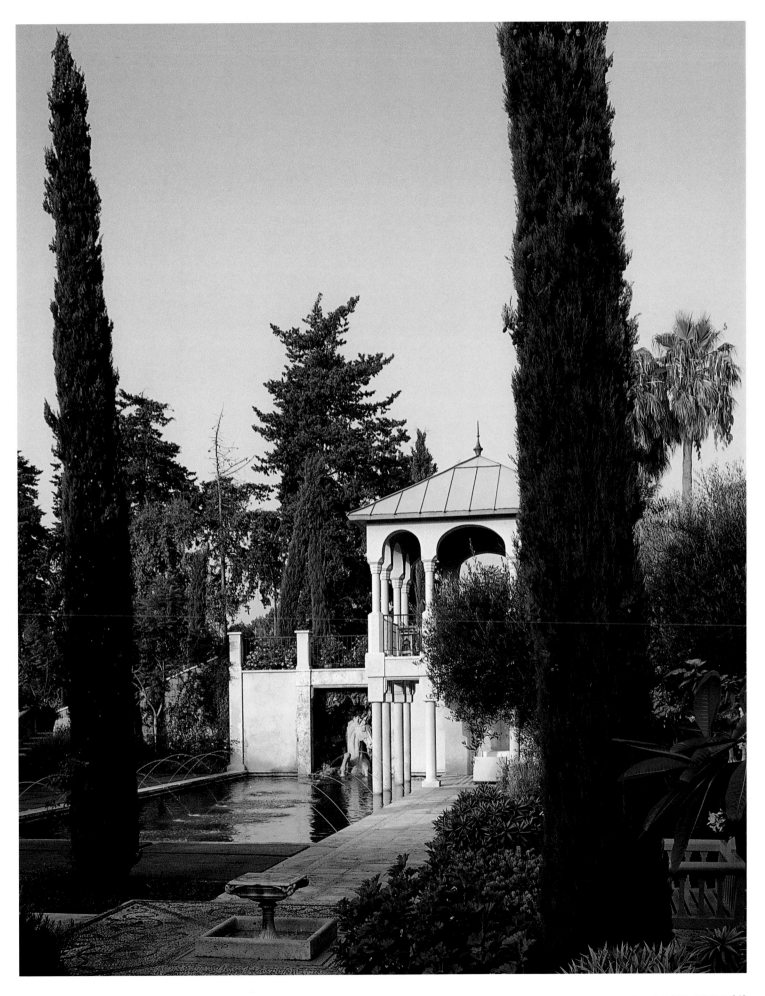

69

West Green House

Marilyn Abbott is an Australian gardener who likes her spring and summer. So, as well as running the gardens at Kennerton Green in Australia (see pp. 46–49), she has taken out a long lease from the National Trust on West Green House in Hampshire. While parrots parade through the trees in Abbott's antipodean property, the garden at West Green House has a decidedly English atmosphere, although she has brought witty touches to this traditional backdrop, particularly in Alice's Garden, where a topiary Mad Hatter and White Rabbit are set on a chessboard of box and gravel. Much of the garden's structure was in place when she arrived, but she has edited it and filled beds with her idea of what English planting should be. The *pièce de résistance* is the kitchen garden, where a pair of giant octagonal fruit cages with curved chinoiserie roofs, designed by Oliver Ford, are filled with soft fruit, and radiating out from them is a sybaritic display of vegetables and flowers.

In the middle of a circular bed on the central axis of the vegetable garden stands a piece of intricate wrought-ironwork from a well. This bed also holds an asymmetric collection of topiary that casts dramatic shadows and a pastel-coloured assortment of annuals, bulbs and short-lived perennials. Foxtail lilies, pale-pink foxgloves and the dusty-pink-flowered *Verbascum* 'Helen Johnson' are joined by lemon-coloured mulleins.

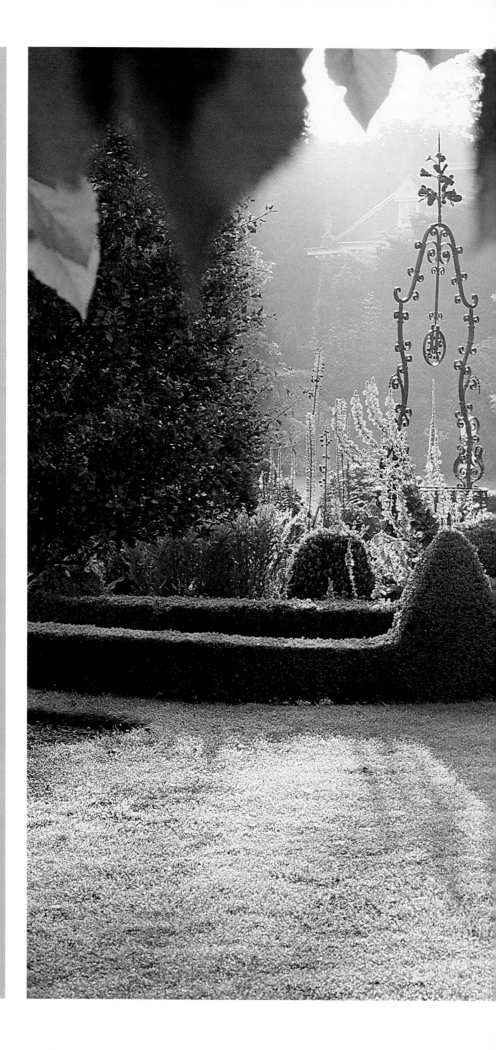

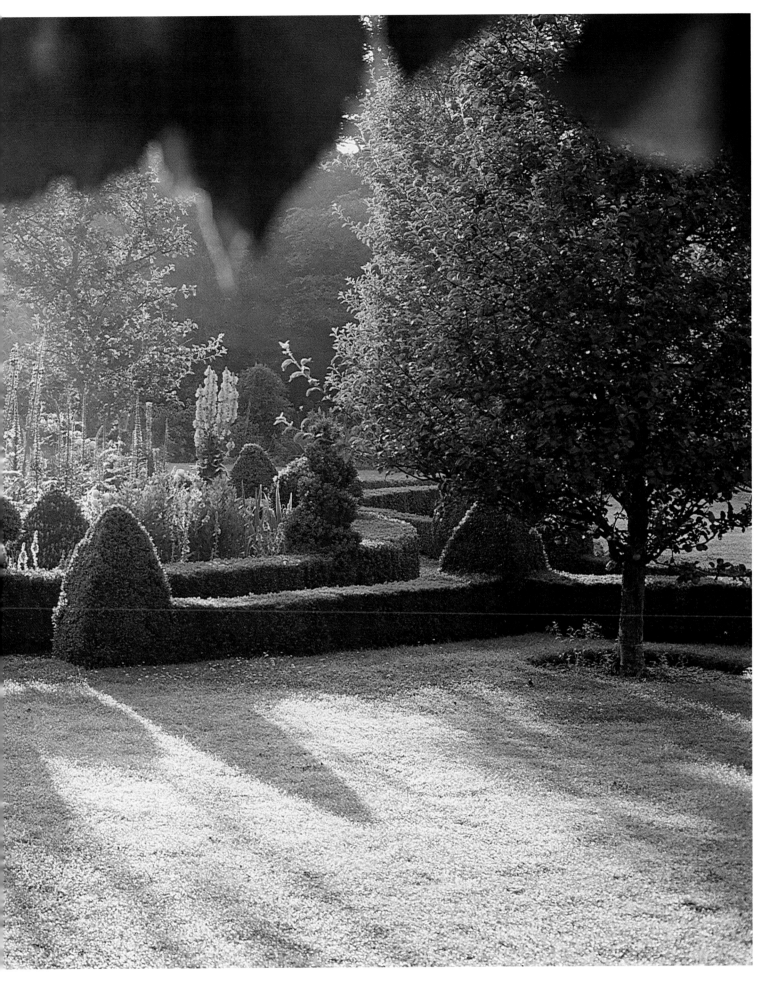

LEFT Shell-pink sweet peas are grown up tripods of hazel and underplanted with *Cerinthe major* 'Purpurascens'.

OPPOSITE, TOP Hummocks of cotton lavender are tightly clipped and not allowed to flower, in contrast with the hedges of blue-flowered lavender that surround them. This arrangement radiates around the ornamental fruit cages with chinoiserie roofs, one of which is seen here beyond a line of standard *Viburnum* × *burkwoodii* lollipops.

OPPOSITE, BOTTOM After descending from the cascade and water garden one re-enters the vegetable garden by a moon gate that frames an axial path lined with box hedging.

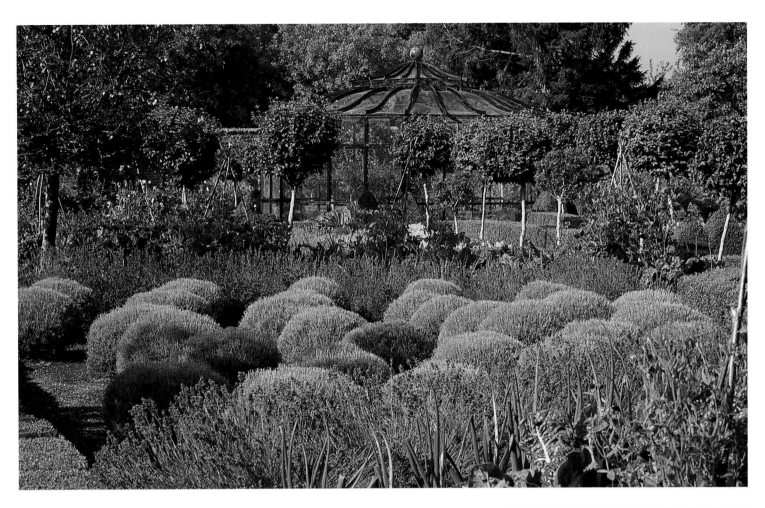

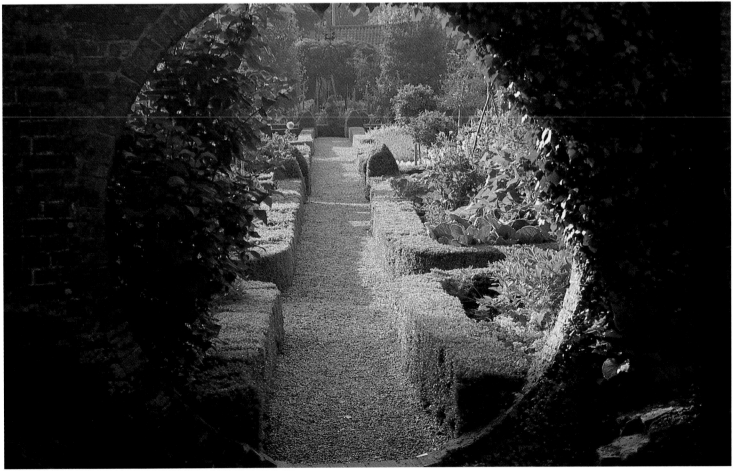

70

Crech ar Pape

The tapestry of textures in this invigorating garden in Brittany results from a mixture of inventive planting and necessity. Winds of 190 km/h (120 mph) frequently crash through this maritime garden, but shrubs kept in tight, smooth shapes are less vulnerable to a gale. It is not just the evergreens, such as box, narrow-leaved bay, myrtles and ilex, that are kept compact by clipping; feathery partners in the form of salvias and wormwoods are also given a tight annual pruning. Great use has been made of contrasting leaf textures, so ornamental grasses and such strappy-leaved bulbous plants as agapanthus, red-hot poker and crocosmia are juxtaposed with solid spherical shrubs. Repetition reinforces the impact and creates a unifying colour theme. Locally sourced granite setts laid in a geometric pattern among healthy-looking turf is another of the original and successful combinations in this garden.

In the Round Garden the robust forms of clipped evergreens are set beside shaggy domes of the mound-forming grass *Hakonechloa macra*. White agapanthus fills the circle at the centre of the garden and is repeated around the outer ring with the star-like daisy *Coreopsis verticillata* 'Moonbeam' and the creamy-yellow spires of *Kniphofia* 'Little Maid'. Little *Viola* 'Bowles's Black' and *Verbena bonariensis* self-sow in and around the granite-sett paving.

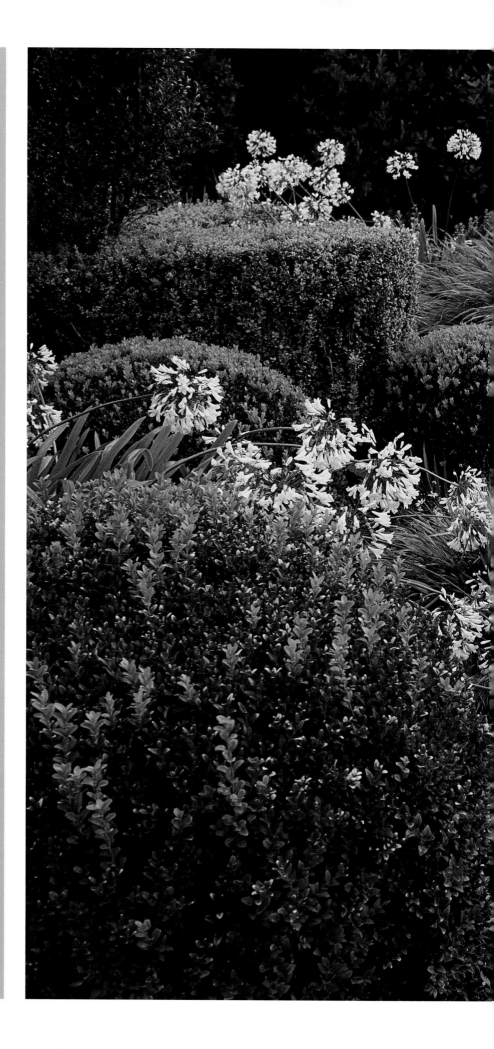

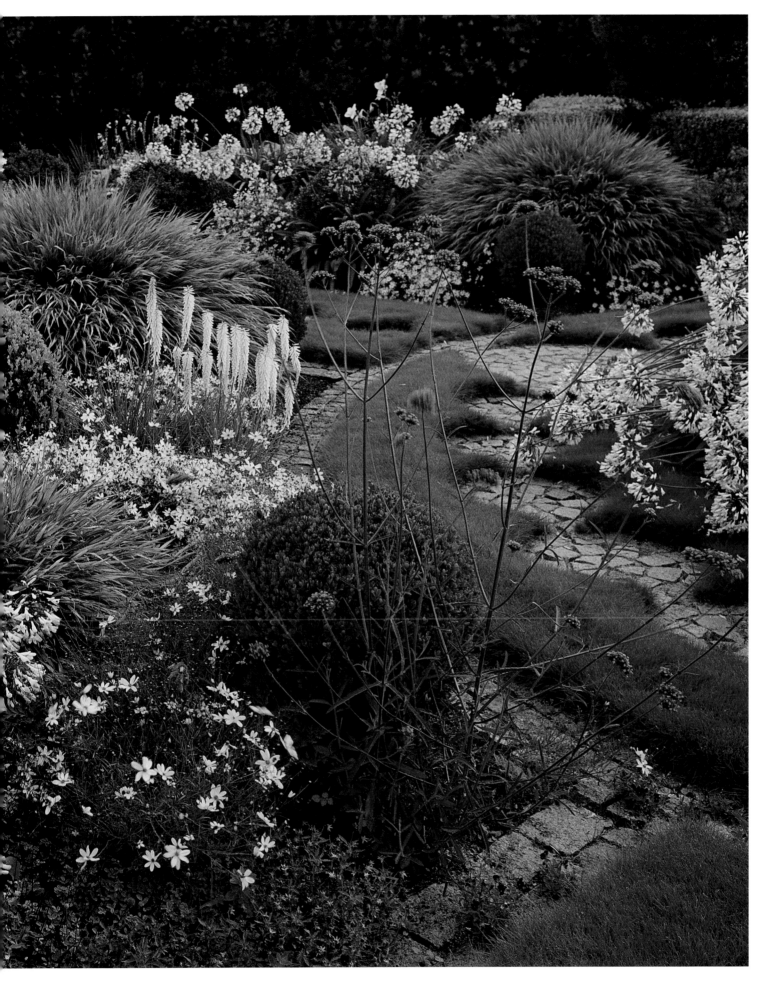

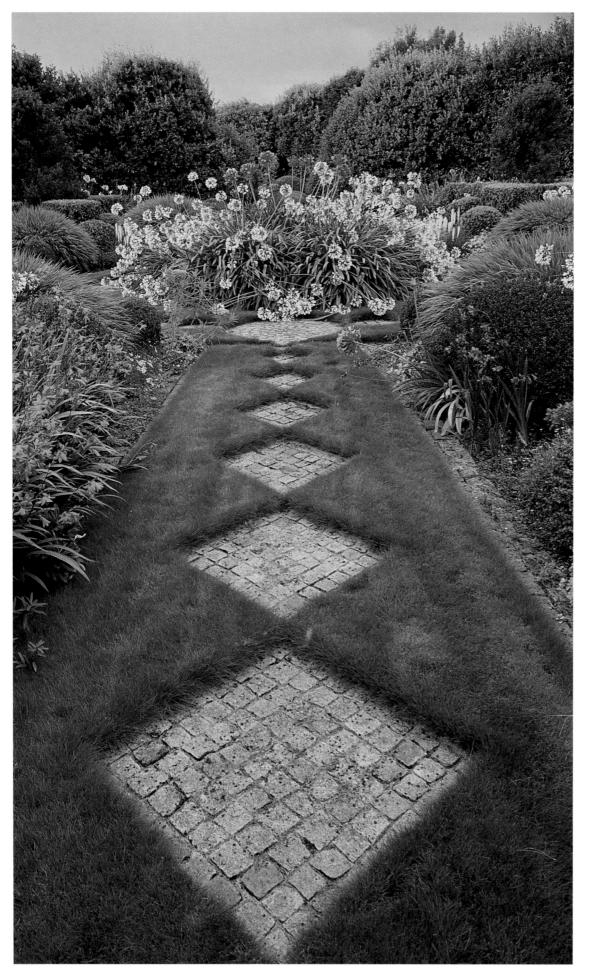

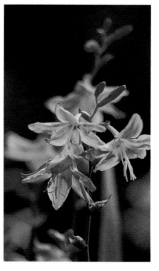

LEFT A path made of setts laid in diamond shapes, like stepping stones in the lawn, leads to a circle in the Round Garden, making a pattern suggestive of a Celtic cross. The centre of the circle is a mass of white agapanthus, and flanking the diamond path is the bright-orange *Crocosmia × crocosmiiflora* 'Star of the East'.

ABOVE *Crocosmia × crocosmiiflora* 'Star of the East'.

OPPOSITE, TOP The Lower Garden is enveloped by the wings of the house, and the steep slope has been transformed into an arena of dynamic planting. Mounds of box surrounded by the yellow-variegated *Hakonechloa macra* 'Aureola' echo those elsewhere in the garden, and there is repeat planting of *Kniphofia* 'Little Maid'. *Convolvulus sabatius* spills out of beds on to paths and steps.

OPPOSITE, BOTTOM A large glazed pot surrounded by box at a cross axis in the garden is backed by evergreens clipped into unusual forms.

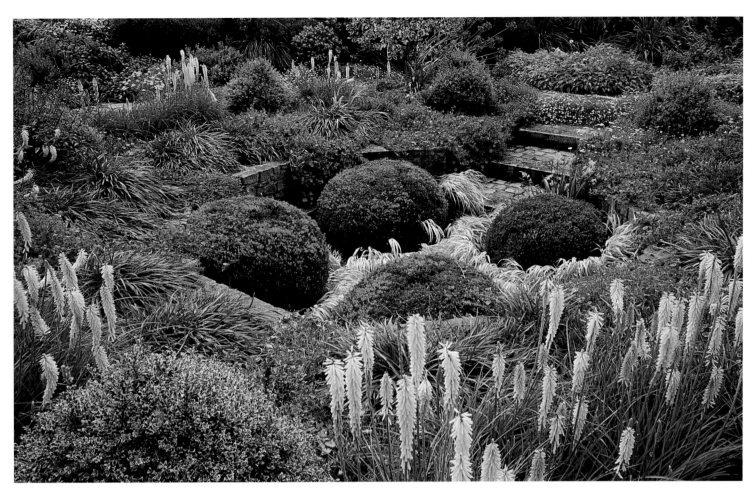

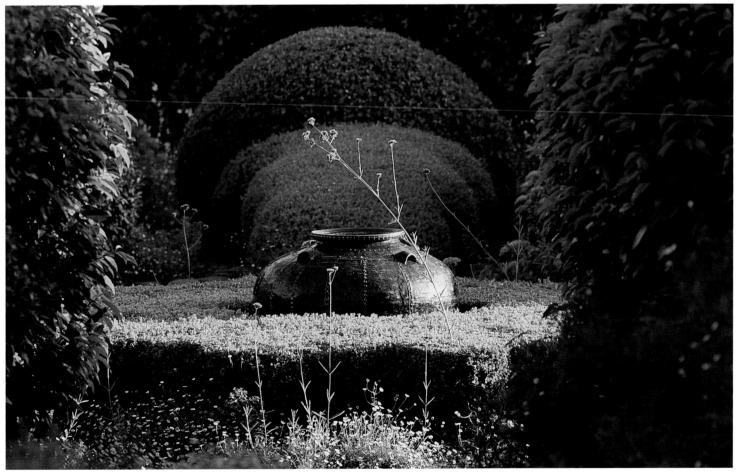

71

Villa Marzotto

The photographs of this private Italian garden in the Fruili region of north-east Italy, designed by Penelope Hobhouse in association with Simon Johnson, were taken only a few years after planting and show how quickly an impression of maturity can be established by the use of large plant specimens and a generous number of fast-growing perennials and annuals. Instant results have also been achieved in the vegetable garden, which is laid out as an ornamental potager with pebble paths dividing beds that were made narrow for easy cultivation and crop rotation. In the stuccoed courtyard large terracotta planters brim with a healthy and well-fed mixture of trailing plants, scented-leaved pelargoniums and standard lollipops of privet. The owners wanted the garden around their restored villa, which was devastated by an earthquake in the 1970s, to echo the past, but they were also keen to embrace the present with modern plant cultivars and up-to-date irrigation.

RIGHT, TOP Giant terracotta pots that match the limewashed walls are filled with the variegated, scented-leaved *Pelargonium* 'Lady Plymouth', trailing variegated ground ivy, *Glechoma hederacea* 'Variegata', and white busy lizzies under standard mophead privet.

RIGHT, BOTTOM In the central section of the vegetable garden cabbages, leeks and tomatoes grow among the standard 'Iceberg' roses.

OPPOSITE, TOP In this view towards the house from the vegetable garden, metal arches spanning neat pebble paths are hung with runner beans, one batch sown early, the other later, to give successive crops. Between the two arches is a large circle ringed with standard 'Iceberg' roses, and from the central bed a topiary bay tree rises above clipped hummocks of cotton lavender.

OPPOSITE, BOTTOM A view in the opposite direction includes box cones that provide permanent decoration and rows of brightly coloured annual zinnias.

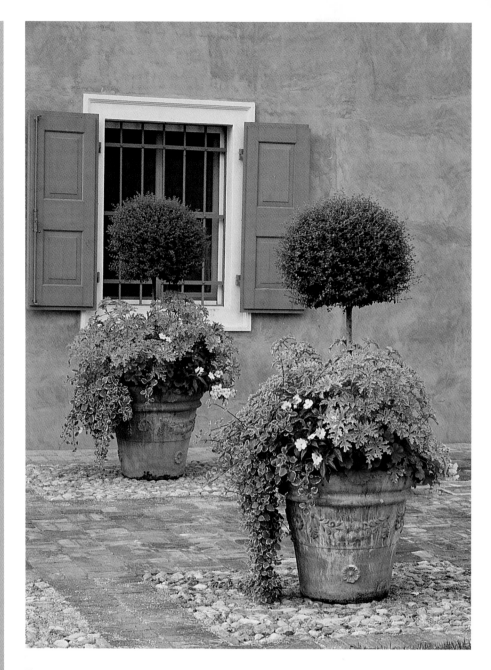

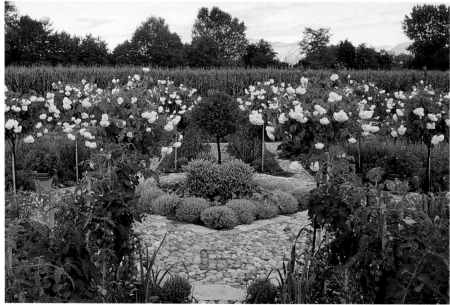

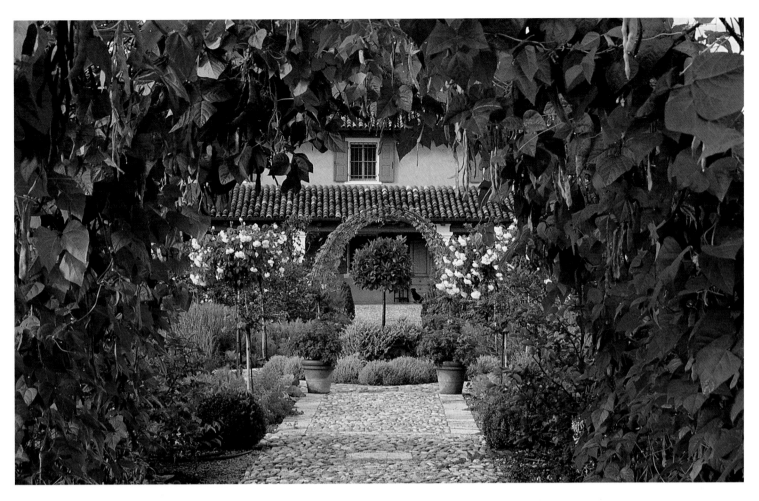

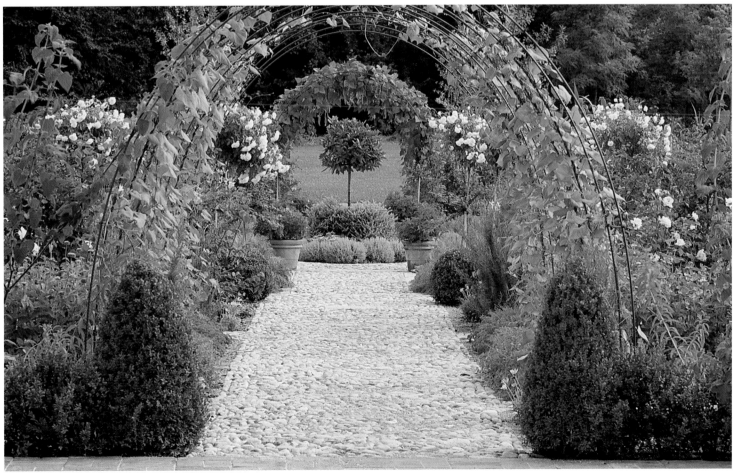

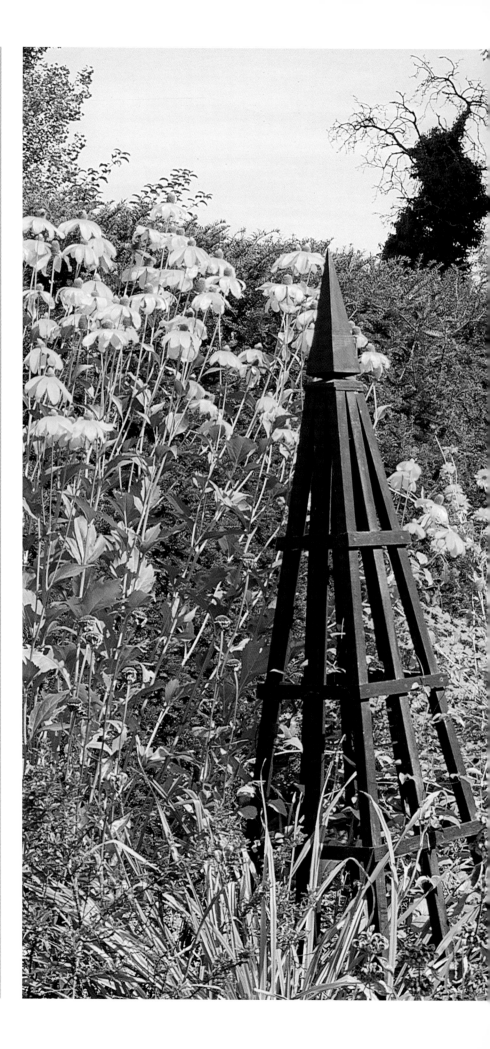

72

Arrow Cottage

Chac Mol, the ancient Mayan god of lightning, thunder and rain, may not need to be invoked to bring the elements to this garden on the border of Herefordshire and Wales, but being also a symbol of fertility and agriculture he nestles happily among fennel and verbena at Arrow Cottage. The bowl that rests on his lap, designed as a receptacle for hearts from human sacrifice, is used instead here as a well-frequented birdbath. There are many surprises in this compact, 0.8-hectare (2-acre) garden that contains more than twenty themed compartments laid out by the original creator, Lance Hattatt, and continuously embellished by the new owners. The main vista, which ends in a pale-yellow stuccoed tower, has been cleverly manipulated to appear longer. The hedges at the entrance to the walk are set wider apart than those at the tower end, but the strong central line of the stone-flanked rill distracts the eye from noticing.

A dark-green yew hedge separates a border of brightly coloured perennials from the yellow-painted summer house called the Tower. Timber obelisks painted dark indigo punctuate planting that includes the tall single *Rudbeckia* 'Herbstsonne', shorter black-eyed Susan, *Rudbeckia fulgida* var. *deamii*, and the double yellow-flowered *Helianthus* 'Loddon Gold'.

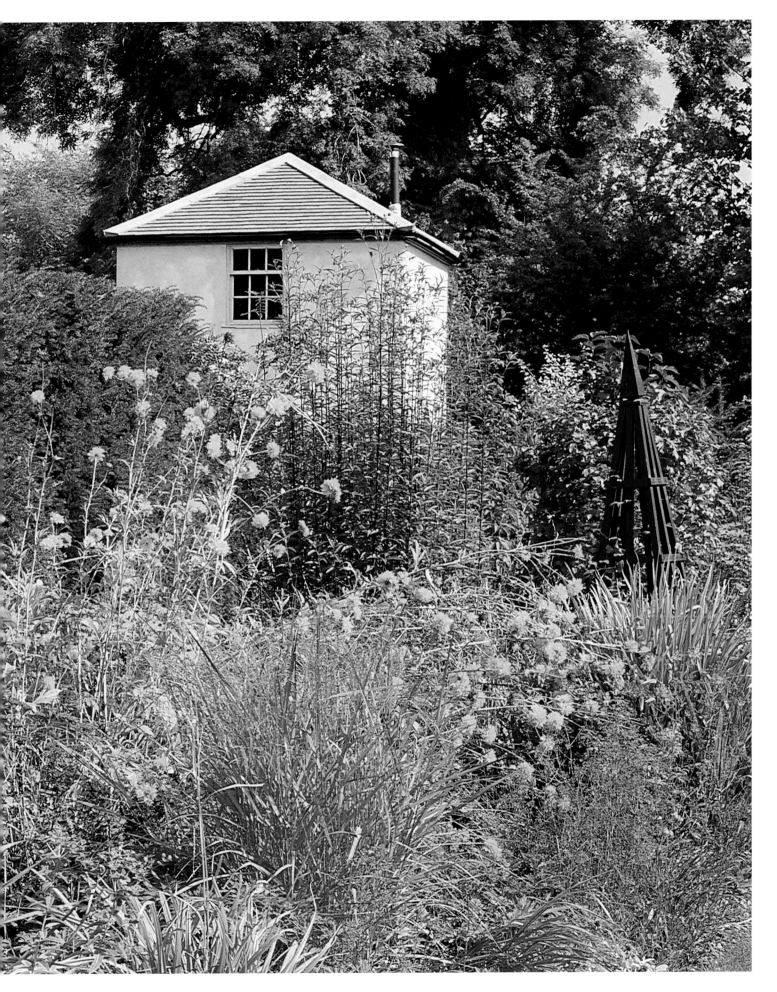

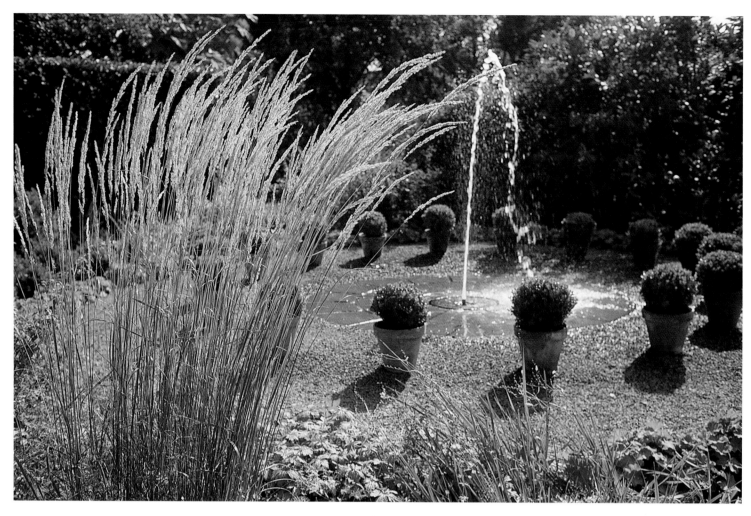

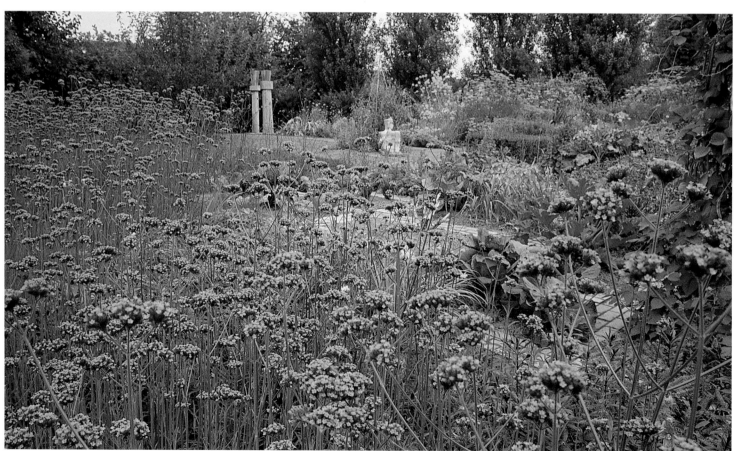

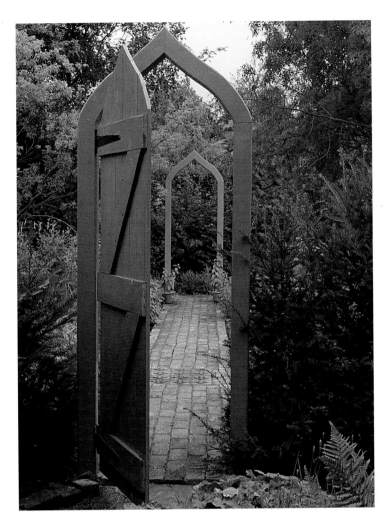

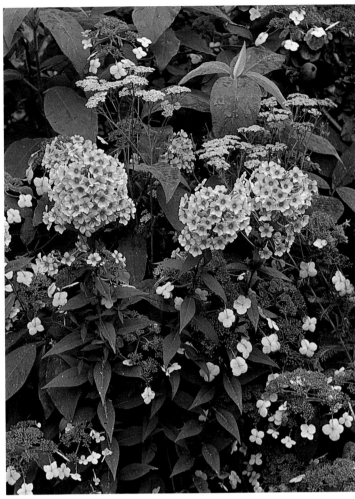

OPPOSITE, TOP A simple jet fountain amid pots of clipped box harnesses sunlight and enlivens the centre of the garden. *Calamagrostis × acutiflora* 'Karl Foerster' sways in the wind.

OPPOSITE, BOTTOM A sculpture of Chac Mol stands at the centre of the vegetable garden, where wigwams of scarlet sweet peas and bands of *Verbena bonariensis* grow among cabbages and leeks.

TOP LEFT Gothic timber archways frame the entrance and exit of one of the many compartments in this garden.

TOP RIGHT *Hydrangea aspera* is planted with *Phlox paniculata* 'Miss Pepper'.

RIGHT *Echinacea purpurea* 'Magnus' grows with the steely-blue sea holly *Eryngium planum* and *Achillea millefolium* 'Cerise Queen'.

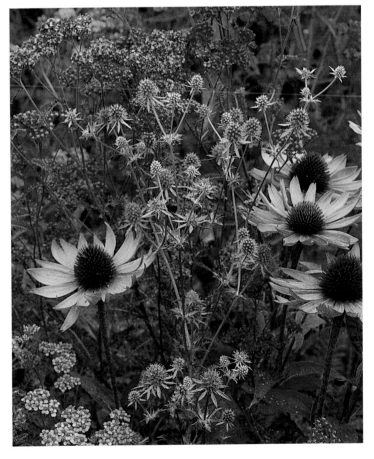

73

Highover, Dawlish

Gardening by the sea is not easy. Gusting, salt-laden winds scorch young leaves or lift plants straight out of the ground, but the main challenge for most seaside gardeners is how to relate the foreground composition to a backdrop as majestic as a panoramic view of the ocean. In this Devon cliff-top garden Naila Green has brought together her twin talents as a trained graphic artist and garden designer. The blue-painted bench with its lobster pot buoy is a perfect foreground touch to set the scale and relate the garden to its setting. Decking, expanses of gravel and seating areas are casually enclosed by plants perfectly suited to this environment: *Rosa rugosa*, agapanthus and euphorbias, crocosmia, helichrysum and phlomis. The maritime theme is reinforced by the deployment of upturned green bottles to delineate space and the use of objects found on the beach, along with crab and clam shells and pebbles scattered in bowls and around paths, to decorate the garden.

RIGHT Many of the native and exotic plants that colonize the cliffs below Naila Green's home are cleverly integrated into the cultivated part of her garden and mixed with plants that are suited to the site but do not spontaneously grow here. *Verbena bonariensis*, crocosmia, agapanthus and roses, all of which thrive and multiply along this stretch of coastline, are seen here with lavender.

OPPOSITE A rugosa rose hedge covered with Russian vine lines the edge of the cliff, giving stability to the setting without impeding the spectacular views.

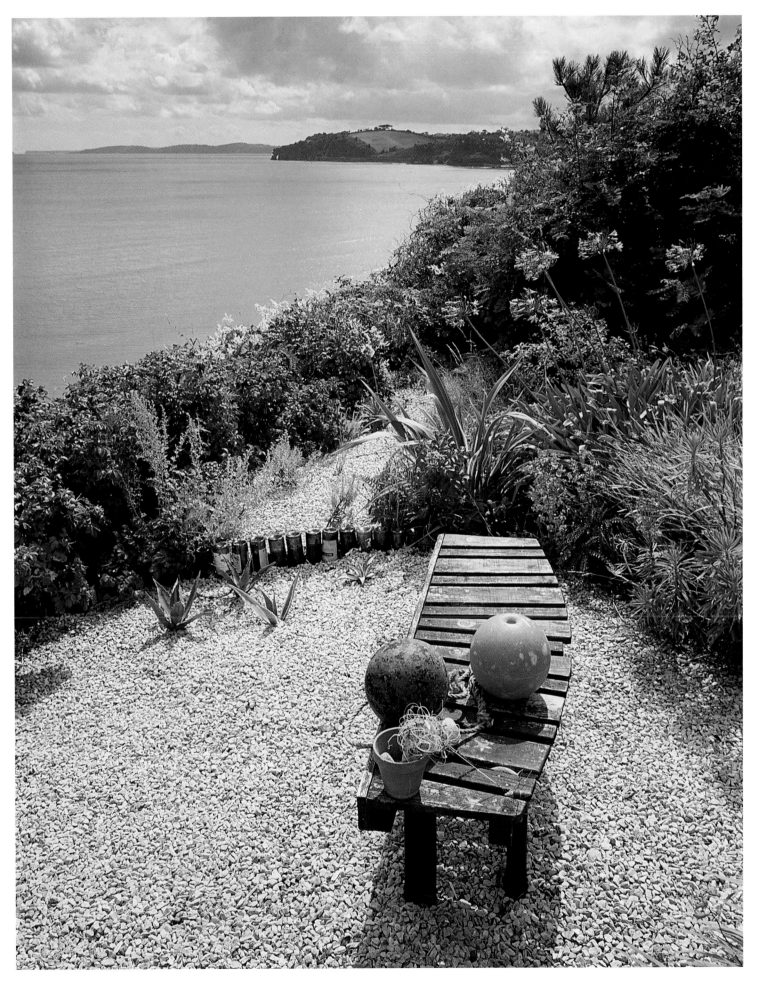

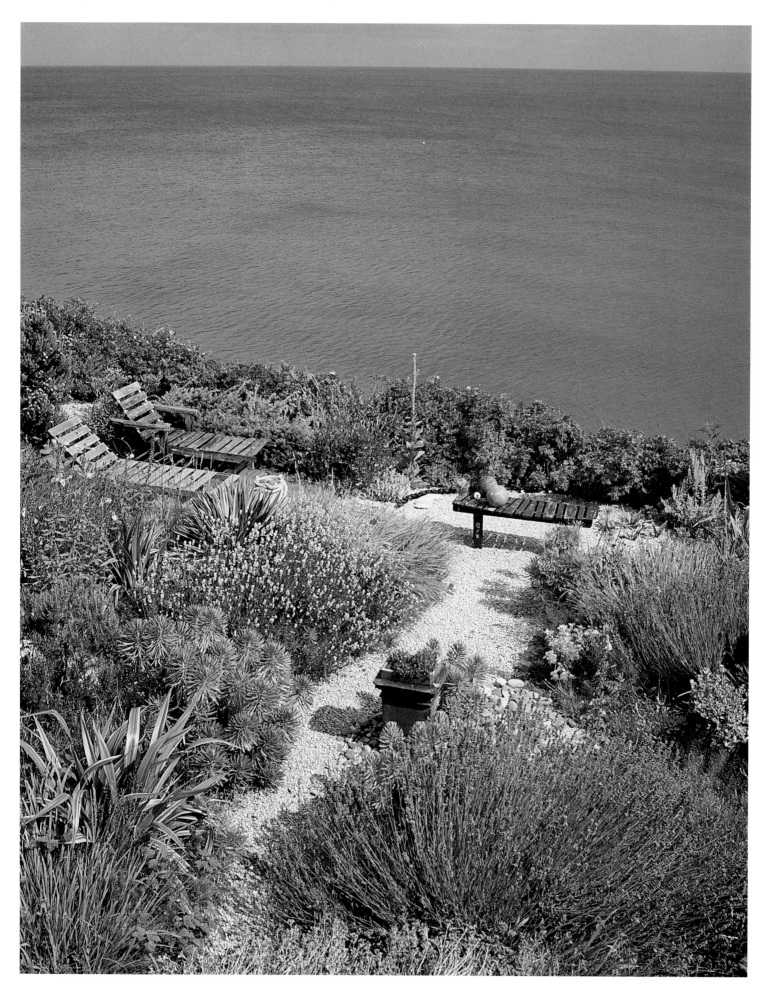

OPPOSITE An overview of the garden shows the clever delineation of space. Wide borders filled with plants suited to the maritime environment, such as lavender, euphorbia, phormiums and the curry plant, *Helichrysum italicum*, envelop the seating areas, lending a sense of solidity at the cliff edge.

TOP LEFT A reclaimed Victorian chimney is filled with an assortment of pebbles and shells picked up on the beach.

TOP RIGHT Green's 'Alice Through the Looking Glass' gate, designed for a show garden, now decorates her own garden.

BOTTOM LEFT A clay bowl brims with whelk, scallop and razor shells.

BOTTOM RIGHT Upturned green bottles are used to define the boundaries of the garden's various zones.

74

London

Dan Pearson's London garden is large for one in the city. But by dividing the 120 × 35-m (394 × 115-ft) space into open zones of decking, paving and clearly defined pathways that are kept clear, in contrast to the areas of intensive planting, he has made it work as a place in which to sit and entertain as well as somewhere to grow a copious variety of plants that reflect the rhythm of the seasons. The garden is a wildlife sanctuary where decaying logs are left for stag beetles, beds are not cleared until birds take nesting material in March, aphid-guzzling hoverflies and bees zoom in on key nectar and pollen plants, and *Eupatorium album* 'Braunlaub' and *Verbena bonariensis* attract late-summer butterflies. There are raised vegetable beds and compost heaps, lush combinations of cannas and dahlias as well as understated combinations of rosette-forming eryngiums with delicate *Stipa barbata*. So much thought has gone into this space that it is a microcosm of any large project by Pearson where visual stimulation is matched by seasonal atmosphere.

RIGHT A path made of broken slates meanders through the perennial planting that separates the limestone terrace from the decking beyond. *Dierama pulcherrimum* is positioned to arch gracefully over the path. Among the other plants are magenta *Geranium* 'Patricia', *Hemerocallis* 'Stafford' and orange *Lilium henryi* with *Digitalis ferruginea*, *Eryngium agavifolium* and *E. giganteum*.

OPPOSITE, TOP LEFT The vibrant tones of *Geranium* 'Patricia' and *Hemerocallis* 'Stafford' are picked up by a trio of low wicker seats.

OPPOSITE, TOP RIGHT The sun shafts through the plants bordering the broken-slate path, lighting *Nicotiana suaveolens* and *Lilium regale* on the terrace.

OPPOSITE, BOTTOM A copper lily pond holds *Nymphaea* 'Marliacea Chromatella'. The lemon-coloured flowers of *Alcea rugosa* come through the silver stems of the coyote willow, *Salix exigua*. Bright-red geraniums extend the flowering season.

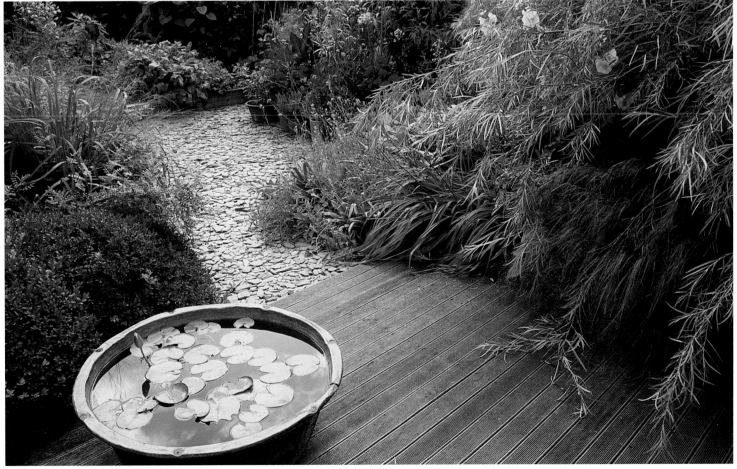

75

Poplar Grove

Gordon Cooke is a ceramic artist whose garden is like an outdoor studio in which he can observe the subtleties of the forms found in nature that often inspire his work. It is also his gallery for annual exhibitions, so it is pivotal in teaching him about the relationship of his sculpture to the garden. Situated in the Manchester suburb of Sale, this town garden makes the most of its compact long and narrow shape: cleverly angled at forty-five degrees to the house, it gives an impression of greater width. Other illusory effects include a tall mirror behind a small arch, also set at an angle, and here, because you do not see yourself in scale, the path and sculpture that it reflects prolong the impression of depth, as does the water in which the mirror itself is reflected. A sunken cave with a plant-covered arched roof has niches for Cooke's works and all-important hooks for a hammock.

RIGHT, TOP A mirror placed at an angle catches the reflection of one of Cooke's sculptures but cleverly also prevents you seeing yourself as you walk towards it, thereby increasing the sense of illusion.

RIGHT, BOTTOM Facing the setting sun, the sunken cave has an arched roof covered with drought-tolerant plants and festooned with the dark-leaved vine *Vitis vinifera* 'Purpurea' as well as the twining annual *Ipomoea lobata*.

OPPOSITE The mirrored sculpture is seen from further back, across the rectangular pond and behind a mixture of soft and structured planting. *Carex flagellifera*, at the front, contrasts in form with Cooke's tall, conical sculptures and the lush leaves of *Zantedeschia aethiopica*.

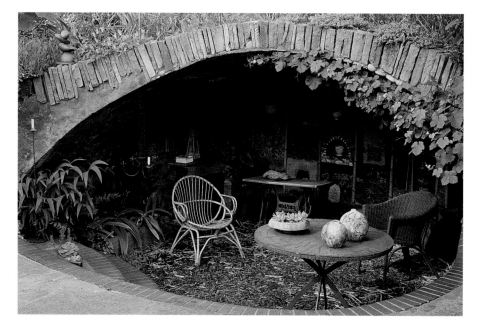

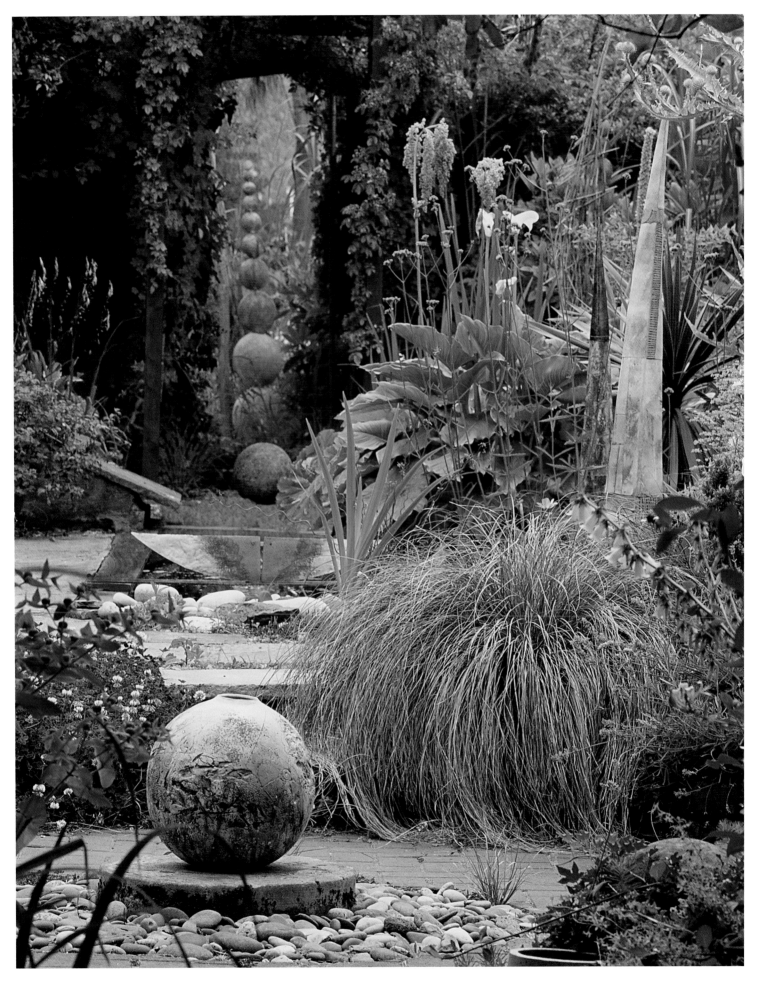

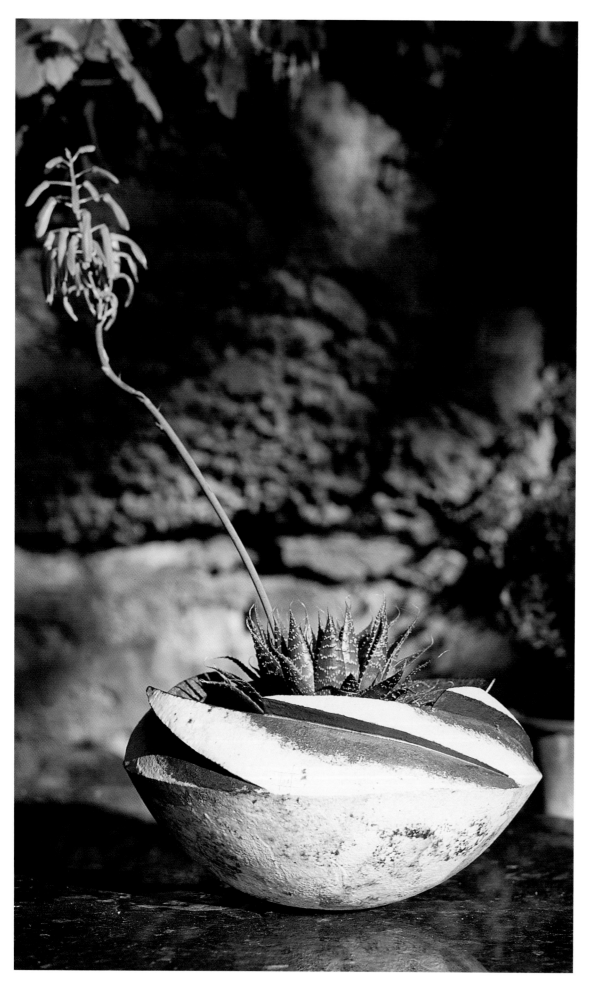

LEFT A small aloe growing inside one of Cooke's pots illustrates his interest in the relationship between plants and ceramics.

ABOVE, FROM TOP This spiral container is embossed with the pattern of a leaf set into the wet clay before firing; like an exploded ostrich egg, a ceramic container by Cooke sits in one of the niches for pots in the cave wall.

OPPOSITE, TOP The mixture of spiky-leaved cordyline, yellow variegated phormium and *Spartina pectinata* 'Aureomarginata' is set against the huge, glossy leaves of arum lilies and *Darmera peltata*.

OPPOSITE, BOTTOM, LEFT TO RIGHT *Oenothera stricta* 'Sulphurea' with *Stipa tenuissima*; an upright tower of shards of slate and stone is seen with campanula and *Acanthus mollis* against a backdrop of eucalyptus and broom; Cooke's sculptures rise through a dreamy combination of campanula, penstemon and foxgloves.

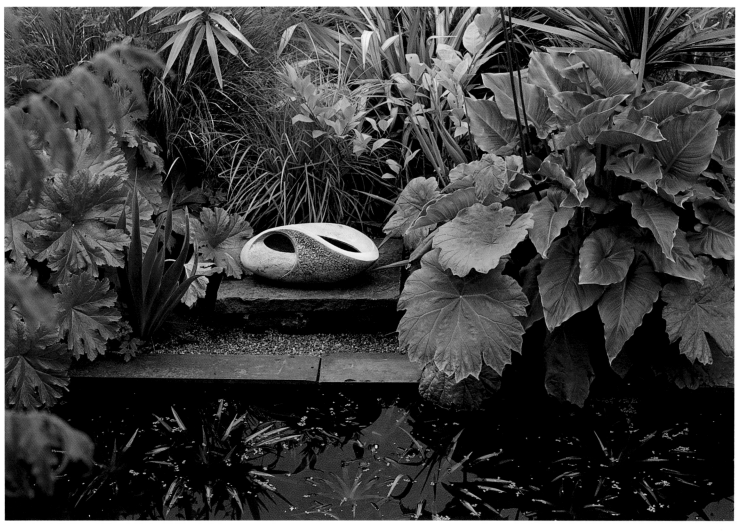

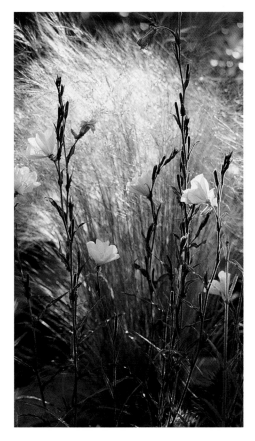

76

Scampston Hall

When Charles and Caroline Legard could no longer bear to see their 1.8-hectare (4½-acre) walled garden at Scampston Hall in North Yorkshire full of sickening cash-crop Christmas trees, they called in the Dutch maestro of perennial planting, Piet Oudolf, to carry out a radical makeover. The once sad and derelict Victorian glasshouses now proudly overlook a gleaming new garden full of extraordinary plant associations and burgeoning topiary, hedges and trees. Although still in its infancy, the garden has a remarkably well-established feel to each of its eight sections, in particular the grass garden, which greets you when you enter. Here, thousands of plants of *Molinia caerulea* subsp. *caerulea* form serpentine drifts interspersed with meandering ribbons of lawn, and at the centre, pairs of low, cube-shaped chairs by Piet Hein Eek face one another across a square of brick paving. Lining the edges of this section are bands of *Salvia nemorosa* 'Amethyst', which confidently reappears in blocks throughout the walled garden.

TOP The Perennial Meadow has a large, circular pond with a central arching fountain around which four beds radiate with a dazzling display of modern planting. Purple *Salvia* × *sylvestris* 'Blauhügel' and mauve *Nepeta racemosa* 'Walker's Low' are joined by the black, rayless cones of *Rudbeckia occidentalis*, the chrome-yellow grass *Sesleria nitida*, *Stachys officinalis* 'Hummelo', silver-blue *Eryngium planum* and the exploding seed heads of *Allium schubertii* with *Astrantia* 'Ruby Wedding'.

BOTTOM A view of the borders in the summer box garden and, beyond these, the Woodland Grove, which is filled with katsura trees underplanted with grasses and shade-loving perennials.

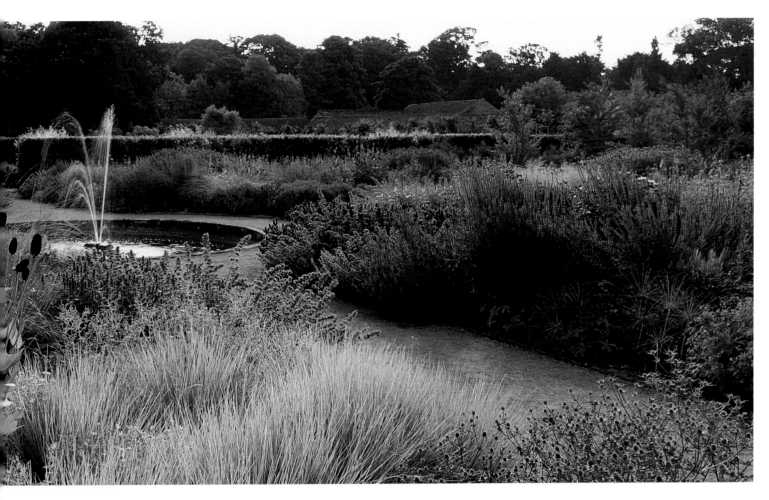

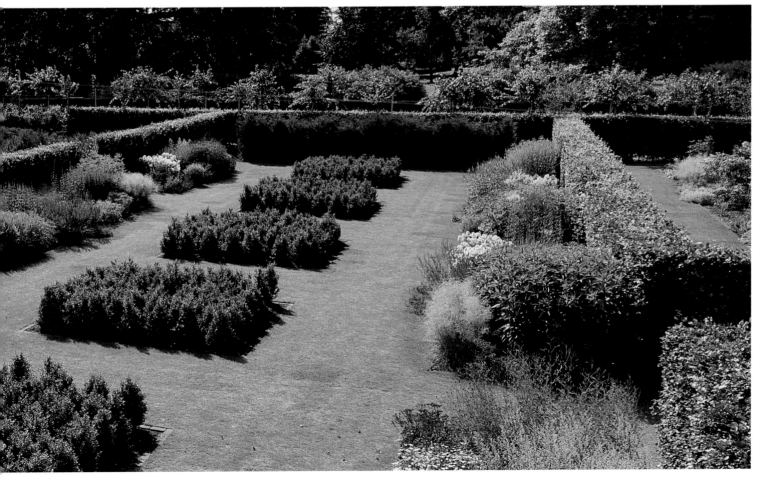

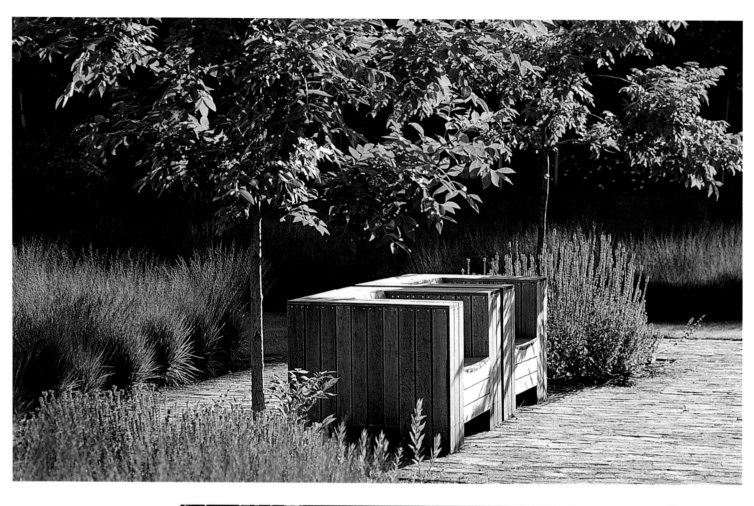

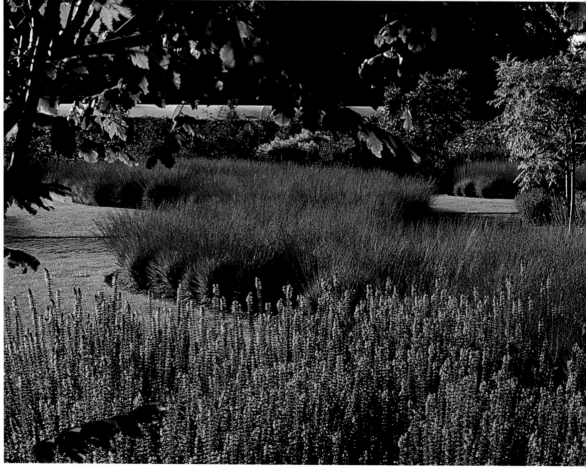

TOP LEFT A pair of cube-shaped chairs by Piet Hein Eek under *Phellodendron chinense*.

TOP RIGHT A grove of katsura trees, *Cercidiphyllum japonicum*, in the Woodland Garden frames a view of the restored Victorian conservatory. A large oval bed in the foreground is filled with *Molinia caerulea* subsp. *arundinacea* 'Transparent' and *Monarda* 'Pawnee'.

BOTTOM The first of the garden's eight compartments is filled with ribbon-like bands of swaying grasses. More than six thousand plants of *Molinia caerulea* subsp. *caerulea* are contained in a wavy edging of brick with contrasting bands of closely cut lawn. Blocks of deep mauve *Salvia nemorosa* 'Amethyst' are interspersed around the edges and within the brick-paved central square, where two pairs of Piet Hein Eek's cube-shaped chairs are set.

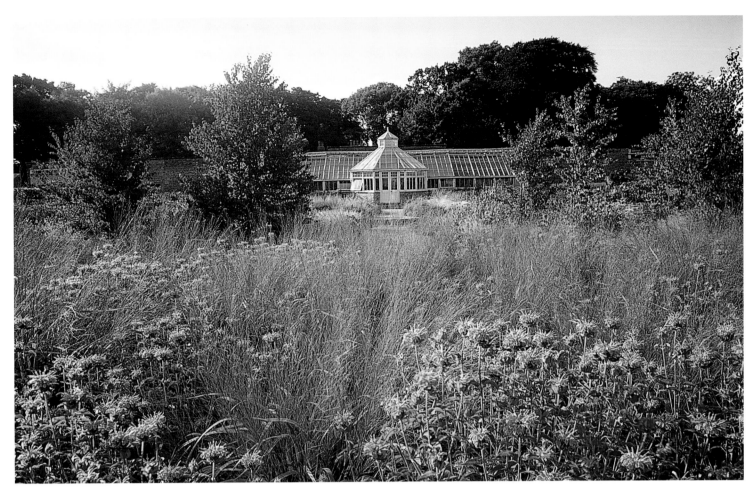

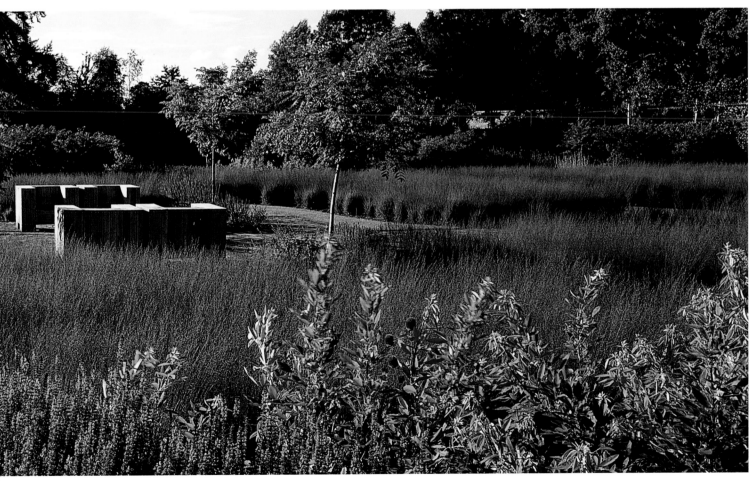

Serge Hill Barn

The Hertfordshire house that Tom Stuart-Smith shares with his wife, Sue, and their three children was a barn and piggery when he was a boy. The courtyard, now full of waist-high box hedges and exuberant planting, was a farmyard, and the fields behind the buildings, where the garden compartments now teem with experimental plant associations, were desolate, windswept fields. Taking his cue from the idea of dividing this sort of space into small paddocks and sheep folds, he made a number of hedged enclosures surrounded by grassy meadows. For contrast, this ordered design is filled with riotous planting. Serge Hill Barn is home, not a client's garden, so Stuart-Smith relishes anarchic self-seeders. It is here that he learns which plants are colonizers, and their true height, volume and impact. He likes plants that will challenge his best-laid plans and bring a haphazard element, so maintaining a balance between nature and horticulture.

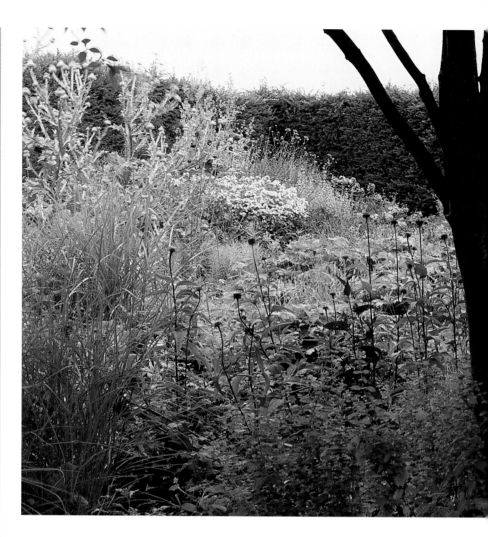

TOP A multi-stemmed tree is a solid anchor to a profusion of planting that consists of a large number of rampantly self-sowing or spreading plants such as the lemon balm under the tree. The border to the left has such tall plants as the Scotch thistle, *Onopordum acanthium*, and coral plume poppy, *Macleaya cordata*, at the back and there is a gradual descent in height through *Campanula lactiflora* and phlox. In this dense planting the neatly mown and bordered path gives structural definition.

BOTTOM, LEFT Two L's of box contain a bed of oak-leaf lettuce.

BOTTOM, CENTRE *Dianthus carthusianorum* and *Salvia sclarea* var. *turkestanica*.

BOTTOM, RIGHT In Stuart-Smith's ever-changing border, where he experiments with naturalistic planting, candelabra verbascums sow themselves among *Veronicastrum virginicum* 'Fascination', *Hemerocallis lilioasphodelus* and campanulas.

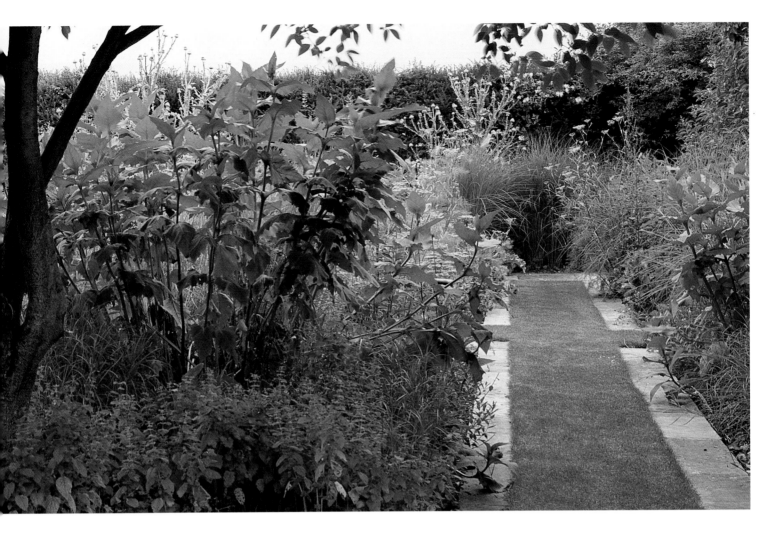

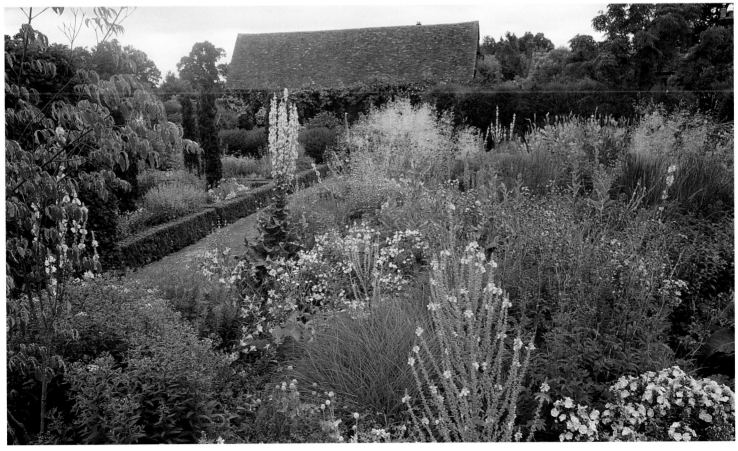

TOP A mown path elegantly follows the contours of a sweeping meadow that forms a contrast with the densely planted hedged enclosures in Stuart-Smith's garden.

LEFT *Phlomis russeliana* grows here among *Stipa gigantea* and the seed heads of verbascum and opium poppies.

OPPOSITE, BOTTOM, LEFT TO RIGHT The yellow hollyhock *Alcea rugosa* with *Stipa gigantea*; the unfurling flower heads of *Anemanthele lessoniana* with *Achillea* 'Moonshine'; the elegant flowering head of a self-sown verbascum, and behind it the irregular spikes of *Veronicastrum virginicum* 'Fascination'.

78

Daluaine

Winters in the highlands of Scotland are long and hard, so it is hardly surprising that the summer borders in this Aberdeenshire garden should showcase some celebratory concoctions of hot colour to mark the longer days while they last. Earlier in the season these borders, planted by Mary Ann Crichton Maitland at Daluaine, are blue, mauve, pink, silver and cream, to match the sky on both grey days and bright. A water garden is being created along the banks of the River Bogie, where otter play at dusk. Fortunately they are more interested in feeding on fish than on the candelabra primulas, irises and marginal aquatics that she is establishing to be visible from the Pleasure Dome, a stone-and-cedar shelter given to her by her husband, David. Aberdeenshire is home to some of Britain's most ancient standing stones, and the Crichton Maitlands have an exceptional early stone with a carving of a leaping salmon situated in a field that overlooks the distant Cairngorm mountains.

RIGHT, TOP A mixture of striking silhouettes and vibrant colour combinations makes the herbaceous border zing in late summer. Here *Achillea filipendulina* 'Gold Plate', with bright-golden flowers that balance on tall stems, towers over a cerise *Phlox paniculata* and a pair of heleniums, the brown-flecked orange 'Wyndley' and bright-red 'Bruno'.

RIGHT, BOTTOM *Crocosmia* 'Lucifer'.

OPPOSITE, TOP The Crichton Maitlands' Pleasure Dome commands views over the river and landscape beyond. The banks are covered with shrub roses.

OPPOSITE, BOTTOM Prominent among the components of the herbaceous border are orange lilies, *Crocosmia* 'Lucifer', *Eryngium alpinum*, *Ligularia przewalskii*, *Echinops ritro*, *Coreopsis verticillata* and *Anthemis tinctoria* 'Sauce Hollandaise'.

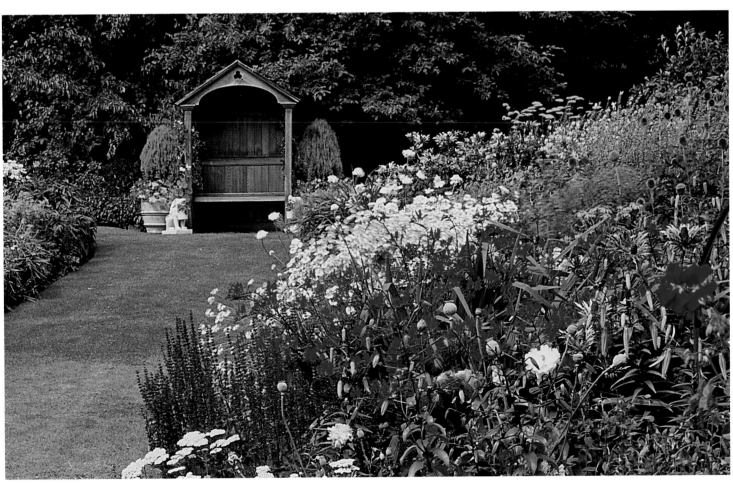

79

Waltham Place

Unlike so many gardens where the primary aim is to be visually captivating, the garden at Waltham Place in Berkshire puts the needs of nature first, and in this case a garden has been created that feeds more than just the eye. Strilli Oppenheimer's aspiration to make her entire garden, not just the meadow to the side, a space in which to nurture the ecological relationships between plants, animals and the environment with minimal interference from humans has yielded glorious results. Artifice is by no means eschewed – the amorphous hummocks of box that snake through the Square Garden are kept in shape by clipping, and the borders are filled with plants from around the world – but the philosophy that underpins the planting gives a great sense of cohesion. In the Dutch designer Henk Gerritsen, whose gardens are dramatically presented evocations of nature, Oppenheimer found a kindred spirit who was happy to let her showcase the decorative qualities of bindweed, which has grown into 'wigwams' in the wild and wonderful borders at Waltham.

RIGHT Counterbalancing the geometry imposed by the pergola in the Arts and Crafts style and the hard landscaping, box hedges with organic curves and abstract shapes have been used to soften the scene.

OPPOSITE, TOP Deep beds with dramatic planting also give a contemporary edge to an early twentieth-century setting. The creamy-white, billowing mass of *Persicaria polymorpha* is surrounded by tall calamagrostis and spiky Scotch thistle, *Onopordum acanthium*. Beyond these is a lily pond with two sections.

OPPOSITE, BOTTOM The view from the path that divides the lily pond takes in a lookout-post gazebo in the background.

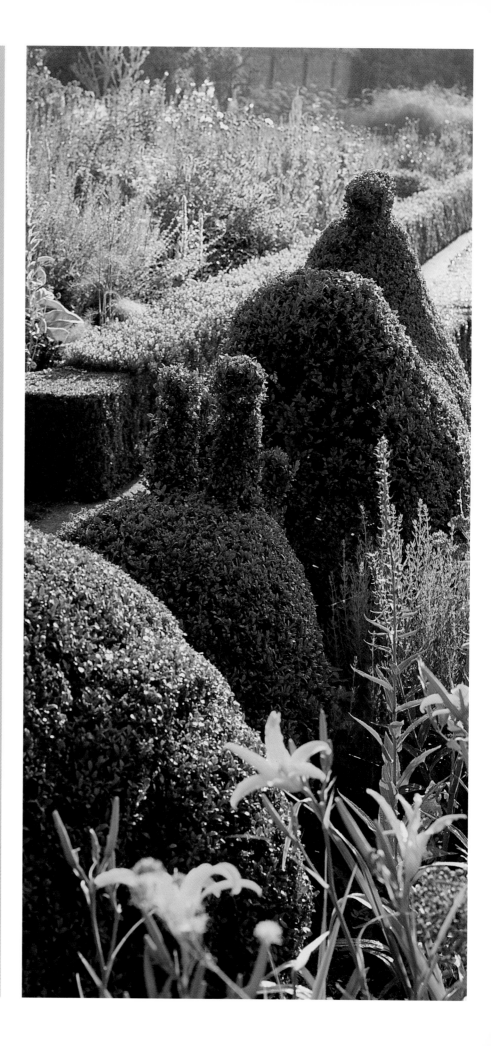

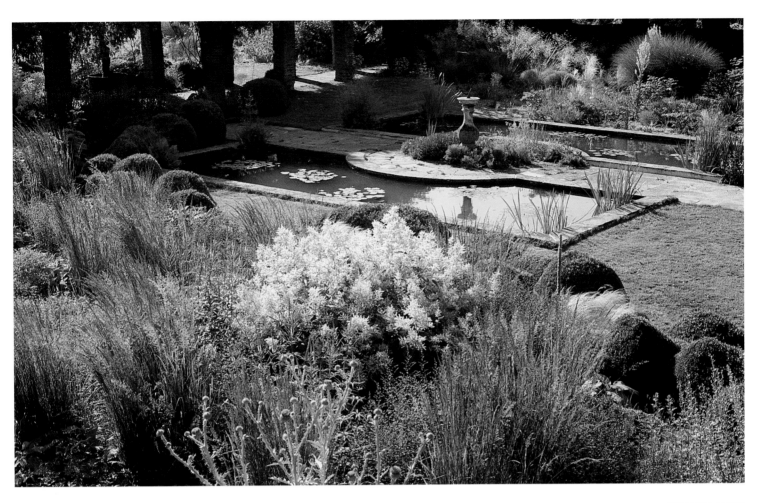

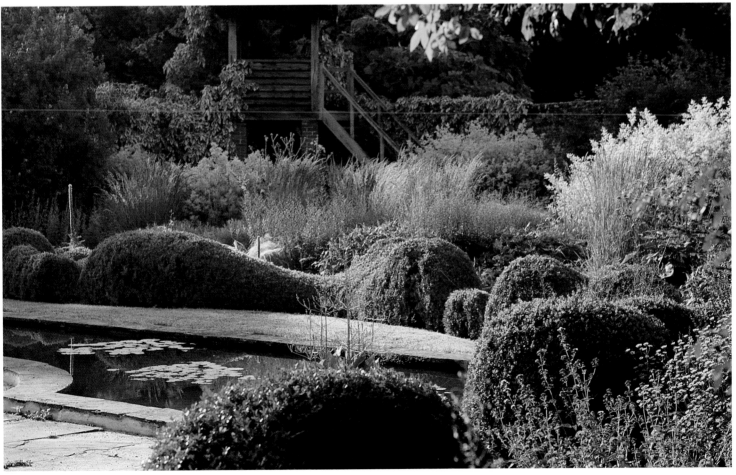

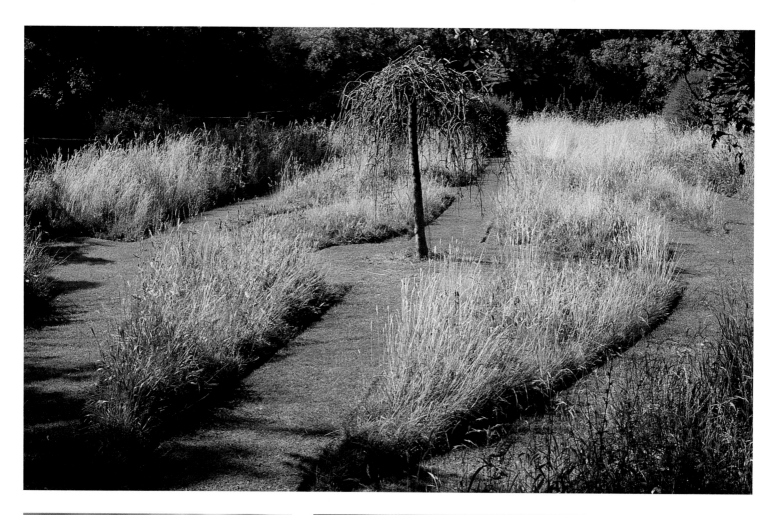

TOP Rhythms and patterns have been incorporated by applying different mowing regimes to certain parts of the garden so that spring bulbs get a chance to set seed. To prevent blurring of the edges of the beds, the turf is cut around the edge of each.

BOTTOM LEFT The pretty pink tints of honesty's newly formed seed pods will gradually fade to translucent white.

BOTTOM RIGHT Leek flower pods burst out of their papery sheaths.

OPPOSITE A stone path leading to the gazebo is lined with elecampane, *Inula helenium*, and the magnificent giant bistort, *Persicaria polymorpha*.

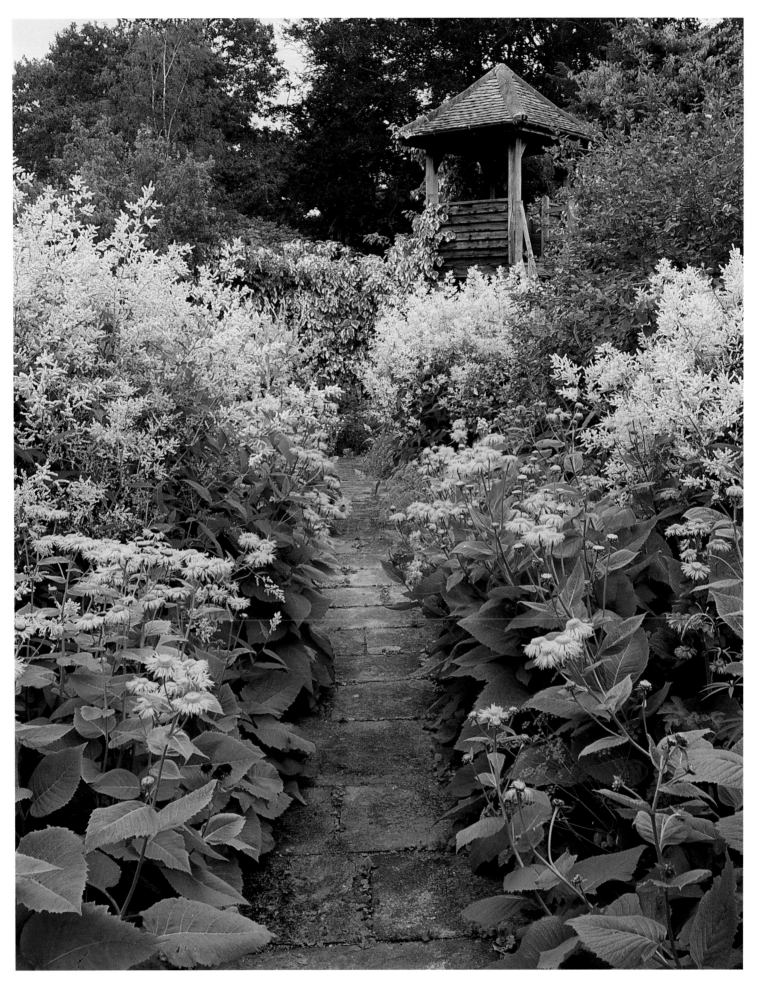

80

Hummelo

The Dutch garden designer Piet Oudolf trained as an architect, and he fills his schemes with multiple layers of structure, form and texture that together create garden tableaux with a year-round dramatic impact. In the garden that he and his wife, Anja, share at Hummelo in The Netherlands, his bold and innovative approach to planting is apparent from the asymmetric delineation of space and the fine details of his exquisite plant combinations. Yew hedges are pruned in undulating waves with the effect of overlapping stage curtains that blur the otherwise sudden boundary at the bottom of the garden. Cylindrical columns of yew and *Pyrus salicifolia*, silver-leaved pear, contrast with the delicate outlines of massed perennials. Each plant is chosen to enhance its neighbour, so diaphanous veils of *Stipa turkestanica* partner dark-purple globes of *Angelica gigas*, while the cascading tiers of the catkin-like *Sanguisorba tenuifolia* grow next to sturdy Joe Pye weed.

RIGHT The deep-red, domed, corymb-like panicles of Joe Pye weed and fluffy pink *Filipendula rubra* 'Venusta Magnifica' are tall accents in a rich mixed planting that looks towards the interlocking wave pattern of yew hedges.

OPPOSITE, TOP The dramatic geometric shapes of topiary, hedges and pattern of beds give the garden a solid structure against which the planting is shown to advantage. A flat-topped barrel of yew is juxtaposed with a staggered bracelet of brick and yew filled with a mound of *Miscanthus sinensis* 'Malepartus' ringed by *Carex muskingumensis*.

OPPOSITE, BOTTOM A brick-edged bed set asymmetrically into the lawn is filled with the soft and silky silver-leaved *Stachys byzantina* 'Big Ears' with accents of the bright red day-lily *Hemerocallis* 'Pardon Me'.

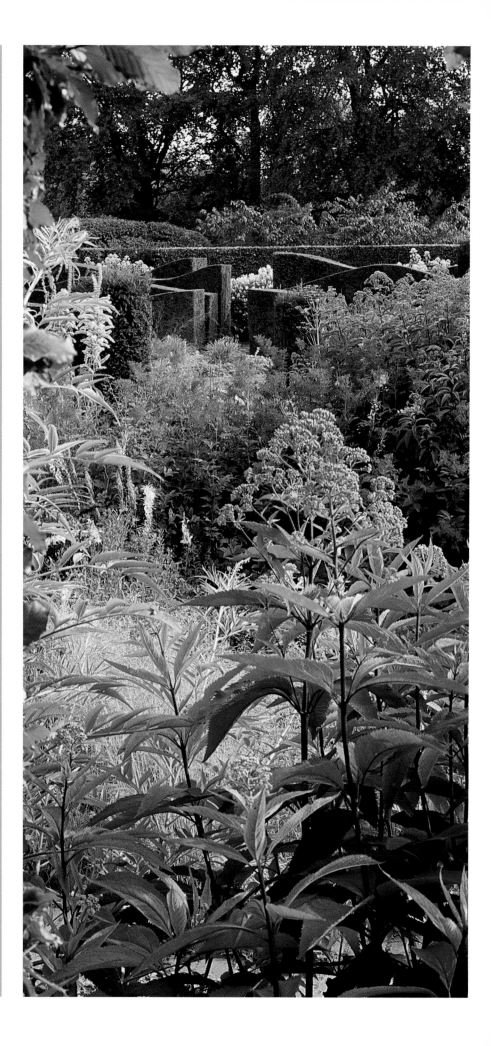

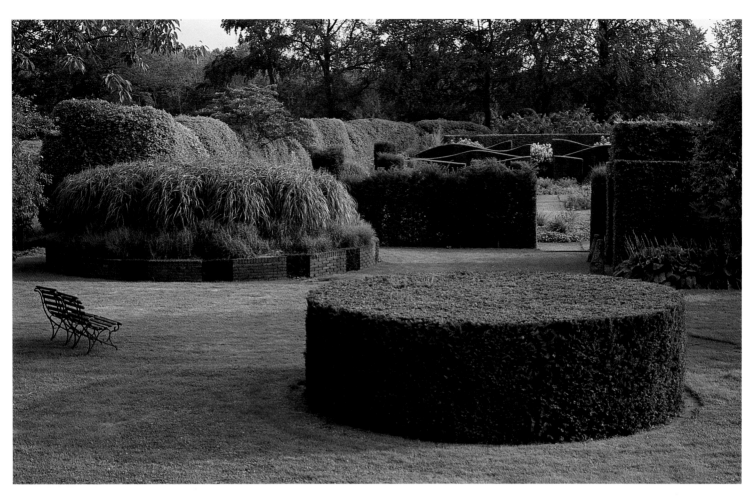

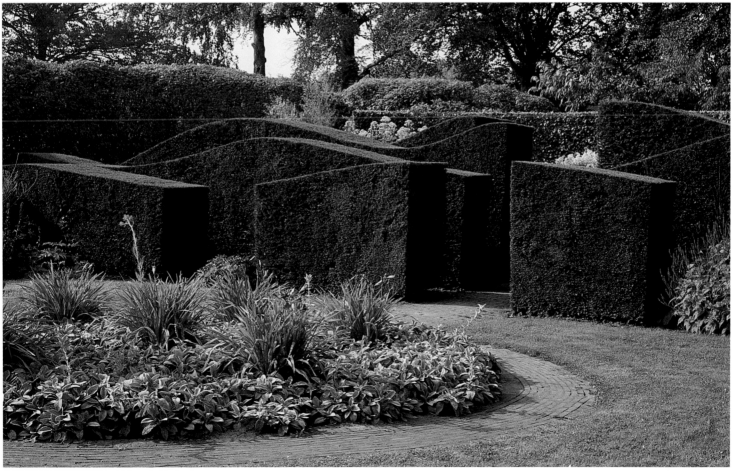

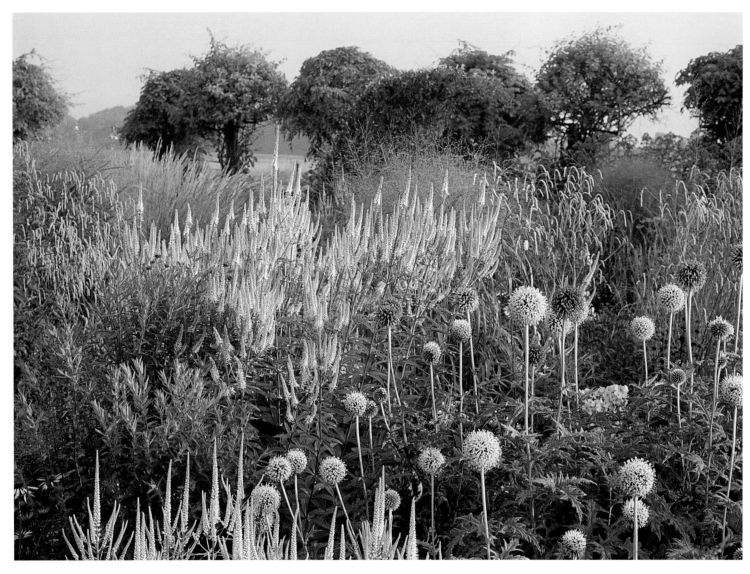

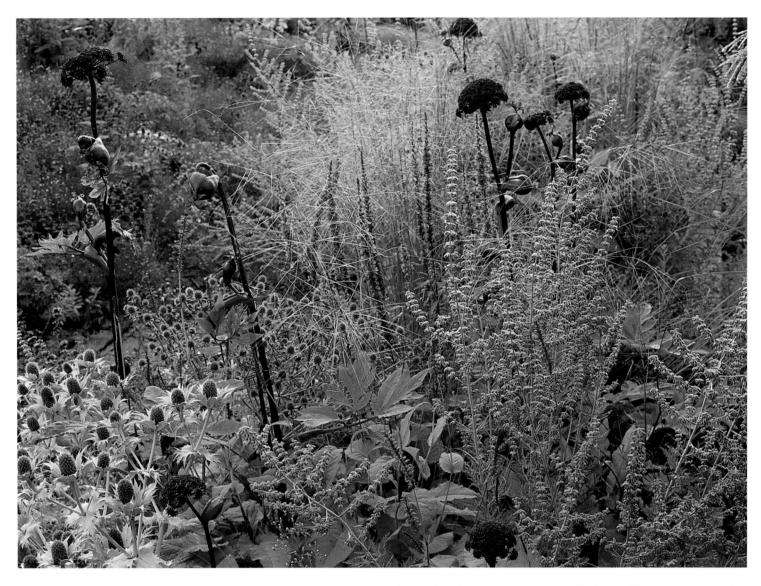

OPPOSITE, TOP The Oudolfs' stock beds in the nursery make exuberant borders and showcase Oudolf's juxtapositions of plant shapes. These include the globes of *Echinops sphaerocephalus*, spires of *Veronicastrum virginicum* 'Fascination' and the wispy, tumbling flowers of *Sanguisorba tenuifolia* 'Alba'.

OPPOSITE, BOTTOM, LEFT TO RIGHT *Sanguisorba tenuifolia* 'Alba' with sturdy Eupatorium; *Echinacea purpurea* 'Magnus' separated from bright bergamot, *Monarda* 'Purple Ann', by arching fawn wands of *Calamagrostis brachytricha*; *Angelica gigas* rising through *Stipa turkestanica*.

TOP The spires of pink loosestrife, *Lythrum salicaria* 'Stichflamme', blend with the soft-lavender Russian sage, *Perovskia atriplicifolia*, silver sea holly, *Eryngium giganteum*, and *Angelica gigas*. *Stipa turkestanica* threads through the plants.

RIGHT The evergreens' form is matched by the artful blend of plant shapes and colours. The red in the spires of *Persicaria amplexicaulis* is picked up in *Helenium* 'Kupferzwerg'; pink, purple and silver eryngium, loosestrife, *Lythrum virgatum*, and limonium are mixed with grasses.

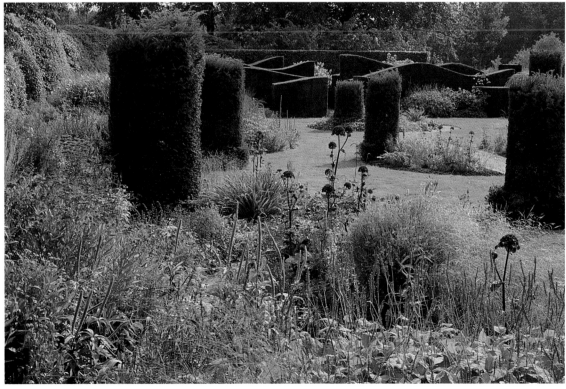

81

Breakspears Road, London

The south London garden designed for Biddy Bunzl by her partner, James Fraser, looks like one of Rousseau's jungle scenes come to life. Fraser has given the space a strong sense of unity by selecting plants mainly from his native New Zealand and constructing the hard landscaping from weathered boards of oak, elm and iroko in all shapes and sizes. Reclaimed lengths of water-weathered timber dredged up from the docks have made funky irregular decking, an eccentric front gate and a boundary trellis with a difference. Even the pond water is recycled down thin, algae-covered planks. The lush foliage of tree ferns, cordylines and banana plants contrasts with collections of feathery grasses pierced by the strange, rocket-like form of New Zealand's *Pseudopanax crassifolius*. A palette predominantly of greens and browns is varied by the spiky, silvery leaves of *Astelia chathamica* and a ferocious collection of agaves in pots.

RIGHT, TOP A trailing squash spills over the fence on to the pavement beside the wacky front-garden gate, flanked by a pair of elm jetty posts reclaimed from the docks in east London.

RIGHT, BOTTOM The outdoor dining table, made, like the chairs, from salvaged wood, holds a collection of architectural plants in clay pots.

OPPOSITE, TOP A jungle-like mood exists in the back garden, where variations in foliage, form, colour and texture are played off between groups of plants. Tall, tawny grasses flourish among lush tree ferns, spiky cordylines and the toothed lancewood tree, *Pseudopanax ferox*.

OPPOSITE, BOTTOM LEFT Seen from an upstairs window, the dense tapestry effect of the planting contrasts with the quiet seating areas.

OPPOSITE, BOTTOM RIGHT Water drips into the pond off a pair of algae-encrusted wooden planks, giving a constant but gentle natural sound.

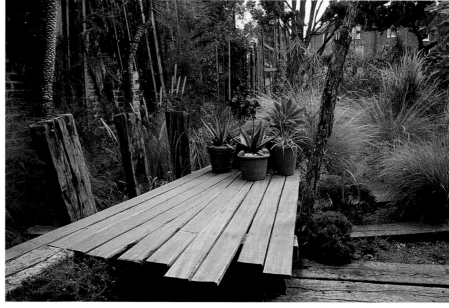

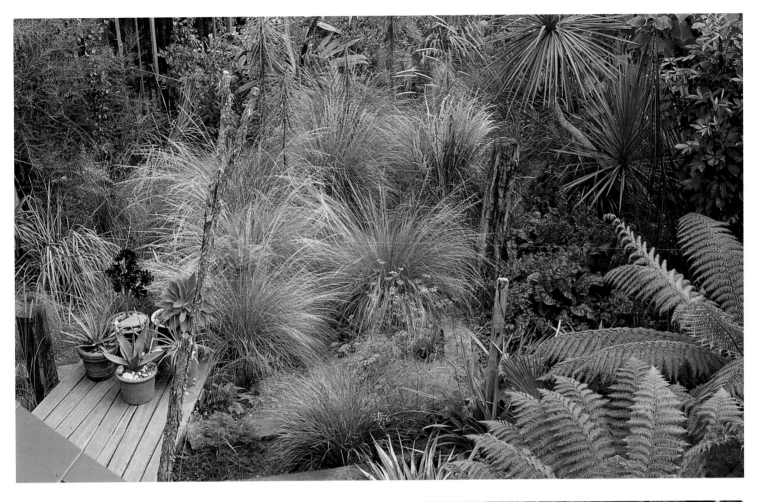

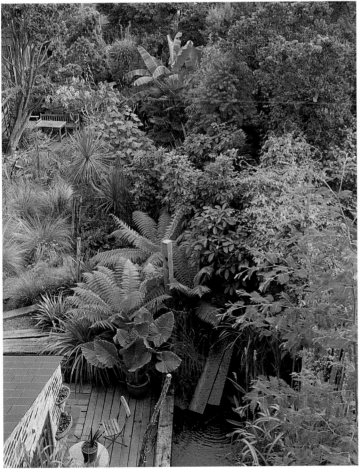

82

Barton Court

Terence Conran, fixer, mover and shaker in the design and restaurant worlds, is well known for his passion for good seasonal food. He is a *bon viveur* by conviction: what you eat, the clothes you wear and the furniture you live with should combine beauty, quality, practicality and simplicity. A place where all these characteristics come together is the restored walled garden of his country house. This is a productive kitchen garden, where food is grown for the table, not just for show. His wife, Vicki, keeps bees that pollinate the blossom on the apple trees, which are trained as arches and low, step-over hedges to delineate paths. Apple, plum, peach, pear and apricot trees are fan-trained against warm brick walls, and forcing pots provide early sticks of rhubarb. In spring the staging in the rejuvenated glasshouses is covered in pots of seedlings, and come autumn lifted onions line the shelves beneath clusters of borlotti beans hung up to dry. This is a garden devoted to taste in both senses.

RIGHT, TOP Arches loaded with apples span the gravel path that bisects the walled garden.

RIGHT, BOTTOM Ornamental cardoons are partnered by sunflowers, the seeds of which, in winter, attract birds that feed also on slugs and snails.

OPPOSITE, TOP Plants selected to attract pollinating insects and to increase the garden's decorative impact are kept in borders outside the cultivated vegetable beds. They include English lavender, *Lavandula angustifolia*, the robust Aaron's rod, *Verbascum thapsus*, bronze fennel, *Foeniculum vulgare* 'Purpureum', and the giant cardoon, *Cynara cardunculus*, seen in flower behind.

OPPOSITE, BOTTOM Sweet peas, and late beans for successional cropping, are grown up bamboo-cane wigwams circled with twine. A line of canes is covered in runner beans. Terracotta forcing pots stand on the path beside vigorous clumps of rhubarb, and a crop of leeks grows in one of the plots.

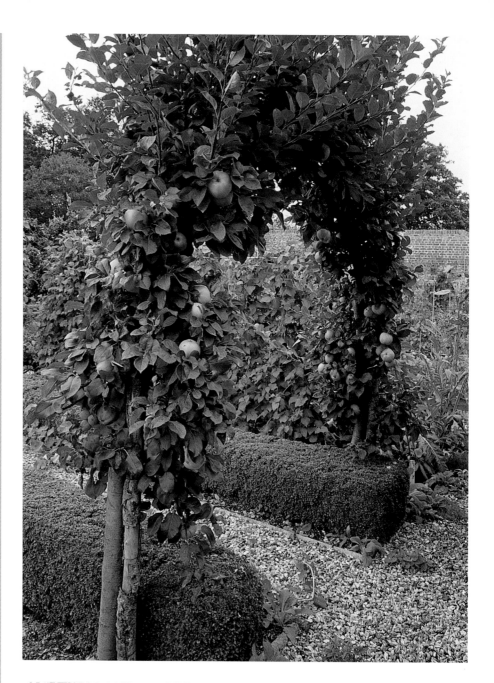

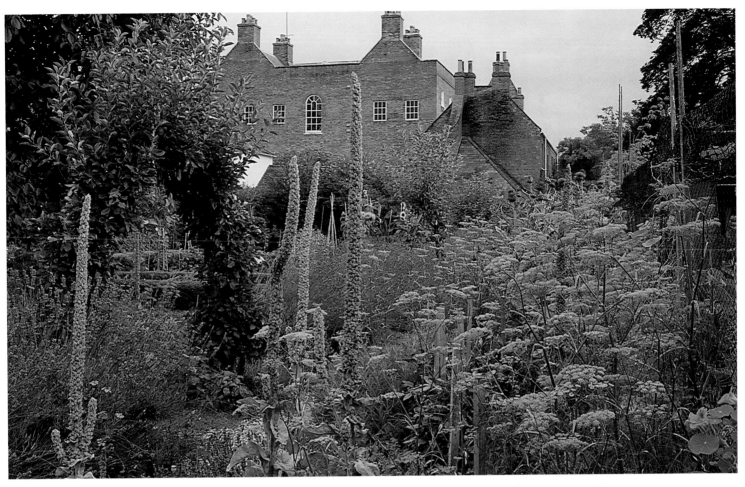

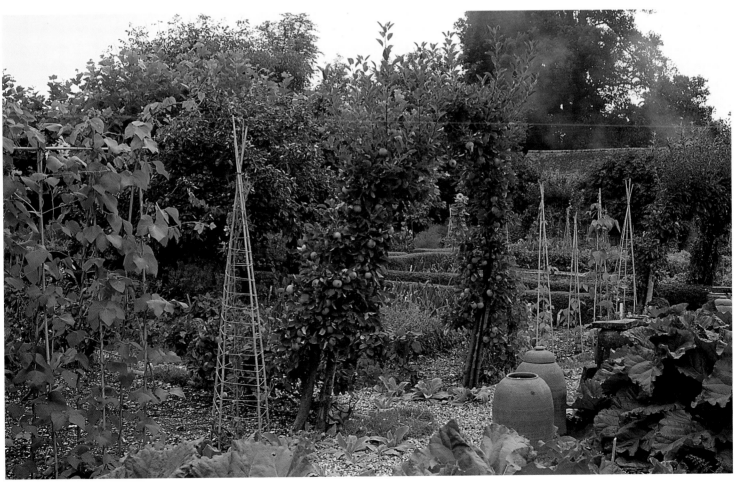

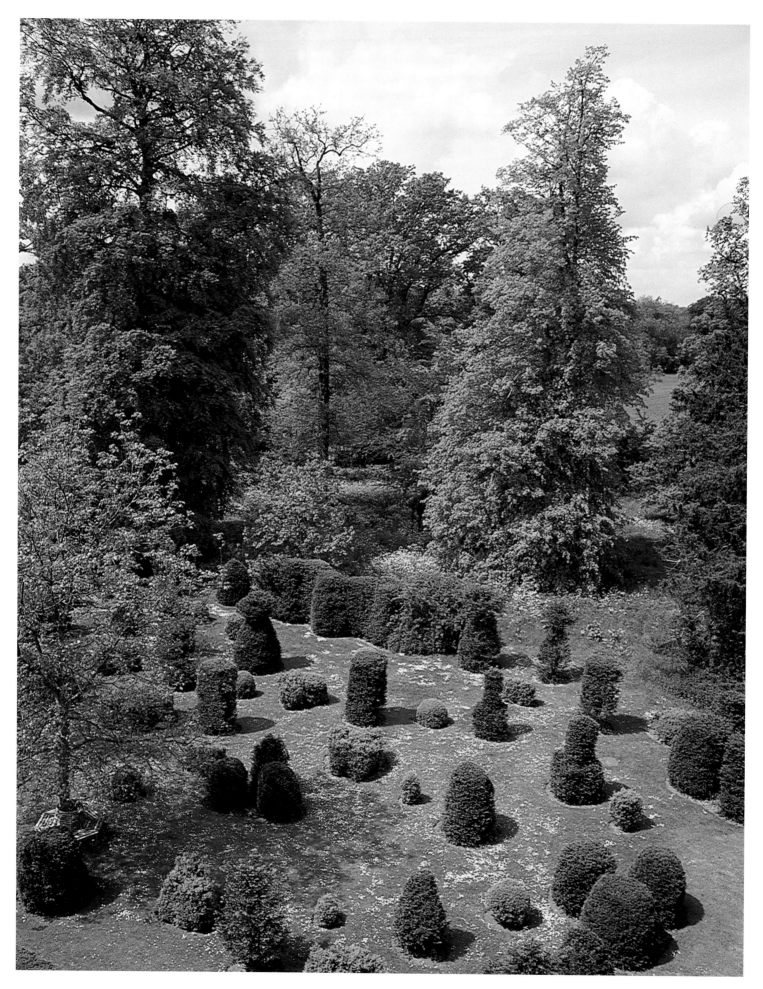

OPPOSITE In early summer the abstract forms of topiary rise out of a lawn that is spangled with daisies, while cow parsley grows around the mature trees in the park beyond.

TOP LEFT Red and white onions are laid to dry on shelves in the greenhouse.

TOP RIGHT Borlotti beans are lifted with their rootballs intact and hung to dry.

BOTTOM LEFT A path in the centre of the kitchen garden is edged with step-over apples and *Sedum acre.*

CENTRE RIGHT The crimson-and-green pods of borlotti beans look vibrant against a mellow brick wall.

BOTTOM RIGHT Pumpkins and squashes such as the green-and-white-striped 'Sweet Dumpling' and 'Yellow Bush Scallop' are stored on shelves without touching one another and remain good to eat all winter.

83

Lower Mill House

Until they retired, Robert and Maryrose Hodgson used their millhouse as a store for oats, wheat and barley. When the sympathetic conversion of the handsome brick building into a living space was complete it followed that the garden needed equally sensitive handling. Jinny Blom created a garden with ingredients that marry the house to the setting by means of a simple design of red-brick paths surrounded by plants that themselves originate in meadows. Silver-leaved willows lining the brook beyond the garden's boundary are echoed within it by the coyote willow, *Salix exigua*, which will create a feathery canopy above the perennials. A mixed hedge of roses, hawthorn, viburnum and privet will hide the rabbit-proof fence but be kept low by grazing horses to maintain a view that connects the garden to the adjoining meadow. Boldly repeated clumps of bronze fennel, *Knautia macedonica* and sedums combined with the upright grass *Calamagrostis* × *acutiflora* 'Karl Foerster' impart a sense of rhythm throughout the planting.

RIGHT, TOP *Digitalis ferruginea*, which matches the vertical thrust of the brick millhouse, is accompanied by *Verbena bonariensis* and bronze fennel, *Foeniculum vulgare* 'Purpureum'.

RIGHT, BOTTOM *Knautia macedonica* and *Sedum telephium* 'Matrona' provide a striking colour contrast.

OPPOSITE, TOP A mature elder acts as a focal point at the end of the garden, which is bordered by the river. Straight and narrow paths opening into large brick circles produce an impression of rhythm and space.

OPPOSITE, BOTTOM LEFT Behind *Knautia macedonica* and *Foeniculum vulgare* 'Purpureum' is part of a timber-and-rope support for honeysuckle and roses. This makes an informal screen between the garden and the meadow and contributes to the garden's circular theme.

OPPOSITE, BOTTOM RIGHT A cluster of *Digitalis ferruginea*.

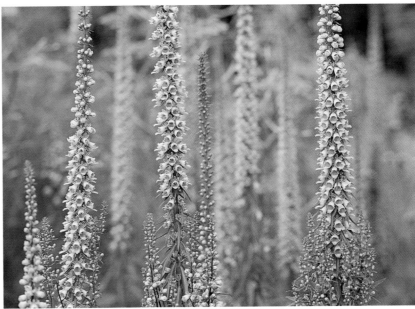

84

Hadspen

Nori and Sandra Pope wanted the garden at Hadspen in Somerset to reflect their twin passions for music and colour, Bach and blues, Monet and Rothko. In the sloping, D-shaped 1.6-hectare (4-acre) walled garden, 0.8 km (½ mile) of brick walls 3 m (10 ft) high supplied a background of mottled ochres, burnt sienna and colours suggestive of apricots, peaches and plums, in front of which a kaleidoscope of planting was orchestrated. The couple laid out the garden, which is no longer in existence, like a series of musical movements, each denoted by its own colour theme but blending subtly into the next. In this garden, which was open to visitors from hellebore season to sunflower time, foliage and form were on an equal footing with colour, keeping the compositions vibrant, as when, for example, tulips and poppies were being replaced with dahlias and cosmos. This was intensive gardening for dramatic effect, every bit of space dextrously packed with bulbs and annuals, perennials, shrubs, climbers and vegetables, all performing in a harmony of carefully selected colours.

RIGHT The season of interest in the colour-themed borders was extended by mixing a range of annuals that matched the colour of each section with the permanent planting of shrubs, roses and perennials. Here a trio of plants from the daisy family – *Rudbeckia hirta* 'Toto', coral *Zinnia peruviana* and the taller burnt-orange *Tithonia rotundifolia* 'Torch' – crackle with colour opposite the scarlet *Dahlia* 'Bishop of Llandaff'.

OPPOSITE The parabolic curve of a wall that the Popes originally saw as perfect for ripening fruit was instead exploited as a background for a colourwheel border that ranges from purple to pink and peach.

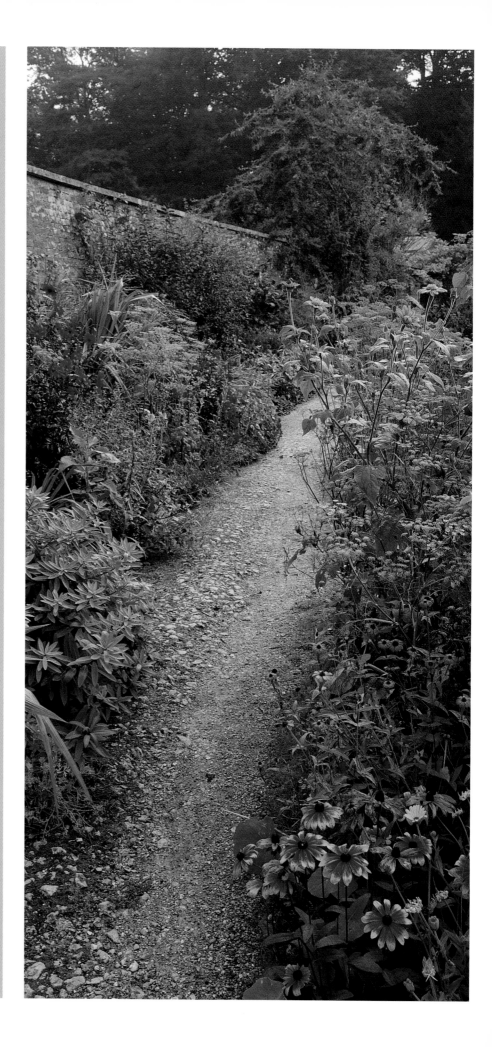

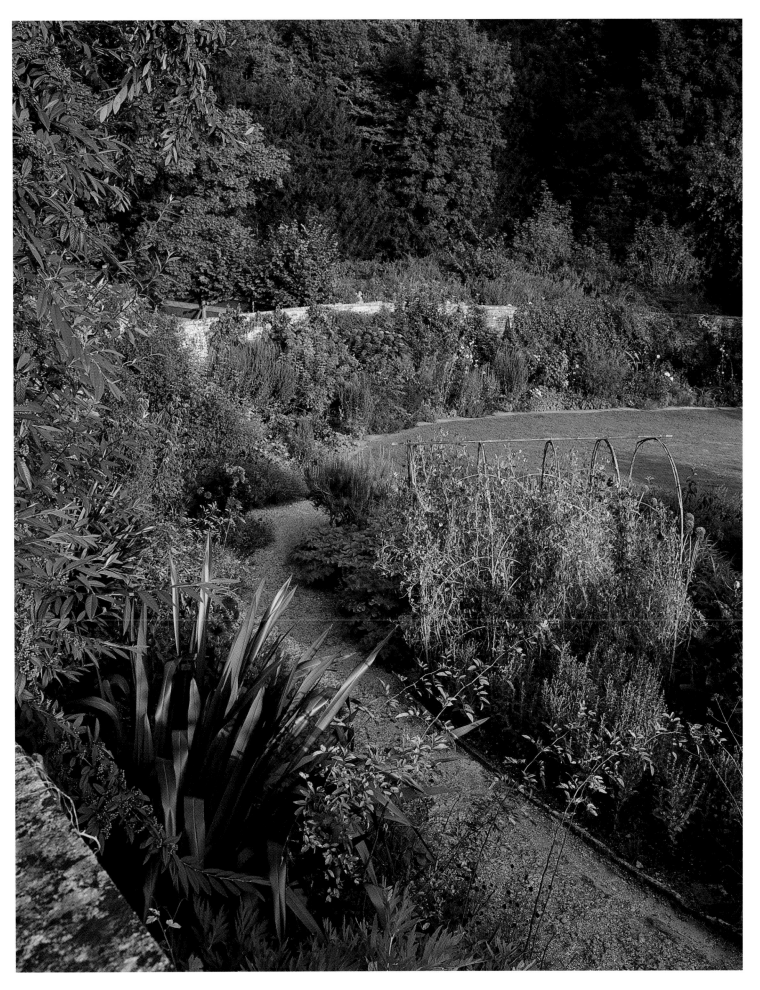

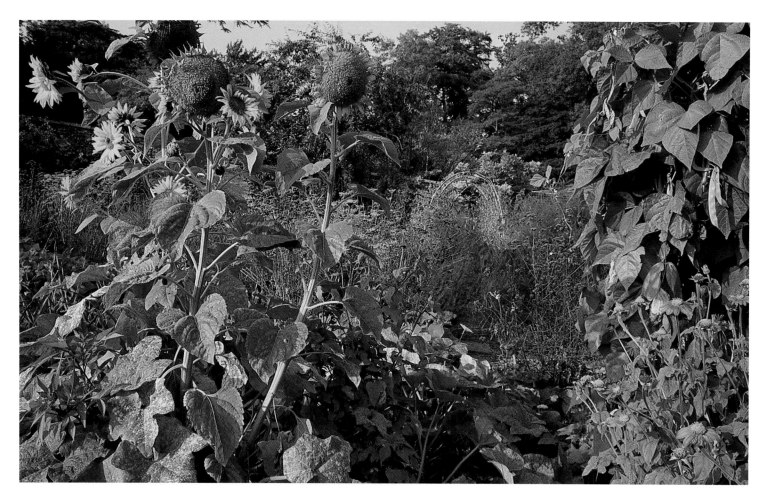

TOP *Helianthus* 'Russian Giant', *Tithonia rotundifolia* 'Torch', squashes and a wigwam of runner beans frame the path that leads to a bamboo tunnel of sweet peas.

ABOVE *Anemone hupehensis* var. *japonica* 'Prinz Heinrich'.

RIGHT *Anemone hupehensis* 'Hadspen Abundance'.

OPPOSITE, TOP *Paulownia tomentosa*, pruned hard every year so that it develops larger leaves, punctuates the beginning of the colourwheel border, along with pale-lemon *Alcea rugosa* and towering *Oenothera glazioviana*.

OPPOSITE, BOTTOM Claret-leafed beetroot 'Bull's Blood' with fennel seed heads and *Verbena bonariensis*.

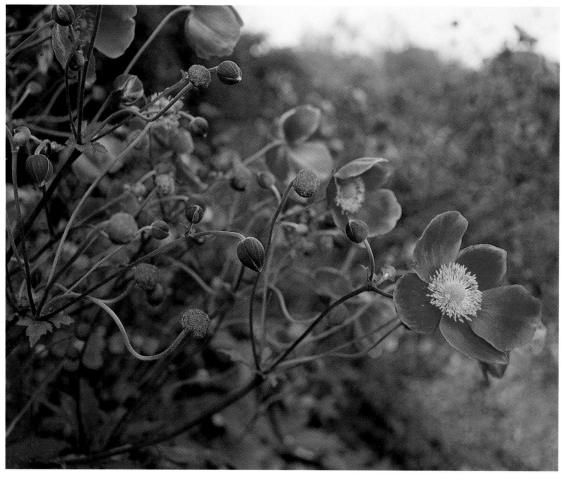

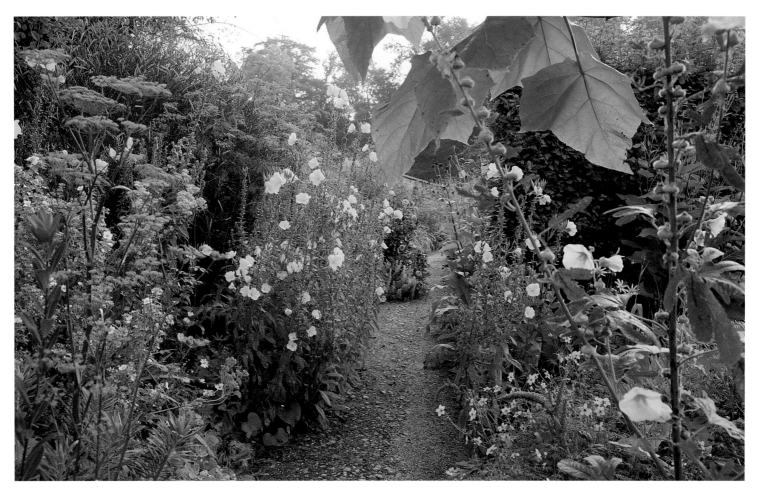

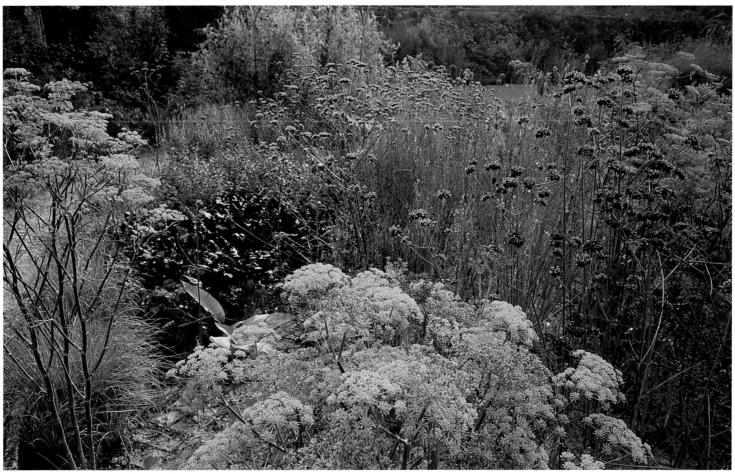

Bamboo Garden

The Czech-born, Sydney-based landscape architect Vladimir Sitta creates gardens that are full of drama and mystery. These are notable for an innovative use of planting and for hard materials laid out with great attention to detail. The water lying like a film of mercury on this rectangular, black-marble pool is a mirror to the sky, bringing light to the floor of the shady courtyard while emphasizing the upward thrust of the clean-stemmed bamboos. Bands of hummock-forming helxine run between stretches of gravel and grey marble. Juxtaposition of hard and soft is also expressed in another garden by a low line of arching Japanese reed grass, *Ophiopogon japonicus*, planted between the base of a brick wall and a limestone-edged canal. Sitta also uses misting devices to soften stone and lend an ethereal quality to his designs, which at night take on a new life through atmospheric lighting.

RIGHT AND OPPOSITE, TOP Oriental simplicity comes together with technical wizardry in this Sydney courtyard garden, where rectangular bands of gravel are broken up by lines of green helxine, *Soleirolia soleirolii.* The colonizing tendency of this rampant self-seeder is held in check by a thin edging of grey marble. The sparse but strategic planting of black- and green-stemmed bamboo, *Phyllostachys nigra* and *Phyllostachys nigra* var. *henonis*, creates a dynamic vertical contrast to the low horizontal paving and mirror pool that is enhanced by pruning side shoots off the canes until they reach a certain height. At night judicious lighting retains the mirror effect of the water in the polished black-marble pool.

OPPOSITE, BOTTOM In another Sydney garden water runs over a symmetrically carved granite chute into a jade-green canal that has a variety of moods, depending on whether the misting device and uplighting are in use. Uplighting is also used to heighten the dramatic effect of the black-stemmed bamboos.

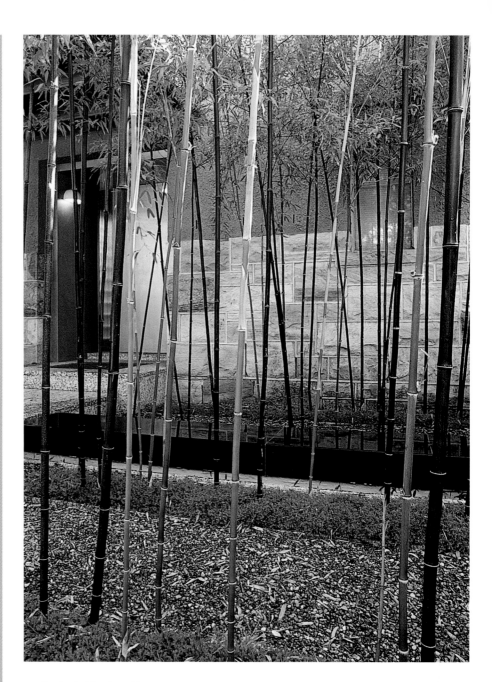

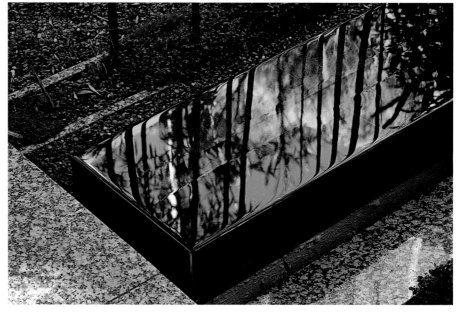

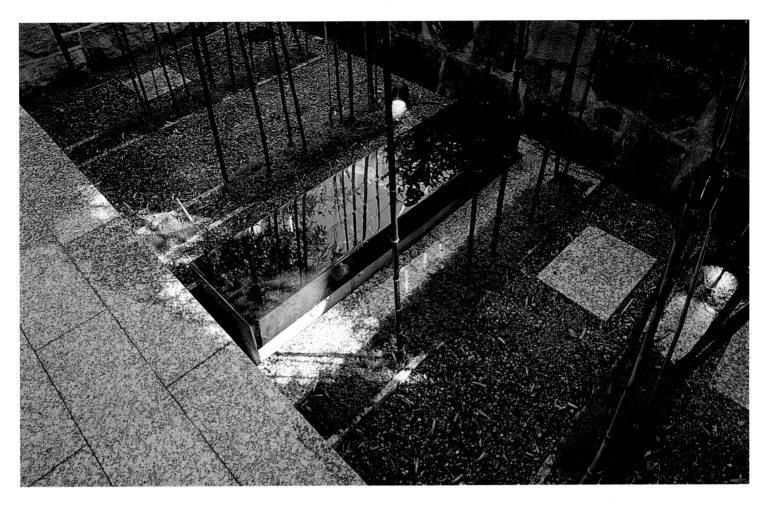

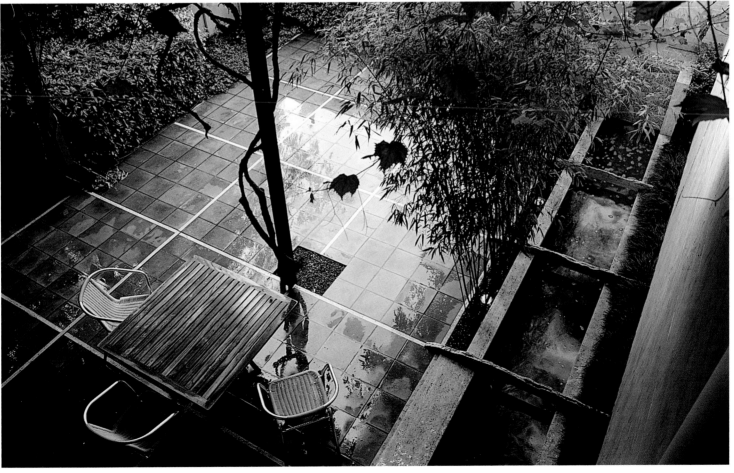

Great Dixter

The legacies to horticulture of Christopher Lloyd (1921–2006) are manifold. He produced volumes of incisive writing on the art of gardening and gardening as art. His persuasive belief that innovation and boldness matched by a keen eye and the highest standards of horticulture were essential to the creation of interesting gardens inspired generations of gardeners. Great Dixter was both artist's studio and laboratory in which his powers of observation were tuned as much to the aesthetic possibilities of plant combinations as to the conditions and nurturing necessary to keep plants healthy. The pictures here show plant associations devised with Fergus Garrett that contain all Lloyd's favourite characteristics: good form, foliage, texture and flower power, colour and vibrancy. Tulips and wallflowers in spring would morph by clever planning into brilliant cannas and dahlias for summer and autumn. In the herbaceous border, meadow buttercups would blend with scarlet oriental poppies and magenta cranesbill.

The riot of colour and texture in the old rose garden is to gardening what couture is to clothes in its immense attention to detail and skilful arrangement of tender and half-hardy plants. The giant green-leaved rice-paper plant, *Tetrapanax papyriferus*, is grouped with the tricolour *Canna* 'Durban', ferns, *Dahlia* 'Moonfire' and the twining *Ipomoea lobata*. Foliage is considered to be just as important as flowering.

LEFT, TOP A stupendous array of plants in pots from the greenhouse decorates the porch all year round. In late summer the mixture includes begonias, scented lilies, cannas, tagetes, *Argyranthemum maderense* and *Gladiolus murielae*.

ABOVE, FROM TOP *Dahlia* 'Hillcrest Royal'; *Dahlia* 'Moonfire'.

LEFT, BOTTOM *Dahlia* 'Wittemans Superba' with *Salvia involucrata* 'Bethellii'.

OPPOSITE Great wands on naked stems of *Cyperus papyrus*, which the ancient Egyptians dried to make a form of paper, is used as a delicate foil to the flapping, sail-like leaves of the banana plant, *Musa basjoo*, seen here with *Canna* 'Durban'.

87

Maryland

The owners of this recently remodelled eighteenth-century colonial-style house set beside a tributary of the Chesapeake in Maryland desired a garden that would artfully merge the house with the surrounding landscape. They wanted an informal but glamorous space in which to relax, entertain and watch the world go by across the water.
By commissioning the landscape architects OvS, headed by partners Wolfgang Oehme and James van Sweden, the Washington-based masters of matching a house to its wider landscape, they got exactly what they wanted. The practice is primarily known for its bold use of grasses and perennials, situated *en masse* in drifts for a naturalistic effect, but this garden displays another OvS hallmark: its skill with the siting of water. The sweeping oval pool, reflecting the house and the sky like a sleek sheet of mirror, is exquisitely set against the backdrop of the river.

RIGHT *Pennisetum alopecuroides* in front of a vigorous swath of *Calamagrostis* × *acutiflora* 'Stricta'.

OPPOSITE, TOP The mirror-like water in the oval pool reflects the colonial-style house and the surrounding planting. Its reflective quality makes it an integral feature of the garden even when it is not being used as a swimming pool.

OPPOSITE, BOTTOM Sections of tumbled brick interspersed with bands of Pennsylvania bluestone surround the pool and make a generous, level space for entertaining and lying out in the pool chairs designed by James van Sweden. The juxtaposed waters of the pool and the wide river are separated but also united by a band of *Pennisetum alopecuroides* – an OvS masterstroke.

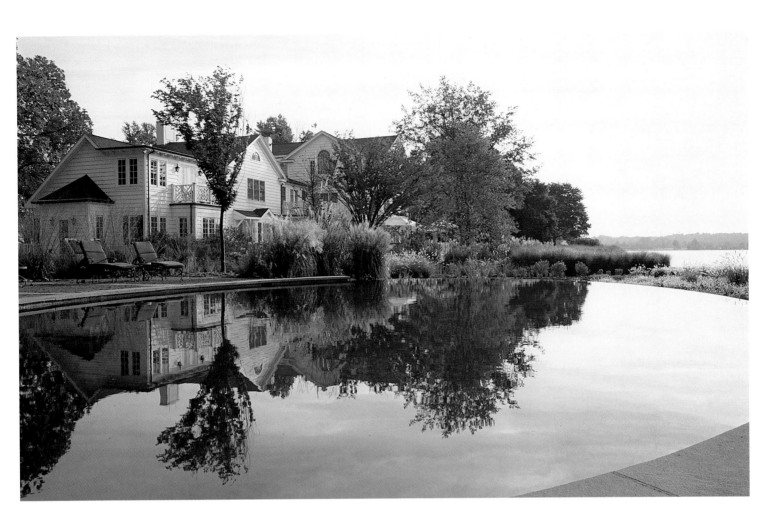

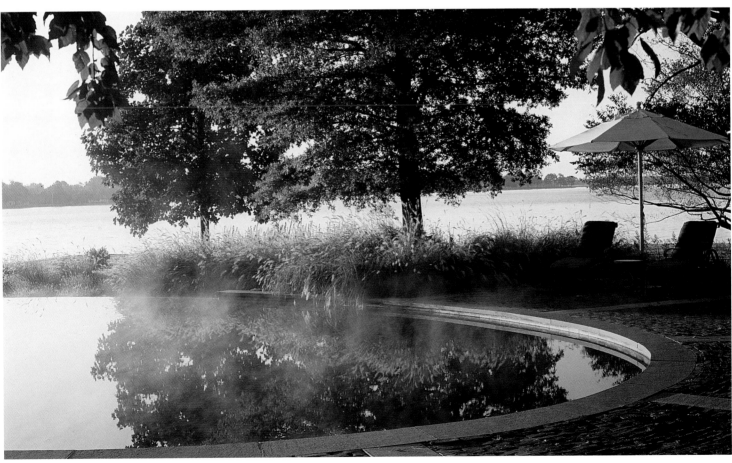

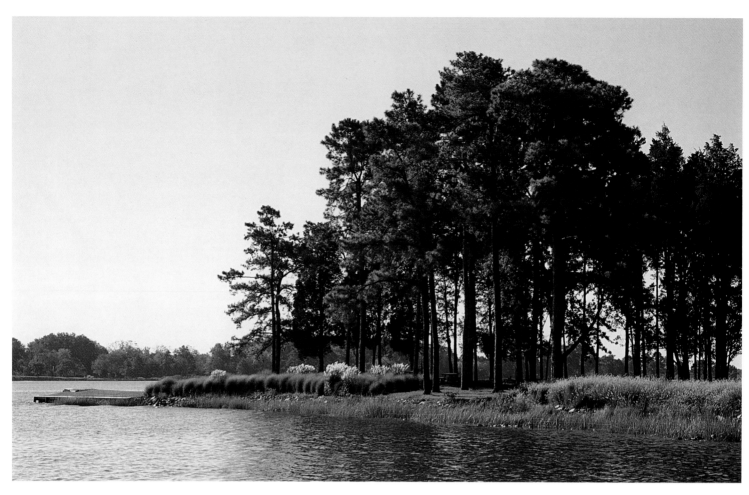

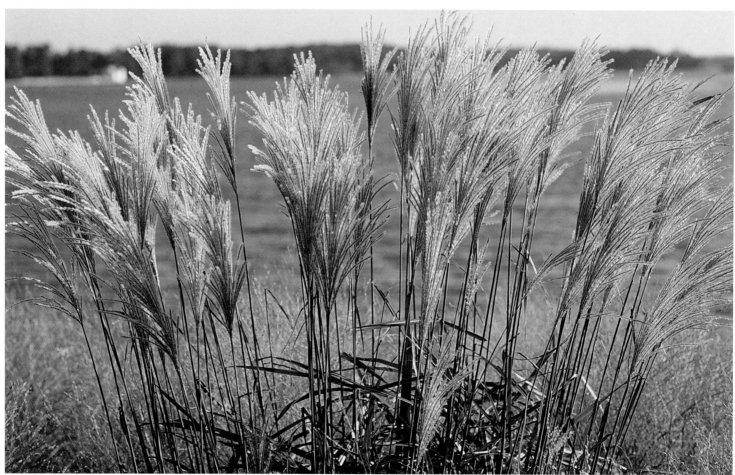

OPPOSITE, TOP Drifts of ornamental grasses merge the garden with the shoreline, looking as though they were the natural partners to the mature native conifers that tower over them.

OPPOSITE, BOTTOM With the river as a backdrop, *Miscanthus sinensis* 'Rotsilber' punctuates the planting on the shoreline, rising high above *Panicum virgatum* 'Rotstrahlbusch'.

BELOW, FROM TOP *Pennisetum alopecuroides* is used extensively in the garden: swirling along the drive, around the swimming pool and spreading in drifts down to the river; *Miscanthus sinensis* 'Rotsilber' grows beside a white-painted picket fence near the house.

RIGHT A millstone from Thailand adds strong sculptural impact under a mature oak that stands beside a mass planting of *Miscanthus sinensis*.

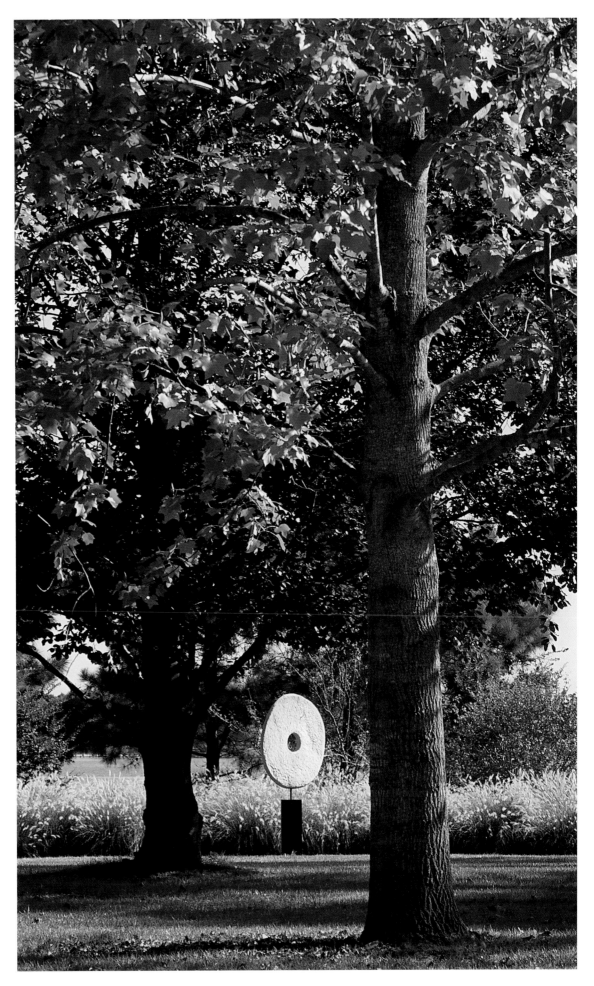

88

Bingerden

Eugenie van Weede's garden at Bingerden in The Netherlands is a mixture of old and new. The Monks, as the majestic yew sculptures set in an emerald lawn are known, date back to long before the hundred-year-old yew hedges that contain them. By comparison, the flower-filled parts of the garden are young but full of interesting theatrical touches and imbued with a joyful atmosphere. The Happy Borders in the Children's Garden are so called for the riotous mix of scarlet and yellow flowers, seen to great effect against an arbour of copper beech. The kitchen garden is as much a cut-flower garden as a source of vegetables, and new combinations are tried out each year. Among these, a favourite is a single, dark-pink opium poppy mixed with black-flowered cornflowers and lavender-blue *Phacelia tanacetifolia*. Elsewhere in the garden the deep aubergine colour of *Angelica gigas* contrasts dramatically with filigree bronze fennel and the rich red of *Crocosmia* 'Lucifer'.

RIGHT, TOP A riot of annuals grows in the kitchen garden amid salad plants. Many forms of marigold, hollyhock, cosmos, zinnia and pale-yellow double forms of the corn marigold, *Chrysanthemum coronarium*, flower from summer until winter in front of the greenhouse.

RIGHT, BOTTOM In the Children's Garden a copper-beech arbour is the backdrop to bright-scarlet roses, *Phlomis russeliana* and heucheras.

OPPOSITE, TOP *Tagetes tenuifolia* 'Starfire Mixed' and *Zinnia angustifolia* covered with starry egg-yolk-yellow flowers are ranged in front of wigwams smothered in morning glory, *Ipomoea tricolor* 'Heavenly Blue'.

OPPOSITE, BOTTOM LEFT Dark-pink single opium poppies are planted with *Phacelia tanacetifolia* and the black-flowered cornflower *Centaurea cyanus* 'Black Ball'.

OPPOSITE, BOTTOM RIGHT The intensely red *Helenium* 'Bruno' is combined with the purple-stemmed cow parsley *Anthriscus sylvestris* 'Ravenswing'.

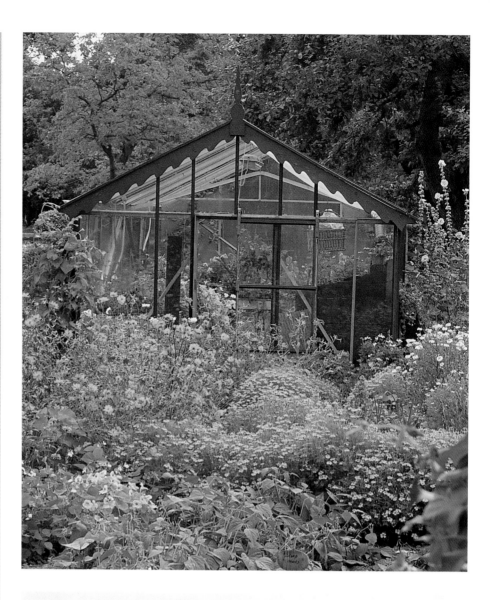

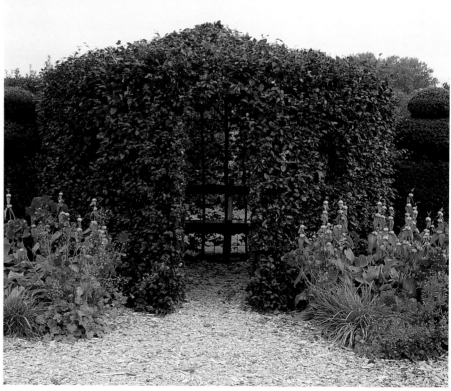

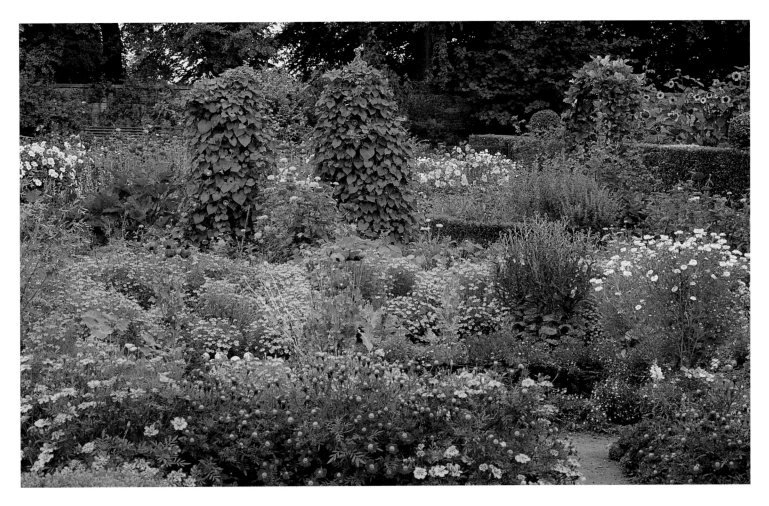

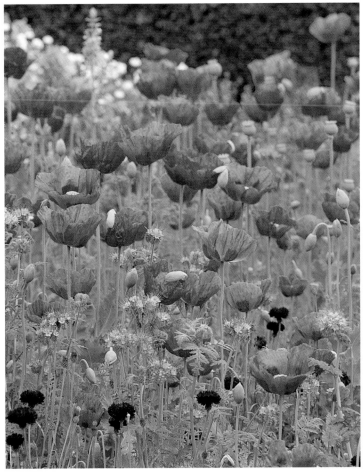

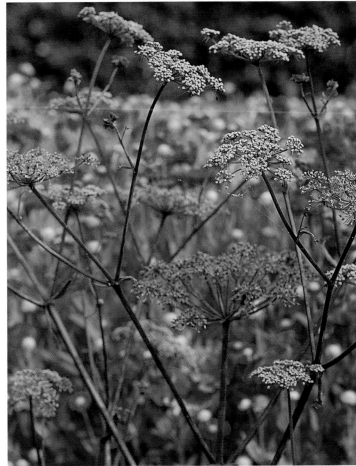

89

Bury Court

This garden designed by Piet Oudolf for John Coke at Bury Court, at Bentley in Hampshire, is noticeably different from the one on the other side of the house, designed by Christopher Bradley-Hole (see pp. 322–23), yet the two areas subtly complement each other and are united by their designers' use of bold structure and plants with extremely long seasons of interest. This is a garden as instructive and inspiring when seen as a whole from upstairs windows as it is on the ground, where you can admire details such as the camber of the granite sett paths or the gently spiralling topiary. The garden is divided into zones, each with its own character: a gravel garden with sun-loving silver-leaved plants, densely rich herbaceous plantings and some simple bands of ornamental grasses under trees. Oudolf's love of volumes and shapes is conveyed in both the layout and the details of the planting. Diaphanous grasses are planted next to stout colourful perennials with winter silhouettes that are judged to be as important as the plants' appearance when in flower.

RIGHT Upright golden sprays of giant oats, *Stipa gigantea*, are planted with the horizontal *Achillea millefolium* 'Lansdorferglut'.

OPPOSITE, TOP The garden is completely enclosed, on two sides by the L-shaped house, by a magnificent barn and by a long wall of stone and brick (not shown). The planted areas are balanced by an expanse of lawn, and the garden is traversed by a series of gently cambered paths of Belgian cobblestone, some of which are seen here.

OPPOSITE, BOTTOM LEFT A spider's web of clipped box lies beside a densely planted border holding a large proportion of ornamental grasses that soften the bulk of robust shrubs and perennials.

OPPOSITE, BOTTOM RIGHT The sloping spiral of tightly clipped yew at the end of the canal is echoed by the swirl of pink *Dianthus carthusianorum*, growing with bands of moor grass, *Molinia caerula* subsp. *arundinacea* 'Poul Petersen', that follows the sweep of the path's circular feature.

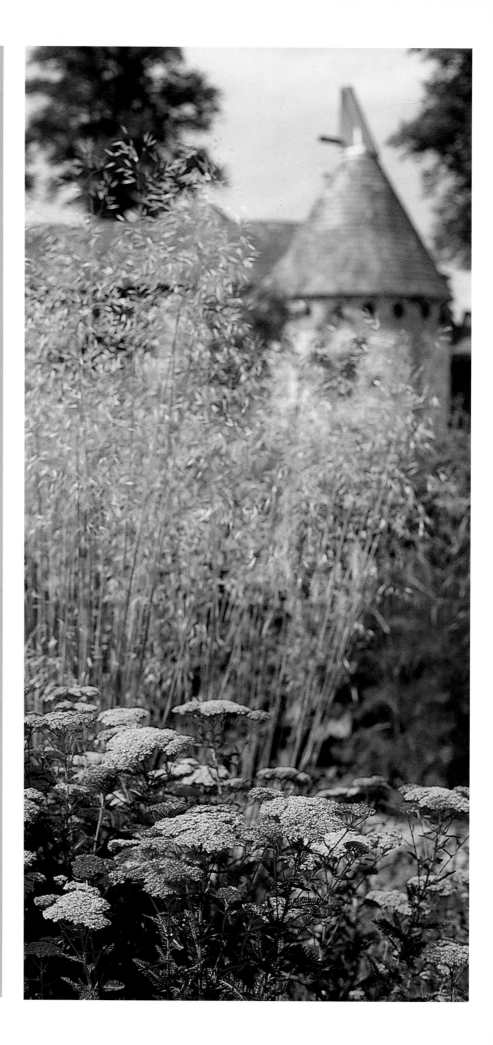

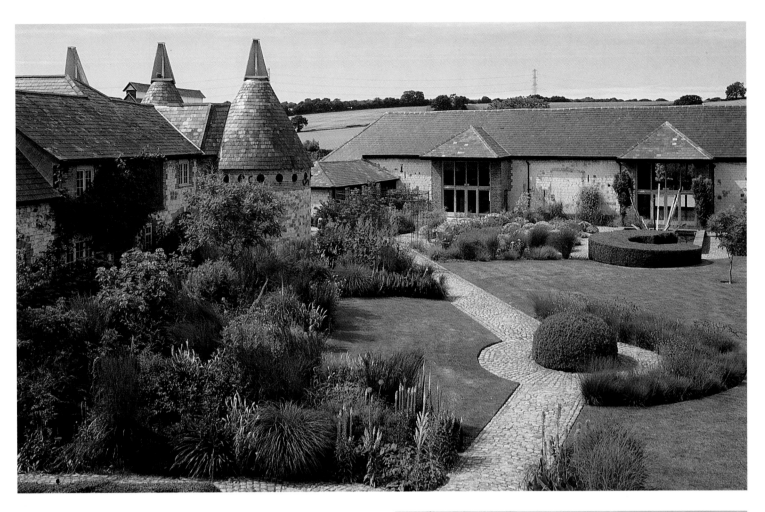

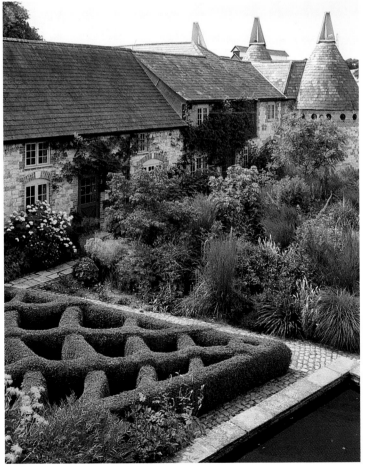

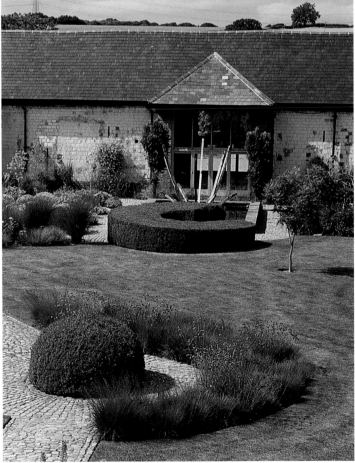

Cynthia and Edwin Hamowy Garden

Cynthia and Edwin Hamowy, the owners of this property in Westhampton, on Long Island, USA, saw their blank and disconcertingly overlooked suburban garden metamorphose into a tree-filled sanctuary in just a year. OvS, the Washington-based landscape-architecture partnership of Wolfgang Oehme and James van Sweden, recommended radical changes, so levels were altered, the driveway rearranged and the new layout extravagantly planted with great sweeps of herbaceous perennials and ornamental grasses. The single-storey house was whitewashed as part of the reorganization and the pool repainted a subtle dark blue. The luxuriant planting seen from the open-plan living-room with its wide sliding glass doors is an expanse of *Sedum* 'Herbstfreude', the russet flower heads bringing out the warm pink and brown tones of the multi-stemmed peeling paper bark birches, *Betula nigra* 'Heritage'. Large specimen trees and the phenomenally vigorous growth of such grasses as *Miscanthus sinensis* 'Rotsilber' created an air of maturity in a very short time.

Morning mist rises from the chic slate-blue pool. A delicate veil of *Molinia caerulea* subsp. *arundinacea* 'Transparent' screens the pool from the house but still allows a view of the dramatically peeling trunks of multi-stemmed *Betula papyrifera*, which are generously underplanted with *Liriope muscari* and *Sedum* 'Herbstfreude'. Pots holding agapanthus, trailing *Helichrysum petiolare* and fuchsias add accents of seasonal flowering.

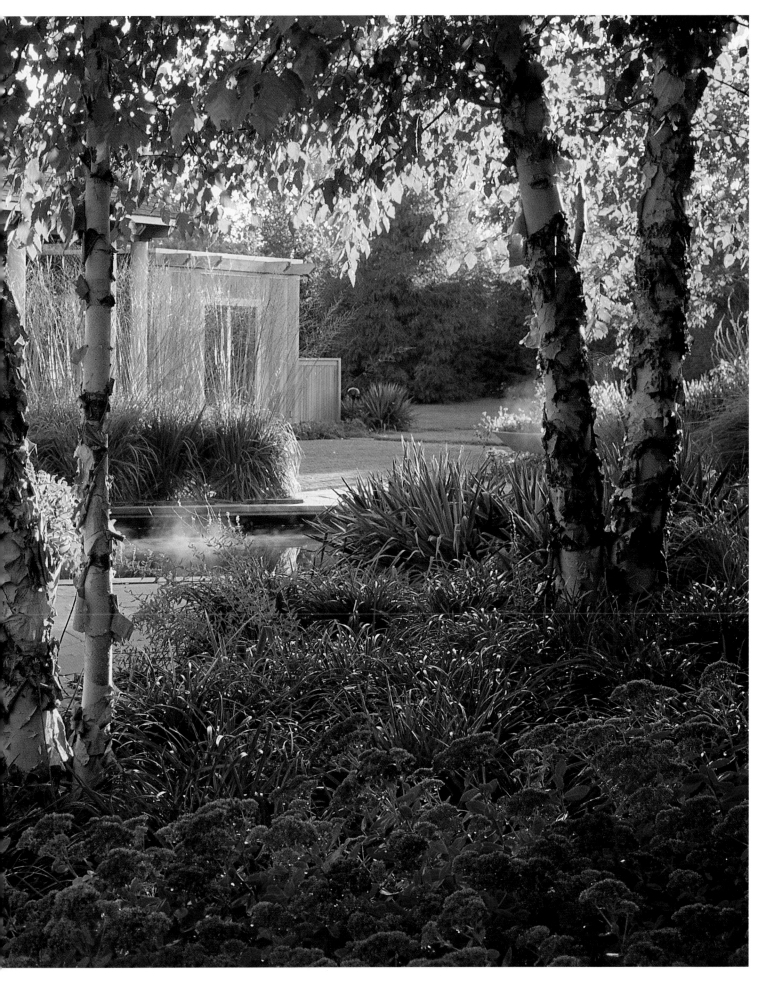

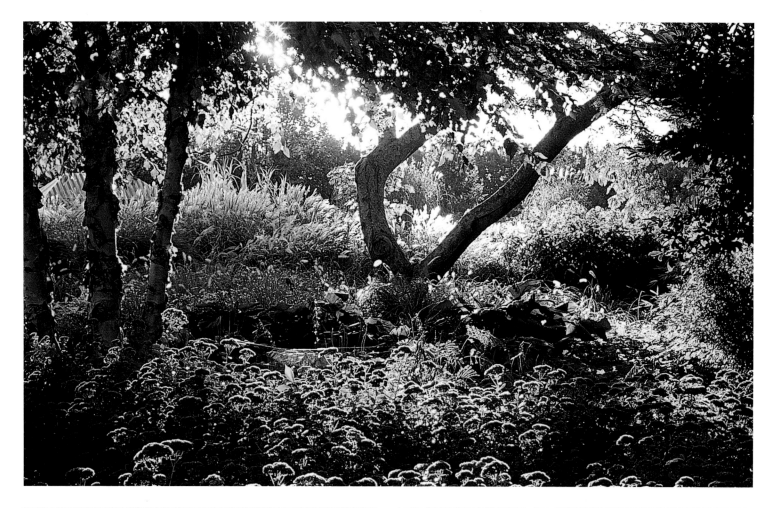

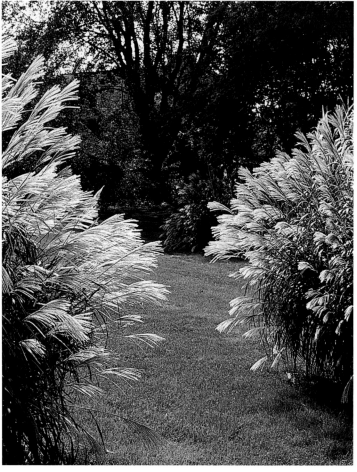

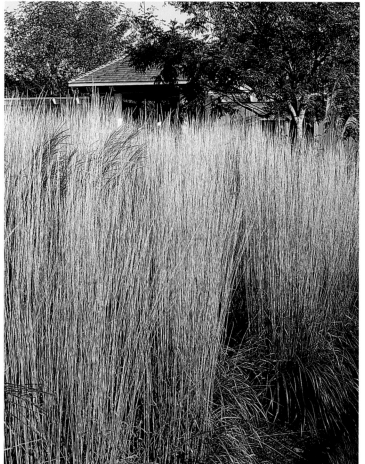

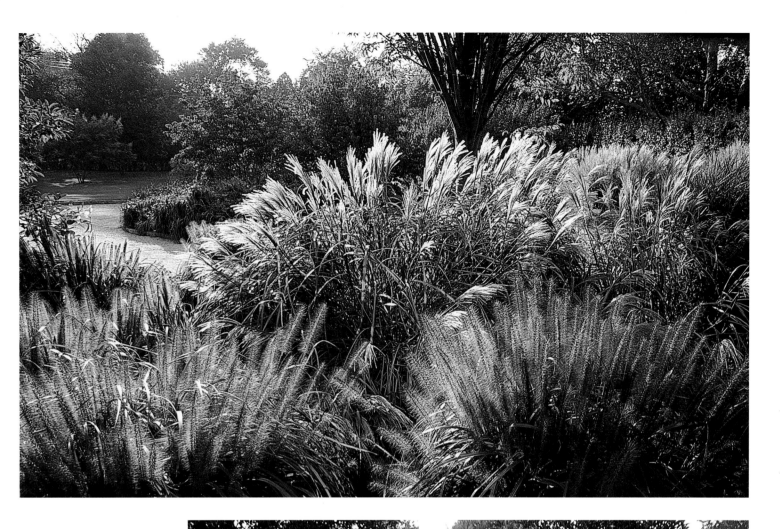

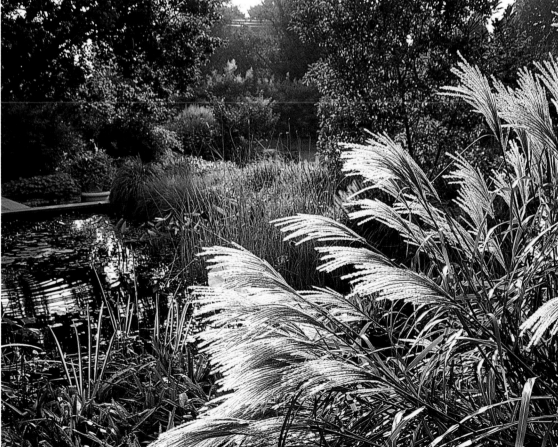

OPPOSITE, TOP The flower heads of *Sedum* 'Herbstfreude' glow in the sun.

OPPOSITE, BOTTOM The luxuriant planting of architectural grasses includes *Miscanthus sinensis* (left) and spiky clumps of *Calamagrostis* × *acutiflora* 'Karl Foerster' (right).

RIGHT, TOP What was once a dead expanse of tarmac has been transformed with swaths of ornamental grasses. Clumps of *Pennisetum alopecuroides* 'Hameln' are seen here in front of *Miscanthus*.

RIGHT, BOTTOM Afternoon sun streams through the spraying wands of silvery-plumed *Miscanthus*.

91

Bury Court

The garden at Bury Court harmoniously blends the creative input of three luminaries of late twentieth-century design and horticulture. On one side of the house is the work of the Dutch designer Piet Oudolf (see pp. 316–17), while the impeccably sophisticated front garden is by Christopher Bradley-Hole. The client is John Coke, whose nursery, Green Farm Plants, now closed, was the one-stop shop favoured by anyone inspired by the New Perennial Movement. Bradley-Hole's garden, seen here, employs form and geometry that are expressed in strategic blocks of colour. Its apparent simplicity is underpinned by a plethora of detail. The layout was conceived in terms of strata: water in the pond; bands of chunky Yorkshire stone in varying widths around the beds; fine compacted gravel for the paths; and soil. Twenty beds 4 m (12 ft) square edged with Cor-ten steel are laid out in a grid and filled with perennials that originate from a meadow habitat. A preponderance of grasses is joined by a host of sophisticated relations of buttercup, dock and cow parsley. This is a garden that is as full of texture and form in February, before the bleached grasses are given their annual cut, as on any summer's day.

RIGHT The creamy plumes of eulalia, *Miscanthus transmorrisonensis*, retain their feathery form throughout winter. Cohesion is achieved not only by repeating particular plants but also by growing many different species or cultivars of a genus. For example, seven different types of *Miscanthus* are scattered throughout the garden, from the giant *M. floridulus* down to *M. sinensis* 'Little Kitten.'

OPPOSITE, TOP Plants were selected that would fit into the context of a meadow and require no staking. Seen here are *Molinia caerulea* subsp. *arundinacea* 'Skyracer', *Sanguisorba canadensis* and *Miscanthus sinensis* 'Hermann Müssel'.

OPPOSITE, BOTTOM At the heart of the garden is a building formed from two interlocking cubes of green oak, one at ground level and the other above, creating a staggered roof structure. At the same time sturdy and delicate, it is reflected in a jet-black pond of identical dimensions to the beds.

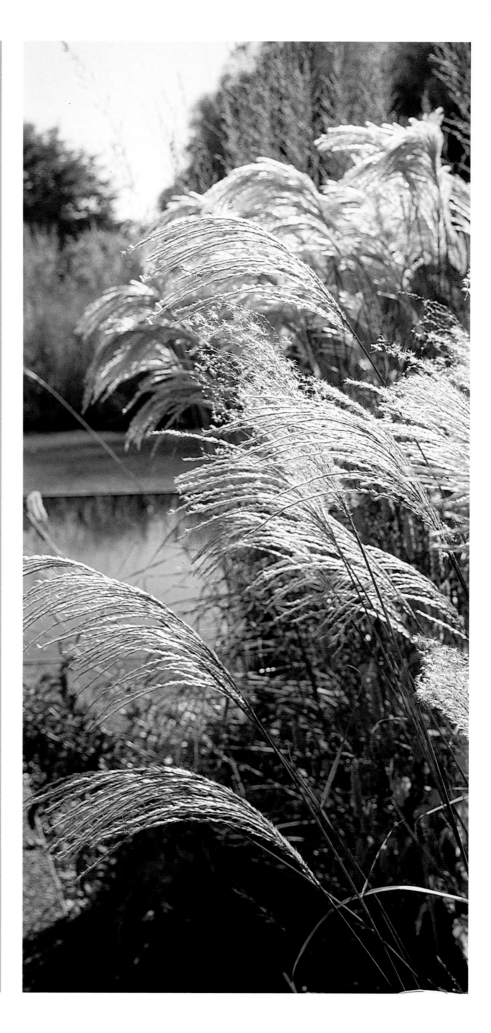

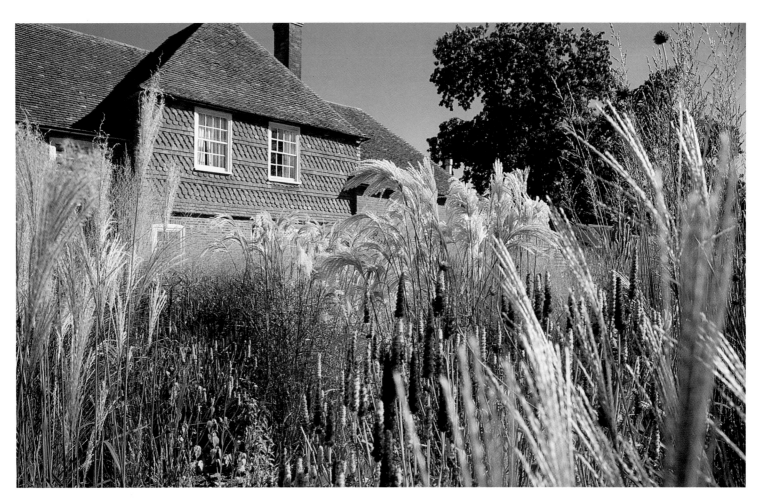

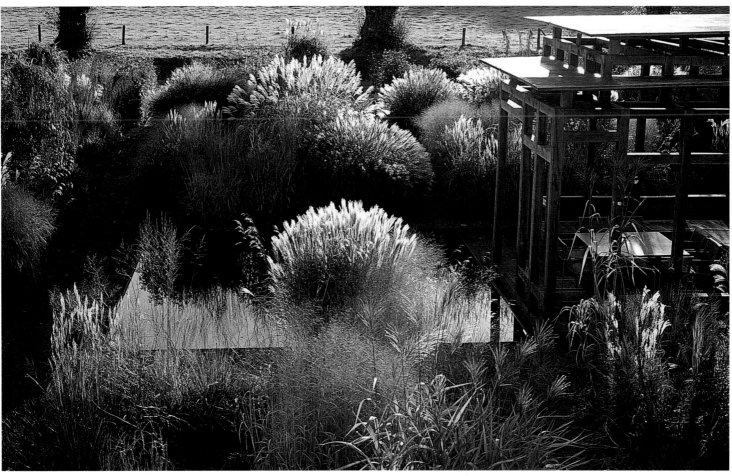

92

Gilcombe Cottage

Nori and Sandra Pope never intended to bring this Somerset garden into being. As custodians of the exhilarating colourist garden at Hadspen (see pp. 300–03) they were determined to keep their own garden maintenance-free, but, having converted the farmhouse, this energetic couple could not resist the temptation to experiment. Colour-themed planting here was executed in looser, more naturalistic combinations and with larger groups of plants than those at Hadspen. A gravel terrace on the windswept site outside the 25-m (82-ft)-long, south-facing conservatory was filled with vivid burnt-orange flowers through which a trio of ornamental grasses were woven to turn down the heat. The end of the terrace was punctuated with a triangle of *Calamagrostis* × *acutiflora* 'Karl Foerster' that acted as a weathervane and wind chime. A canal provided for the swallows became Nori's lap pool and was surrounded by bold groups of flowers and foliage in plums, purples, blues and silver with shots of signature orange.

TOP The conservatory became a glass-fronted sitting-room where sun-ripened figs, dripping bunches of sweet 'Muscat of Alexandria' grapes and heady *Jasminum sambac* grew with the continuously flowering ice-blue *Plumbago auriculata*. Its windows look on to fiery-orange border planting.

BOTTOM LEFT A simple band of 'Miss Jessop's' upright rosemary forms a low hedge outside the conservatory.

BOTTOM RIGHT The lead-lined canal, which doubles as a lap pool, has a wide border containing *Miscanthus sinensis* 'Malepartus', *Potentilla* 'Gibson's Scarlet', *Astrantia* 'Hadspen Blood', *Achillea* 'Summerwine', purple orach, *Atriplex hortensis*, and the short *Miscanthus sinensis* 'Nippon'. *Nepeta* 'Six Hill's Giant' lines the end of the canal, with *Cotinus coggygria* 'Royal Purple' to the left.

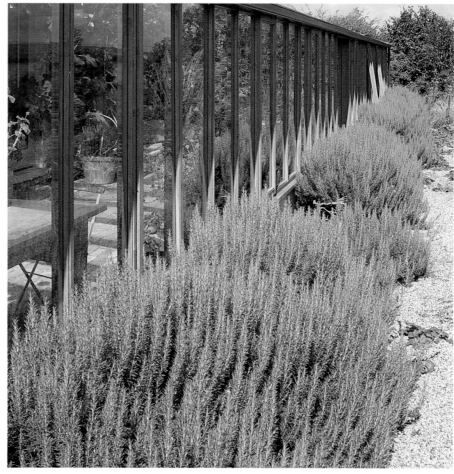

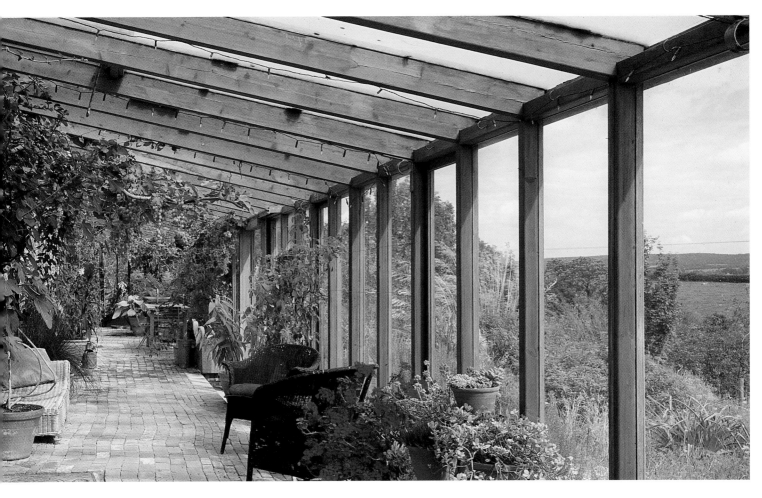

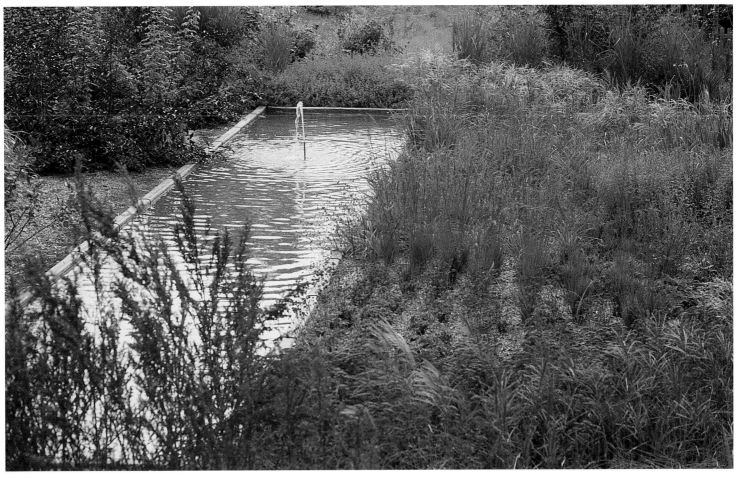

93

East Sussex

Until recently this rigorous minimalist garden, designed by Christopher Bradley-Hole, was an unremarkable slope of mown grass. Conventional terracing has been eschewed in favour of a subtle grid of beds and paths, thirty-six steel-edged squares that each fall away by 20 cm (8 in.) from north to south and east to west. This introduces a vibrant rhythm that is reinforced by exhilarating planting. Large blocks of ornamental grasses and perennials that rocket out of their chessboard beds have a random distribution throughout the garden but in such large quantities that there is a unifying theme of colour and texture each month. Whether you see this garden as a whole from above and get the impression of a unified contemporary parterre, or from within, when you are engulfed in a maze of *Stipa gigantea* and *Calamagrostis × acutiflora* 'Karl Foerster', the garden is typical of Bradley-Hole's work: deceptively simple but rich in attention to detail and superb craftsmanship.

RIGHT, TOP The tall oat grass, *Stipa gigantea*, and its fluffy relation *S. tenuissima* grow here among the white coneflower, *Echinacea purpurea* 'White Swan', and rusty-brown helenium.

RIGHT, BOTTOM A view along the gradually descending path.

OPPOSITE, TOP The tawny tones of the yarrow *Achillea* 'Walther Funcke' match the panicles of the upright grass *Calamagrostis × acutiflora* 'Karl Foerster', seen here with *Veronicastrum virginicum* 'Album'.

OPPOSITE, BOTTOM LEFT A view down the length of one section of the garden shows the random but pattern-forming distribution of the main ingredients, *Stipa gigantea*, *Calamagrostis × acutiflora* 'Karl Foerster' and *Verbena bonariensis*.

OPPOSITE, BOTTOM RIGHT The airy white flowers of *Gaura lindheimeri* edge the path among stipa and achillea.

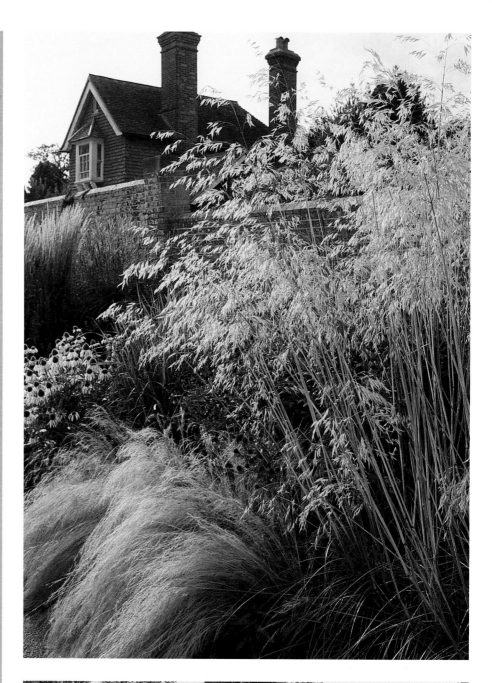

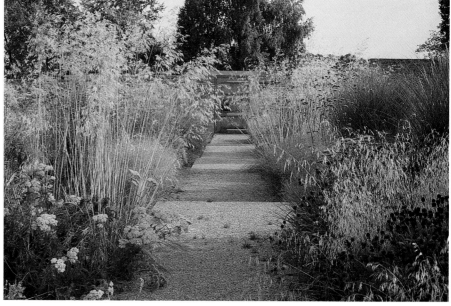

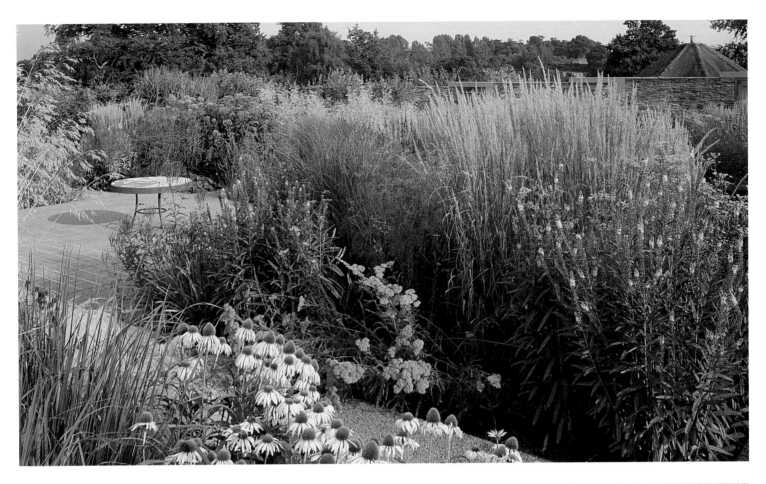

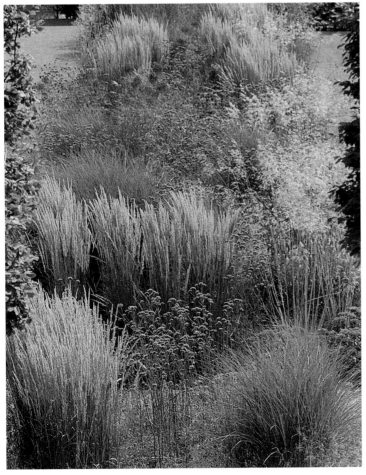

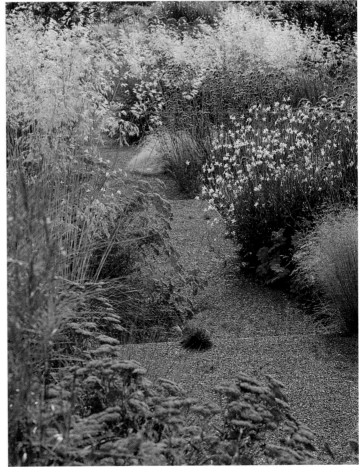

94

Pettifers

Gina Price, who created this private Oxfordshire garden, was inspired by a vase of autumn flowers she saw when attending a lecture to create a border that would have similar impact. It is not easy to replicate outdoors the textures, colours and volumes of a collection of cut flowers, but several years of readjustments, plant additions and subtractions have resulted in a composition that Gina, her husband, James, and their gardener are justly proud of. The siting of the border against the field fence gives it a backdrop of rolling open countryside, so the planting needed to be bold but not too tall. Instead of the giant forms of miscanthus they used *Miscanthus sinensis* 'Yakishima Dwarf', a perfect partner for Michaelmas daisies and aconites. There is no strict colour palette: blues and white mix with fiery oranges of the red-hot poker, *Kniphofia rooperi*, while burnt-orange *Crocosmia × crocosmiiflora* 'Emily McKenzie' positioned in front of *Rosa moyesii* enhances the intense red of the rose hips.

RIGHT, TOP In front of the house a formal garden of clipped topiary leads to the lawn and less formal borders of *Sedum* 'Herbstfreude', *Verbena bonariensis*, *Aster × frikartii* and the tall, plumed seed heads of *Macleaya microcarpa*.

RIGHT, BOTTOM *Gleditsia triacanthos* 'Sunburst' and *Lonicera nitida* are planted in borders close to the house.

OPPOSITE The Gothic windows of the Prices' house overlook raised beds where self-sown silver-leaved *Cerastium tomentosum* spreads among the stones and ornamental urns. An injection of red is added in autumn by sedum flower heads and the glowing leaves of *Acer palmatum*.

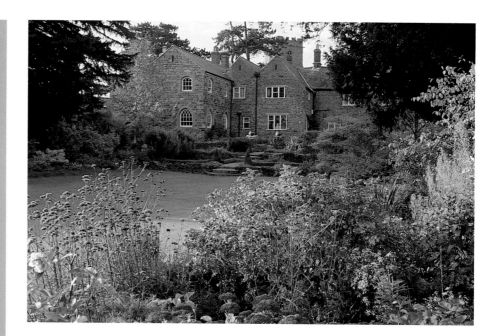

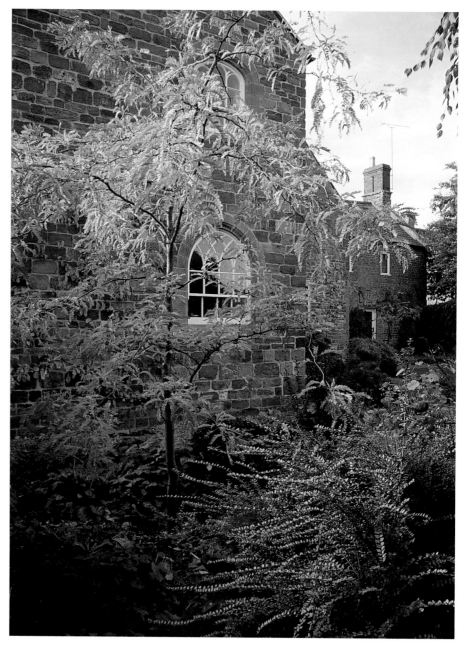

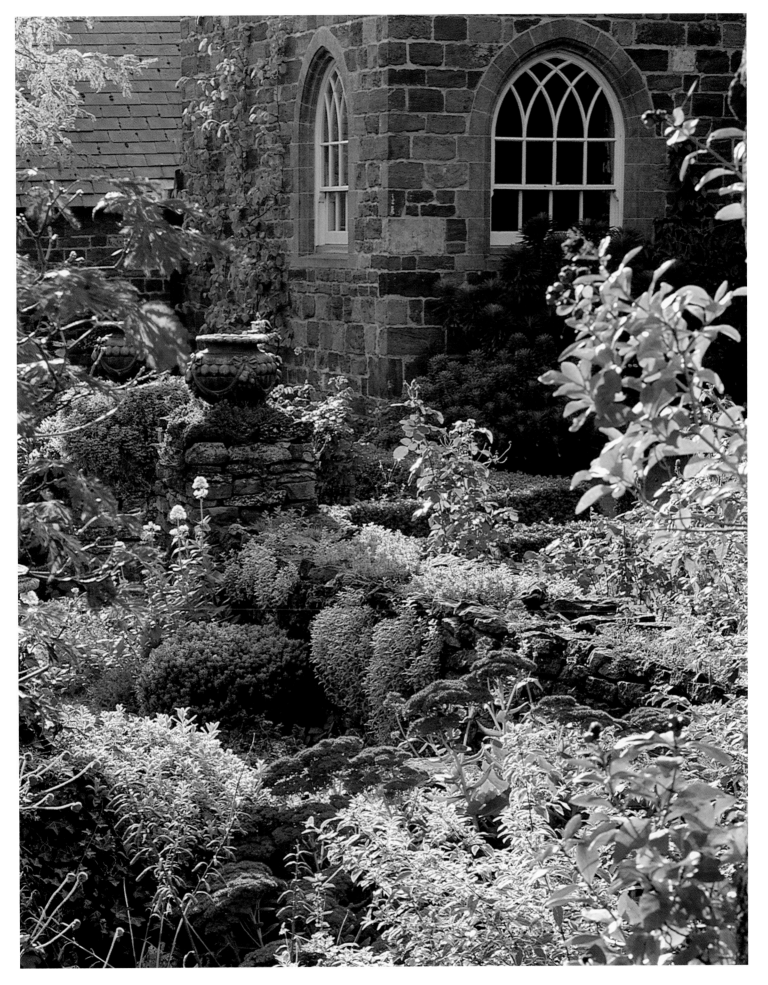

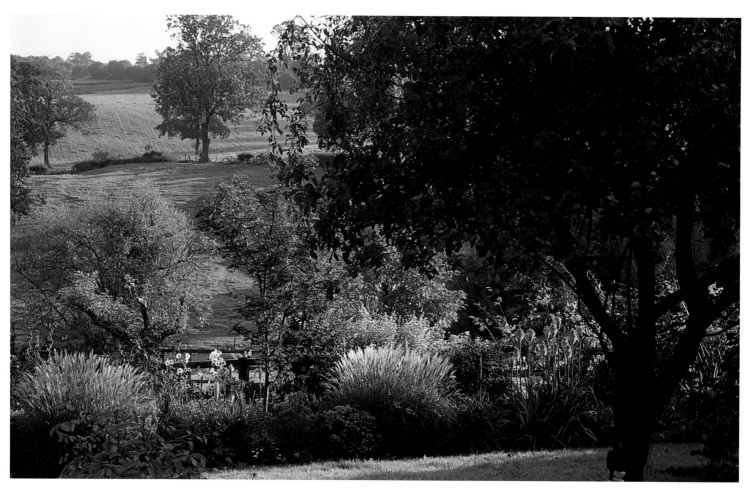

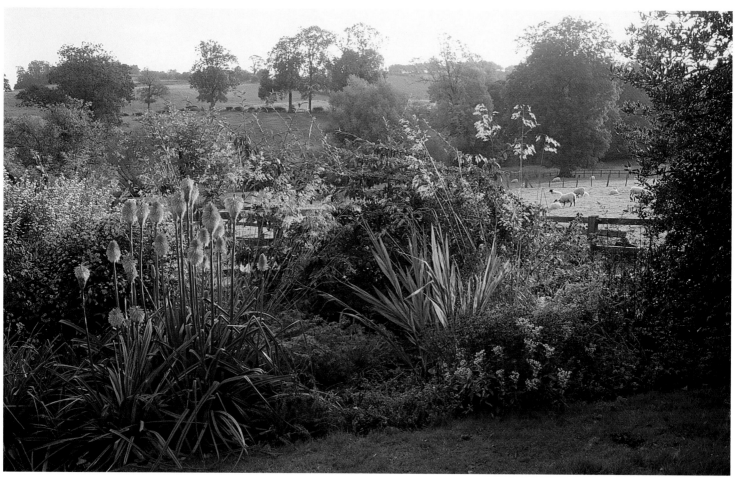

OPPOSITE, TOP Short plants preserve views across the rolling Oxfordshire countryside. Instead of towering eulalia grasses, *Miscanthus sinensis* 'Yakushima Dwarf' partners a wide range of autumn perennials.

OPPOSITE, BOTTOM Tall clumps of *Kniphofia rooperi* are mixed with crocosmia, *Stipa gigantea* and helenium.

RIGHT The bright flowers of *Aster amellus* 'Veilchenkönigin' and the silver-plumed *Miscanthus sinensis* 'Yakushima Dwarf' are balanced by the indigo aconitum behind.

BOTTOM LEFT *Sedum* 'Herbstfreude' and *Stipa tenuissima*, with their contrasting textures, make perfect partners.

BOTTOM RIGHT *Crocosmia* × *crocosmiiflora* 'Emily McKenzie' grows with a particularly late-flowering *Polemonium careuleum*, with the hips of *Rosa* 'Geranium' behind.

95

The Garden in Mind

Ivan Hicks designs gardens in which he likes to meld fantasy with reality. In this walled enclosure at Stansted Park in West Sussex he created The Garden in Mind (no longer in existence) to provide drama, excitement and humour. An exponent of living sculpture, he uses trees as the raw material, and a passion for and knowledge of trees informs the way he experiments with shape. A trembling poplar, for example, was here kept low so that the shimmer of its leaves could be appreciated at eye level. He likes to give trees partners that will enhance their salient characteristics, so a twisted ribbon of iron was placed beside a contorted willow and the shining red stems of *Prunus serrula* were backed by scarlet-stemmed dogwoods that blazed with yet more red in autumn. Rusted ironwork was paired with the brown winter silhouettes of teasel and the burnt-orange berries of sea buckthorn were set beside a tower of terracotta pots.

RIGHT The gnarled and twisted upper branches of the contorted willow, *Salix babylonica* var. *pekinensis* 'Tortuosa', are echoed by a spiral of rusted and twisted metal placed against the willow's fast-growing, upright trunk.

OPPOSITE Tall metal poles of varying height were topped with an assortment of garden tools in this clever sculpture. Alongside them two birch trees are being encouraged to grow up intertwined.

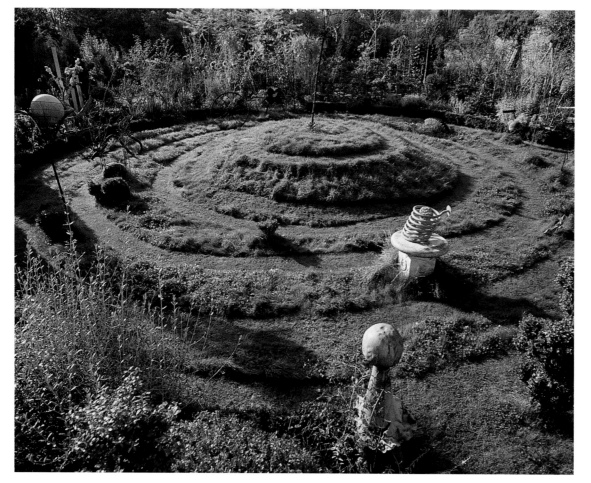

LEFT, TOP The plum-coloured plumes of *Miscanthus sinensis* 'Variegatus' are seen in front of a tripod sculpture of stacked terracotta plant pots.

LEFT, BOTTOM Surrealist *objets trouvés* are placed on and around the spiral mound at the heart of the garden.

ABOVE Shards of mirror dangle from a painted mannequin's hand that hangs from a vine.

OPPOSITE, TOP LEFT A single stack of terracotta pots stands beside a sea buckthorn, *Hippophae rhamnoides*, covered with bright-orange berries.

OPPOSITE, TOP RIGHT Two sculptures are made from carefully piled pebbles.

OPPOSITE, BOTTOM LEFT Rusted metal harmonizes in colour with the seed heads of teasels and docks.

OPPOSITE, BOTTOM RIGHT Precision-cut pieces of timber from a sitka spruce, *Picea sitchensis*, form a tapering tower.

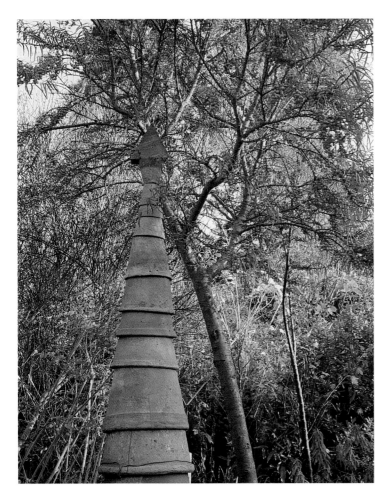

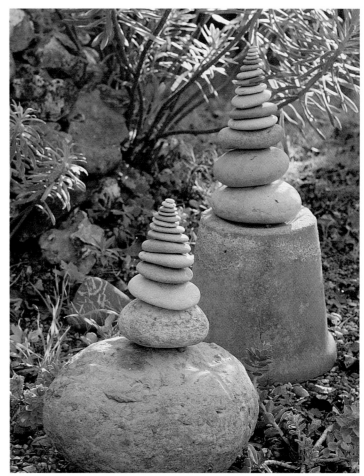

96

Mamoroneck

Many of the gardens designed by OvS, the landscape-architecture practice of Wolfgang Oehme and James van Sweden, are on a monumental scale, but in this garden in Mamoroneck, 32 km (20 miles) north-east of New York, all the hallmarks of an OvS design are seen within a property of 0.4 hectare (1 acre). Terry Blumer wanted a garden that would not demand excessive maintenance and that would blend with the local marshland habitat of Long Island Sound. The solution was to use a large proportion of ornamental grasses to form a link between the naturally occurring marshland grasses and the more decorative cultivars favoured by OvS. Terraces, wide steps and seating areas provide zones of calm surrounded by towering plants laid out in bold blocks that create diaphanous divisions between the various sections of the garden.

RIGHT The upright, creamy-white plumes of tall eulalia grass, *Miscanthus sinensis*, surrounding a stone-paved seating area are an elegant match for the drooping branches of a mature weeping willow. When one sits here quietly in the evening, the grass fills with perching and chattering birds.

OPPOSITE, TOP The old stone cottage sits at the top of the steeply sloping garden that descends in a series of steps and terraces. Adjoining banks are covered with bold planting such as this expanse of *Pennisetum alopecuroides*.

OPPOSITE, BOTTOM Through winter both *Pennisetum alopecuroides* and *Sedum* 'Herbstfreude' will continue to look much as they do here.

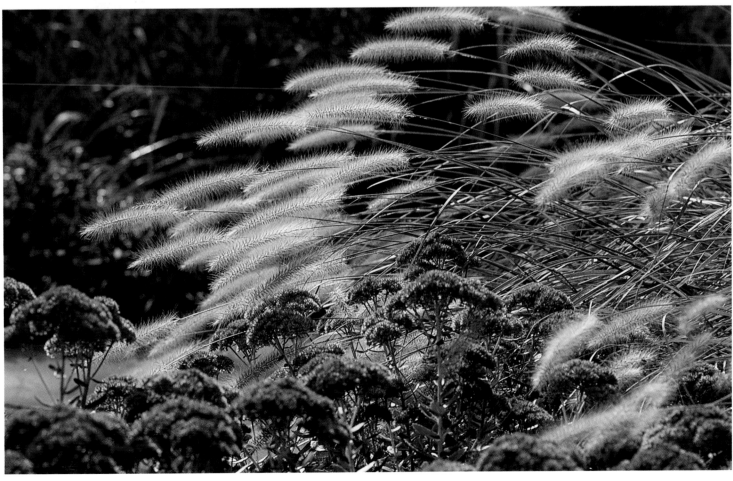

97

The Picton Garden

Since the explosion of admiration for ornamental grasses in the late twentieth century there has been renewed interest in other good plants for autumn displays, and at the Picton Garden in Colwall, near Malvern in Worcestershire, the Michaelmas-daisy borders prove that it need not be all bleached seed heads or sunset tones in autumn. The onslaught of ultra-violet rays from Paul and Meriel Picton's collection, displayed like a series of impressionistic tapestries, is an invigorating reminder not to put our gardens to bed too early or dismiss the aster tribe because of its propensity to be blighted by mildew. There is a uniformity within various groups of asters that is particularly good for massed planting, but other asters also display striking variation in height and habit. In height they range from the rocketing 2-m (6½-ft) mauve-flowered *Aster cordifolius* 'Chieftain' via the delicately filigree white-flowered *Aster pringlei* 'Monte Cassino' to the hummock-forming *Aster novi-belgii* 'Lady in Blue', which squats at around 25 cm (10 in.). Soft colours and psychedelia: essential autumn fare.

RIGHT, TOP The mauve *Aster* 'Little Carlow' fills the foreground, while the white plumes of *Sanguisorba canadensis* and arching sprays of yellow-flowered *Solidago rugosa* 'Fireworks' are behind and the striking magenta *Aster novae-angliae* 'Andenken an Alma Pötschke' is at the back.

RIGHT, BOTTOM Taller mixtures of both New York and New England asters are backed by other tall perennials that the Pictons recommend as companion plants, such as golden rod, rudbeckia and eupatorium.

OPPOSITE This kaleidoscopic carpet of New York asters zings with colour from late summer to late autumn in the Pictons' garden. The more compact and dwarf cultivars of *Aster novi-belgii* are used for these sweeping beds, and they make this display in their first year, grown from cuttings.

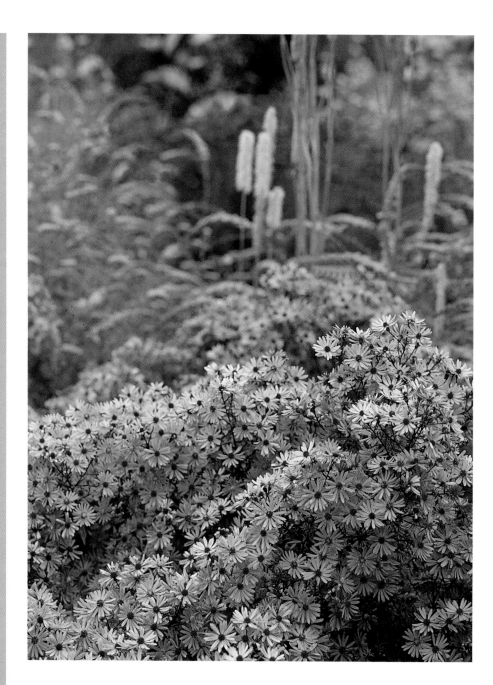

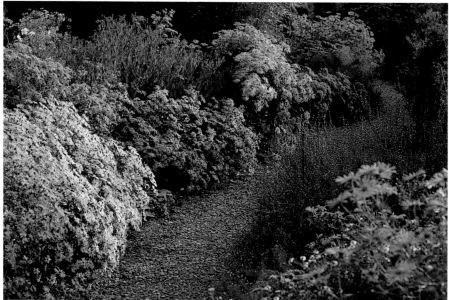

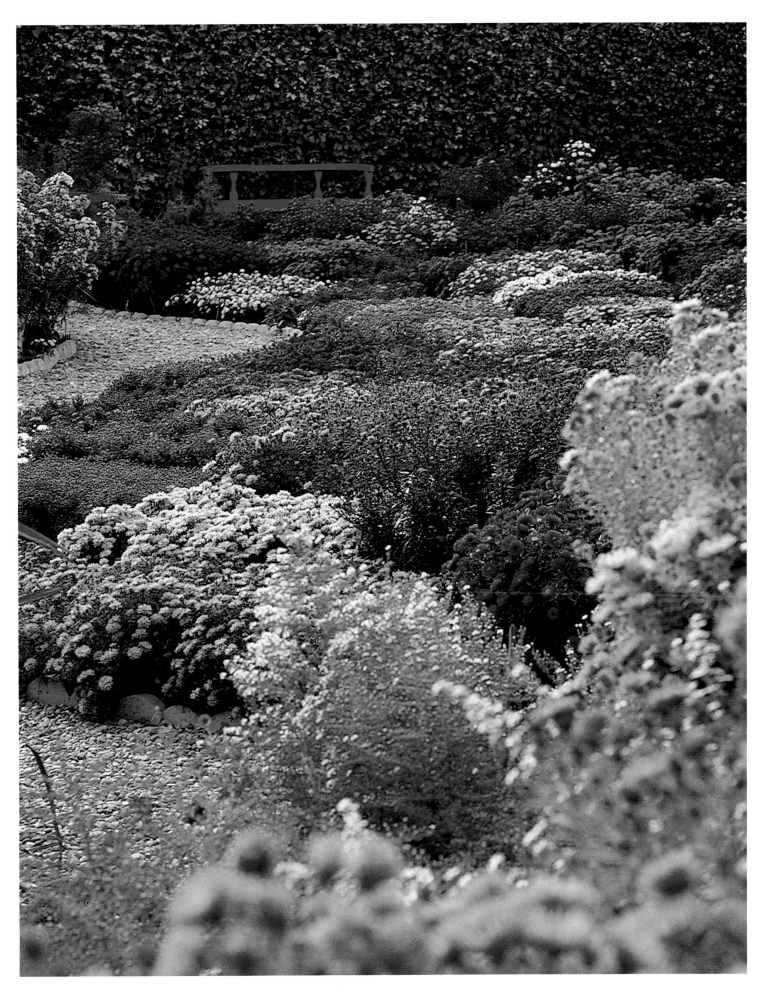

Lady Farm

The swaths of prairie- and steppe-style planting at Lady Farm in Somerset came about after Judy and Malcolm Pearce were left with two massive banks of clay subsoil after building a tennis court. Judy, with the help of garden lecturer Mary Payne, chose only plants that would flourish in subsistence conditions. Planting holes were hacked out with a pickaxe, and, apart from a surface mulch of bark chippings, the plants received little attention. The prairie, with its extravagant drifts of massed grasses and perennials, rocketed into growth, displaying various miscanthus, *Stipa gigantea* and *S. tenuissima*, *Calamagrostis* × *acutiflora* 'Karl Foerster', with bands of yellow *Rudbeckia fulgida* var. *deamii*, eryngiums and white coneflower. The steppe was given barrow-loads of gravel mulch, and shorter, tuftier plants were selected: a lot more *Stipa tenuissima* to link the two areas, abundant mounds of silvery *Artemisia arborescens* 'Canescens' and golden coreopsis.

RIGHT, TOP Fountain-like plumes of *Calamagrostis* × *acutiflora* 'Karl Foerster' rise out of a mass of *Rudbeckia fulgida* var. *deamii* on the prairie-style bank.

RIGHT, BOTTOM *Origanum laevigatum* 'Herrenhausen' grows with feathery *Stipa tenuissima* and small, starry *Coreopsis verticillata*.

OPPOSITE, TOP Seen from across the ornamental lake – the left side of the bank is fringed with purple loosestrife, *Lythrum salicaria* – the prairie planting is laid out on a steep, wide slope. This offers excellent drainage and creates a more dramatic impression than if the planting were on flat terrain.

OPPOSITE, BOTTOM Large groups of plants are scattered across the bank, resulting in a unified composition. *Stipa gigantea*, *S. tenuissima* and *Anemanthele lessoniana* thread through the planting with echinacea, crocosmia, golden rod, red-hot pokers, silver artemisia and towering verbascum.

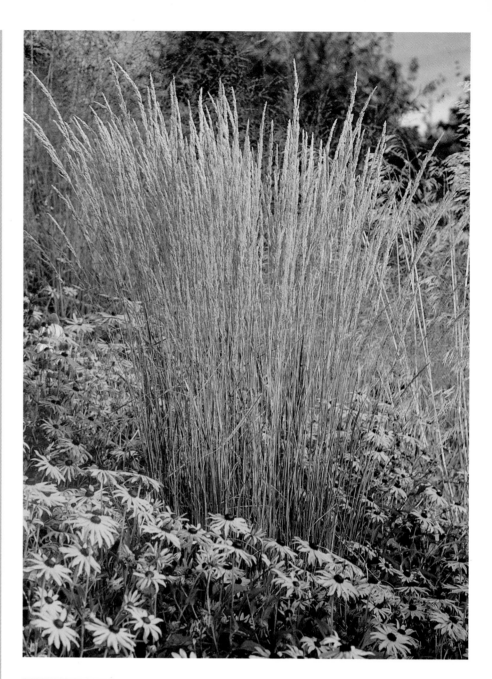

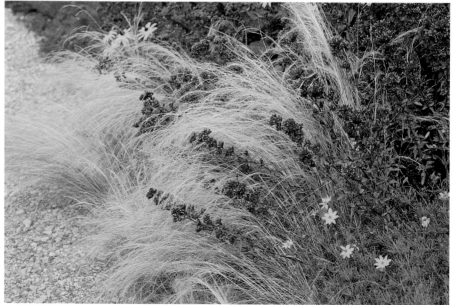

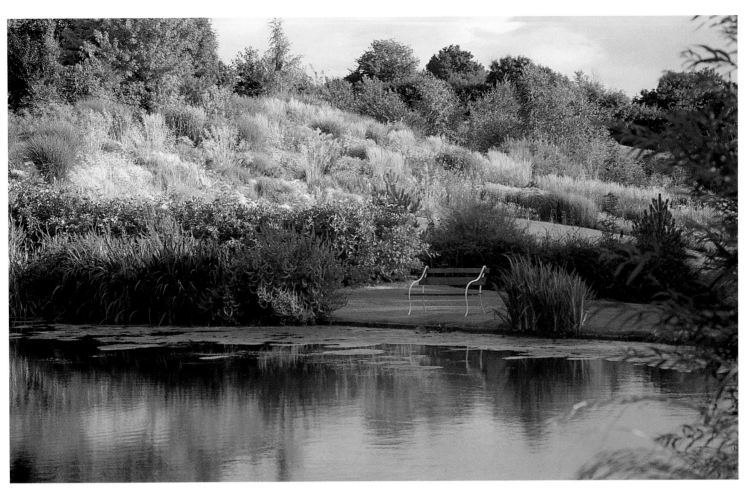

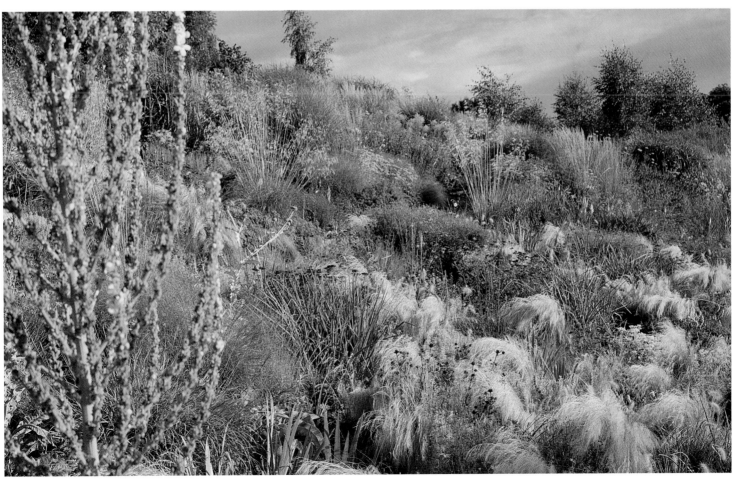

99

Crockmore House

Christopher Bradley-Hole trained as an architect before leaping over the fence into landscape architecture. The overriding sense of harmony in his gardens and their detailed components derives from his use of the compositional principle known as the golden section. A sense of proportion and order is prominent in all his designs, from the hard surfaces to his luxurious swaths of naturalistic planting. His distinctive mix of grasses and perennials has a particularly delicate touch and softer results than most other proponents of the New Perennial Movement. The garden at Crockmore House in Oxfordshire shows his masterly plant associations, both in the bank garden, where muted creams and pinks interweave in a scene that manages to be at once bold and quiet, and also in the grid beds. These beds are 2 m (6½ ft) square and something of a Bradley-Hole trademark, born of his desire for the planting to be experienced from all sides and as a whole.

The idea behind the grid beds was to create a tableau redolent of a meadow. To achieve this effect Bradley-Hole blended ornamental grasses and delicate perennials that give a soft, romantic feeling to the planting and backed them up with such robust plants as purple eupatorium and *Helenium* 'Dunkelpracht'. Prominent among the plants that thread their way through the composition, giving it visual unity, are various deschampsias, sanguisorbas and miscanthus, *Persicaria amplexicaulis, Gaura lindheimeri, Stipa gigantea, Verbena bonariensis* and *Lysimachia ephemerum.*

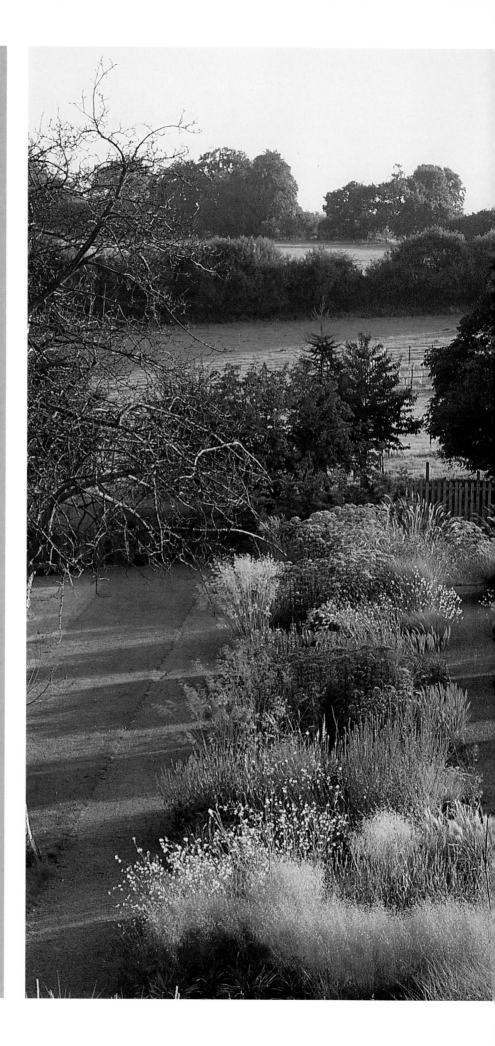

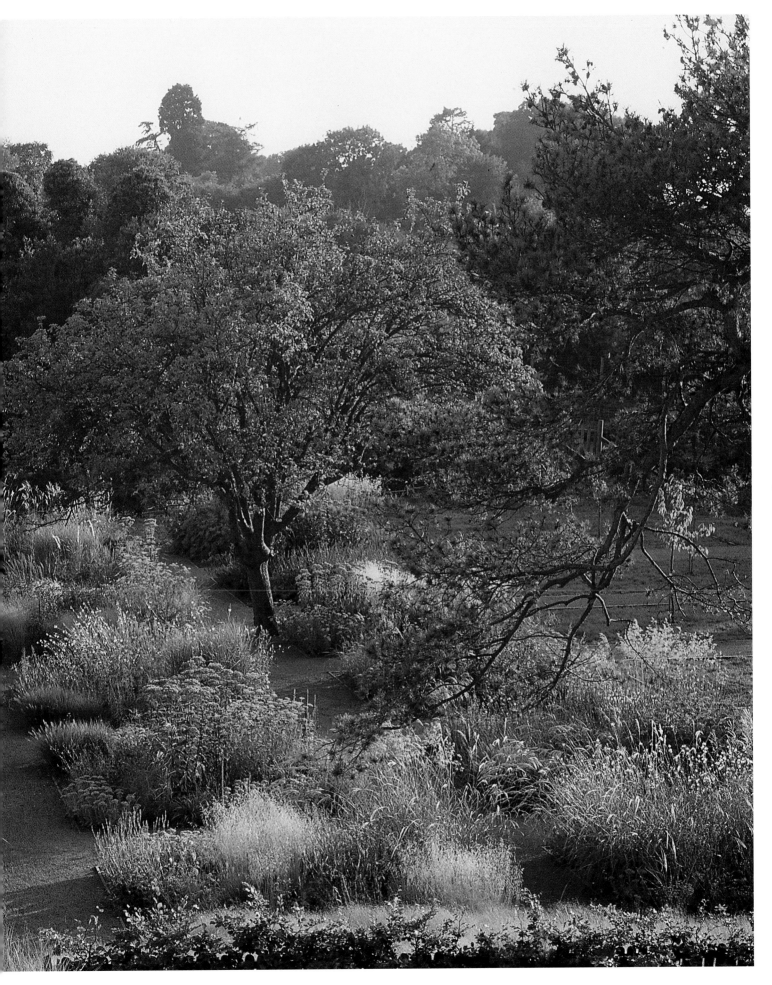

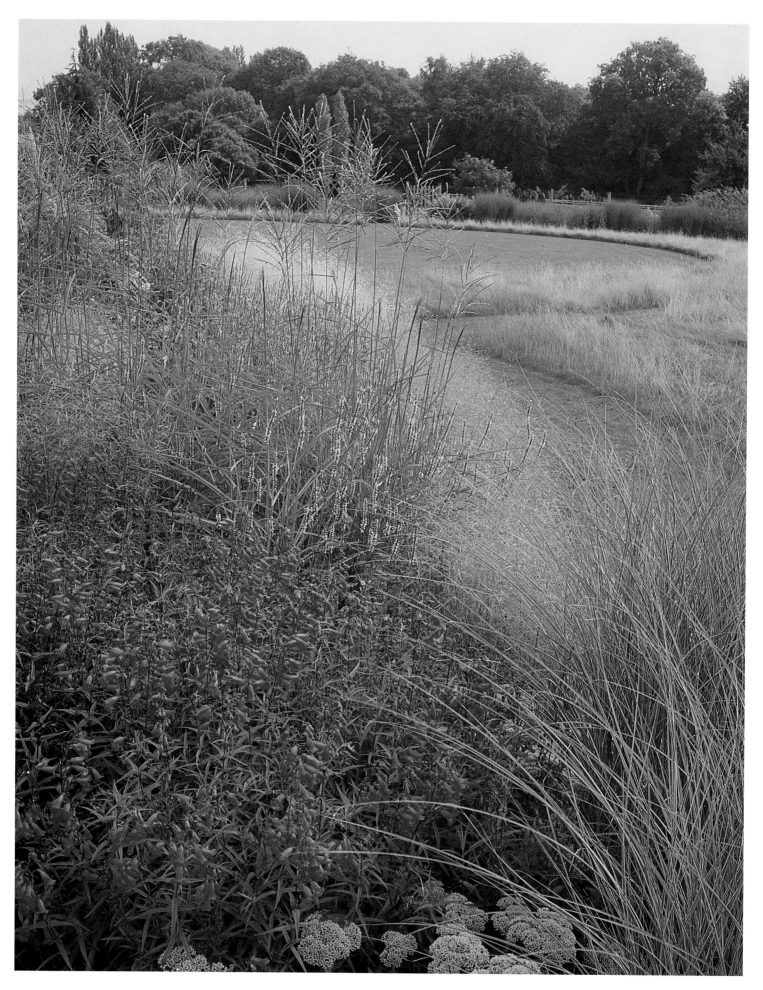

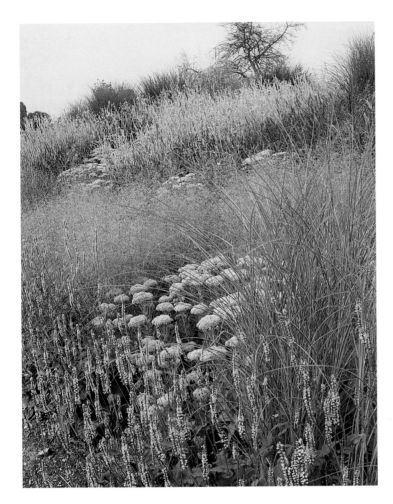

OPPOSITE The bank garden cuts a long, sloping swath separating the top terrace from a beautifully levelled lawn. The lawn has various zones with different mowing regimes so that there are strong textural contrasts between the smooth, green lawn and the bleached long grass. Among the plants in this section of the bank are *Penstemon* 'Andenken an Friedrich Hahn', *Persicaria amplexicaulis* 'Rosea', *Miscanthus sinensis* 'Ferner Osten', *Sedum* 'Herbstfreude' and *Deschampsia cespitosa* 'Goldtau'.

TOP LEFT The planting on the bank seen from below.

TOP RIGHT Sturdy sedum is partnered with delicate deschampsia.

BOTTOM LEFT Sunlight streams through *Stipa gigantea* and arching *Miscanthus sinensis* 'Flamingo'.

BOTTOM RIGHT A view down a long section of the grid beds.

100

Denmans

The garden at Denmans in West Sussex, the home of John Brookes, designer and lecturer to aspiring landscape professionals, is peaceful, understated and unusual. Unlike most designers' gardens it has evolved in a loose, organic way, partly because of the collaborative nature of the planting that Brookes shared with the previous owner, Joyce Robinson. The 1.4 hectares (3½ acres) are subtly divided, flowing in bold sweeps rather than rigid geometric lines, and the transition from lawn to meadow to water's edge, whether one is on grass or gravel, under the canopy of trees or out in the open, feels very natural. This garden is intended to show how planting to give a wide variety of interest throughout the year can be managed with minimal maintenance, and its use of gravel as a mulch and planting medium has been particularly influential. Self-sowing eryngiums, verbascums and salvias unite the garden's various areas in summer, and many of the trees have been chosen for their good autumn colour.

RIGHT The juxtaposition of form and foliage gives great character to this garden view looking past a Cretan pithoi with *Yucca recurvifolia* planted at its base, to a bench painted in deep but vibrant blue. The silver birch is partnered by a rose and the glossy, leathery, rich-green leaves of a Chinese redbud.

OPPOSITE, TOP A veil of butter-yellow birch leaves is seen here with the bright scarlet autumn leaves of *Acer griseum*, and the two are set off by a carpet of low-growing *Euphorbia amygdaloides* var. *robbiae* and *Persicaria affinis* 'Darjeeling Red'.

OPPOSITE, BOTTOM Small orange rose hips and dark-indigo *Aconitum* 'Spark's Variety' contrast vividly.

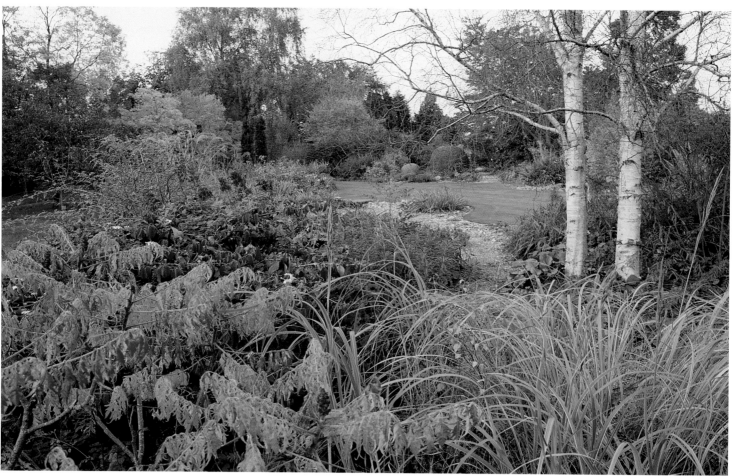

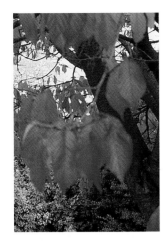

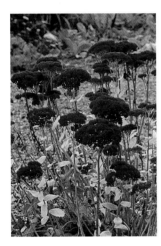

OPPOSITE, TOP A multi-stemmed snake-bark maple on the other side of the pond has butter-yellow autumnal tints that match the field maple on the far left.

OPPOSITE, BOTTOM A wide bed of mixed shrubs, perennials and grasses includes the fiery-orange *Rhus × pulvinata* 'Red Autumn Lace', golden variegated pampas grass and russet *Viburnum plicatum*.

ABOVE, FROM TOP An intense red is provided by the leaves of an ornamental cherry tree; the seed heads of sedum will keep this outline throughout winter.

RIGHT Cutting back *Salix alba* var. *vitellina* to 30 cm (1 ft) above the ground in winter ensures that bright young stems will decorate the garden in spring. Here it is combined with the felty leaves of *Verbascum olympicum*.

dream gardens: design credits

1 David Hicks

2 Michael Balston

3 James Ursell

4 Mary Keen

5 Alice Coptcoat

6 Carol Klein

7 Dame Miriam Rothschild

8 Sir Thomas Hanbury

9 Brenda Colvin and Hal Moggridge

10 Marylyn Abbott

11 Brian MacDonald

12 Simon and Antonia Johnson

13 Katherine Swift

14 Caroline Tisdall

15 Gil Cohen and Paul Gervais

16 Ann Pearce

17 Anthea Gibson

18 Matthew Robinson and Louise McClary

19 Harold Peto

20 Mirabel Osler

21 Gordon and Annette Collier

22 Jill Walker.

23 Dan Pearson and Frances Mossman

24 Anouska Hempel

25 John and Fiona Owen

26 Princess Michael of Kent, with Rosemary Verey and Jane Fearnley-Whittingstall

27 James Fraser and Dan Pearson

28 Arne Maynard

29 Gabriella Pape and Isabelle van Groeningen

30 Paul Bangay

31 Reginald Cooper; Alastair and Mary-Anne Robb

32 James Aldridge

33 Gordon Ford

34 Arne Maynard

35 Tessa and John Manser

36 Geoffrey Jellicoe and Suzy Lewis

37 Bob and Jo Munro

38 Gervase Jackson-Stops

39 Anita Pereire and Marcel Catoire

40 Ian Hamilton Finlay

41 Polly and Andy Garnett

42 Arabella Lennox-Boyd

43 Dan Pearson

44 William Martin

45 Emma Keswick

46 Penelope Hobhouse

47 Tom Stuart-Smith

48 Susannah and Hector Riddell

49 Arabella Lennox-Boyd

50 Martin Lane Fox

51 Lesley Jenkins

52 Anthony Noel

53 Frank and Marjorie Lawley

54 Christina Williams

55 Anne and Frank Cabot

56 John Hubbard

57 Derek Jarman

58 Isabel King and Arabella Lennox-Boyd

59 Tom Stuart-Smith

60 Arabella Lennox-Boyd

61 Margaret Knox

62 Pam Lewis

63 Helen Dillon

64 Todd Longstaffe-Gowan and Tom Stuart-Smith

65 John Belcher, Mary Keen and Carol Klein

66 James Aldridge

67 Lionel and Katherine Fortescue; Keith and Ros Wiley

68 Arabella Lennox-Boyd

69 Marylyn Abbott and others

70 Timothy Vaughan

71 Penelope Hobhouse and Simon Johnson

72 Lance Hattat

73 Naila Green

74 Dan Pearson

75 Gordon Cooke

76 Piet Oudolf

77 Tom Stuart-Smith

78 Mary Ann Crichton Maitland

79 Henk Gerritsen

80 Anja and Piet Oudolf

81 James Fraser/Avant Gardener

82 Terence Conran

83 Jinny Blom

84 Nori and Sandra Pope

85 Vladimir Sitta

86 Christopher Lloyd and Fergus Garrett

87 OvS (Wolfgang Oehme and James van Sweden)

88 Dirk and Eugenie van Weede

89 Piet Oudolf

90 OvS (Wolfgang Oehme and James van Sweden)

91 Christopher Bradley-Hole

92 Nori and Sandra Pope

93 Christopher Bradley-Hole

94 Gina Price

95 Ivan Hicks

96 OvS (Wolfgang Oehme and James van Sweden)

97 Paul Picton

98 Judy Pearce

99 Christopher Bradley-Hole

100 John Brookes and Joyce Robinson

index of designers

Author's acknowledgements

I would like to thank Andrew, the real star of the book. Being allowed to pick my way through his library was more a treat than hard work. I am indebted to his team at Noah's Ark, especially the telepathically efficient Judy Dod. Trips to Charlbury were a joy for lunch with Andrew and Briony 'Three Soups' Lawson. Several wonderful lunches were also had with Julian Honer, Merrell's Editorial Director; thank you, Julian, and Hugh Merrell, for asking me to do the book, and to all at Merrell, who combined fun with serene organization. I am deeply grateful to Sue Crewe, who was pivotal in my getting to know all these gardens, gardeners and designers, and to the rest of the team at *House & Garden*, particularly Matthew Dennison and Nicola Shipway. Thank you to all the fabulous designers and garden owners, and to Erica Hunningher, Lyn Lucas, Henry Johnson and Shelley Rogers. But most of all, to Jamie, Sophie and Freddie.

Photographer's acknowledgements

Dream Gardens have dream owners who have permitted me to take photographs, often at nightmare times of day. I have found, without exception, that people associated with gardens are kind, courteous and generous. I am grateful to them all. I am thrilled to have worked with Tania Compton on this her first book, though she had written brilliantly for magazines already. Julian Honer at Merrell has been supportive throughout, abetted by his dream team of Nicola Bailey, Rosie Fairhead and Michelle Draycott. Special thanks to my home team, led by Judy Dod, on whom my work is totally dependent. Finally, my dear wife Briony remains a constant support, anchor and inspiration.

First published 2007
by Merrell Publishers Limited

Head office
81 Southwark Street
London SE1 0HX

New York Office
740 Broadway
Suite 1202
New York, NY 10003

merrellpublishers.com

Publisher Hugh Merrell
Editorial Director Julian Honer
US Director Joan Brookbank
Sales and Marketing Manager Kim Cope
Associate Manager, US Sales and Marketing Elizabeth Choi
Sales and Marketing Assistant Abigail Coombs
Foreign Rights Manager Anne Le Moigne
Managing Editor Anthea Snow
Project Editors Claire Chandler, Rosanna Fairhead
Editor Helen Miles
Art Director Nicola Bailey
Designer Paul Shinn
Picture Research Manager Nick Wheldon
Production Manager Michelle Draycott
Production Controller Sadie Butler

Text copyright © 2007 Tania Compton
Photographs copyright © 2007 Andrew Lawson
Design and layout copyright © 2007 Merrell Publishers Limited

All rights reserved. No part of this publication may be reproduced, stored in a retrieval system or transmitted, in any form or by any means, electronic, mechanical, photocopying, recording or otherwise, without the prior permission in writing from the publisher.

British Library Cataloguing-in-Publication Data:
Lawson, Andrew, 1945–
Dream gardens : 100 inspirational gardens
1. Gardens – Design 2. Gardens – Pictorial works
I. Title II. Compton, Tania
712.6

ISBN-13: 978-1-8589-4368-8
ISBN-10: 1-8589-4368-X

Produced by Merrell Publishers
Designed by Martin Lovelock
Copy-edited by Richard Dawes
Printed and bound in China

Jacket front (UK edition): Sticky Wicket, designed by Pam Lewis (see pp. 224–27)
Jacket front (US edition): Thorpe Park, designed by Arabella Lennox-Boyd (see pp.218–21)
Jacket back, from top: The Grove, designed by David Hicks (see pp. 14–17); The Woodyard, designed by Ann Pearce (see pp. 68–71); Broughton Grange, designed by Tom Stuart-Smith (see pp. 214–17)
Pages 12–13: *Iris reticulata*
Pages 50–51: *Allium hollandicum* 'Purple Sensation', *Lavandula stoechas* subsp. *pedunculata* and *Foeniculum*
Pages 232–33: Leaves of *Cercis canadensis* 'Forest Pansy' and *Quercus rubra*